Jacky Klein

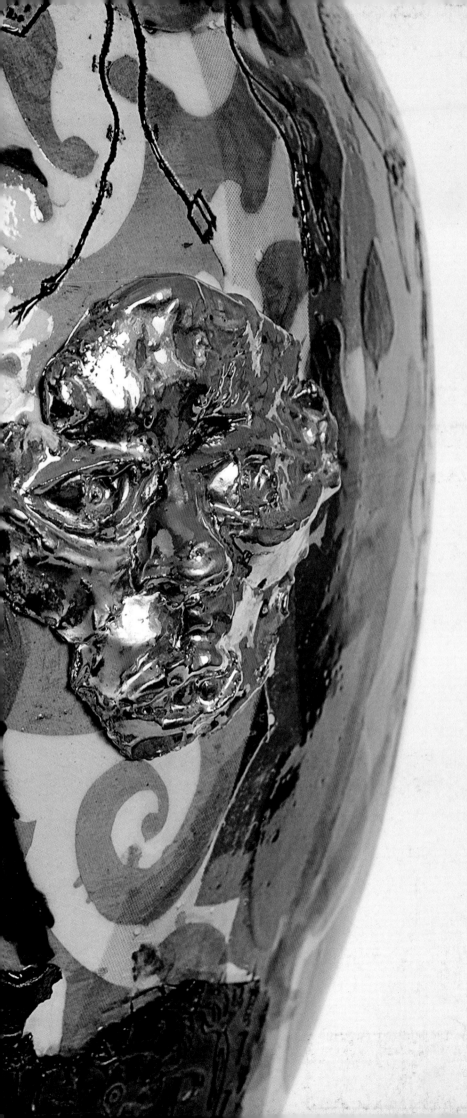

Grayson Perry

UPDATED AND EXPANDED EDITION

with 374 illustrations, 357 in colour

Thames & Hudson

To Suzy, for book days

p. 1 *I Love Beauty*, 2005. Glazed ceramic, 35 × 25 (13¾ × 9⅞).

pp. 2–3 *I Saw this Vase and Thought it Beautiful, then
I Looked at it* (detail), 1995. Glazed ceramic, 45 × 28 (17¾ × 11).

pp. 6–7 75 shards, 1988–2003. Glazed ceramic,
dimensions variable.

All measurements are given in centimetres
(followed by inches).
Dimensions for all works are height × diameter
or height × width × depth unless otherwise stated.

First published in the United Kingdom in 2009 by
Thames & Hudson Ltd, 181A High Holborn, London WC1V 7QX

This updated and expanded edition published in 2013

British Library Cataloguing-in-Publication Data
A catalogue record for this book is available from
the British Library

ISBN 978-0-500-29080-4

Printed and bound in Singapore by Tien Wah Press (Pte) Ltd.

To find out about all our publications, please visit **www.thamesandhudson.com**.
There you can subscribe to our e-newsletter, browse or download our current catalogue,
and buy any titles that are in print.

contents

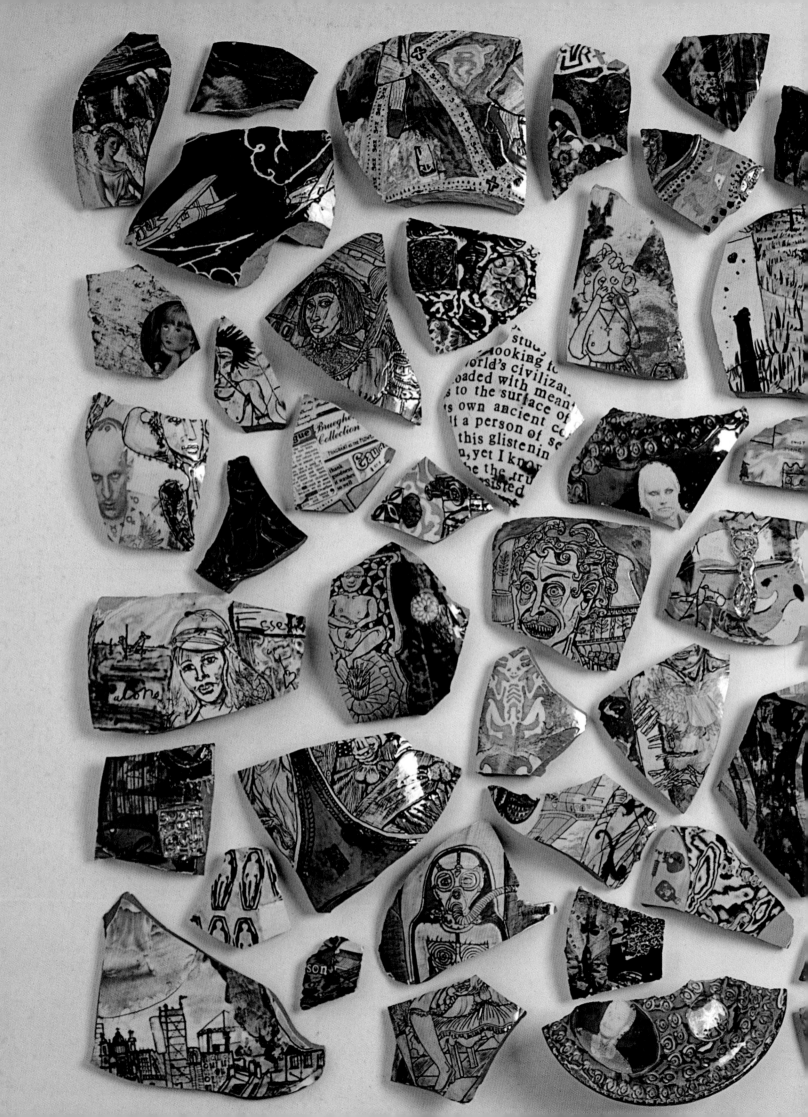

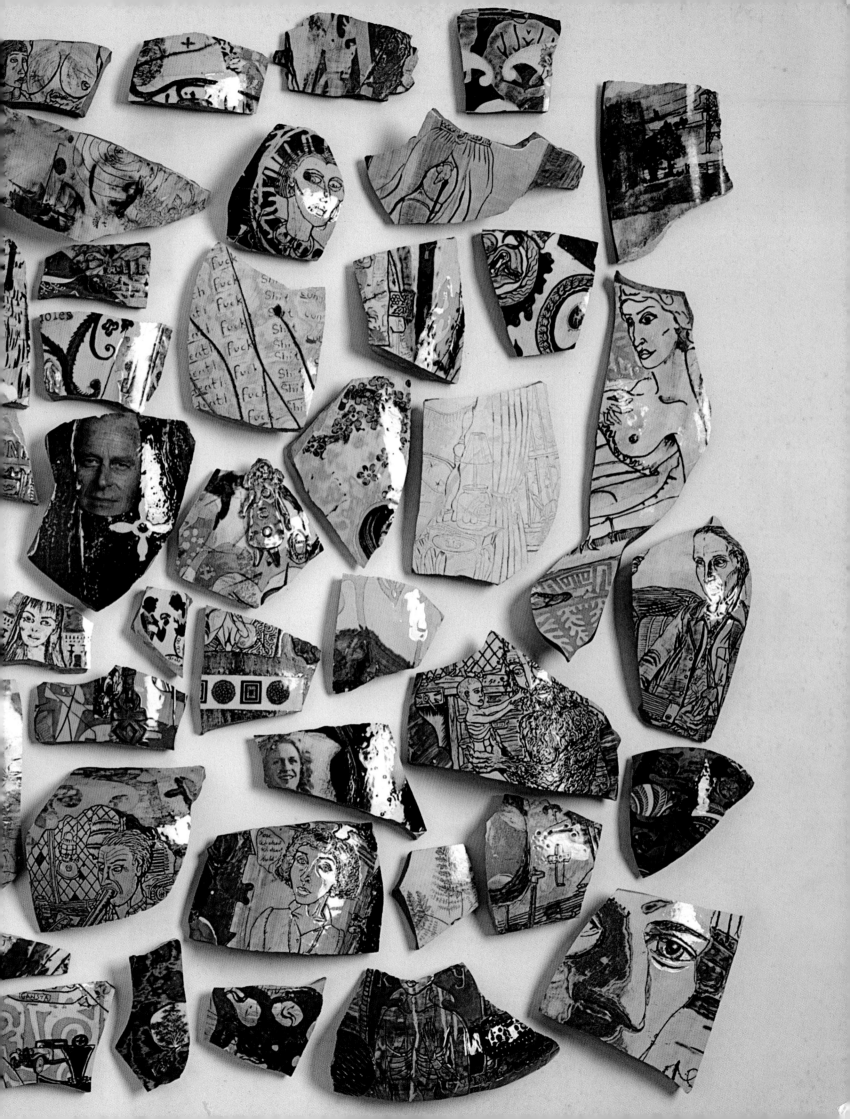

introduction mapping the world of grayson perry

Grayson Perry has been widely hailed as one of the most thoughtful and provocative artists to have emerged on the international art scene since the early 1990s. He has received public praise and art-world plaudits alike: winning the Turner Prize in 2003, he has gone on to stage blockbuster exhibitions, to write a column in a national newspaper, to design his own building, set himself up as an alternative fashion icon, and get elected into the elite society of Royal Academicians.[1] Something of a media celebrity, Perry has made numerous appearances on radio and TV, becoming a regular on everything from the BBC's 'Culture Show' and 'Newsnight Review' to the popular satirical quiz progamme 'Have I Got News for You?'.[2] Dubbed by journalist Rosie Millard 'the most articulate contender in the art world's premier league', his work is loved by everyone from media pundits to politicians – both the UK Culture Secretary and the Chancellor of the Exchequer selecting his art to hang in their private offices.[3] Perry is now arguably the most popular British artist since Lucian Freud and David Hockney – the latter of whom he pipped to the post when he won the 2012 South Bank Sky Arts Award for visual art with his exhibition at London's British Museum, beating Hockney's landscape restrospective across town at the Royal Academy of Arts.

Born in Chelmsford, Essex, in 1960, Perry is a contemporary of the YBAs, the generation of celebrated Young British Artists that includes Damien Hirst, Rachel Whiteread, Sam Taylor-Wood and Jake and Dinos Chapman. Like them, he has hit the headlines for his provocative work; he, too, has been feted internationally and enjoyed the patronage of major art collectors, including the highly influential Charles Saatchi. Yet unlike most of the 'Brit Artists', Perry has divided the art establishment of curators and critics, and there is a lingering doubt about him in certain quarters of the art world where, even today, he is viewed as something of an oddity. He seemingly opens up a fault line, and for all his enthusiastic supporters there are just as many who have viewed him with derision or

outright disdain.[4] Perry's work has rarely been reviewed in art magazines and has only once been the subject of serious critical comment in an exhibition catalogue – a situation almost unprecedented for an artist of such high profile.[5]

What could account for this divergence of views, and what is it that discomforts many in the art world? One answer lies in the nature of Perry's art and aesthetics. His work, filled with text and narrative, contemporary storytelling and snippets of popular culture, runs counter to the more allusive and coolly conceptual vein of much contemporary art. In contrast to what he describes as 'the aimless, apparently transcendent thing in sub-Rothkos: "Oh, this is all about spirituality",' Perry instead opts for work very clearly 'about your mother-in-law or poverty or war'.[6] His art is also inherently accessible, in an art world where accessibility is often taken for banality and where, instead, intellectual difficulty and abstraction are highly prized. During the Turner Prize television broadcast, artist Tracey Emin essentially articulated this position, pulling a sardonic grin when asked about Perry's work and, in lieu of any judgment as to his artistic merits, offering only, 'Grayson is pretty popular with the masses'. When the prize was announced later that evening and, against the odds, Perry had won, the response of presenter Matt Collings was less coy: a simple, and bewildered, 'Freaky!'

But two other factors have been perhaps more signficant in contributing to the split in opinion over Perry: that he is a potter, and that he is a transvestite. The first might seem innocuous enough: there are artists, after all, who have used pots and pans, cellophane-wrapped sweets, vaseline and ketchup to make their work. Pottery, however, represents a particular affront to the art world, and Perry deliberately exploits its scandalously unfashionable associations with decoration, domesticity and craft. He brings into the gallery works that look dangerously like they might be for sale at a country fair or in the homeware section of a department store. Indeed, the very appeal of ceramics, to him, rests on its presumed second-class status, its amateur overtones, and the assault it launches on the art world's cherished assumptions about what is and what isn't contemporary art. And if his pots occupy an uncomfortable border territory, in this case between art and craft, so too does Perry's transvestism. His flamboyant dressing up suggests a similarly dangerous blending of boundaries: between male and female, intellectual and sensuous, serious and comic. It is this, more than his work, that has obsessed commentators, spawning endless

column inches which dissect his cross-dressing, presenting it as an amusing diversion at best and, at worst, as little more than a shrewd publicity stunt.

While no major survey of Perry's work can ignore the central importance of both his pottery and his transvestism, this book aims to explore more deeply Perry's imaginative world, uncovering for the first time the full breadth of his practice as well as the thinking that underlies it. It includes around 175 of his most important works – from the very earliest, made while he was still a student at Portsmouth Polytechnic in the early 1980s, to his most recent, and increasingly ambitious, projects. Alongside his ceramics, it features his work in other media, much of it little known, from his prints and drawings to tapestry, sculpture and photography. Each work is accompanied by Perry's own commentary, giving unique insights into its making and meaning. Also included are photographs from Perry's personal archive, as well as some of the unexpected sources he has turned to for inspiration, from seventeenth-century English slipware and rugs from modern-day Afghanistan to medieval world maps, Sumatran batiks and the paintings of American Outsider artist Henry Darger.

What this book reveals is a riotous and inventive body of work from an artist who lies somewhere between a punk and a craftsman, and whose natural tone is one of playful mischief. Perry's subjects are topical and contemporary, ranging from consumer culture and kinky sex to teenage crime and religious extremism. In many ways, though, his sensibility is more in keeping with the art of the past than with that of the present. If we try to locate him in the genealogy of art history, he descends not from the obvious forebears of contemporary art, such as Marcel Duchamp, Joseph Beuys and Andy Warhol, but from a rather different line: that of the great satirists. In its bawdy humour, his art recalls the eighteenth- and nineteenth-century caricaturists William Hogarth, James Gillray and George Cruikshank. His quirky and literary wit echoes that of Aubrey Beardsley and Wyndham Lewis, while his linear drawing style and predilection for social comment, erotica and the grotesque are reminiscent of the work of Otto Dix, George Grosz and the Expressionists whose art flourished in the smoky nightclubs of 1920s Berlin. Perry's working practices also place him at some distance from most of his contemporaries. His ceramics are all laboriously handcrafted and made without the aid of studio assistants; even his tapestries are drawn out and coloured by hand (albeit on a computer) before

being transferred, for the sake of pragmatism, to a mechanical loom.[7] Perry eschews the model of the mini-factory favoured by many of today's successful artists, choosing instead to work independently in a small converted corner shop in a run-down part of northeast London. Here, he rifles through his library of ceramic and art history sourcebooks, as likely to take inspiration from a Chinese vase or a Gothic altarpiece as he is from the menus of local fast-food restaurants or junk-mail catalogues pushed through the letterbox.

This iconoclastic mix of the new and the old, the venerated and the throwaway, is typical of Perry's art. He revels in the collision of opposites, and awkward juxtapositions have become his stock in trade. Almost every one of his works presents us with an intentionally uncomfortable clash between form and content, while questions of good and bad taste are never far from the surface. Highly traditional, classically decorative objects are packed with unexpected or explicit imagery, including maimed children and aborted foetuses, swastikas and sadomasochistic porn. A cast of oddball characters fills his pots: everyone from dowdy housewives to sexual deviants and modern-day shamans. In the end, of course, each of these could be seen to reflect aspects of Perry himself. When we note how frequently, too, elements of his own biography appear – whether in his visions of sexual fantasy or in the repeated references he makes to his family, and to the people and places he has known – we can begin to see Perry's works as maps of his own creative universe. Indeed, as much as any artist might be said to divulge something of themselves through the making of their work, Perry's pots could even be taken for self portraits of a sort. The idea is all the more suggestive because, of all art forms, pots are perhaps the most anthropomorphic, their various elements, from the foot and belly to the shoulder and neck, named after parts of the body.

Some of the chapters that follow explore these very personal themes and subjects – looking at Perry's early work and the attitudes and friendships that informed them; his childhood; his inner, psychological world and experiences of psychotherapy; and his very particular views about pottery, craft and the art world. Others, though, point to his interest in subjects of far more universal concern, such as sex, class, war and religion. Ultimately, his pots might chart the terrain of his interior life and imagination but they also present, in vivid 3-D, reflections of our own world. Like strange, revelatory globes, they lay out before us landscapes both delightfully foreign and unnervingly familiar.

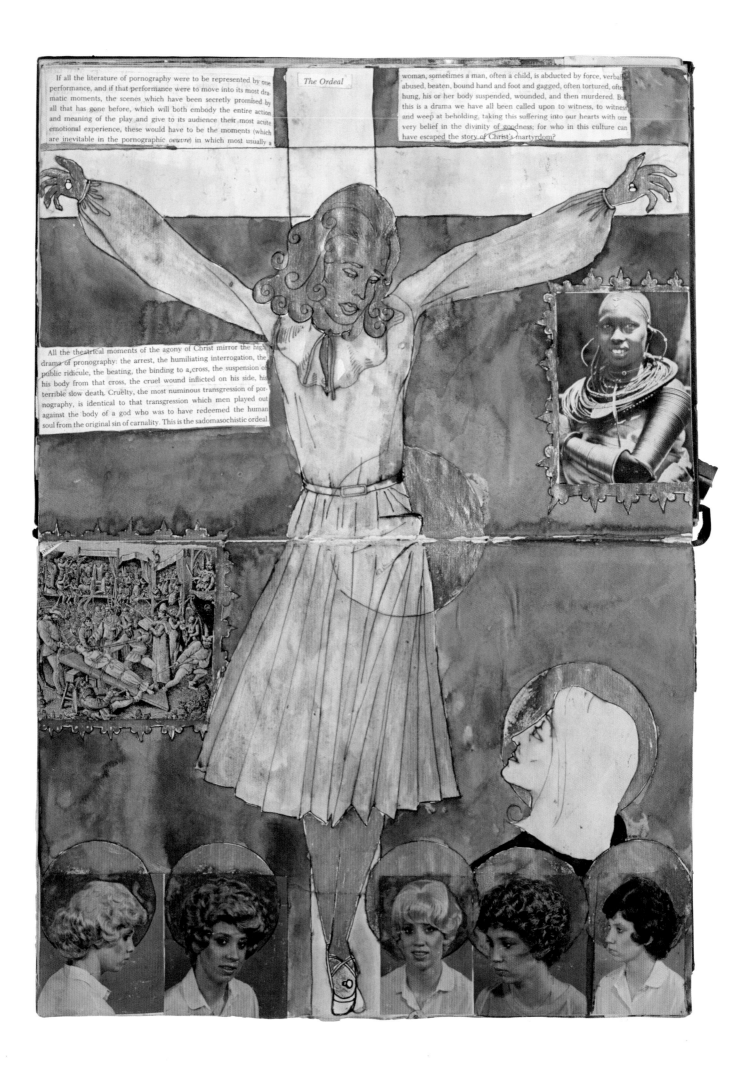

If all the literature of pornography were to be represented by one performance, and if that performance were to move into its most dramatic moments, the scenes which have been secretly promised by all that has gone before, which will both embody the entire action and meaning of the play and give to its audience their most acute emotional experience, these would have to be the moments (which are inevitable in the pornographic *oeuvre*) in which most usually a

The Ordeal

woman, sometimes a man, often a child, is abducted by force, verbally abused, beaten, bound hand and foot and gagged, often tortured, often hung, his or her body suspended, wounded, and then murdered. But this is a drama we have all been called upon to witness, to witness and weep at beholding, taking this suffering into our hearts with our very belief in the divinity of goodness; for who in this culture can have escaped the story of Christ's martyrdom?

All the theatrical moments of the agony of Christ mirror the high drama of pronography: the arrest, the humiliating interrogation, the public ridicule, the beating, the binding to a cross, the suspension of his body from that cross, the cruel wound inflicted on his side, his terrible slow death. Cruelty, the most numinous transgression of pornography, is identical to that transgression which men played out against the body of a god who was to have redeemed the human soul from the original sin of carnality. This is the sadomasochistic ordeal.

beginnings

'There was a wilful, awkward squallishness in me at the time. "Awkwardness" is a word that I used a lot then: I liked anything that didn't feel right.'[1]

Transvestite Jet Pilots, the piece Grayson Perry recognized as his first real work of art, was in many ways prophetic of much that was to come (pp. 18–19). A strange assemblage of found and hand-crafted objects, it incorporated ceramics, photography, sculpture and textiles, each of which would later develop into a distinct genre within his work.

It rang out loudly with the artist's autobiography – its intentionally macho allusions to jet planes sitting alongside images of Perry dressed up as a woman. And, with its secret drawers and compartments, it ensnared the viewer in a darkly mysterious narrative web. It was a pivotal work for Perry, made during his studies at Portsmouth Polytechnic in the early 1980s under the tutelage of a group of British sculptors that included Edward Allington and Darrell Viner.

Central to Perry's early work and to the development of his creative thinking was the circle of friends and fellow artists with whom he lived and worked, first in Portsmouth and later, from early 1983, in London. Of greatest significance were the Binnie sisters, Jennifer and Christine, the former a gregarious painter with whom Perry had started a relationship while at college, the latter her elder sister, a life model and performance artist. Their lives were focused around the squat they shared with the poet Angus Cook and the filmmakers Cerith Wyn Evans and Sophie Muller in Camden Town, northwest London. Perry's life at 43 Crowndale Road was one of sociability but also relative poverty. He and his girlfriend shared the house's burnt-out basement, subsisting on vegetable concoctions prepared on a 1940s gas cooker. Perry would later describe the place as 'a weird Dickensian cubbyhole full of smelly furniture and dope smoke'. It was a period when, to help make ends meet, he took a variety of low-paid jobs, from shifts as a security guard at the Sobell sports centre in Finsbury Park to stints as a hair-salon tea boy.

His work at the time, in both drawing and sculpture, was made with the meagre materials that were readily to hand. Lacking dedicated studio space, Perry used the squat's living-room table, spending hours a day drawing, painting in watercolour and collaging together his odds and ends. His sketchbooks resonate with the mixture of sexual fantasy and gritty reality that would soon become his hallmark. His sculpture displayed a similar preference for collage, showing the influence of another of his college lecturers, Larry Knee, who worked with found objects unearthed in Victorian landfills. Among Perry's early sculptures were a 1983 tower construction grafted from urban detritus and fitted with an electric light, a throne fashioned from disused scaffolding planks, and *Baba Yaga's Hut*, made from recycled wood mounted on chicken's feet (p. 32).

A parallel, and significant, strand in Perry's work from the early 1980s was filmmaking, another activity

Opposite | Untitled (sketchbook page), 1982.
Mixed media on paper, H. 41.2 × W. 29.6 (16¼ × 11⅝)

he had first started at college. Film was in fact the dominant experimental art form in Perry's circle, and the squat was a lively hub from which he met many of London's leading avant-garde filmmakers, among them Derek Jarman and John Maybury. Perry was soon receiving small production grants from the Arts Council and showing shorts at venues like the Leicester Super-8 Film Festival and London's ICA, the latter at the invitation of Jarman, a mentor figure for a number of emerging filmmakers. But while Jarman and Maybury were very much part of London's gay underground – mixing with, among others, choreographer Michael Clarke, performance artist Leigh Bowery and pop star Boy George – Perry was always on the fringes of their scene and he saw his work as an antidote to their serious and self-conscious trendiness. In addition, while many of the filmmakers around him were experimenting with the new medium of videotape and moving into the world of the pop-music promo, Perry's films were more wistful and personal (pp. 20–23). Intentionally nostalgic, they were shot on Super-8

with soundtracks that used deliberately unfashionable music from the 1970s: everything from Prog rock and Barry White to Leonard Cohen and recordings of Girl Guide singing troupes. The films were characterized by an aesthetic similar to Perry's drawings, collaging together disparate elements and using materials readily to hand, whether props, locations or actors, who were usually his friends and lovers. His productions embodied a spirit of rebellious fun with their oddball narratives, deadpan humour and strange juxtapositions of the surreal, the imaginary and the everyday. They were also, like Perry's drawings, highly charged with his erotic and sexual fantasies, often featuring a man amidst a world of powerful women, or pointing to the darker delights of bondage and sadomasochism.

What the films shared, in addition, was a love for organized, if slightly shambolic, performance, influenced strongly by Perry's close connection to the counter-cultural Neo-Naturist group. Founded by Christine Binnie, along with her sister and their friend Wilma Johnson, this proto-feminist bohemian

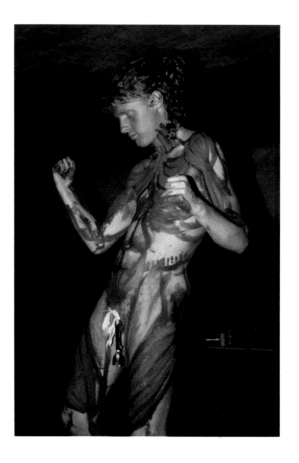

collective put on nude cabaret performances at clubs like Blitz and The Fridge, as well as in public spaces, including the fountain at London's iconic Centre Point and the British Museum. The Neo-Naturists mixed the aesthetic of the traditional English village fair and Girl Guide practicality with a taste for everything that was resolutely uncool in Thatcherite London, from pagan ritual and tarot to patchouli oil and body paint. Where the New Romantics were busy putting on frilly white shirts and eyeliner, the Neos were defiantly taking their clothes off, heading to clubs to whip up Scotch pancakes, cover themselves in paint and Sellotape, and chant pseudo-mystical incantations. Perry regularly took part in these performances. Neo-Naturism, for him, was about 'doing naff things seriously in the nude',[2] and he loved the Neos' blend of silliness and provocation, New Ageyness and 1960s hippiedom. Their playful, earnest exuberance and anti-establishment irony chimed with the look and feel of much of his own work during the period – unsurprising, perhaps, given how close-knit a group of friends they were.

The Binnies' brand of homely rural comfort and their knowing rejection of urban cool resonated deeply with Perry's own fascination with his native Essex. Growing up in the village of Broomfield, north of Chelmsford, and later in nearby Bicknacre, he had a childhood familiarity with the flat, largely featureless landscapes of suburban Essex. Although Perry left the county in his late teens, its tracts of barren countryside, pockmarked with electricity pylons and deserted World War II pillboxes, recur in much of his early work. The landscapes he drew were reminiscent of the scarred and windswept plains of the Neo-Expressionist painter Anselm Kiefer, whose work had made a deep impression on him when he was a student. Perry brought the idea of Essex, too, into his explorations of the occult, adding to the Neo-Naturists' fascination with black magic his own particular interest in Essex's ancient associations with witchcraft. Yet his references to the county were not only connected to its dark underbelly. His feelings about the place were deeply ambivalent, and the images of Essex that he kept returning to were

Far left | Grayson Perry working on his degree show at Portsmouth Polytechnic, 1982
Left | Grayson Perry in Neo-Naturist 'Punk Keep Fit' performance at The Fridge, Brixton, London, 1982
Right | ANSELM KIEFER *Nuremberg*, 1982

as much about a sense of his own roots and personal identity, even personal mythology, as they were a critique of its dreariness. In Essex he recognized both the horrors of suburbanization and the possibilities of rural idyll. Alongside allusions to the ugliness of the place, he drew on the idea of a highly idealized, romantic countryside, the Essex immortalized a generation earlier in the nostalgic photographs of his fellow countryman John Tarlton.

The various attitudes that were emerging in Perry's early work – a resistance to fashion, a fascination with Essex and his own mythical-autobiographical roots, and a proclivity for perverse sexual fantasy – came together in an explosive new mix when, in 1983, Perry started experimenting with a very different sort of medium: ceramics. In September of that year, on the advice of Christine Binnie, he started going to pottery evening classes, as a means both to continue making sculpture and to prove just how naff and rebellious he could be. Yet Perry's attitude of punkish dissent, of 'going with the line of most resistance' as he called it,

in fact soon began to pay positive dividends, and he found that he enjoyed enormously the physical process of working with clay. His earliest ceramics were quickly executed plates, the flat surface of the clay being used by Perry rather like the pages of his sketchbooks. The first such plate bore the title *Kinky Sex*, the words emblazoned below an image of a crucified Christ whose groin radiates a heavenly aura (pp. 26–27).

As his confidence and ability grew, Perry quickly picked up a host of techniques, from paper-cut stencils and sgraffito drawing to stamped lettering and sprig moulding.[3] He also began to make more obviously three-dimensional works, starting with a pair of coiled vases intended to suggest something of the aesthetic conventions of decorative domestic ware for the middle-class home (p. 29). From the first, Perry chose to make very particular types of ceramic object – plates and vases, rather than cups and saucers – that embodied a history of display rather than function. These were no mere decorative ornaments, however, as their tastefulness of form was invariably combined with

subversive content. Explicit sexual imagery and punk icons, such as skulls and swastikas, rubbed shoulders with classical and archetypal shapes. Perry's highly personal and iconoclastic work was an affront directed simultaneously at the art and craft worlds. Rebelling against what he labelled the 'Fish-and-Doric-Column' school, his work proposed a potent alternative to what he saw as the craft legacy of the 1960s and 1970s, those emptied, inoffensive symbols of 'seedpods and spirals that tended to be done by women with dangly earrings or earnest thin boys in jumpers'.

It was through this radical new work in ceramics that Perry began to gain recognition in the London art world. In 1984, he was taken up by the dealer James Birch, whose quirky gallery, first on Waterford Road in Fulham and later in Soho, sold an eclectic mix of art, from the paintings of Jennifer Binnie and English Surrealists like Eileen Agar to Soviet fashion design and contemporary jewelry. Perry's first exhibition at the gallery, consisting entirely of pieces he had produced in evening classes, immediately sold well.

The work had a rough and raw energy, its technical ineptitude an inevitable feature of Perry's inexperience with his new medium as much as it was a conscious aesthetic. Perhaps unsurprisingly, the response of the critical art community was mixed, for his work occupied a sort of cultural no-man's-land, unnervingly bringing pottery into the rarefied space of the gallery. There was shock within the craft world too, where many derided his limited technical ability and took offence at the suggestion that his ceramics deserved serious consideration. Perry, all the while, clearly revelled in just this uncomfortable ambiguity, his pots intentionally straddling the line between sculpture and vase, art and craft.

For a number of years, Perry's pottery continued in parallel with his work in film, drawing and collage. It was not until 1987, when he bought his own kiln, that he felt fully committed to his new medium. As he says himself, 'It took a long time for the marriage to be certified.' Once it had been, however, the partnership was to prove a fruitful and long-lasting one.

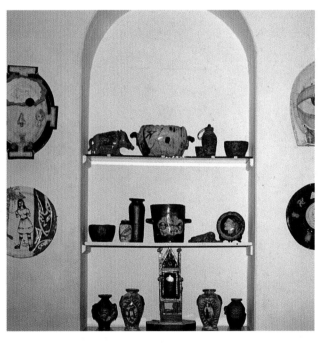

Opposite | JOHN TARLTON Hatfield Broad Oak
family picking potatoes, from *John Tarlton's Essex:
A County and its People in Pictures 1940–1960*
Above and right | Grayson Perry's first exhibition
at James Birch Fine Art, Waterford Road, London, 1984

transvestite jet pilots | *c.* 1980/81

Mixed media, *c.* 300 × 350 × 100 (9' 10" × 11' 6" × 3' 3")

At the beginning of my second year at Portsmouth I told my tutor, the sculptor Darrell Viner, that I was a bit stuck with my work. He was a very intense guy, like something out of a German Expressionist film: a hunched man with a little cigarette, very angular. He was the first person I'd met who'd had psychotherapy. He told me to write an essay about myself. I don't think he even read what I wrote: he just said, 'now make a work about what you've written.' The piece I made was *Transvestite Jet Pilots*.

I was a big fan at the time of the 'bish bash bosh' German Neo-Expressionist school. I'd been looking at artists such as Anselm Kiefer and A.R. Penck: I liked their sort of crude aesthetic. For this work, I got an old Utility dressing table and carved it in vaguely primitive style on the front with an aircraft's cockpit controls. Then I made some strange Stone Age artefacts that sat on the top and inside the drawers, like the ring tray you get in a dressing-table set and the pot for keeping bits and bobs in. They were aggressively male though: one was in the shape of a pair of testicles with glass embedded in it. In the bottom drawer there were five images of me transforming from Michelangelo's *David* into a kind of Oxfam auntie. Finally, surrounding it all was a big parachute that looked like a halo.

It touched on themes and motifs that I come back to again and again: the idea of an altarpiece, a reliquary, a sort of tomb in the bedroom. The work was full of energy and the tutors raved about it. I felt it gave me permission to bring what I had previously thought was something terribly indulgent and trivial into my work: my feelings. I look back on it now as the beginning of my artistic career.

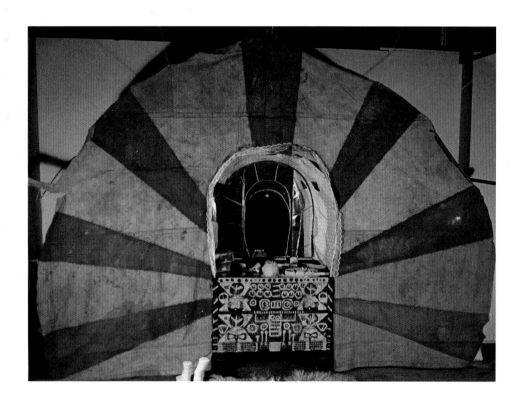

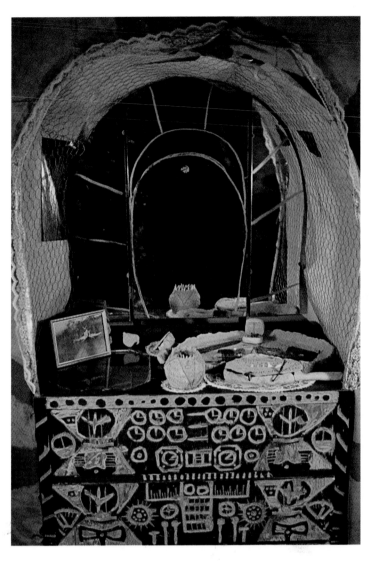

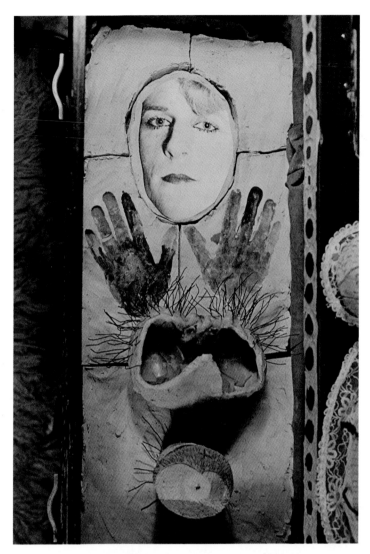

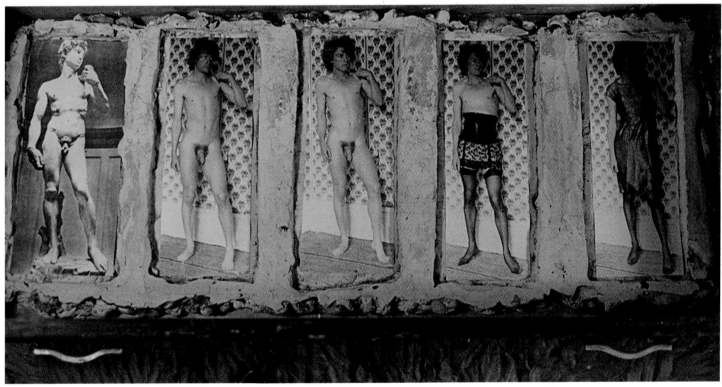

bungalow depression | 1981

Standard-8 film transferred to DVD, 3 minutes 21 seconds

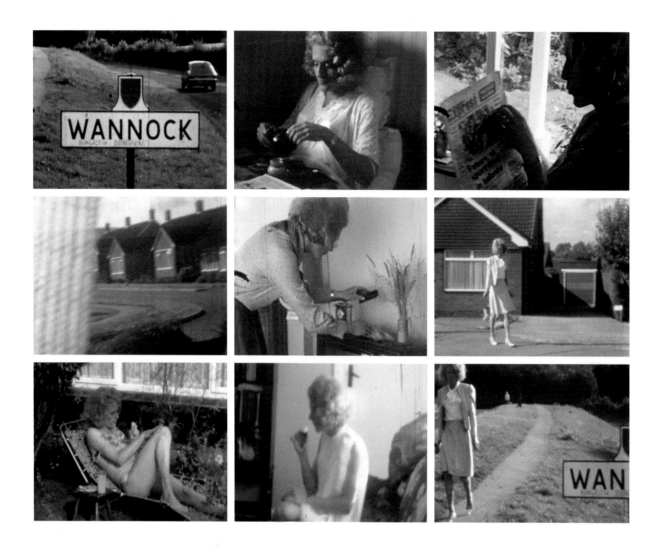

I went to an enormous number of jumble sales when I was at college to buy clothes, books and records. One day I bought a clockwork Standard-8 camera. I got my flatmates and girlfriends to run about the woods in wedding dresses and their New Romantic clothes while I filmed them enacting Gothic-looking fantasies. I didn't look far for inspiration: in this and most of my other films I just played out my desires.

Bungalow Depression was another of my eccentric fantasies. It showed a day in the life of a Women's Institute member and was very much a collaboration with Jennifer Binnie, whose mother was a stalwart of the WI and also a leader of a local Brownie pack.

It has nine little vignettes, each with me dressed up as my transvestite self, Claire, in different scenarios throughout the day. It opens with her in bed, nibbling toast and

sipping tea in her nightgown, with her hair set in curlers. Later on, she's dressed in a floral housecoat, watering the plants and sitting down to catch up on local news in the *Eastbourne Express*. The camera peers through the net curtains, a big part of the day's activities. She dusts her knick-knacks, has a spot of lunch, sunbathes, goes for a walk through Wannock village, and has her evening sherry.

the green witch and merry diana | 1984

Super-8 film transferred to DVD, 19 minutes 52 seconds

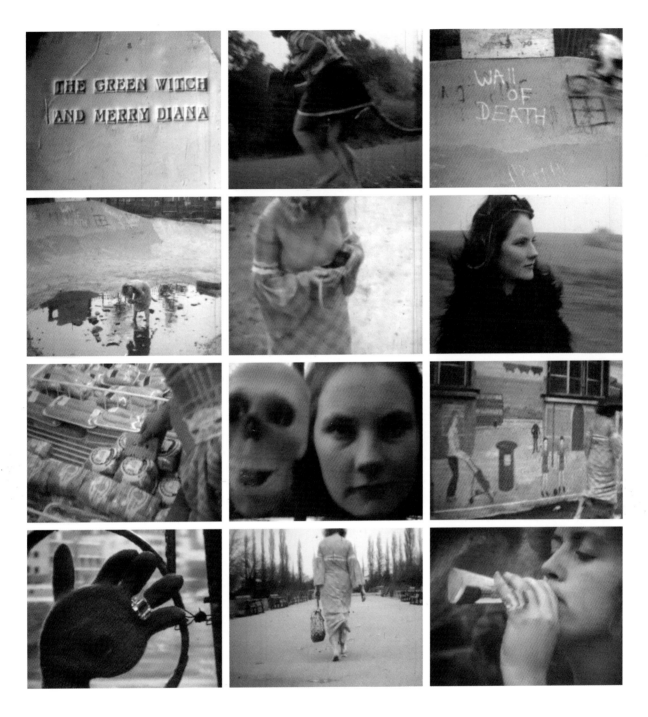

" **My very first film** had been shot on an old reel, and when I got it back it was all yellowing and romantic. That sense of instant nostalgia was very appealing to me and I went on to buy a Super-8 camera. You could buy out-of-date stock fairly cheaply. Most people were using 16mm but I liked Super-8 because I could do it at my own pace, just messing about. I enjoyed playing with all the stop motion and object animation.

This film is about a witch cursing a girl with a tail. In order to rid herself of her tail, she has to go on a quest for a series of day-glo green objects that I secreted in the naffest places you could find, such as the frozen-food section of the supermarket and skateboard parks. Looking back, I think the film resonates in some small way with the psychogeography of writers like Iain Sinclair and Will Self. It is a fairytale set in Camden Town.

I was living and socializing with a number of filmmakers at the time, who were all based in the area. We were working independently but we sometimes showed together, like at Derek Jarman's film night at the ICA. James Birch showed my films too: he had what he called the 'sardine cinema' which was the size of a tiny front room. It'd be packed and we had screenings and premieres there. It was great fun.

the poor girl | 1985

Super-8 film transferred to DVD, 47 minutes 13 seconds

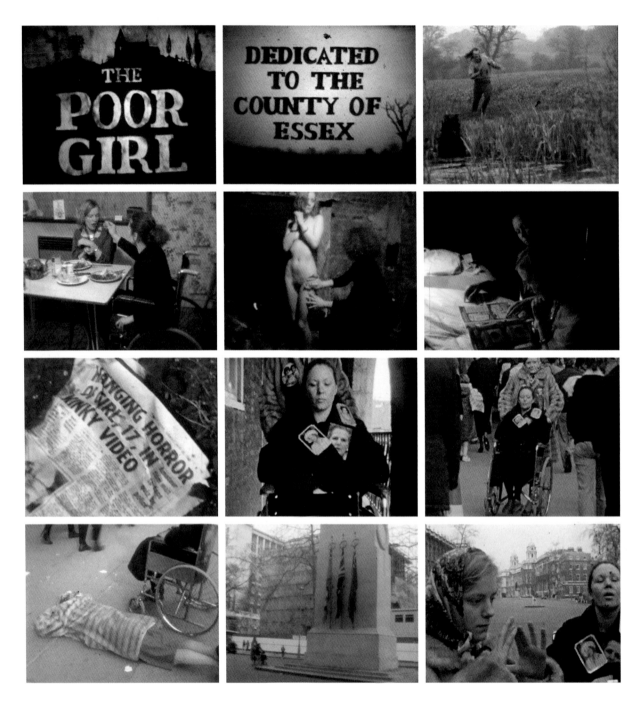

This was my last film. It was about a girl who summons up a brutal murderer in her imagination, and a cult of women whose religion is consumerism. They wear big badges of Margaret Thatcher and they carry boards covered in mystical symbols, like a weird cult. We walked around the West End and filmed outside Selfridges, worshipping the shops. We did one sequence near the Cenotaph, where we almost got arrested.

I called this 'A Welsh Dresser Film' as a joke name for my production company, because the films were mostly funded by the sale of my pottery. I put a lot of effort into it, but by 1985 it was getting ridiculous for a Super-8 film. It had scripts, sets, actors and props; we spent three months of Saturdays doing it on a budget of about £200, and yet it only ended up on this tiny delicate strip. Also, I began to see how much of my friends' time was spent trying to raise money to make their films. I didn't want to have to go begging. I was much more interested in just getting on with my work, so ceramics started to appeal to me more.

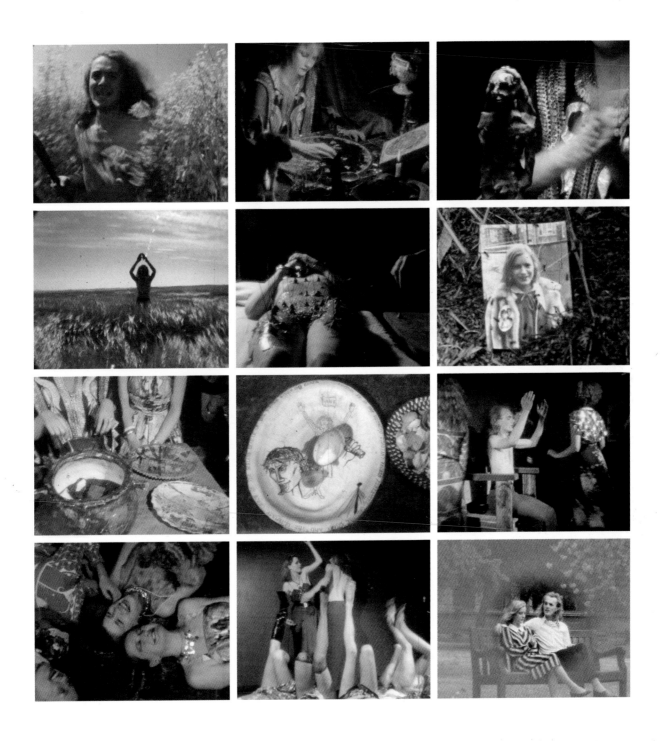

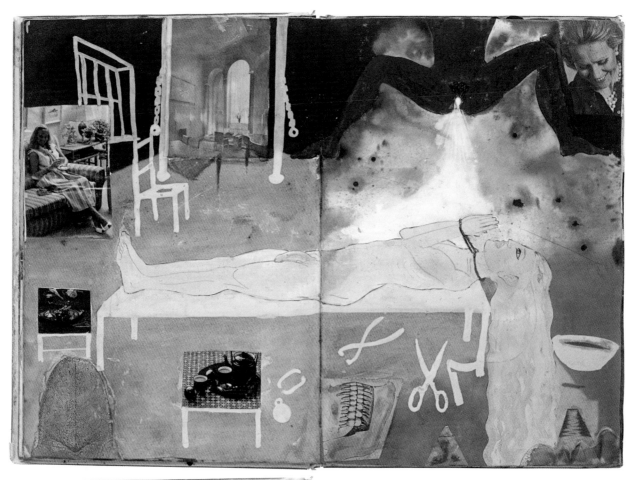

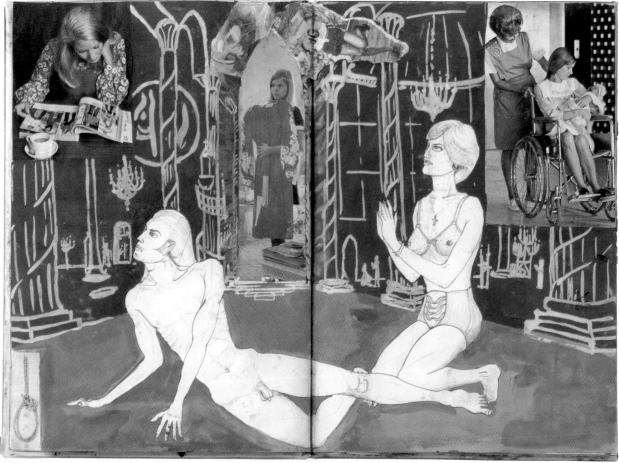

untitled (sketchbook pages) | 1983, 1985

Mixed media on paper, each H. 29.6 × W. 41.2 (11⅝ × 16¼)

Opposite above: 1985
Opposite below: 1985
Below: 1983

" **I worked on** my sketchbooks intensely just after I'd left college, in the days when I didn't have a studio. I'd have a huge pile of collage material and watercolour pots on the table in the squat, and I'd sit there working for hours. The images were layered and detailed, with several hours going into each page. Working on them overlapped with my early ceramics, but I would spend far more time on them than I would at pottery classes.

They were a combination of diary, artwork and artefact. They're sexual fantasy meets artistic mischief meets political commentary and confessional diary. In them, I could experiment with the vocabulary of my unconscious without feeling 'this is an artwork', and that was very liberating.

The landscapes in them are those of Essex, flat and mundane with lots of electricity pylons, sheds, playgrounds, abandoned barns and caravans, council estates and tower blocks, almost always with an aeroplane in the sky. The sketchbooks have been the source of much of my later ceramic work in terms of style and imagery. I wasn't aware at the time what a condensed amount of ideas there was in those pages, but even now I refer back to them.

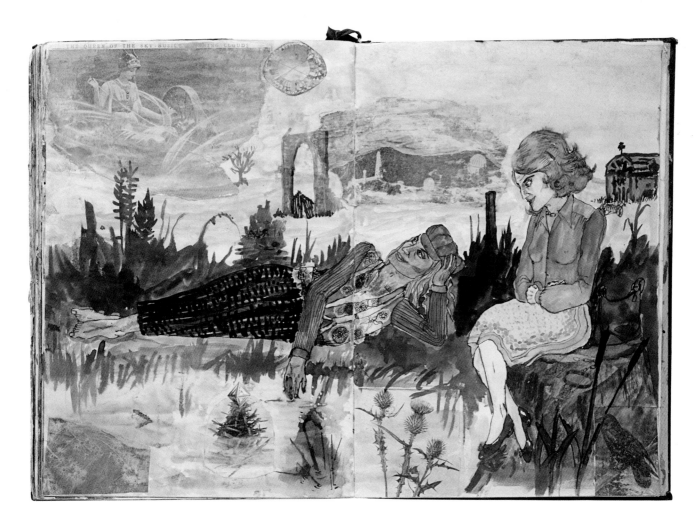

When I went to evening classes to learn pottery, the first things I made were little sculptures of a small devil and a pig. The nature of ceramics is that there is a lot of waiting around, so if you want to occupy your time fully you need to work on several pieces at once. I was watching what other people in the class were doing and somebody was making a press-moulded plate. I thought that it looked easy, since it gives you a surface to decorate. So I tried one, and quickly realized that I could make an artwork in a single week: with three hours of evening classes I could roll out the clay, put it on the kiln, dry it out, decorate it, press a few things in and it was done. The following week it was dry and I fired and glazed it. I thought, Christ, I'm onto a winner here! I had a much shorter attention span in those days.

This was the very first plate I made. I like the fact that it looks a bit bashed about now; it has an archaeological quality to it. At college I'd made a few rough ceramic things, which were never technically any good, but I had enjoyed sticking bits of metal and glass into them. *Kinky Sex* has a melted coin in the middle of it. It was a habit I got out of quite soon though, because it's so unpredictable how these sorts of additions will melt and what they'll look like. If I remember rightly, one of the tutors had recently taken us to the V&A to see their ceramics collection. That's where I saw early English slipwares, the style of which fed into the border and the writing on this plate.

I made lots of plates and lined them up on our mantel shelf in the squat. Our sitting room was a place we took a lot of pride in, in a kind of dishevelled, chaotic way. We always made sure it was very busy and looked interesting for anybody who came round to visit. There were fabrics and paintings pinned up, and ceramics, photos and knick-knacks on display.

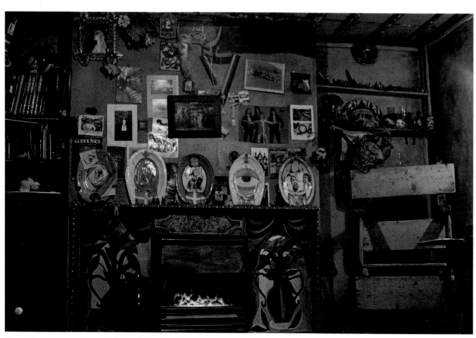

The sitting room, 43 Crowndale Road, Camden Town, London, 1984

kinky sex | 1983

Glazed ceramic, DIAM. 24.5 (9⅝)

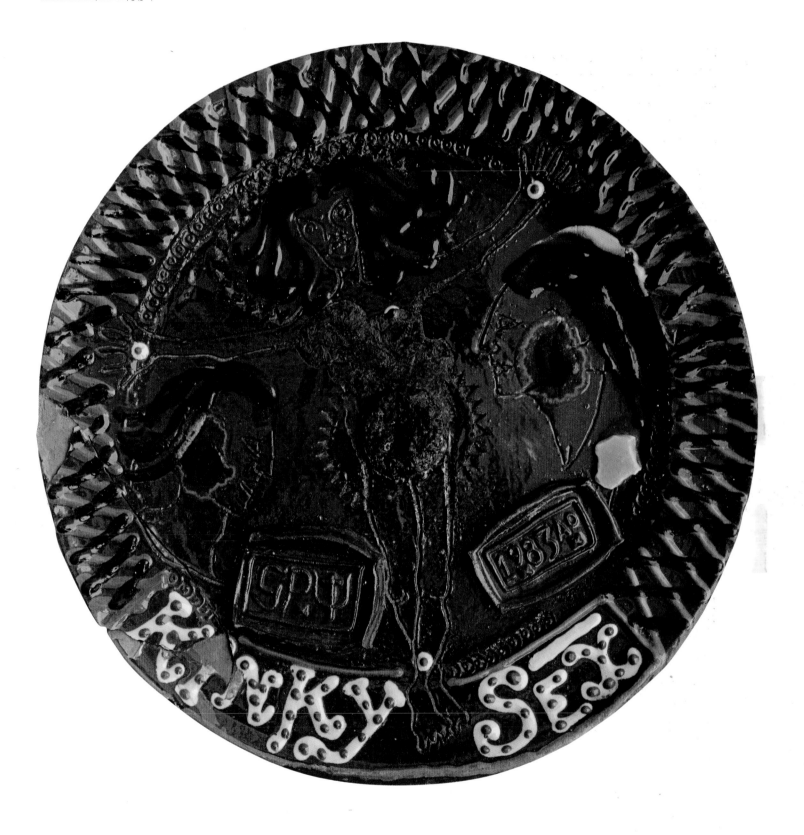

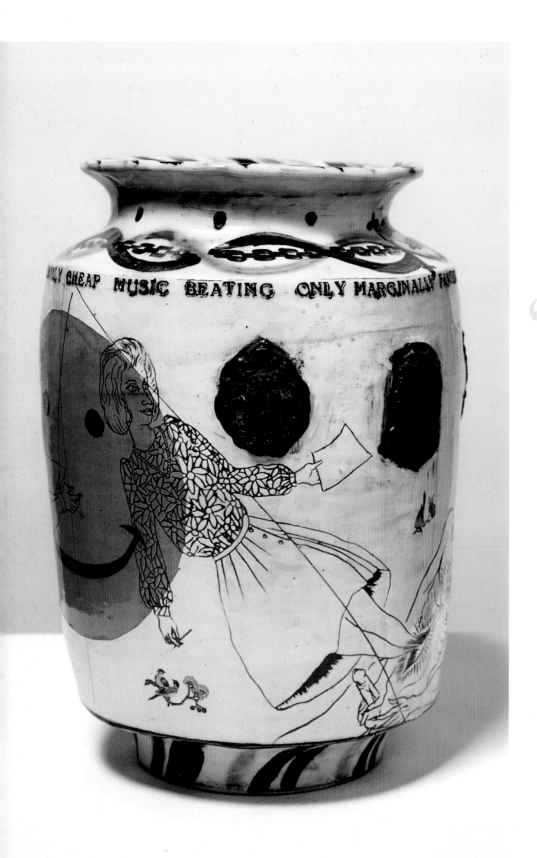

'Lady newsreader' was my shorthand for a well-groomed, powerful woman in her thirties. There is a frisson for me around these sorts of intelligent authority figures. So, on the pot, there's a woman being born from a devil's stomach with a piece of paper in her hand. The smiley face image is pre-Acid House, before it became a ubiquitous symbol of the rave generation. I stuck it on as something cheesy and ironic.

I was fascinated at the time, as I still am, by the Masons, shamanism and the occult. I always liked the mystery of secret societies, such as the Skull and Bones Society – it was part of my teenage Goth thing. It was also connected to my ideas about Essex, which was renowned as a witch-burning county. Many of my friends at the time were into the same things, and one of them, Timothy Prus, gave me a load of masonic regalia – aprons, medals and heavy brass badges – which I made into sprig moulds. I included an eye in a triangle, like the eye of God that you see on top of the pyramid on the one dollar bill, as a reference to masonic imagery. I was in my twenties and believed in many of the paranoid conspiracy theories typical of hippy drug-taking squattie youths.

as i laid in the arms of a lady newsreader | 1987

Glazed ceramic, 30.5 × 25 (12 × 9⅞)

untitled | 1984

Glazed ceramic, left 40 × 22 (13¾ × 8⅝);
right 40 × 20 (13¾ × 7⅞)

" **These were the** very first vases that I made. I created a pair because that's the cliché of vases: 'Oh, I have this Ming vase', 'Yes, but if you had the pair it would be worth five times as much!' They were sold in the first exhibition I had at James Birch's gallery in December 1984. I did very well at that show; I think it was because people bought the works as Christmas presents.

I made the pots from the idea I held of generic vase shapes, rather than by studying particular examples. That's how I worked then: I went to evening classes and I never took a sketchbook, I just made things off the top of my head. The imagery was me being an angry punk trying to shock people, so there's a Valkyrie in a wheelchair with a Swastika wheel decoration, bestial sex and references to drugs alongside Indian erotic miniatures.

Before these vases, I couldn't really do sides – I could only do flat plates. It was too difficult to make them stand up. Coiling isn't tricky, of course – though I'm a lot better at it now.

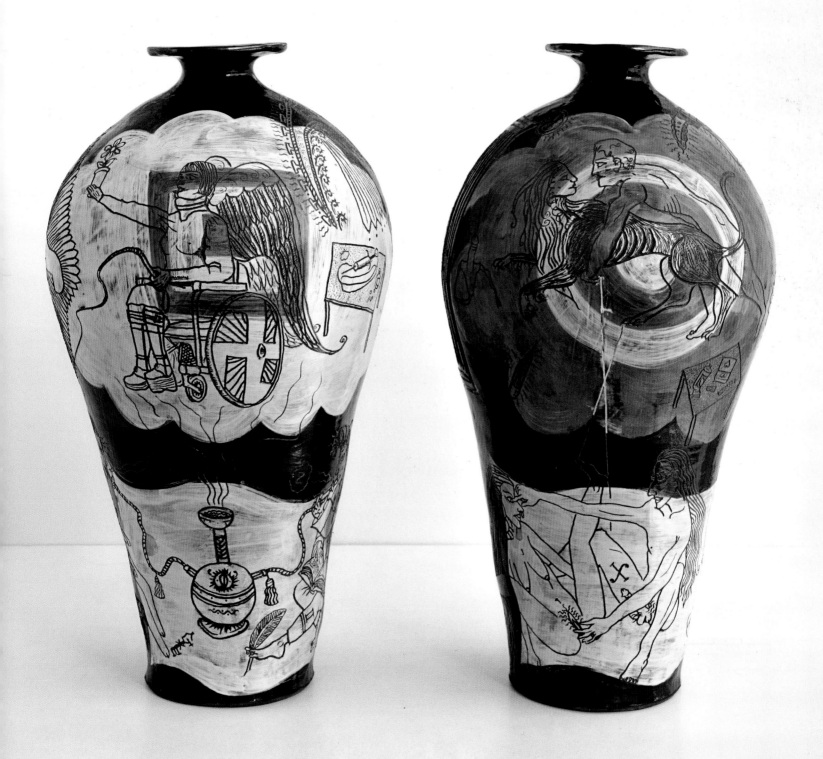

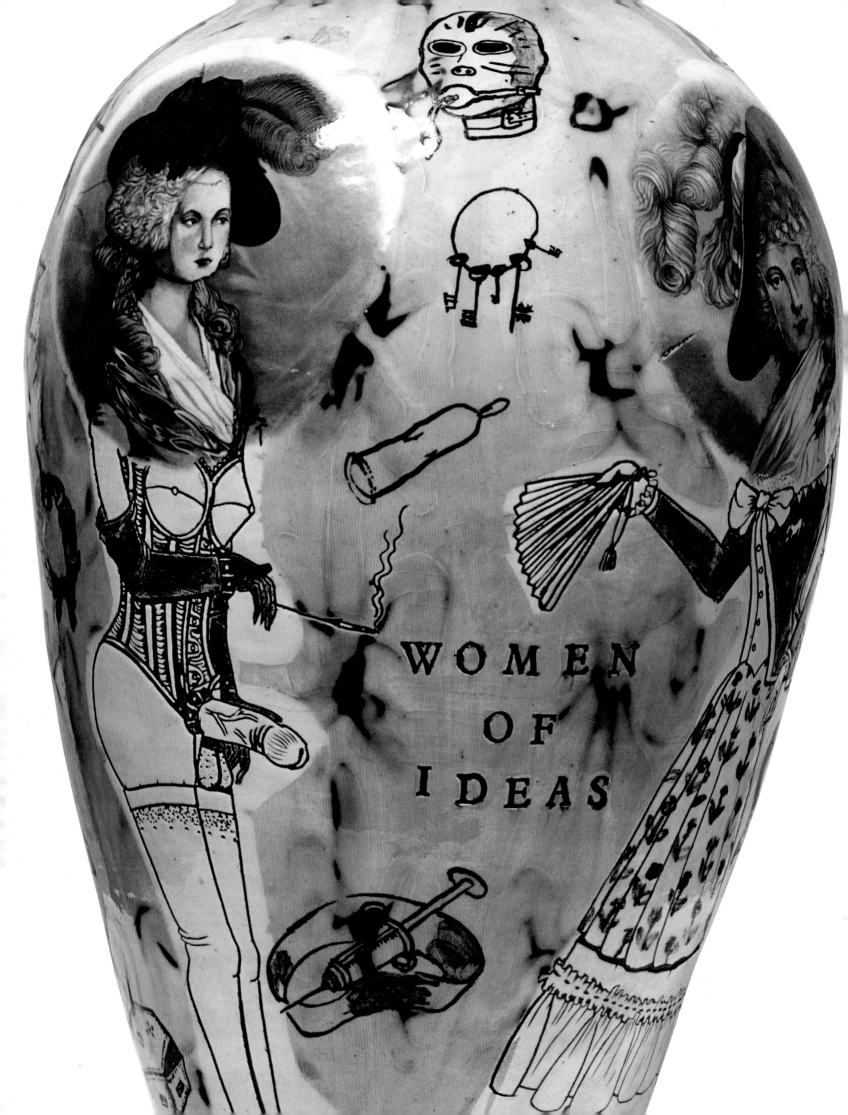

WOMEN
OF
IDEAS

"I made this pot when I was just starting to use open-stock transfers and was taking more technical risks with my work. The transfers were a set of portraits I got from Bailey's in Stoke-on-Trent: illustrators' versions of Gainsborough paintings. I've always gone out with women whose minds I enjoy, and this pot is like a history of strong women. They all looked a bit mean and frightening on the transfers, so I capitalized on that. It was partly a celebration of women of ideas but the title was also joking about the fact that women are flesh-and-blood creatures and not just ideas.

The pot probably shows one of the earliest examples of the use of a mobile phone in contemporary art. I can imagine looking back at it on TV in years to come, cropping up as a piece of archaeological social history on the 'Antiques Roadshow'! This was when mobiles were great big lumpy blocks. I put one on as part of the women's get-up. Elsewhere there is a squash racket, a BMW key-fob and a cafetiere, which were all yuppie symbols at the time.

women of ideas | 1990

Glazed ceramic, 42 × 27 (16½ × 10⅝)

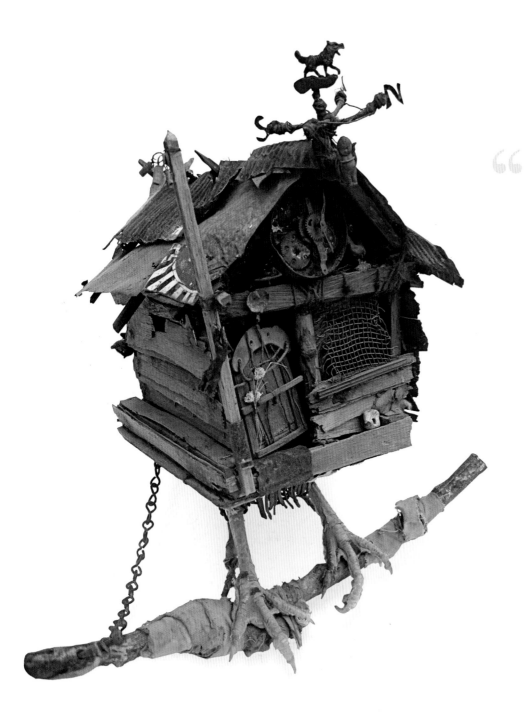

66 **This piece was made** after I'd finished college and moved to London. I went through what I called my 'Bilbo Baggins' period, making twee little sculptures, I think because I took acid too much. *Baba Yaga's Hut* was the zenith of this in some ways.

I made it almost entirely from stuff I found lying around our squat in Camden Town: scraps of wood, Catholic memorabilia and other bits and pieces. I'd always been interested in the image of the hut from fairytales, and in its sinister darkness. Baba Yaga is a witch from a Russian story who eats children and lives in a hut standing on chicken legs. I'd first heard of her during a music lesson at school. We were listening to Mussorgsky's *Pictures at an Exhibition* and 'Baba Yaga's Hut' is one of the movements in that. I conjured up this powerful image of the hut on legs. The idea of a shed that moves spoke to me on an unconscious level. It's a bit like being in your mother's tummy, or a kangaroo in the pouch: you're in a safe environment and yet it's moving about, so you can observe the world from your cocoon. Though the image has the frisson of being a terrifying thing, I didn't find it scary. I quite like the idea of being in a shed – a space that I see as the equivalent of the male womb.

baba yaga's hut | 1983
Mixed media, 45 × 38 × 38 (17¼ × 15 × 15)

commemorative plate no.17 | 1985

Glazed ceramic, 25 × 24.5 × 3 (9⅞ × 9⅝ × 1⅛) FROM A SET OF 30

commemorative plate no.30 | 1985

Glazed ceramic, 25 × 24.5 × 3 (9⅞ × 9⅝ × 1⅛) FROM A SET OF 30

" I was fascinated by the idea of commemorative plates. I bought a book from Oxfam on their history: they go back to the nineteenth century. Now there's even something called the Bradford Exchange, a kind of stock exchange for collectors' plates. I remember relief plates on the wall from my own childhood – my grandmother had ones showing idealized scenes of water mills and thatched cottages. Sometimes they marked occasions like a coronation but often they were just decorative.

I wanted to make my own plates that would be a bit more spooky, featuring my un-idealized Essex country scene. They show a derelict house with bomb damage, almost at the point of collapse. As a teenager, I had seen this fantastic TV adaptation of a Graham Greene story called *The Destructors*, about some kids who set out to destroy a house like this. They tie a lorry to the house with a chain, so that when the lorry pulls off it tears the house down. I also put an Anderson shelter and a tractor in the garden. It's windy, and there's a pollarded tree.

To tap into the idea of a series, I made thirty of these press-moulded plates. I treated each one differently: some had figures, others had transfers or different textures, and with a few I treated the clay in different ways, such as marbling it before I pressed it in the mould. They were very experimental.

secret woman | *c.* 1986

Glazed ceramic, 38 × 20 (15 × 7⅞)

> **This pot was** about my acknowledgment of Claire as a central plank of my creative drive. I was already starting to build up a narrative of her, a sort of internal iconography. Here, there's an angel figure with a hard-on and Claire, wearing a dress from the office, appears with a halo, patting the angel on the shoulder. It's like the spirit of my femininity descending to earth and blessing me with inspiration. There's also an elfin-looking boy in a suit, perhaps as a more integrated idea of the male and female.

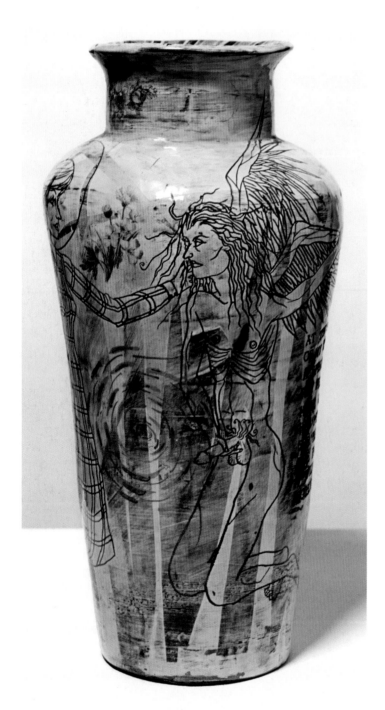
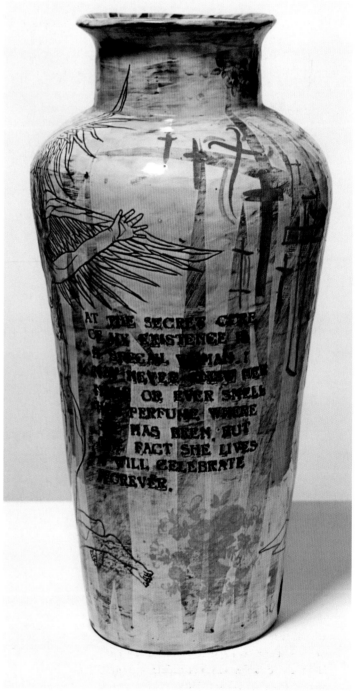

i was just an ordinary person | 1988

Glazed ceramic, 46.6 × 38.1 × 3.8 (18⅜ × 15 × 1½)

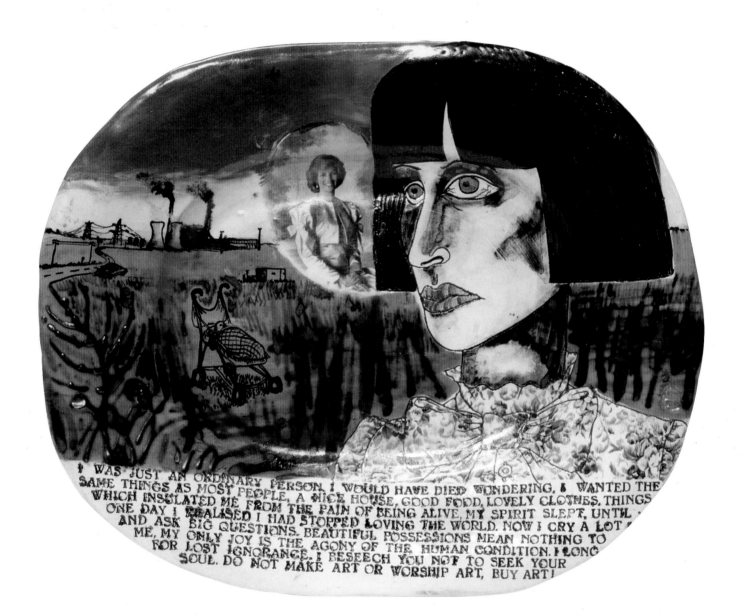

In the late 1980s, I made a number of TV-screen-shaped plates and dishes. All my plates are press-moulded but each one is treated in a unique way. Technically, stylistically and content-wise this plate reflects very well the work I was doing at that time. It's got everything from my early iconography, including Princess Diana in a speech bubble and a power station on the horizon. I used Diana as a shorthand for idealized womanhood. The trannie in me was always interested in her deification.

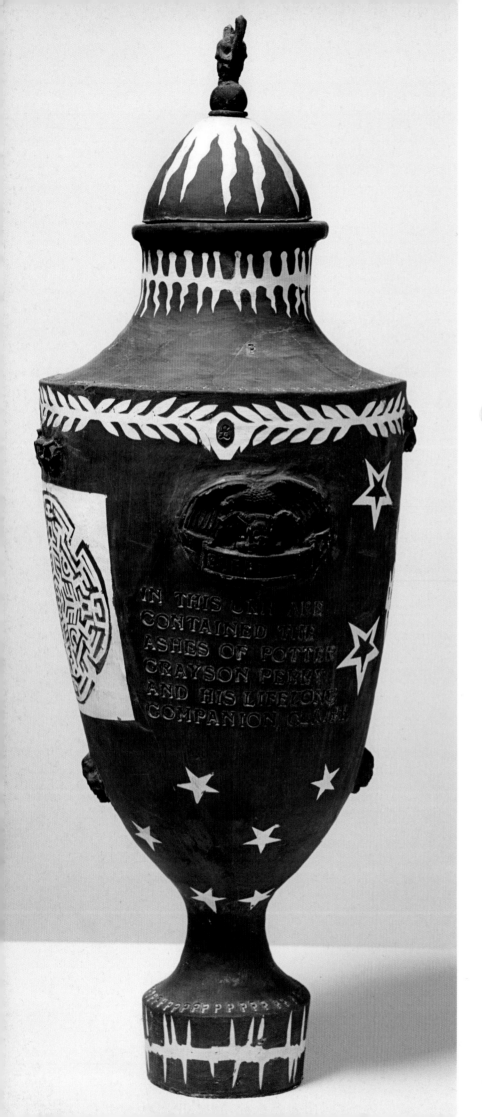

the ashes of grayson perry | 1988

Glazed ceramic, 52.8 × 18.5 (20¼ × 7¼)

❝ **I can remember** the owner of this piece, my friend Louisa Buck, shuddering at the morbid message on it. On one side it says, 'Grayson Perry made this urn to earn the money to buy the motorcycle on which he was killed'; on the other: 'In this urn are contained the ashes of potter Grayson Perry and his lifelong companion, Claire.' I was interested in the idea of funeral urns and I made several of that ilk. Death and pottery have long gone together, and the way urns reference death is quite common. Pots are containers but they also have an anthropomorphism, with their necks, shoulders, bellies and feet.

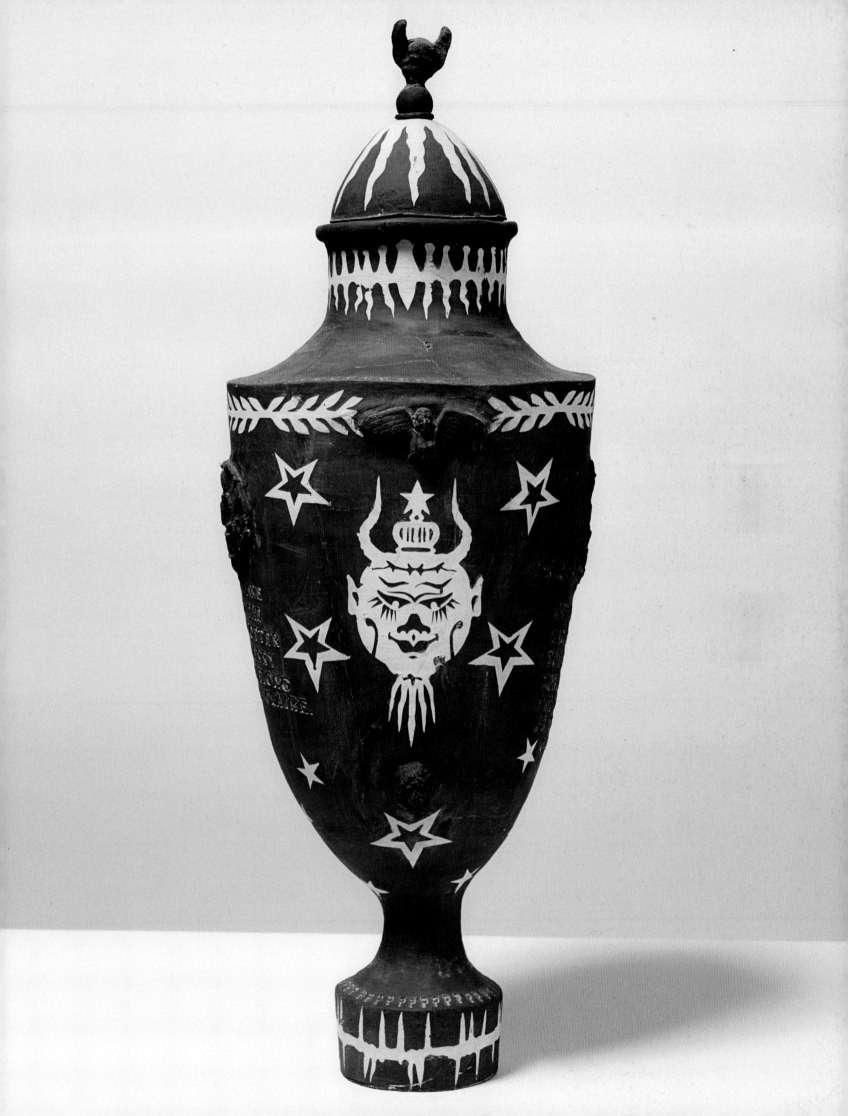

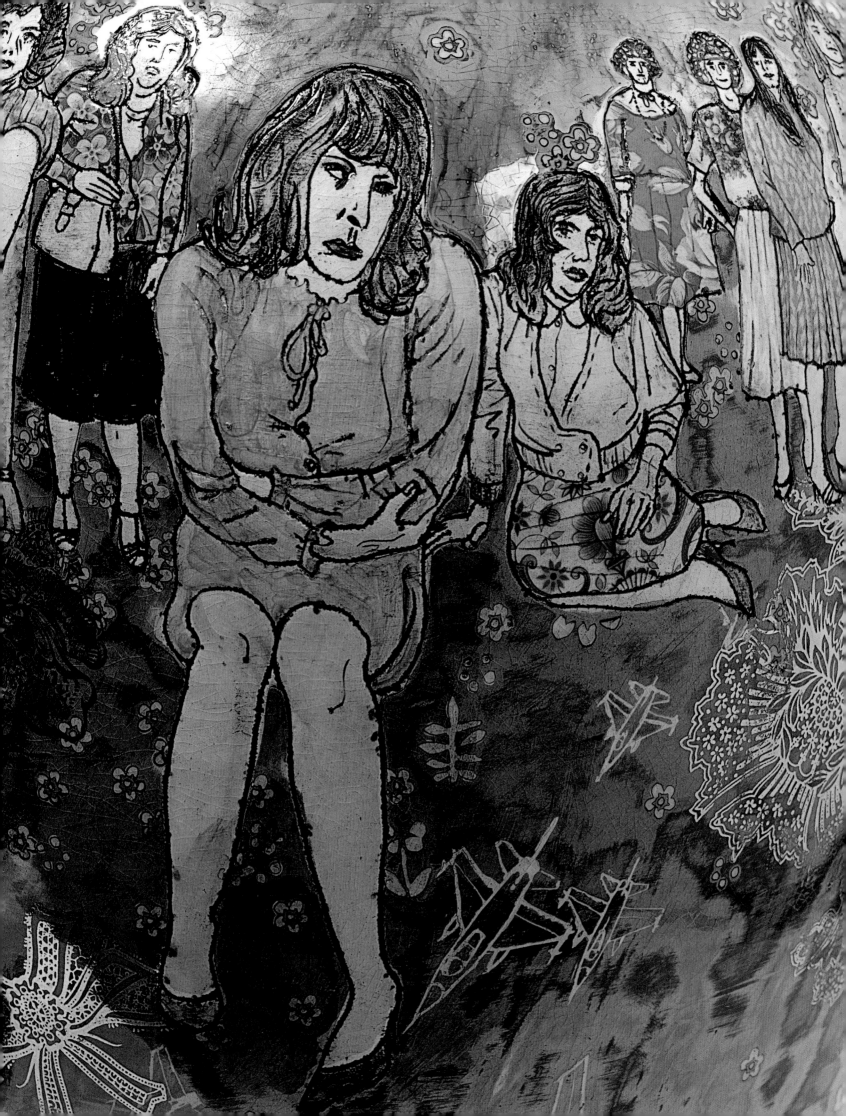

chapter 2 pottery and aesthetics

'I've never seen myself as a potter or as part of the crafts movement. I am a conceptual artist masquerading as a craftsman.'

Over the course of his career, Grayson Perry has made work in many media – prints, drawings, photographs, embroideries and sculptures – but it is, without doubt, pottery that has made his name.

In one piece, *Ultimate Consumer Durable*, he acknowledges that his pots have become an identifiable brand in the global market of luxury goods (p. 61). Despite this, however, Perry has never considered himself a ceramicist. In fact, he first came to pottery less because he felt a special affection for it than because he saw it as irretrievably twee, middlebrow and parochial. It was precisely because ceramics was, as he put it, 'an area of discomfort' for the contemporary art world that he embraced it with such vigour. And when he began using clay as his medium, he purposefully chose to ignore much of its 30,000-year history, its associations with everything from bricks and altarpieces to teacups and urinals. From his earliest pieces he honed in, almost exclusively, on just one ceramic trope, perhaps the most awkward in terms of its liminal status between art and craft: that of decorative display pottery and its most precious and iconic object, the vase.

Perry's pots always reference archetypal, historic forms, for the most part what he calls 'classical invisible' shapes of indeterminate oriental origins. The majority of his vases present intentional chinoiserie clichés, with their designs acting like frames to a painting, unnoticed surrounds that are subservient to the content and meaning they contain. This act of framing is an essential element of Perry's work and a core part of its effect on us as viewers, for he actively exploits our familiarity with these generic forms and the built-in cultural preconceptions we invariably bring to such pottery. Whether we recall memories of decorative knick-knacks on a grandmother's mantelpiece, watch experts enthuse over Staffordshire ware on the 'Antiques Roadshow', or admire the elaborate ceramic splendours of country houses, we bring to the viewing of vases a complex bundle of associations, assumptions and expectations.

The potency of Perry's work, its radical edge, is rooted in the conscious clash he sets up between his medium and message. If his forms are the very epitome of the middle-class drawing-room aesthetic, his spiky and explicit content undermines that, repeatedly and intentionally wrongfooting the viewer. In works such as *I Saw this Vase and Thought it Beautiful, then I Looked at it*, he explores just this disjunction between allure and vulgarity, presenting an attractive vase in muted grey, blue, black and gold that on closer inspection reveals a loose calligraphy of violent expletives and racial abuse (p. 56). Similarly, *Sex and Drugs and Earthenware* sets up a clash of cultures, juxtaposing an elegant Chinese form with images of rock stars, bottles of brandy and S&M porn (p. 46). Perry has quite rightly called his vases 'stealth bombs', seemingly innocent, homely objects that, on viewing, explode in a mass of impropriety and perverse humour.

It is little surprise, given this, that Perry's work has not always sat comfortably within the world of contemporary craft. Indeed, he has been unequivocal in distancing himself from the ceramics community, and in a series of outspoken invectives that have appeared in newspapers and craft magazines since the mid-1990s, he has written repeatedly about the craft world's inward-looking tendencies and its often slavish emphasis on technique over ideas.[1] In one article for the *Guardian*, he described the art world as an ocean and the craft world, damningly, as no more than a lagoon in which 'some artists shelter … because their imagination isn't robust enough to go out into the wider sea'.[2] Unlike many ceramicists, too, Perry has little interest in the material qualities of clay itself. He is indifferent to its much-vaunted mythical associations, those Promethean legends that seem to hover, even now, over exhibitions of ceramics. In works such as *I Dunno*, he lampoons the lingering fixation with ceramic earthiness and the power of fire, making his own mock-primitive pot whose surface was created not by the flames of a bonfire but through the application of modern-day photo transfers of suburban houses and fast-food packaging (p. 52). Similarly, in *Western Art in the Form of a Saki Bottle*, Perry critiques the fetishization among ceramicists of the authentic, rusticated surface, creating his own artificial wood-fired 'look', which he promptly sends up by adding in some obviously incongruous and discordant imagery (p. 53).

This punkish attitude, and Perry's wilful disregard for many of the central principles on which contemporary ceramics is founded, place him firmly outside the mainstream of British pottery. Not for him the philosophy of the studio-pottery movement, which has argued, since the 1920s, for a subservience of decoration to form, and for an authenticity arising from the potter's 'truth to materials' approach. His vases might, in fact, be seen as the very opposite of the 'ethical pots' proposed by that great father of studio pottery, Bernard Leach. Leach argued in his 1940 treatise *A Potter's Book* that the finest ceramics should always have an intrinsic 'fitness for purpose', a practical utilitarianism, to complement their perfection of form, their understated beauty and visual restraint. Where many today still work on the Leachian principle of 'less is more', Perry abides instead by his own counter-

Left | BERNARD LEACH Globular vase with folded rim, 20th century
Right and far right | Grayson Perry's potter's marks, before and after winning the Turner Prize

philosophy: 'When in doubt, bung it on.'[3] His pots are for the most part highly decorated and visually excessive, crammed with images and ideas. Technically, too, they are an affront to the Zen art of throwing clay on the wheel, as practised by Leach and his followers. In place of the elegant choreography of throwing, Perry deliberately employs the amateur and clunky technique of coiling. Rolling out his clay into snake-like coils, which are then looped on top of one another to form a solid wall, Perry has called what he does not a graceful meditation but 'a war of attrition'.[4]

While Perry's battles with the contemporary craft world continue, a significant shift has taken place since the mid-2000s in his attitudes towards both pottery and craftsmanship. Over a period of thirty years he has refined his technical skill to a level of sophistication that has engendered a profound change in the way his work both looks and acts upon us. His earliest pieces in the 1980s never strove purposefully to look rough, but they were far less technically accomplished than his work has subsequently become. Pots such as *An Illusion of Depth* from 2003 and *Jane Austen in E17* from 2009 show Perry playing with an impressive range of techniques to produce a complex layering of imagery and rich, deep surfaces (p. 48 and p. 63). As a direct result of this heightened skill, Perry's earlier, dismissive attitude towards craft has undergone a radical about-turn in recent years. While he still mocks the pretensions of many contemporary potters, Perry's views about his medium have softened, and nowadays he is more likely to be heard propounding the joys of craftsmanship than attacking the fetishization of the kiln. He has, if anything, redirected his hostility towards contemporary conceptual art, finding himself unmoved by what he sees as its mechanical deadness and its celebration of tricksy ideas. Certainly, he still values intellectual provocation but he now also posits, unfashionably, the traditional values of craft skill and visual refinement. One vase, for example, defiantly declares, without any of his usual irony, *I Love Beauty* (p. 60). Where for so long the notions of decoration and preciousness have been treated with contempt in the art world, and beauty has been something of a taboo, Perry has been won over to the belief that there is profundity to be found in beautiful objects, in and of themselves. Insisting early in his career that he was a

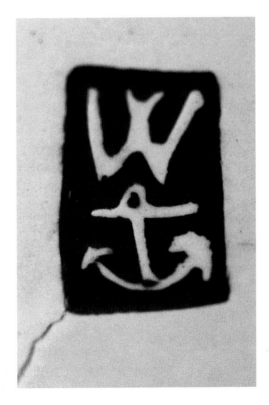
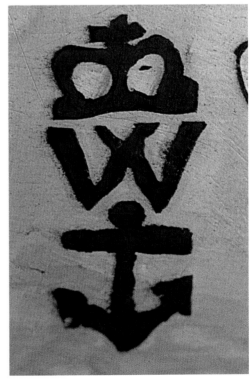

conceptual artist who just happened to make pottery, now he might concede that there is as much craft in his work as there is art.

When one looks across the range of Perry's ceramic work, in fact, it becomes apparent that he has placed himself quite consciously within the rich history of pottery. He has always included on his ceramics, for instance, his own version of the traditional maker's mark, satirically writing himself into the history books with a ribald reworking of the anchor symbol (most famously associated with eighteenth-century Chelsea porcelain), which he surmounts with the letter 'W' to create his very own subversive signature, 'Wanker'. Since winning the Turner Prize, he has added a further regal touch: a crown, with which he now identifies himself as 'Princess Wanker'.

Deepening his appreciation for pottery's illustrious past, Perry has read widely on the subject and has increasingly turned to traditional ceramic designs for inspiration, including ornate Satsuma pottery of the nineteenth century (p. 50). His sources also include a wide variety of folk pottery, from Japanese mingei to the popular forms of North Africa and America. His ceramic plate *Ikea*, for example, takes its motifs directly from nineteenth-century American folk imagery (p. 59). Perhaps his richest source of inspiration, however – as so often for Perry – has come from the vernacular traditions of his own country. A number of his works, such as *Harvest Jug*, reference the drinking traditions of rural England, specifically the seventeenth- and eighteenth-century pitchers used for carrying beer to thirsty farm workers. Others, like *GM* (p. 58), are reminiscent of the slip-decorated ware of the renowned seventeenth-century English potter Thomas Toft, whose work Perry has admired for many years. This English tradition has provided him, moreover, not only with stylistic and formal inspiration, but also with many of his key technical reference points. Alongside his use of commercial decals and photographic transfers, Perry regularly turns to such techniques as slip trailing, sprig moulding, sgraffito and stamping, all of which sit firmly within the tradition of English ceramics.

What captivates Perry, ultimately, about both ornamental and folk pottery is the essential individualism he finds expressed in such work – an individualism premised, most significantly, on its handcrafted qualities. His love for the handmade connects fundamentally to his belief that craftsmanship is not just about perfecting a particular technique, but is to do with the articulation of the deep emotional and organic relationship that a craftsman develops with his medium – often over a lifetime of creative experimentation. Perry himself, importantly, makes all of his pots by hand. He has resisted the practice of taking on studio assistants, which might have enabled him to produce work on an industrial scale, because, as he says: 'I want my fingerprint to be on the work.' This insistence, remarkable for being so old fashioned, is a reflection both of the enjoyment he derives from the physical act of making and the dislike he has for slick, workshop-produced contemporary art.

Perry is, in this respect, rather closer to the world of Bernard Leach than we might have assumed. Leach, too, extolled the virtues of handmade craft, and did so, similarly, as a gesture of defiance against the perils of his own age, specifically mechanization and industrialization. Perry's own critique of the love-lessness, as he sees it, of much contemporary art echoes the rejection by Leach, and by William Morris before him, of so much sterile mass-produced design. Leach went on to argue that the making of objects by hand was a moral activity, and that one could read in such art the emotional intuition and spiritual authenticity of its creator. As he famously said, 'The pot is the man: his virtues and his vices are shown therein – no disguise is possible.'[5] Perry's pots certainly do not shy away from showing us his vices, but they contain, too, reflections of something far deeper and more elemental. With their unique blend of sexual fantasy, political satire, shocking subversion and emotional rawness, they in fact have, at their core, an authenticity that Leach himself might well have recognized. Their peculiar beauty and power lies in Perry's ability to translate that authenticity of personal belief, imagination and experience into more universal truths about contemporary life and the human condition.

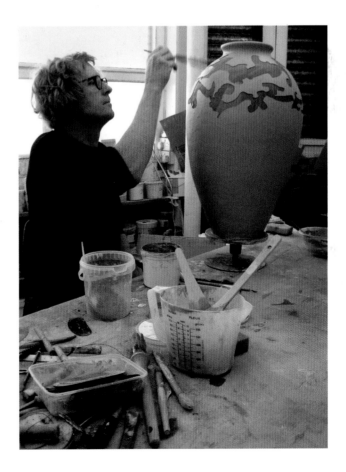

Far left | GRAYSON PERRY *Harvest Jug*, 1990. Glazed ceramic, c. 36 × 28 (14⅛ × 11)
Left | THOMAS TOFT English slipware dish, 17th century
Right | Grayson Perry at work in his studio, 2009

meaningless symbols | 1993

Glazed ceramic, 36 × 35 (14⅛ × 13¾)

"There is a tension in making a piece of contemporary ceramics in a medium that has such a strong history of decorativeness. Now I can joke with Chris Ofili about how much we love making decorative art, and we can agree that it's a noble and profound thing to do. But if you had asked me about the term 'decorative' when I made this pot, I would have found it a loaded word and seen it as derogatory. My title was defensive: I was getting in there first with the idea that everything is meaningless, and that it's all just a melange of style and no substance. What I'm coming to realize as I age is that profundity comes about by letting go, by not worrying about being meaningful.

This pot would have been white, with just the sprig moulds attached, before it was fired. Then I painted the animals in cobalt oxide with the spaces for the transfers left blank. It was not a typical combination of techniques for me at the time.

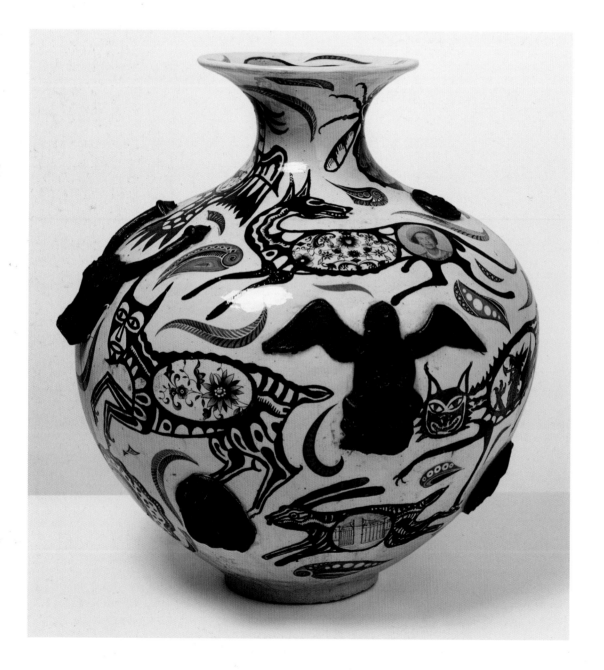

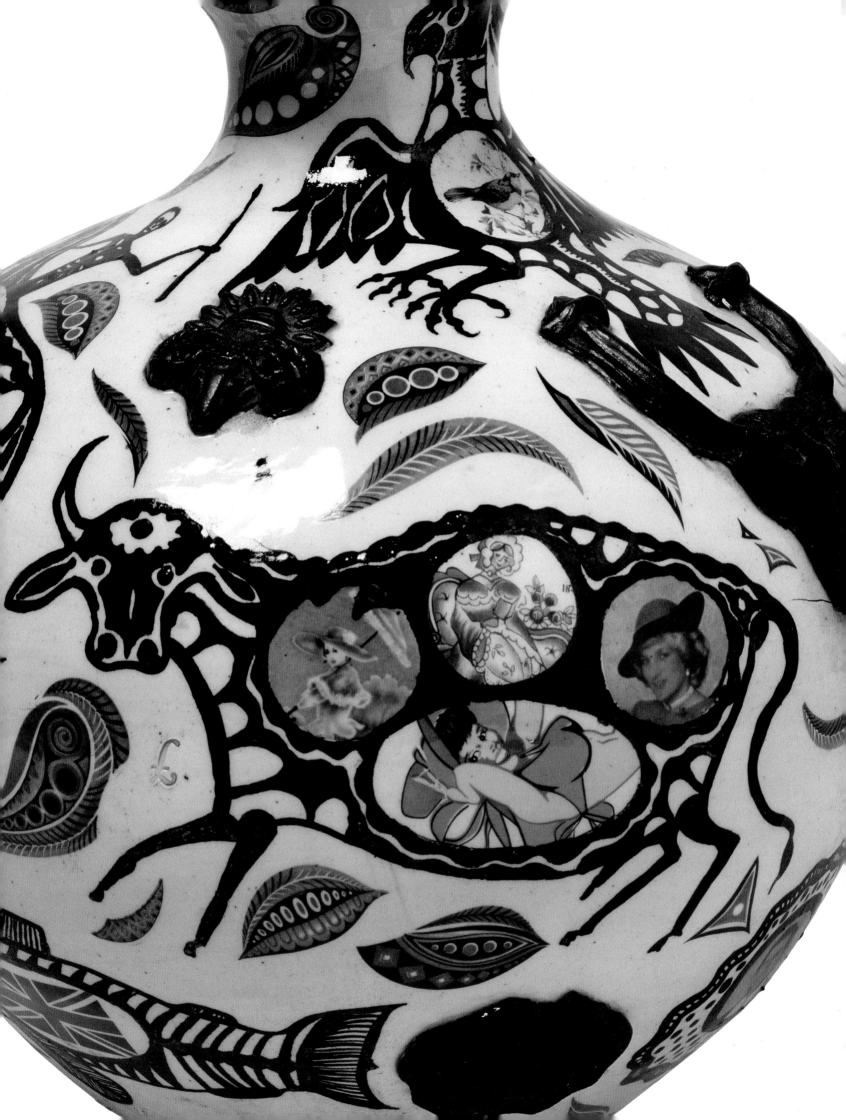

sex and drugs and earthenware | 1995

Glazed ceramic, 54 × 24.5 (21¼ × 9⅝)

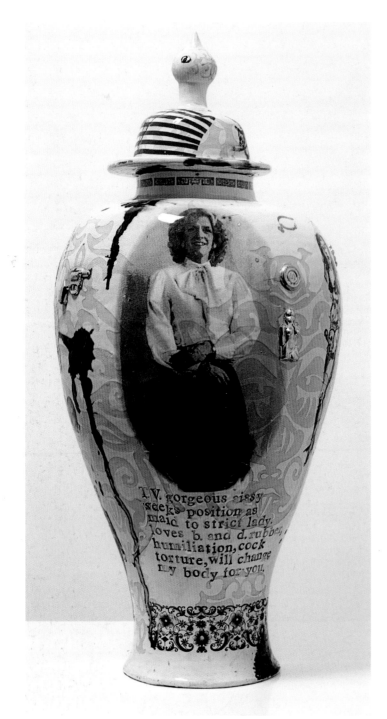
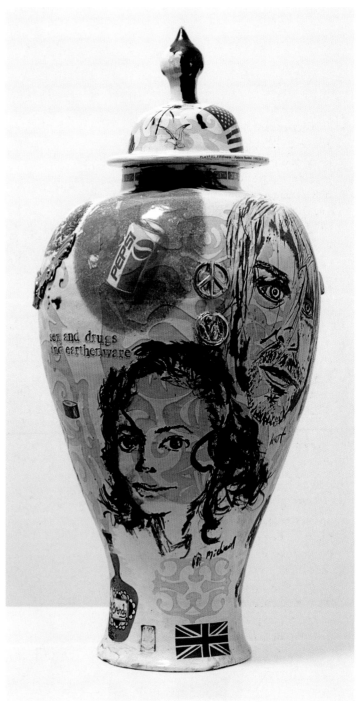

" **This is a Chinese** vase in the spirit of punk. I chose an elegant shape and deliberately covered it in images of rock'n'roll, sex and drugs. There's Kurt Cobain, who'd recently died, and Michael Jackson, who was also a controversial figure at the time, alongside obscene drawings. I was reading a lot of incredibly sexualized American transvestite magazines at the time, so I included a picture of me that I captioned as if it was a perverse lonely-hearts column. The pot has a collaged surface, with the random, throw-away, clip-art look of a fanzine – just the opposite of a classical vase's normally highly organized design.

piss flaps | 1994

Glazed ceramic, 35.6 × 19 (14 × 7½)

"**Commercial pottery is** full of bland, inoffensive, clichéd transfers, and this pot was all about playing with these kitsch, mass-produced images. It was a dialogue between craft techniques, graffiti and abuse. I was being a naughty schoolboy, and turning ideas of beauty on their head. I wanted it to look as though someone had attacked the commercial transfers so, for example, it says 'Whore' on top of a Moll Flanders picture, and 'Arsehole' over a rose. I wanted to transform the hackneyed images – to deconstuct them by adding a layer of abuse. There's a postmodern irony to it though, as I've abused them from within the tradition of ceramics. I didn't get a felt pen out and scribble over them: I scored into the clay, as part of the decorative crafted scheme, using sgraffito. It was very tricky to do, because although it looks like the text sits on top of the photographs, you actually have to put the marks on weeks earlier, as photographic transfers are applied in the final, low-temperature firing.

Everything on my pots is always one hundred per cent authentic ceramic material. I was hideously insulted once when a magazine called me up to talk about painting pottery. I don't make painted pottery: I don't struggle with a kiln for that! All my work goes through the kiln, and all of my techniques are bona fide ceramic techniques. The pots will last forever – if they're not smashed.

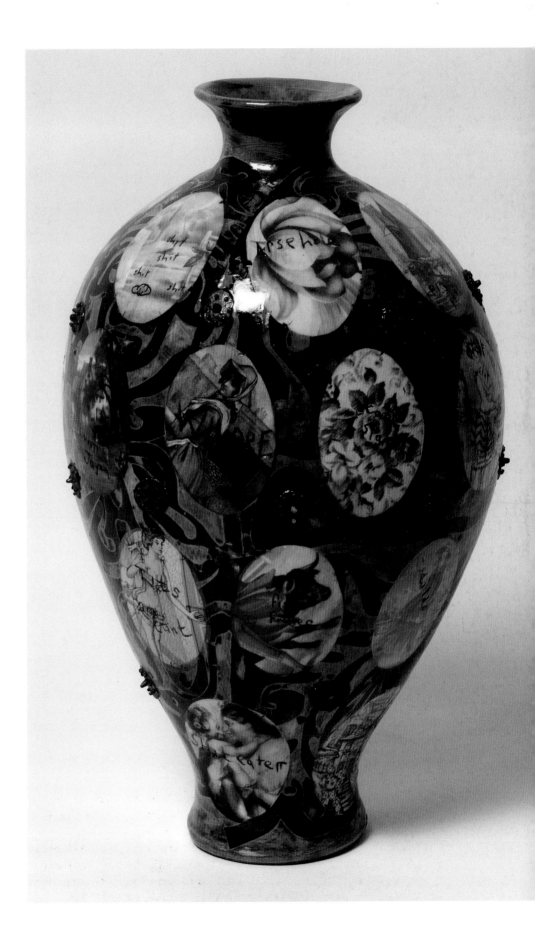

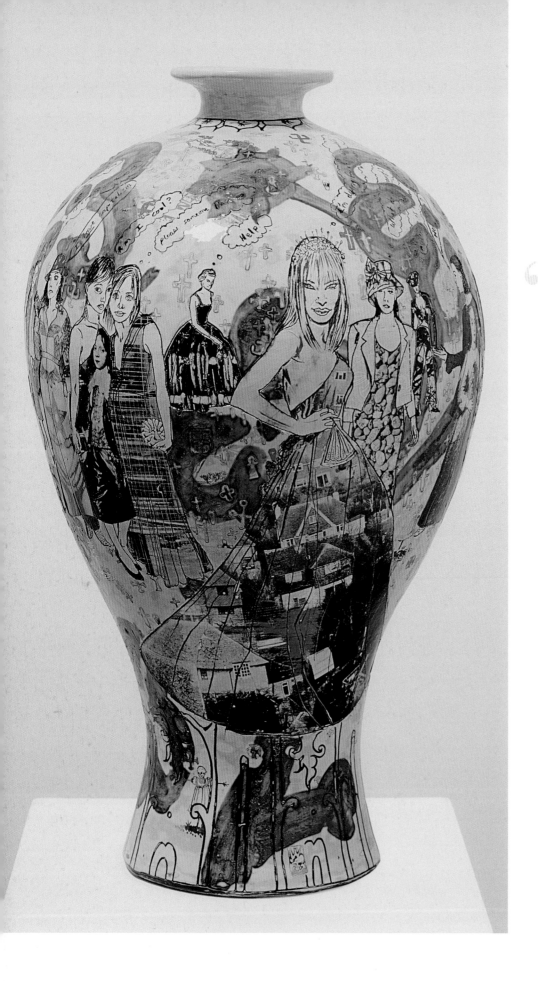

The classic 'illusion of depth' is perspective drawing, but this pot is a play on ideas of depth and surface, or shallowness. I made a lot of work at the time using images of fashion models. Fashion photographs rarely show people smiling, as if the models have some moody significance, a hidden depth, whereas in fact they're just blank pretty faces used to flog clothes.

The surface of this vase is very layered, including pictures from fashion magazines that I used to collage together the women's dresses. It has a muted earthiness about it because of the low-key colours: greys, olives and beiges, with tiny flickers of red and gold. I was interested in getting what I call a 'deep surface', so that even though the actual surface of the pot is only microns thick, the illusion is that there are deep layers underneath, made up from the painted marks, the scored marks, the impressed marks and the gold. I was thinking, too, about psychological depth. I gave each of the models and fashion designers a speech bubble revealing their inner thoughts, not the sort of things you would expect them to be saying. So Stella McCartney says, 'please someone like me' and Kate Moss asks pleadingly, 'Am I cool?' They were facetious comments about the fashion industry and the glossy, advertising-fuelled consumerist project that I so dislike.

an illusion of depth | 2003

Glazed ceramic, 60.5 × 36 (23⁷/₈ × 14¹/₈)

bad art, bad pottery | 1996

Glazed ceramic, 57.2 × 37.6 (22½ × 14¾)

66 **The images on** this pot are mainly made
up from sexual fantasies: pictures of women
bound and gagged, dumped in stinging-nettle-
filled ditches, a sort of suburban sex-fetish
hell. It has a flaccid formlessness to it, what
my pottery teacher would have called a 'wet
paper bag'. I have always liked the wobbliness
of coiling, the slight quirkiness of asymmetry,
but nowadays I follow a profile made out of
cardboard when I'm coiling, so I know where
I'm going from the beginning. Back then, I
would just do a drawing and hope that what
I was coiling would come out a similar shape.

The title speaks about how I felt caught
between two stools at the time. I still felt
a lot of prejudice about my work, as I was being
pigeonholed for using pottery and being kept
out of most art establishments, yet I knew
that technically I wasn't up to scratch as a
craftsperson either. I've always compared my
own work to historical art, which in terms of
craft is usually way out of my league, because
it was often made by people who had been
trained in age-old techniques with strong
local traditions. Someone once said to me,
'Grayson, you're trying to set yourself up
against an eighteenth-century factory', and
I said, 'Yes, I am! And it's hard work!'

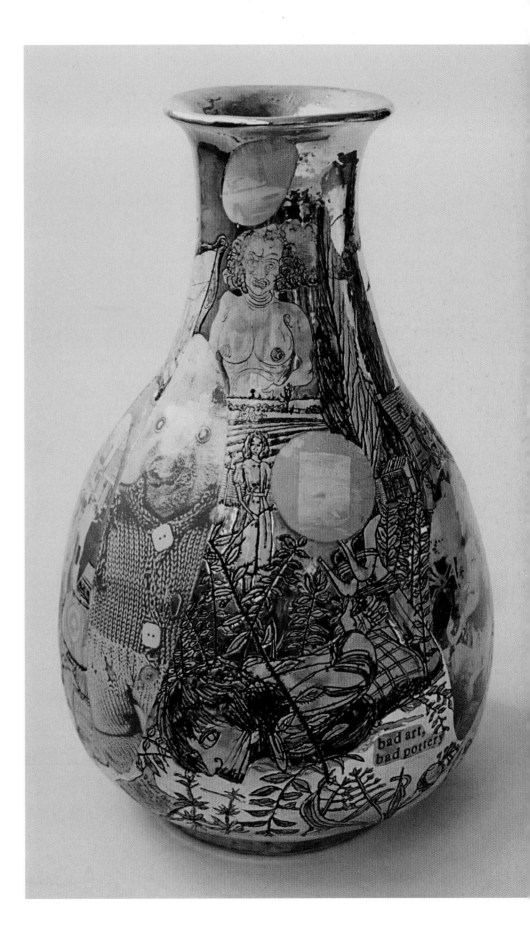

precious boys | 2004
Glazed ceramic, 53 × 33 (20⅞ × 13)

"This is one of the most direct copies I've made. It came from an illustration I saw in a book of Satsuma pottery, an incredibly elaborate type of nineteenth-century Japanese ceramics. There was one Art Nouveau pot that I thought was particularly beautiful. Around the shoulder of the vase were lilypads painted in different patterns, with their roots trailing down. Swimming between the roots were big carp. I copied the design, putting transvestites in place of the lilypads and jet planes in place of the carp, so that there's a sort of brooding masculinity and aggression alongside this quite poignant, attractive surface. I suppose you could see it as a bit of a self portrait.

Nowadays, a lot of my work is inspired by other pots I've seen and admired. That method of working is much more common for me now than it once was, as my relationship with the history of ceramics has changed and deepened. Referencing exquisite works from the past instantly gives me a resonant framework in which to make my own pots.

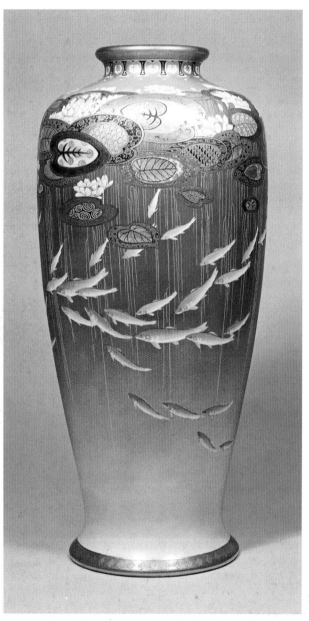

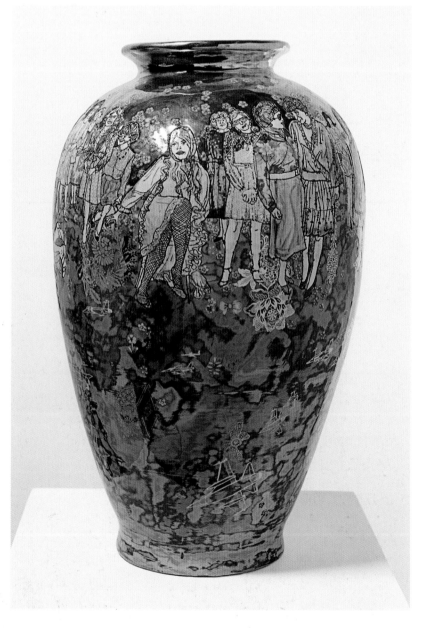

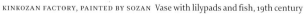

KINKOZAN FACTORY, PAINTED BY SOZAN Vase with lilypads and fish, 19th century

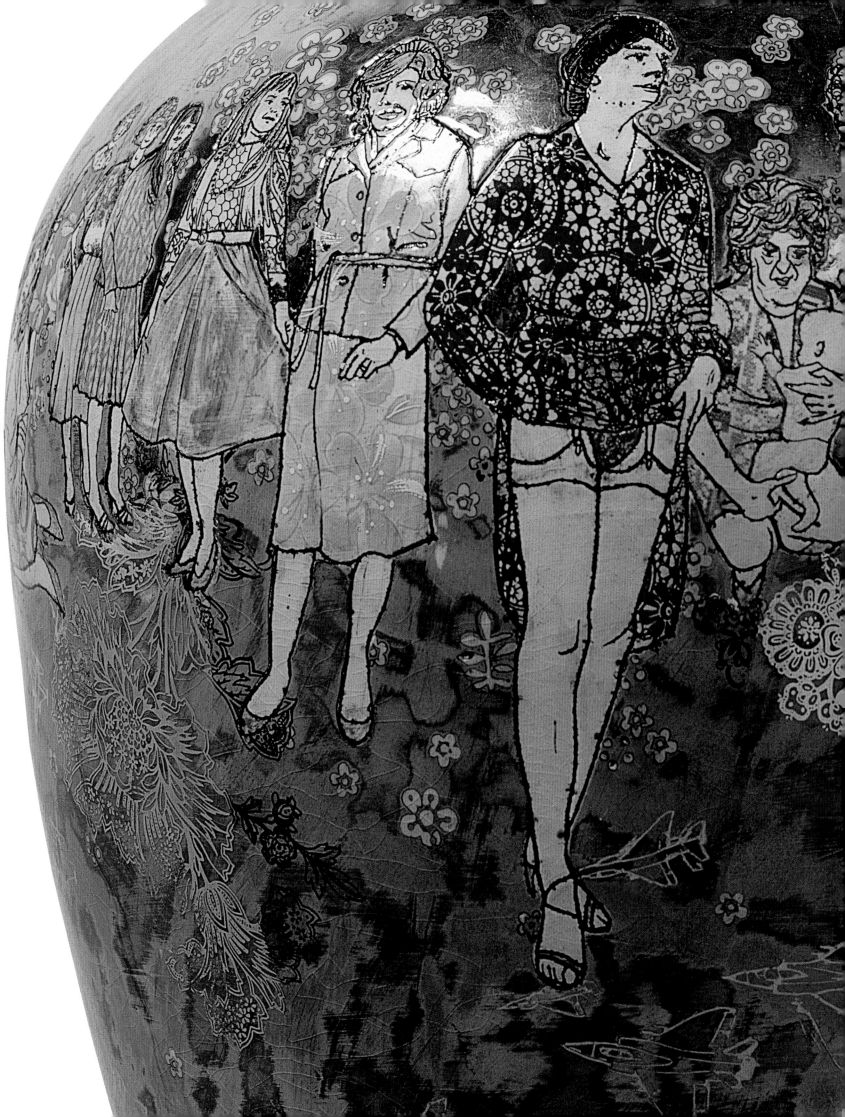

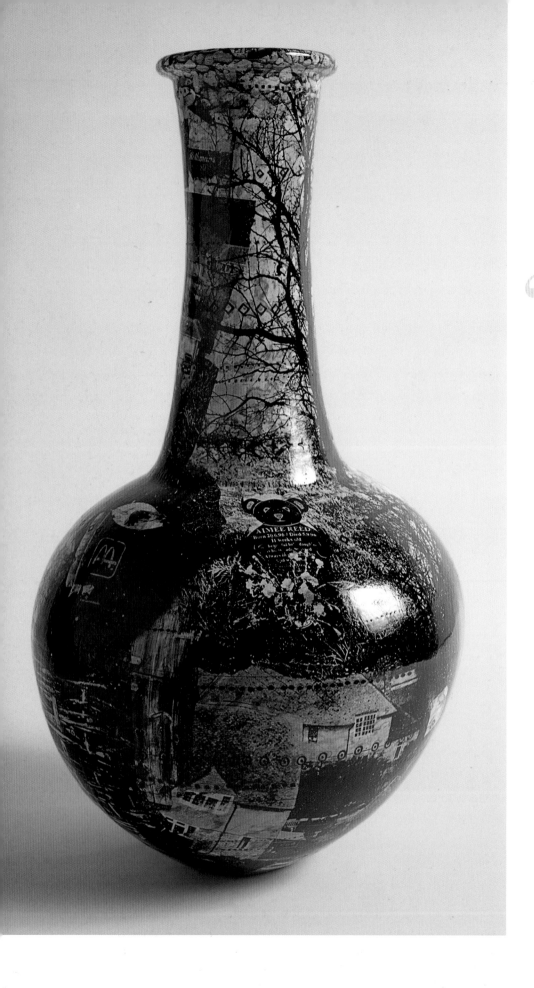

> **A lot of ceramicists** and potters obsess about the craft side of their work and regard the kiln as a fetishized object. Pottery exhibitions always have titles like 'Gifts from the Flames' or 'Fire and Earth', reinforcing the idea of some New Age goddess and celebrating the ancient danger of making pots. One of the things that made Sèvres porcelain so valuable was that for every piece that came out perfectly, there were a hundred that had failed in the kiln. But I don't have that classic potter's attitude that you put five pieces in and might only get three out. I put such an effort into each piece that I don't want a single one to break. I try to make pots as if I were making paintings; when they fail, they do so for aesthetic rather than technical reasons. I'm not after surprises, the chance effects of the kiln. In fact, I often say that I wish there were a microwave kiln.

This pot is a mischievous play on technique. It's a copy of an African pot that would have been fired in a bonfire. At a distance you might think these were the sooty marks of the flames, but actually the surface is covered in a collage of photo transfers. It was a visual pun: I was using carefully crafted modern technology to make a version of an ancient, earthy look.

i dunno | 1999
Glazed ceramic, 48 × 25 (18⁷/₈ × 9⁷/₈)

western art in the form of a saki bottle | 1992

Glazed ceramic, 34 × 29 (13⅜ × 11⅜)

This vase pushed forward my relationship with pottery a bit. I was starting to get a handle on where I felt I stood within the long history of ceramics, and what place I felt there was for irony within this tradition.

I was looking at a lot of Japanese teaware and Edo period ceramics. In Japan, there is great reverence for the peasant aesthetic. The organic aspects of craft pottery, the dribbles, cracks and crumbles, have become central to the Japanese rustic tradition. They loved it when the ash that flew around the wood-fired kiln would chance to land in the glaze, forming little lumps and discolourations. I copied a little saki bottle out of a book and tried to imitate its ash texture. To make it more obvious that my surface was fake, I cut holes in it, like a curtain through which you could see various images, including a scene of a child in a kitchen pleading with its mother. I was playing with the idea of the authenticity of the rusticated surface in ceramics. Both my drawings and the supposedly 'natural' surface of my vase are contrived: the only 'authentic' thing here is the feelings behind my drawings. The kitsch images I included were another way of abusing this revered tradition.

butterflies on wheels | 2001

Glazed ceramic, 42 × 32 (16½ × 12⅝)

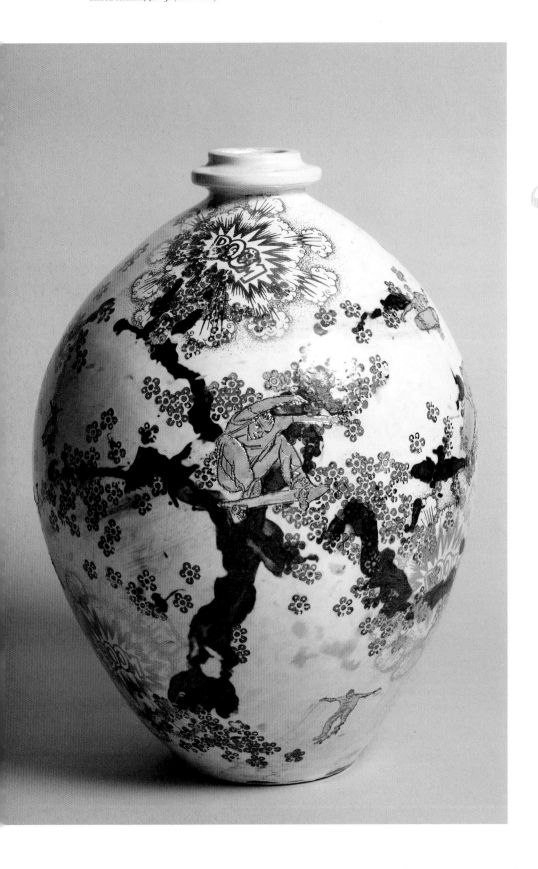

" **Ceramic vases are** usually objects of quiet contemplation and veneration. This piece is based on a Japanese Edo jar from the seventeenth century, using the same colour scheme and cherry-tree imagery, but its subject is skateboarding, the very opposite of gentle reflection. It's about action and destruction, getting 'stoked' and being 'gnarly', a skateboarding word that suggests an aggressive, devil-may-care attitude. Instead of placid flowers, it shows cartoon explosions, reminiscent of the violent movement of skateboarders.

I was into skateboarding for about a decade from 1977. Skateboarding has somehow managed to preserve its cool integrity. It's like motorcycling: it's quite dangerous, so you need a certain amount of dedication to earn your stripes. You have to fall over, to put yourself in danger, so it's not an easy style option.

I always tend to draw in pen rather than pencil because I enjoy the commitment of it. The nature of ceramics is similar, in that it's hard to go back once you've made a mark. Of course, there are some drastic things you can do to change things, but quite often it's difficult. With this vase, I'd decorated it in slip quite elaborately, with lots of patterns and stencilling. It was still relatively wet and I thought, I don't like that, so I scraped it all off. As I was scraping, the colours blended into each other and created these rather attractive patches, which I masked off. Their colour reminded me of bruises, the sort that have halos around them of different colours. *A Pattern of Bruises and Cigarette Burns* was something I might have read in an article about child abuse.

The history of how I make things is interesting. It's not simply that I have an idea and then proceed to make it; there's more of a symbiotic relationship between making and thinking. Art isn't just a calculated thought process but a relationship between you and the material. I enjoy that visceral dialogue very much.

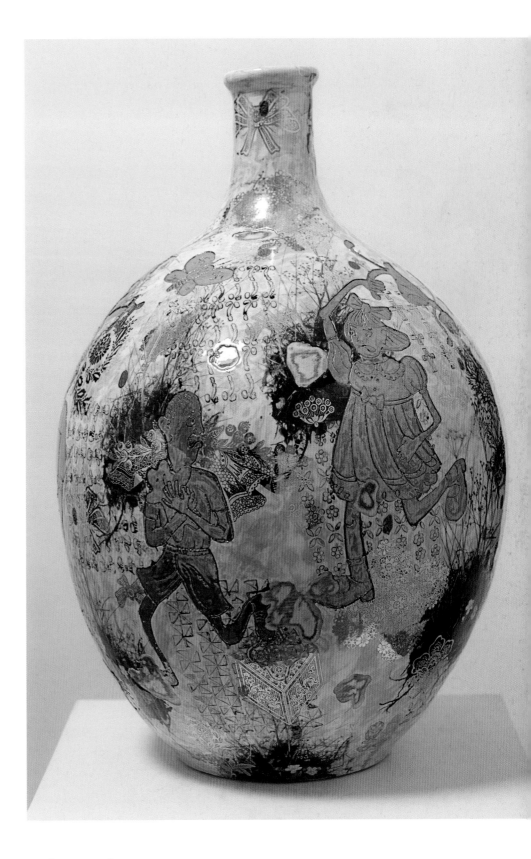

a pattern of bruises and cigarette burns | 2004

Glazed ceramic, 56 × 38 (22 × 15)

i saw this vase and thought it beautiful, then i looked at it | 1995

Glazed ceramic, 45 × 28 (17¼ × 11)

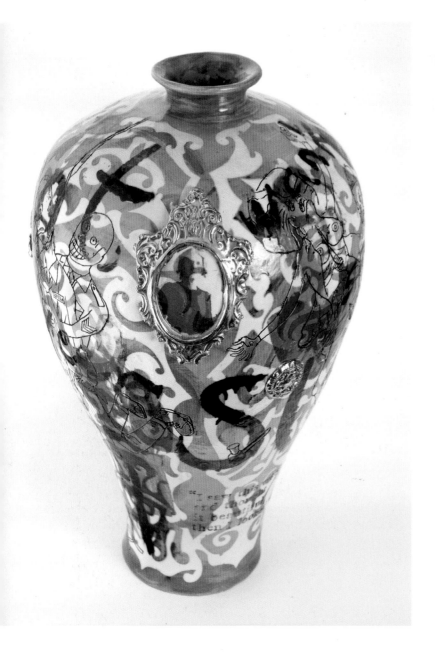
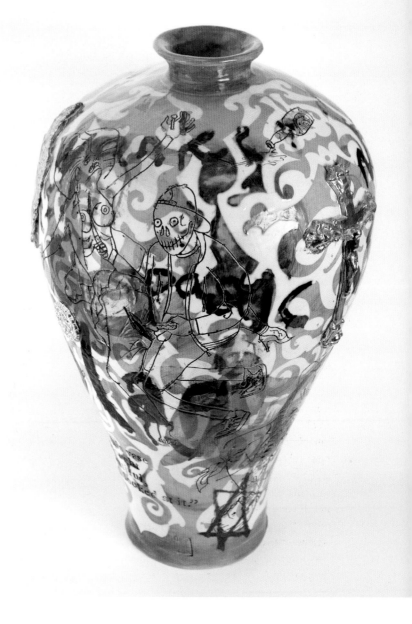

 The title of this piece is a direct quote about my work from one of my wife's aunts. People's expectations of a pot are framed by the prejudices they bring to ceramics, the memories of pottery seen on an auntie's sideboard, at a car-boot sale or in a museum. My pots always carry with them the intellectual baggage of the history of ceramics, its archaeology, geography and value system. But up close, the content of my work can confound all that.

This vase has blue Victoriana pictures on it, and obscene language with words like 'Wanker', 'Slag', 'Queer' and 'Spastic'. It has a grey papercut design and carved-in graffiti with copper-oxide scrawls. I was thinking about the gestural marks you see on oriental ceramics, like a bird painted in just three or four strokes. This is my version of that style, but instead of the spontaneous, flowing gestures of the Zen master I wrote scrawls of hateful graffiti.

At around this time, a collector bought a work of mine with obscene toilet graffiti. The words were partially masked by other layers of imagery and she hadn't looked at it closely. Someone from the gallery called her to check that she really knew what she'd got and, of course, when she looked at it, she decided to swap it for another piece. People often have difficulty reading a message that fights too much with the medium.

This vase has a surreal, rather incoherent jumble of images on it: a Hogarthian print of street-sellers; Claire in her Sloane Ranger clothes wielding a dagger; the christening photo of Prince Harry with the Queen and Princess Diana; and an upside-down floating transvestite who's been castrated. The form is vaguely oriental. The papercut shapes of strange figures are almost Picassoesque, including one with a penis for a brain. There's a strange animal creature with a human face, a sort of pig devil. The title was me suggesting that it all had some greater meaning. I used to have a conflicted attitude to craftsmanship and decoration. Nowadays, I'm much more unapologetic about it but then I still felt I had to cover my back, to be sure I was seen as a conceptual artist and not as a craftsman.

Even early on, though, I did have self-imposed standards. I couldn't ever have pots that were cracked to the extent that it threatened their integrity. A little crack in the edge of a pot doesn't bother me too much but a great big one running through the middle does. The first thing you do when you open the kiln is to hit a pot. If it makes a bright, ringing sound, that's great – but if it responds with a dull thud, you worry, because it means it's got a severe crack in it. That's a heartrending moment, but thankfully it doesn't happen too often these days.

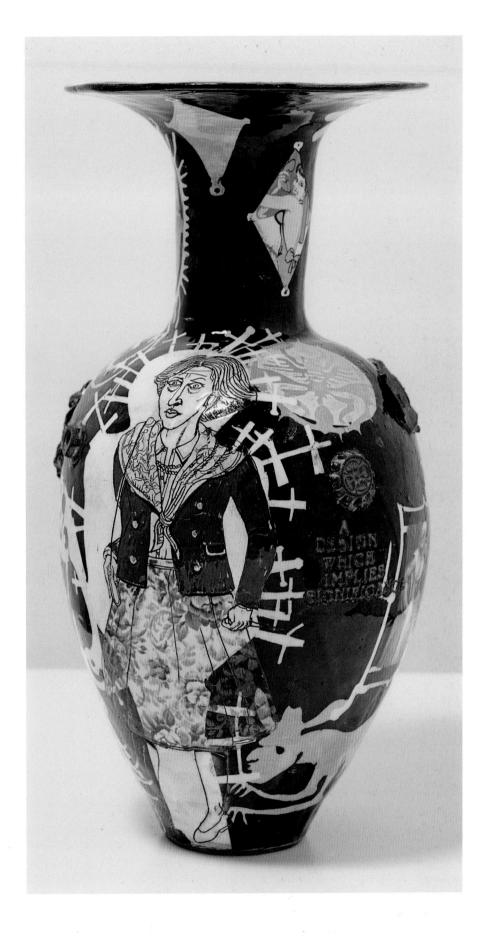

a design which implies significance | 1992

Glazed ceramic, 40 × 20.5 (15¾ × 8⅛)

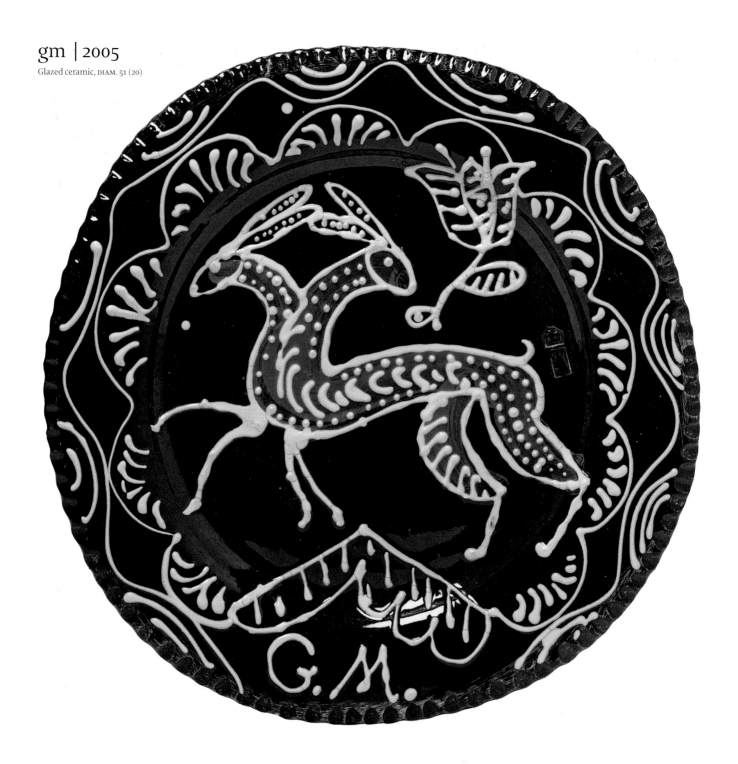

The countryside is an arena of protest nowadays: hunt saboteurs line up against the Countryside Alliance, locals fight second homeowners, and eco warriors object to genetically modified crops. Political actions are almost becoming a new folk tradition. This plate shows a two-headed hare, an animal-rights protester's nightmare vision.

This is a large charger, the sort of plate that would traditionally have been used for serving meat. There is a long history of these, going right back to some of the first ceramic things I was inspired by, such as Thomas Toft's English slipwares of the seventeenth century. One of the things I love about craftsmen like him, who made countless slipware dishes each week, is that their work shows a fluency and ease, a comfort with the craft tradition and the ability to play with particular images or motifs. Nowadays, a technician can be handed a drawing for something that they can make very competently, but there won't be a lot of spontaneous invention and riffing on the idea. That handmade, repetitive practice is central.

I was put off making plates for a while because they seemed too easy, like a ceramic equivalent of drawing. But as my work has become more elaborate, my pots are taking months to do and many man-hours to put together. I have an idea for a pot and I'm then wedded to it for the next three months. A plate takes a matter of hours. I deliberately make them in a loose style, so they're quick to do, which was what encouraged me to go back to them. Usually I spend no more than an hour or two drawing on them; I find that the speedy ones work the best.

ikea | 2005

Glazed ceramic, DIAM. 51 (20)

"The images of a horse and a leaf on this plate are a complete rip-off from early nineteenth-century American folk pottery. I remember looking out on the street from my studio and suddenly thinking, I bet there are some houses out there without a single handmade object in them. In the American frontier world, everything would have been handcrafted. People still cling to a myth of the idyllic countryside full of cottages packed with handmade things, where there are no cars and everybody rides around on horseback carrying baskets of local produce. But where do the locals actually go for their things these days? They don't wander down the road to the village bodger to make them a handsome Windsor chair turned out of raw willow – they drive to the local Ikea, just like everyone else. There's an added irony here, in that this plate is a handmade original, a one-off, and because of that it's going to sell for thousands of pounds.

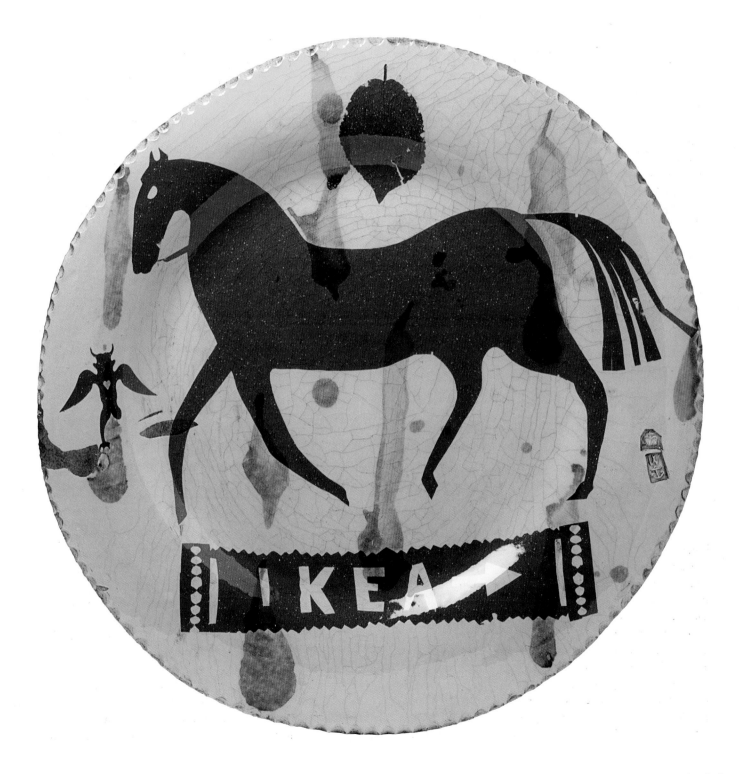

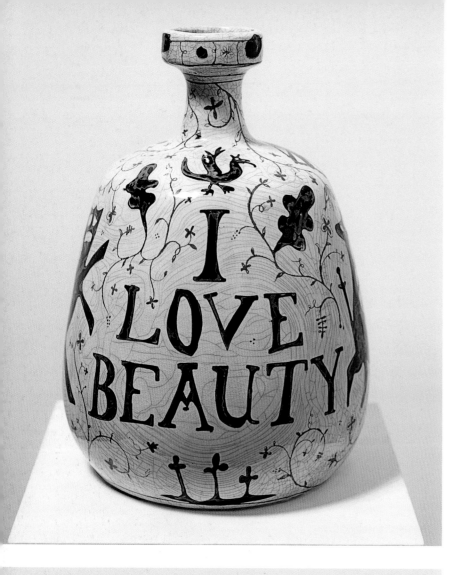

i love beauty | 2005

Glazed ceramic, 35 × 25 (13¾ × 9⅞)

❝ **People ask me** why I often choose discomforting subjects for my work. My latent fear has always been that if I started leaching out the controversy in my work then it would be nothing more than pottery. This is a very uncomplicated vase and it shows me venturing dangerously close to making a pure piece of pottery. That was the charge around it for me.

Decoration and beauty are still often seen as swear words in contemporary art, but as I get older, I realize that there is a profundity to be found in decorativeness. There is an over-privileging of ideas in contemporary culture that can trivialize the power of pure visual beauty, but art doesn't have to have a deep concept behind it to make it serious. In this work, the title is writ large: 'I LOVE BEAUTY'. The images are simple – Claire holding a staff and a bird of prey, some heraldic animals and a Union Jack – but they're not there to ram home any important idea. I am coming round to the notion that in terms of positioning myself in the debate about craft and art, whereas I started on the art side, I'm increasingly creeping back towards the arena of craft. As I gain more confidence, I'm tiptoeing towards crafting decorative art – while trying to drag the definition of contemporary art with me.

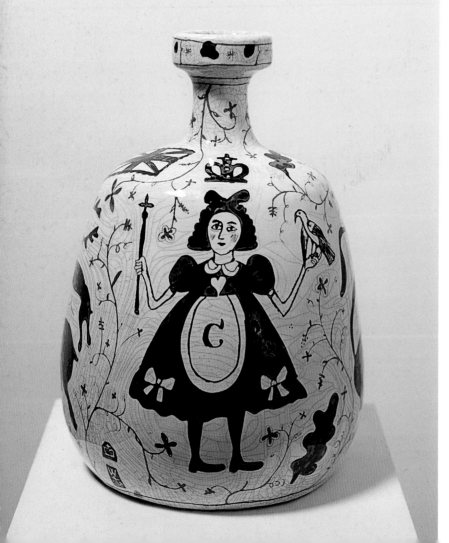

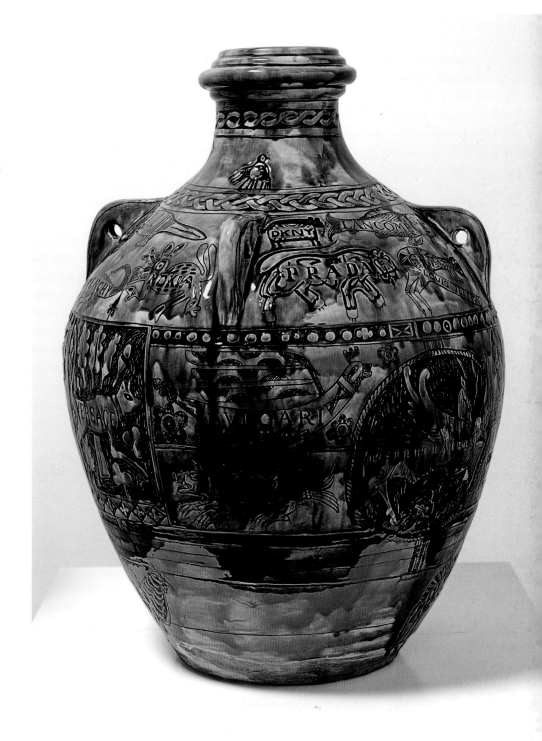

"I made this work for a show in Venice, which got me thinking about the city and its history as a centre of commerce and trade. It looks like a storage jar that would have held spices or expensive oil, the sort of thing once traded there. Now, international brands that you can buy everywhere are all that's sold in Venice: Gucci handbags and Chanel perfume. That great hub of international exotic trade now just sells chain gewgaws to the wealthy tourist. It reflects the rapaciousness of the globalized consumer machine. It's similar to the way in which the creative industries swallow up indigenous cultures. The fashion industry, for example, will have a year of going all Russian peasant, or someone in the music industry might give their new album a Balinese gamelan feel.

I went through a book of traditional animal motifs from different periods and cultures, and I assigned each creature an international brand, so there's an Aztec Sony and a medieval Chanel, for example. Of course, art, above all, is the ultimate consumer durable. And pots are, I suppose, my own brand. So it's a double-edged thing: I was critiquing the vacuousness of brands but also admitting that I'm a brand as well.

ultimate consumer durable | 2005

Glazed ceramic, 65 × 45 (25⅝ × 17¼)

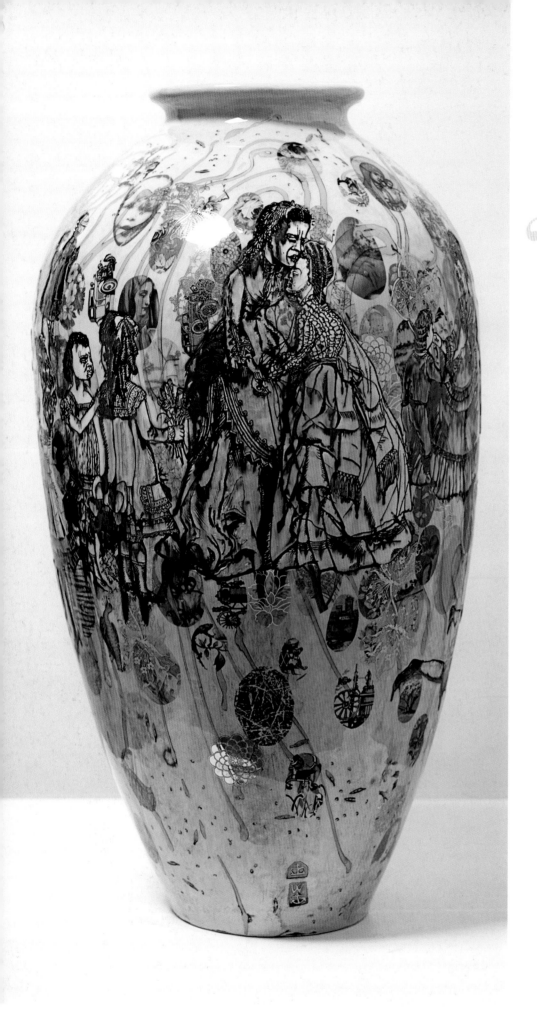

Whatever their subject matter, I try to make my vases attractive, because I think they're more potent if they're beautiful. The pictures here show women and children taken from Victorian clothing catalogues, but I've replaced their faces with documentary photographs of people damaged by the Chernobyl disaster and Agent Orange. It's always a dance for me between the subject matter and the surface beauty.

I was very pleased with this piece: to me, it looks like a proper bit of pottery. It's a lyrical pot with a dreamy, atmospheric quality because the underglazes ran slightly, and that matched perfectly the theme of the vase. Also, the colours and translucency of the hovering transfers complement the slip design in the background. I find the hardest thing to achieve in my ceramics is a harmony between the colours and textures because you're always working in the future, and the firing radically changes the relationship between the two elements. Experience teaches me what might work but I am always trying new combinations of things, so luck plays a part.

memories | 2007

Glazed ceramic, 61 × 35 (24 × 13¾)

jane austen in e17 | 2009

Glazed ceramic, 100 × 51.5 (39⅜ × 20¼)

" **This is one of my** largest vases and
I made it as a kind of technical tour de force.
My main motive was to show my command of
the techniques I've learned. I had a picture of
Memories [opposite] on the wall when I made it,
because I was pleased with how well that had
come out, and I wanted to build on it.

E17 is the postcode of Walthamstow, and it was
about the clash between middle-class polite
culture and the world of North London outside
my studio window, with its rows of council
houses. The drawn imagery shows ladies in
classic Georgian dress doing things like taking
tea. They're from costume illustrations I'd
seen and were inspired, too, by period dramas
I was watching on TV. The imagery in the
background is mostly photographs I had taken
of the urban grit of Walthamstow: CCTV
warnings, guard-dog signs, satellite dishes.

Principally I was interested in it being an
aesthetic whole, though. I wanted the pot to
have a kind of flawless, watery beauty, for the
imagery to look almost as if it was underwater.
It wasn't so much about a dissonance of
imagery but about colour, texture and fluid
lines. I controlled the colour scheme very
carefully; it's all greens, blues and a bit of
purple, with little flashes of red.

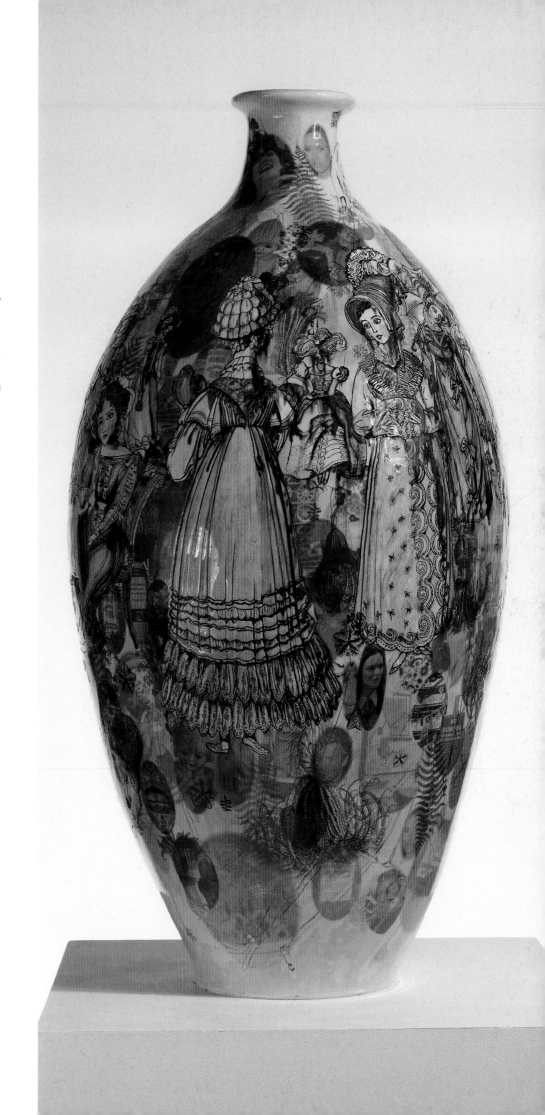

chapter 3 class

'It took me until fairly recently to get over what I would call "imposter syndrome": the idea that high culture, museums and being successful in the arts wasn't something for the likes of me.'

Despite periodic announcements by politicians that the ideal of a classless society has been achieved, class continues to function as a powerful force in contemporary life.

Whether we are conscious of it or not, social divisions and distinctions are sewn into the patchwork of our existence: they shape the way we think about one another and ourselves. However subliminally, we read in everything from a person's name and manners to their politics and profession the signs of social and economic difference.

For Grayson Perry, class is indispensable, inflecting every character and scenario in his work. This may be, at least in part, connected to his coming from Essex, a county of near-mythic reputation in the British popular imagination. Since the 1980s nowhere in the UK has been the butt of more classist jokes or clichéd caricatures: the wide-boy gangster; the boy racer with stereo pumping from his souped-up Cortina; the white-stilettoed, mini-skirted ladette, all bleached hair and bling. The stereotyping of 'Essex Man' and 'Essex Girl' came, of course, with a strong bias against the apparently tasteless working classes. Perry trades on these and other class stereotypes as much as anyone, but his attitude is less one of snobbery and ridicule than of affectionate self-mockery. Acknowledging his own status as an Essex native, for example, he designed a set of bikers' leathers for himself which fused together an absurdly sexualized primitive figure (of the kind found in chalk carvings across England) with machismo motorbike culture. Proudly emblazoning the county name across each arm, he called the outfit his 'Essex Man leathers'.

Perry indeed has a complex and fluid relationship with class. He was brought up in what he describes as a 'culturally working-class' family: his mother was a housewife, his father an electrical engineer, and his stepfather (with whom he lived from the age of four) the local milkman. His mother's staunchly working-class attitudes jostled with his stepfather's aspirations to a middle-class lifestyle, so that from early on Perry was acutely aware of a world defined in terms of 'them' and 'us' – a phrase he later chose as the title for a triptych of pots about the fraught relations between the classes (pp. 72–73). He had the benefits of a good education, going to a venerable and academic grammar school, but home was an 'acultural' environment without books, music or art. The only picture in the house, as Perry recalls it, was 'a print of a tea clipper sailing ship that we got free with washing powder'.[1]

By the time he left home for art college in 1979, it was clear to Perry that class tensions were by no means limited to the domestic sphere. His late teens and early twenties were played out against a national backdrop of social unrest and increasing economic division. Britain under Margaret Thatcher was fractured by class conflict, memorable on the one hand for violent industrial disputes, strikes and mass unemployment and on the other for the rise of big business, ruthless individualism and flagrant personal greed.

Despite the public and private class warfare he observed, however, Perry remained stubbornly outside the strictures of class. Two early decisions were indicative of his fiercely independent streak: the first, the creation during his childhood of an all-consuming fantasy world, devoid of the usual influence of adult authority and led instead by his trusty teddy bear. Without strong parental figures to turn to, Perry 'formed his own theories in the here and now,' according to his wife, Philippa, a psychotherapist. 'He didn't read from the usual scripts that we typically get passed on from our parents. He didn't get this good and bad lens through which to see the world.'[2] The second decision was to go to art college. In doing so, he committed himself to a career that moved him further from his roots, joining that caste of cultural practitioners for whom wealth, education and property ownership – the typical signifiers of class – are valued less than the currencies of ideas and personal expression.

Semi-classlessness has allowed Perry to cast a freer eye than most over the world around him, aided by a finely honed instinct for social detail and a razor-sharp wit. As a teenager in the village of Great Bardfield,

doing the paper rounds for his stepfather (who by then had turned his hand to working as a newsagent), the attentive Perry turned a menial job into an opportunity to peer into the worlds of his neighbours. He noticed which papers they took, what work they did, who their families were, how they lived. This peculiar sensitivity to, and fascination with, the nuances of class has persisted. It places Perry outside the mainstream of contemporary art practice, where conceptual concerns, rather than close observation of social reality, predominate. Class is, of course, an intrinsic aspect of the art world, but it remains a largely unspoken one. And if we encounter social satire in contemporary culture, it is more likely to be in TV comedies or newspaper cartoons than in the art gallery – making Perry almost alone among today's artists in foregrounding class and adopting the satirical mode in his work.

In this context, Perry's art is far closer to that of the great English and French satirists of the eighteenth and nineteenth centuries than it is to his contemporaries. Artists such as William Hogarth (whom Perry references in *An Oik's Progress* and *The*

Vanity of Small Differences; pp. 76–77 and pp. 276–79), James Gillray, George Cruikshank and Honoré Daumier similarly referenced the major subjects of their day, pinpointing with deadly accuracy personalities and social 'types', and lambasting politics and culture alike. They, like Perry, perceived the world as stratified (these being the centuries, after all, in which both human beings and the animal world became almost obsessively classified). They, too, felt at liberty to mock both left and right, upper and lower. Later in the nineteenth century, satirists and realists alike continued to document with relish the bustling panorama of everyday life both in prints and paintings. William Powell Frith's *The Railway Station*, for instance – one of Perry's favourite paintings – shows us mid-Victorian life and all its nuances of class, highlighting the new technological wonder of the railways and the unprecedented mingling on the station platform of everyone from pauper to aristocrat. Nowadays, the three 'tiers' of society – working, middle and upper class – might bear different names ('chavvy', 'Middle England', 'posh'), but the cast of characters in Perry's work is, similarly, instantly recognizable.

Perry's satirical outlook, particularly in his attitude towards class differences, distinctly colours both the tone and content of his work, providing potent ammunition for his long-range critical missiles. He sees elements of class warfare discreetly embedded in almost every aspect of contemporary life, whether it be art and culture (including institutions such as art galleries that delineate 'good' taste), football, consumerism, fashion, psychotherapy or language. Without doubt, his work presents us with parodies and extremes, but it also contains much that is true. A modern-day Hogarth, he too manages simultaneously to love and loathe his subjects, to empathize with his various characters and yet to remain at a distance from them. It is perhaps only slightly in jest that he once remarked: 'I've got it in for all of them: I can hate the underclass [because] of their violence, their dysfunctional families, their noise, their rubbish. And I can hate the middle class for their straitjacket of conventionality, their buying into consumer society, their bloody cars, their Barratt homes. The nobility are probably the only ones I get on with.'[3]

Far left | Grayson Perry in his 'Essex Man leathers' at High Beech biker tea hut, Essex, 1989
Left | GEORGE CRUIKSHANK *The British Bee Hive*, 1840/1867
Above | WILLIAM POWELL FRITH *The Railway Station*, 1862

barbaric splendour | 2003

Glazed ceramic, 67 × 35.5 (26³/₈ × 14)

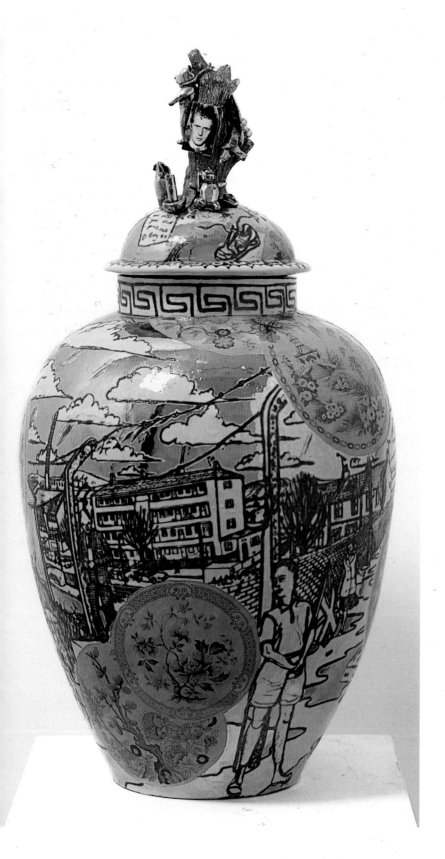

'Barbaric splendour' is a phrase I read in Ernst Gombrich's book *A Sense of Order*. It comes from Greek oratory: if somebody was a bit flashy and prone to theatrical language, the orators would frown on it, calling it 'barbaric splendour'. They thought that speaking plainly was a higher achievement and looked down on other cultures that were more inclined to sensuous pleasures.

That trend in western civilization has been continuous, from Puritanism and classicism right through to minimalism in our modern age, all of which are seen as somehow morally superior. To indulge in decoration, ornateness, precious materials, a kind of visual busyness or emotional excess, is seen as morally inferior. It's because class is central. Restraint has always been seen as having a high moral value and being one of the premier middle-class 'virtues'.

The imagery on this pot is of a depressed northern working-class landscape with puddles drying up after the rain. The roundels have the typical trashy dinner-plate motifs of the working-class wedding present. I wanted to give it a luxurious ordinariness. On the top is one of those little memorials that you see by the roadside with cuddly toys and candles. I was thinking about the emotional outpouring after Princess Diana's death and the whole 'Dianafication' phenomenon. It was seen as an example of barbaric splendour by the middle-class media: you can cry at the right opera, but to cry at the wrong thing like Diana's funeral is 'common' and misplaced.

I am naturally what I would call a 'maximalist'. I make things that are incredibly ornate and shiny so perhaps they adhere to a more 'working-class' aesthetic. Often I use that as a deliberate provocation to my audience in the art gallery: I make gewgaws that might fit in a home with patterned wallpaper, a patterned three-piece suite, patterned carpet and a reproduction of Constable's *Hay Wain* on the wall.

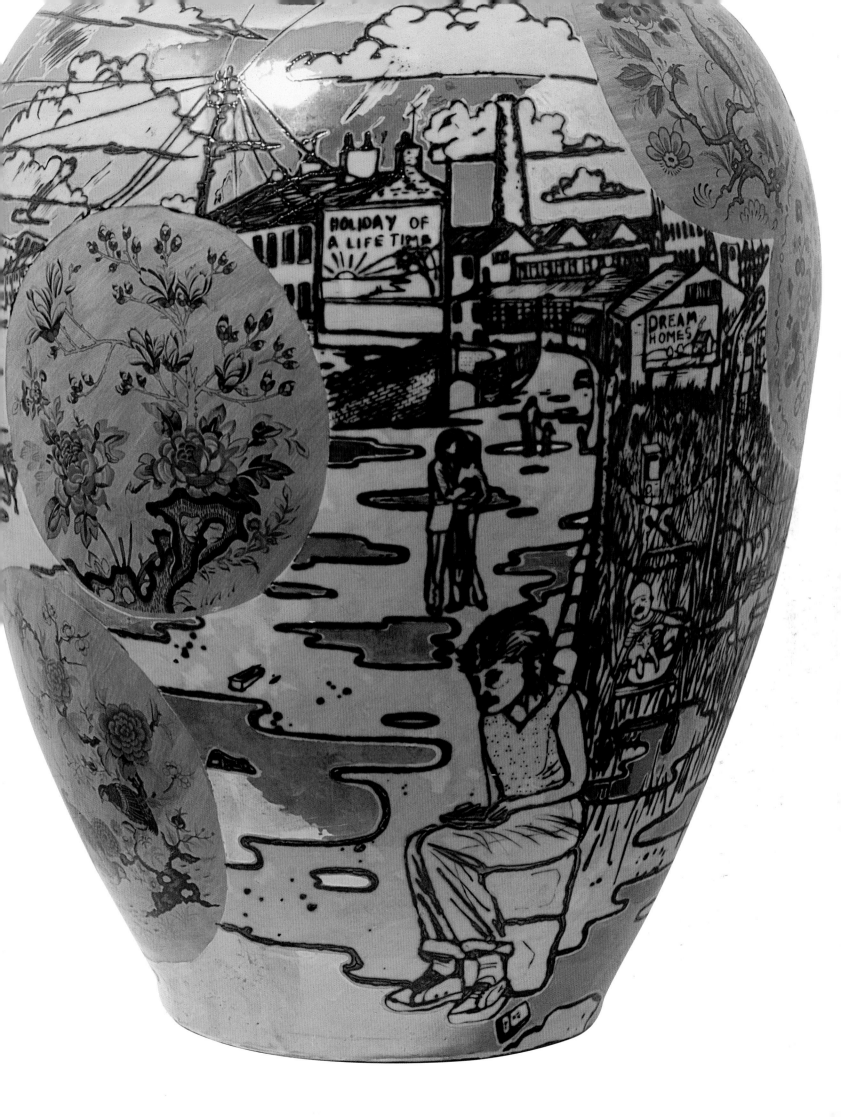

i was an angry working-class man | 2001

Glazed ceramic, 56 × 26 (22 × 10¼)

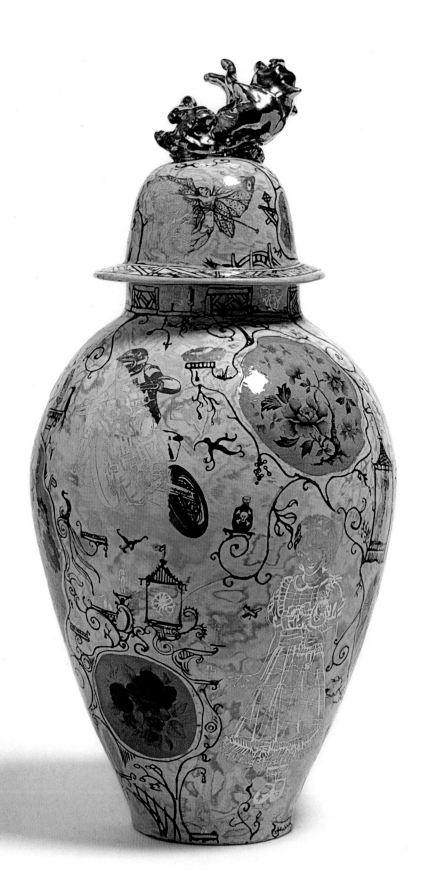

“ **I was a very angry** working-class man! I had a terrible temper. Anger was a big part of the psychological baggage I brought with me from my past. Many people carry anger like this that they need to dissipate in some way.

The title is important and every word counts. I 'was' is in the past tense, in that I hope I'm getting over my inappropriate temper now through therapy. 'Working-class' in that, by the very nature of becoming a successful artist, one does leave one's class to a certain extent. 'Man' is a joke on me being a transvestite. The pot is essentially about working-class male identity, but I've made it poncey-looking and pretty. On the top is a Pit Bull terrier that has been kicked in the balls. I used a chinoiserie style in part because I saw it as the apotheosis of the English middle-class drawing-room aesthetic. It's about occupying the world that I do, making lovely, delicate ceramic things, and yet being a working-class man. Those two things collide in quite an interesting way.

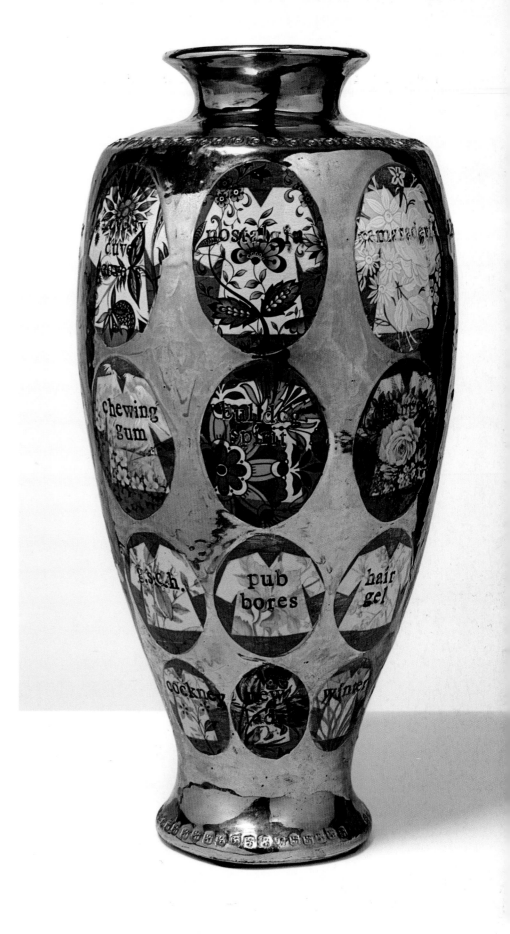

"To coincide with Euro '96, one of those rent-a-galleries on Cork Street put on an exhibition about football. It was quite light and had everything from posters to Japanese prints and eighteenth-century cartoons. I was asked to contribute and I made this piece, which looks like the European Cup, or at least my memory of it. Often those sorts of trophies have little plaques on them with the various winners, so I did my own plaques with football-shirt motifs and different patterns. There are words or phrases on each of them with all the things I detest about football: lonely playgrounds, shouting, special brew, novelty duvet covers, bad tattoos, gangs. I never liked football much because my stepfather used to encourage me to do it. I had to go to football practice every Wednesday, which I loathed. I was never any good at it; I never really warmed to team sports.

football stands for everything i hate | 1996

Glazed ceramic, 41.5 × 22.3 (16⅜ × 8¾)

This was a rare commission, and I wanted to make a piece very blatantly about class, to tease art collectors a little. Wealthy patrons are usually either oblivious to, or sensitive about, class. So I made a class triptych, a dialogue between the two larger side vases, the lower and upper classes, and the central middle-class vase which has a landscape of Dungeness in Kent, a place with its share of friction between poorer locals and trendy weekenders. The working-class pot has a Pit Bull terrier on the top; the upper-class one has a rather triumphant horse and rider. I copied a three-piece set I'd seen in a book of porcelain from the eighteenth century.

The work shows all the insults I could think of that each of the classes might say about, or to, the others. It's in part also about the clash between town and country, so the upper-class women are all set in the countryside saying things like 'Ill-mannered slobs' and 'Smelly junkie squatters'. The working-class men include lots of skateboarders in a derelict landscape, saying 'Working class is the creative class' and 'Stuck up do-gooders' – the kind of thing a working-class person might throw at someone who is middle class. The idea that the working classes are somehow the 'real' world is a recurrent one, and that rich people live in a kind of fantasy. No they don't – they just live in a much nicer real world! There's this belief that you somehow give up your integrity when you become middle class and interested in things like art, which I find ridiculous.

them and us | 2001

Glazed ceramic, left 61 × 31 (24 × 12¼);
centre 38 × 23 (15 × 9); right 67 × 32 (26⅜ × 12⅝)

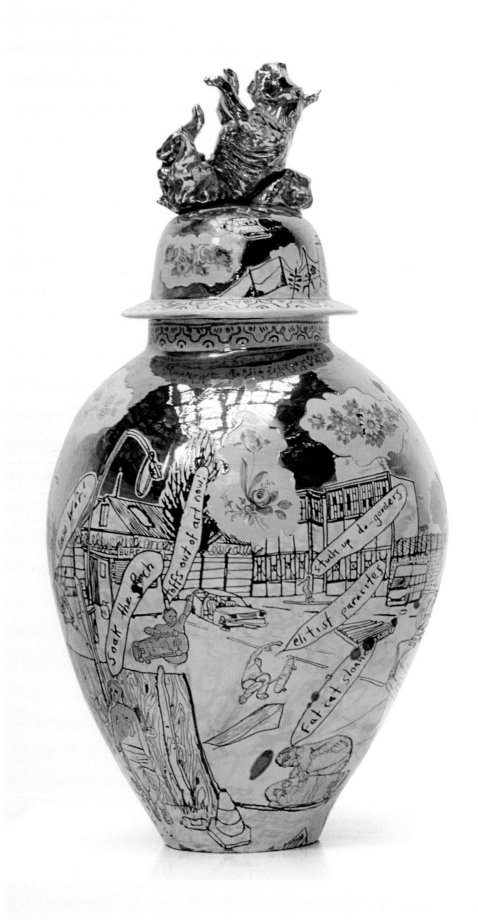

untitled | 2002

Watercolour, crayon, pen and collage on paper, H. 42 × W. 59 (16½ × 23¼)

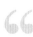

This work is a sort of dysfunctional Nativity scene, set in front of a caravan. It's pure chav culture. Two lonely-hearts columns from the local newspaper have been collaged in – two sets of hopeful dreams framing the brutal banality of the family group in the centre. There's an American Express card hovering over the top. That was prescient: following the 2008 economic crash, I might have called this collage 'Sub Prime Madonna'.

I have made lots of drawings since around 2000. It was a second wave of drawing for me, the first having been the sketchbooks I did just after leaving college. The more recent ones came directly from the games I played with my daughter, Flo, as she was growing up. We'd both think of a character and then draw them along with their fictional family. Our game would be to make a series of pictures, sometimes including where these people worked, where they went on holiday and what sort of car they drove. That casualness was really good for me. Drawing is visual playing; I enjoy it enormously. And I'm much more likely to play in a drawing that only takes an hour or two than I am on a pot that takes months.

When I made this piece I had a studio in Dyers Hall Road in Leytonstone, in northeast London. It was a house rented from the Acme charity, set up to help artists with accommodation. My studio was in the front room looking out on the street. When I'm working I almost always have something on in the background, usually some music or BBC Radio 4, apart from those moments when I'm having a big think. Most of my ideas, though, come by chance, when I'm doodling or watching the telly. I've learned over many years that just sitting down and trying to have an idea doesn't usually work.

The inspiration for this pot was the dissonance between a beautiful piece of music and seeing a poor downtrodden person trudging past my window, a bag lady or a drunk old man. The title is about that schism between uplifting, great art and everyday, working-class reality. Art often has a voyeuristic quality, if you think about art lovers peering at works in smart galleries. There's also a voyeurism in relation to the working classes, where people often think, 'Oh, look at the charming poor people going about their drudgery!' I quite like drudgery myself sometimes.

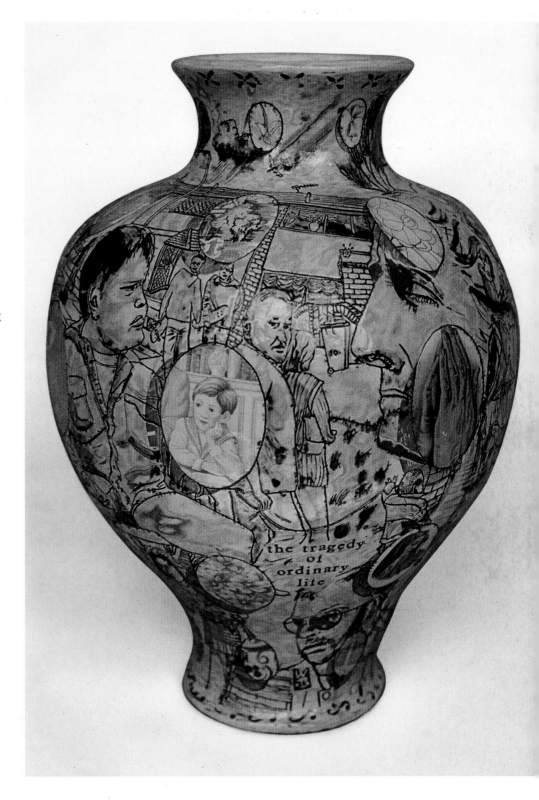

the tragedy of ordinary life | 1996

Glazed ceramic, 50 × 38 (19¾ × 15)

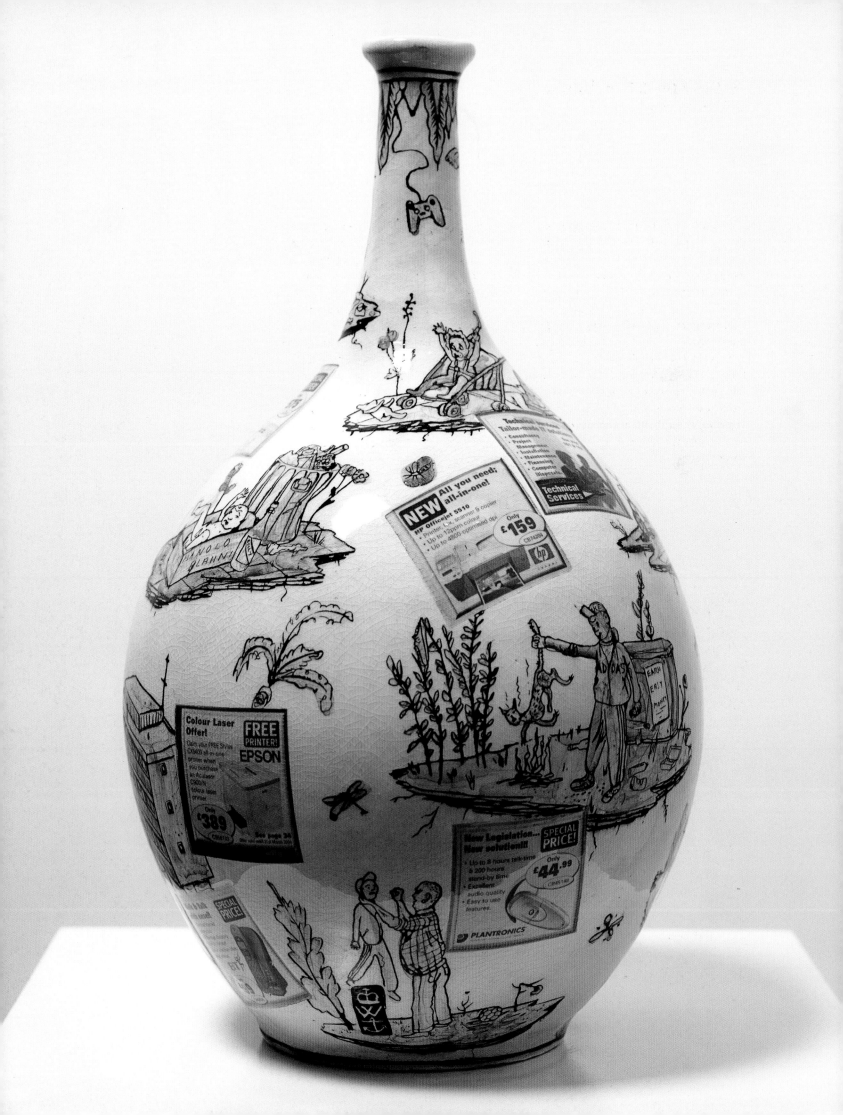

an oik's progress | 2004

Glazed ceramic, 44 × 26 (17⅛ × 10¼)

"The basic pattern of this vase is toile de Jouy wallpaper, of the kind you see in nice houses. It refers to *A Rake's Progress* by Hogarth, a story of a young buck who squanders his inherited wealth, marries for money, gambles away his new fortune and ends up dissolute in Bedlam. My version tells the story of the short life of a young boy, from being an abandoned baby in a Manolo Blahnik shoebox through to throwing TV sets off tower blocks and torturing cats, ending with his death in a joy-riding accident as a teenager. In a series of little vignettes, we see the life of a hoodie: drug abuse, theft and violence, interspersed with images from one of the most depressing publications I found at the time, a computer accessories catalogue. Why wouldn't crime be exciting if that was the world you grew up in? It exemplified for me the unsatisfying drone-hood of youth.

From early on, my work has been referencing Hogarth. There's something about the warm, working-class element of his work that appeals to me; there is a 'man-of-the-people' aspect and a Britishness to him. I sympathize with the feeling of much of his work. I also adore the more vitriolic satires of James Gillray, Thomas Rowlandson and George Cruikshank. Some of them are far more shocking than anything we might see in newspaper cartoons today.

WILLIAM HOGARTH *A Rake's Progress: The Rake at the Rose Tavern*, 1735

the common enemy | 1990

Glazed ceramic, 50 × 23.6 (19¾ × 9¼)

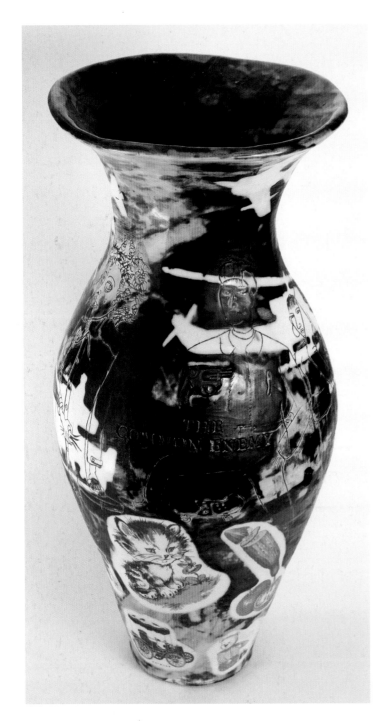
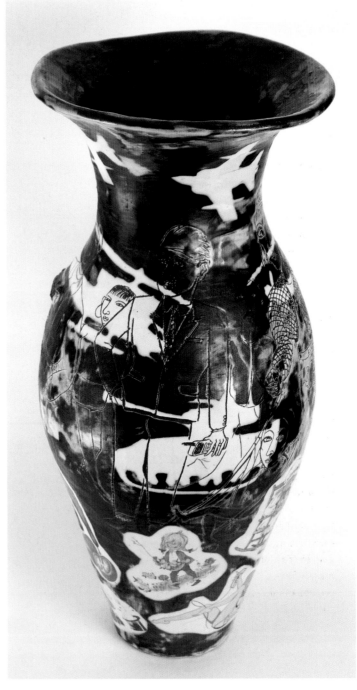

66 **This is an early** work about class war and taste. I used a lot of open-stock transfers at the time, which I saw as symbols of vulgar kitsch: vintage cars, kittens, farmyard scenes, the sort of stuff that would have adorned 1950s kitchenware. I put some around the base of the pot; I was going to war against them. 'Common' was an insult that my mother threw at everything.

This vase was from before I began using classic forms, when I would just start at the bottom, work my way up and see where it ended, making something that was vaguely vase-shaped. I quite like the fact that some of these early works are a bit wobbly and lacking in structure. They're bad because I was just learning how to make them.

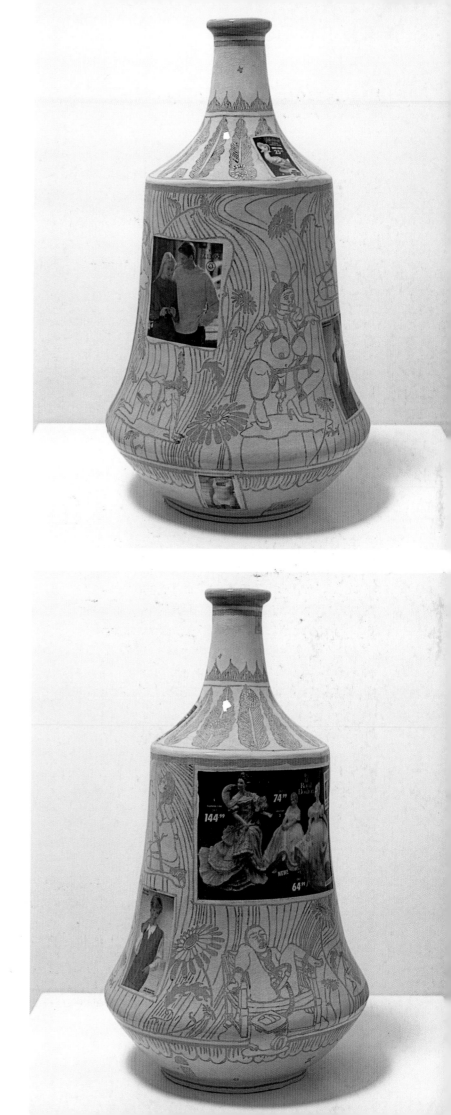

I am fascinated by the notion of taste. Differing tastes are one of the things that most strongly divide social classes. On this vase I was trying to combine two sets of motifs that would be seen by one group as good taste and by the other as bad. I contrasted the pornographic images in blue-grey and lemon, colours that somehow spoke to me of upper middle-class drawing rooms, with photographs from a 1980s shopping catalogue. The chattering classes might be titillated by the radical chic of the porn while being revolted by the dowdy wares in the catalogue. Conversely, the knitted waistcoat-wearing collector of Royal Doulton figurines might be scandalized by the drawings of sadomasochism. The shape of the pot comes from a nineteenth-century Japanese Imari bottle.

I was pleased with how the relationship between the yellow and the blue-grey turned out. It's not entirely luck, but the truth is that I am lazy. I don't do tests, which is a horrible admission for a ceramicist to make. If you are going to risk months of work on something but you haven't even done tests to see if a colour is going to come out how you imagine it will, that is pretty risky behaviour. But that's me.

good and bad taste | 2007
Glazed ceramic, 57 × 31 (22½ × 12¼)

queen's bitter | 2007

Glazed ceramic, 57 × 34 (22½ × 13⅜)

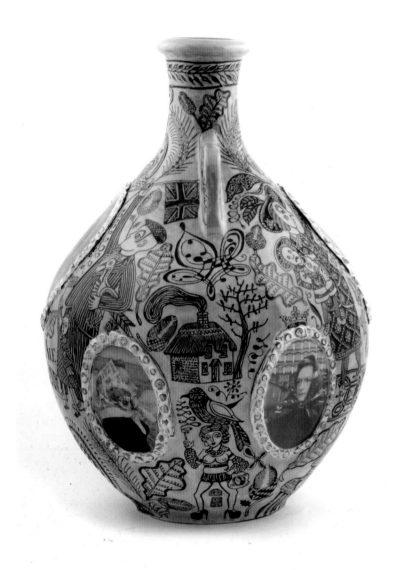

" **This is a celebratory** piece about working-class culture. It was made in response to a show I curated from the Arts Council Collection of post-war British art. My main influences were the ethnographic photographs by Tony Ray-Jones and Patrick Ward, which reminded me of a more innocent Britain of clubs and hobbies and Mackeson stout. Its palette references Jack Smith's painting *After the Meal*.

The two lugs on the pot hint at functionality. In the industrial era, pottery apprentices would make a show-off piece to prove that they had graduated in their craft. I wanted it to look a bit like that sort of object – a primitive drinking flagon, dedicated to beery Britain in the second Elizabethan age.

The pot is covered in patriotic imagery, with drawings that I did in a deliberately folky style. It has pearly kings and queens with their pigeons and lots of Union Jacks. In the 1950s, following the war, there was a revival in folk culture, particularly folk music and dancing. Britons wanted to find things that were distinctly of their culture in order to reassert their national identity.

The medallions have pictures of me in different headscarves, celebrating one of my earliest fetishes. A headscarf is a kind of bonnet enclosing the head, made even more fetishistic by the use of satin. Nowadays, there is a potency in the debate about Islam and the headscarf, but the fetishistic angle never seems to come up. You often hear people talking about modesty but the interesting thing is that it's not women hiding their hair but women being *obliged* to hide their hair: the modesty is imposed. That power relationship is, for me, the fetishistic angle. And, of course, the Queen still wears a headscarf – they are one of the last vestiges of polite clothing and of a dying Victorian civility. More often, though, I associate them with working-class women going to the salon and wanting to keep their nice hairdos in a good state for a Saturday night out.

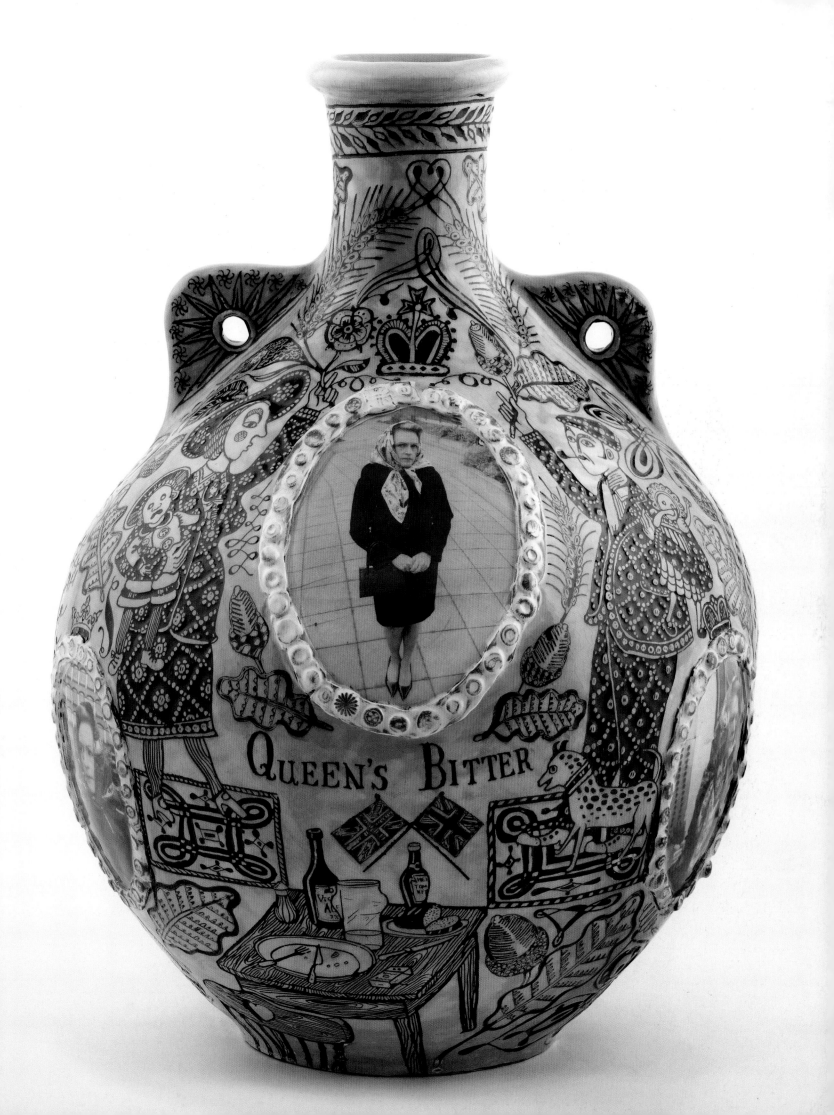

poverty chinoiserie | 2003

Glazed ceramic, 64 × 40 (25¼ × 15¼)

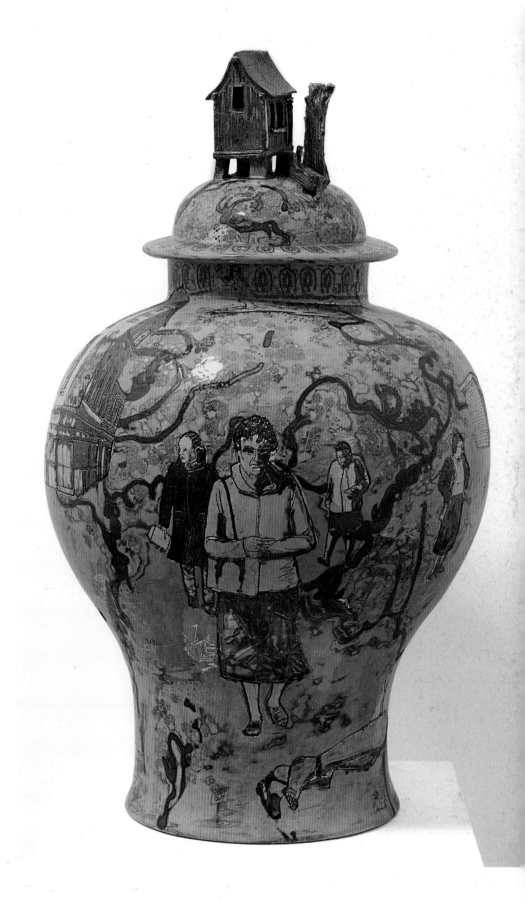

"I started this vase with the idea of the idealized peasant as it crops up in chinoiserie and oriental ceramic work. We often holiday in other people's misery. Our idea of the picturesque is often other people's suffering: a noble painting of workers gleaning the fields is also a document of the hardship of people in the past.

The tumbledown shack on the lid signifies our idea of the twee. It might be one of those parts of the world that are gradually being inundated by global warming. Then there are pretty raw images of the East End and its grittiness: the Flying Scud pub; a woman lying dead, the victim of some horrendous attack; an aggressive skinhead carrying iron bars; a put-upon mother with her pushchair. Placing these scenes of the reality of modern, urban, everyday poverty on a pot challenges us to ask ourselves whether these things really are picturesque.

This is one of my few green vases, and I like the slightly malevolent atmosphere of it. The apple green colour is quite difficult to produce. The shadowy quality of the imagery comes from the way that the copper oxide has bled. I get that effect by trailing copper-oxide slip on first, so that it bleeds through the other layers of the slip and you get this strange, almost ghostly, photographic quality around the thick lines of the tree branches.

what things say about us | 2002

Glazed ceramic, 56.5 × 35 (22¼ × 13¾)

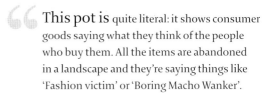

This pot is quite literal: it shows consumer goods saying what they think of the people who buy them. All the items are abandoned in a landscape and they're saying things like 'Fashion victim' or 'Boring Macho Wanker'.

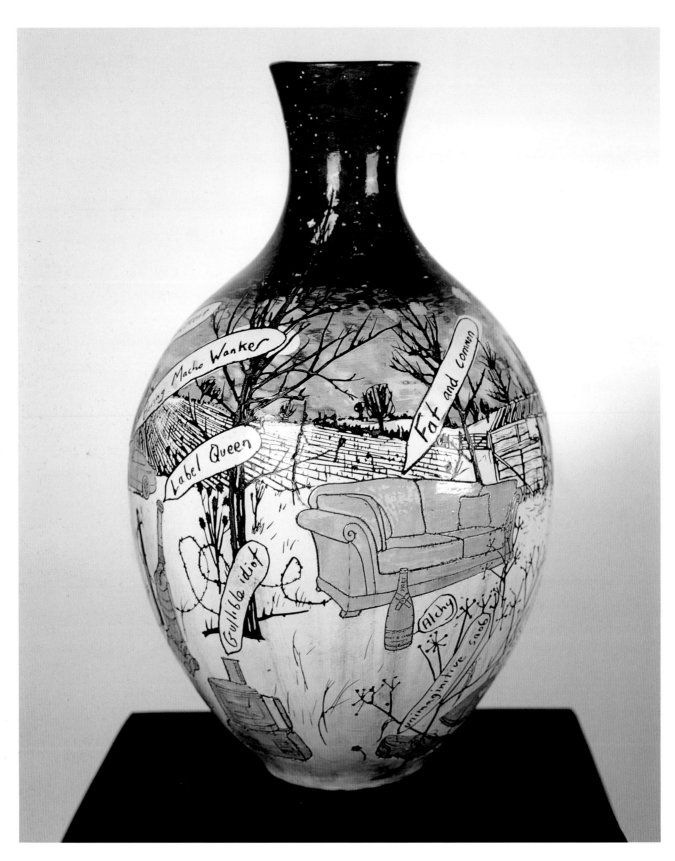

sunset from a motorway bridge | 2002

Glazed ceramic, 46 × 35 (18⅛ × 13¾)

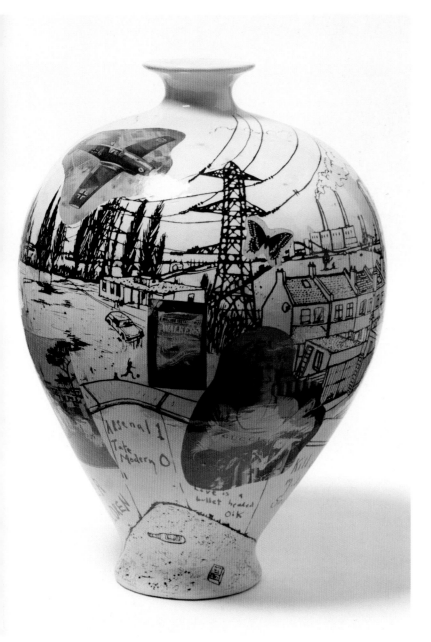
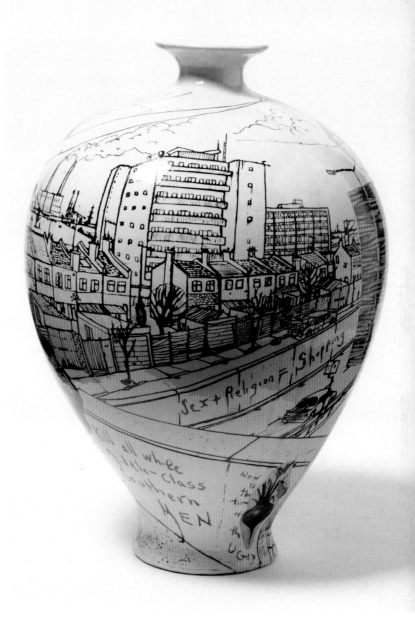

The landscape near my studio in Walthamstow is pretty bleak and uninspiring. This pot was a response to going for walks around there. On a motorway bridge that goes over the North Circular Road I found the most atrocious graffiti I've ever come across. I remember discovering it on one of those winter days when the sun sets at half past three and there is a general sense of depression in the air. It was obsessive, racist and sexist to the max, but it was a meticulous piece of graffiti. There were screeds of hate covering the whole bridge.

I took a load of photographs of it and used them for this pot. I've always thought that even a pile of rubbish can be exquisite or poignant. I'm interested in that clash between things, and I often operate around that moment when art can lift us up from our everyday lives.

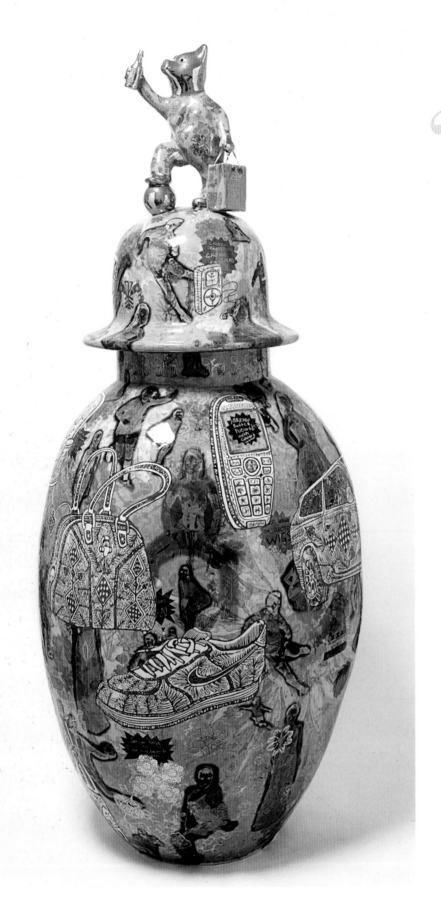

Consumerism is very lazy. It's a sort of sugar rush, like eating sweets. People become addicted to the orgasm of the credit-card purchase, but it's a momentary, low-grade pleasure. Luxury goods are dangled in front of us because people can make money out of them, not because they give lasting satisfaction.

This pot might have a sophisticated visual appeal but it's about what I regard as the trash of contemporary culture: the visual pollution of brands, sport, advertising, footballers' wives and celebrity. The dominant images are slightly folky drawings of floating consumer durables: handbags, trainers, cars, mobiles and iPods. Just behind these are negatives of footballers and their wives, celebrities and soft porn, along with little menu cards and price labels from shops near my studio advertising apple crumble, eyebrow shaving and bread-and-butter pudding. The very deepest level of imagery has trademarks like Apple, Shell, Mercedes, Rolex and McDonalds.

The title is a two-way question. It's saying to working-class people, 'What's not to like about art? Here's a nice piece of decorative gold pottery, an impressive busy thing with imagery that you'll understand, which in some ways celebrates what you like to get up to: there's a bear on the top with his beer, football and shopping.' But it's also asking the middle-class gallery-goer, 'What's not to like about all this lot?', a leading question that suggests there's a hell of a lot not to like. In a way, it's a pot that falls down the gap between the classes.

what's not to like? | 2006

Glazed ceramic, 152 × 60 (59⅞ × 23⅝)

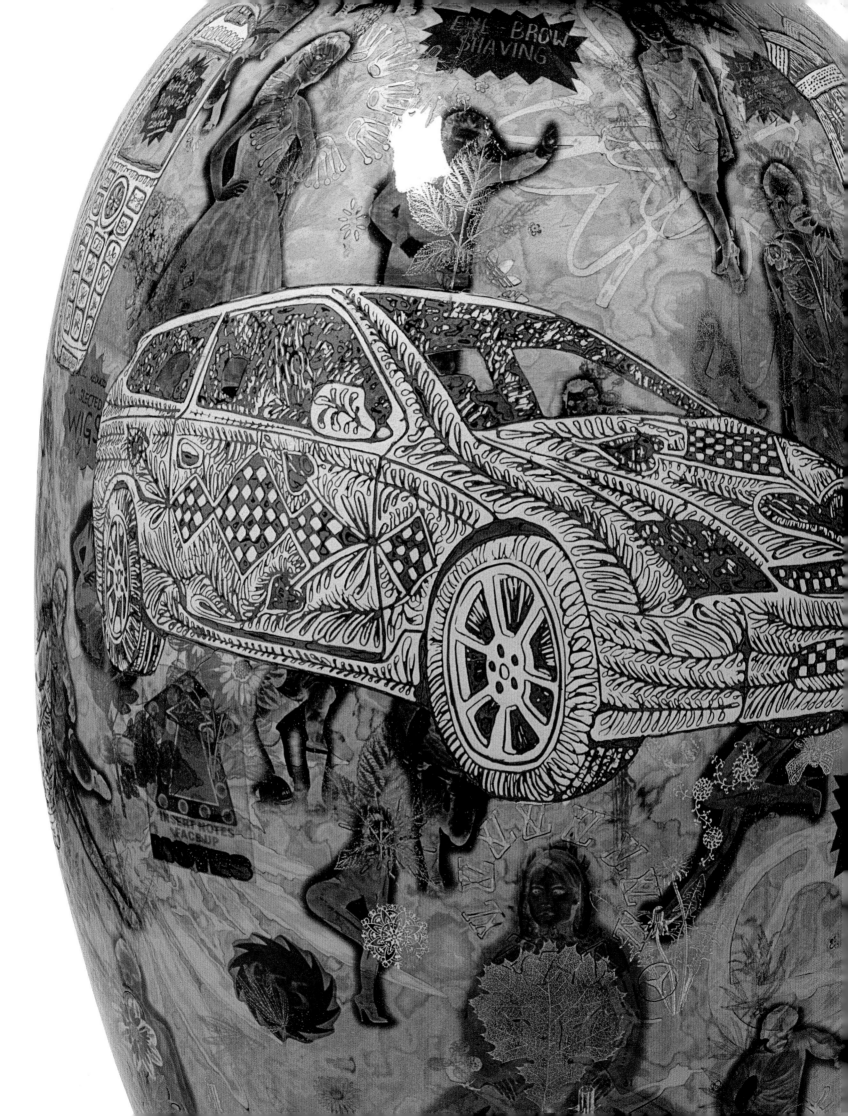

chapter 4 war and conflict

'War is a very important issue for me, because of its metaphorical place in my own imaginative universe.'

Images of war have a hold over our imaginations today perhaps as never before. Arresting pictures of conflict have created an iconic visual lexicon for our times, from the napalm-burnt little girl of the Vietnam War to the inmates of Baghdad's Abu Ghraib prison.

Responding to the twenty-four hour news culture that now drip-feeds us with stories of human misery from conflicts around the world, Grayson Perry takes war as one of his central themes. For him, as for many artists, conflict provides a subject rich in visual immediacy and communicative power, and in images of bombs, fighter planes and gun-toting warlords, he finds dramatic and instantly recognizable shorthands for the worst excesses of human behaviour.

Perry unsurprisingly responds most keenly to the wars of his own lifetime. In works such as *Peasants with Fridge-Freezers* (p. 100) and *Troubled* (pp. 110–11) he expresses his revulsion at the violence and machismo of war – here, the conflicts in the Balkans and Ireland respectively – and rejects the extremes of partisanship that lead people to kill one another in the name of their beliefs. Perry's pots, however, rarely convey straightforward political messages in the manner of grand history paintings or contemporary war reportage. While his anti-war

stance is unambiguous, a number of his works wilfully expose the inherent confusions and messy realities of conflict. In *Us Against Us*, for example, he exploits the circularity of the vase to show two armies of soldiers and little girls locked in a gruesome fray, chasing each other without apparent purpose or resolution (pp. 114–15). *Print for a Politician* shows a similarly ambiguous scene of conflicting groups aimlessly at war with one another, randomly dispersed across a blasted landscape (pp. 108–109).

The inspiration for Perry's work comes not only from TV footage and newspapers, but also from a more unexpected source: the artefacts of indigenous folk cultures. Here, Perry finds a rich vein of art forged in the workshops of war, and borrows much of its imagery for his own work. His unassuming monument to child mortality, *Angel of the South* (pp. 98–99), for instance, takes as one of its formal touchstones the British Museum's 'Benin Bronze' collection, sixteenth- to eighteenth-century plaques of warriors and kings looted by British forces in 1897 as part of their colonial African exploits. Elsewhere, in his anti-militaristic embroidery *Slave Ship*, Perry draws inspiration from the flags of Ghana's Asafo or people's militia groups, appliquéd patchwork banners modelled on European military standards and used to extol ancestral martial prowess (pp. 94–95).

Perry also responds to images of war that have been absorbed into more contemporary folk art, most notably the widespread practice of carpet-weaving in modern-day Afghanistan. Afghan war rugs, as they are known, had their origins in the Soviet occupation

that started in 1979, when weavers began to incorporate into their designs renditions of battle maps, military heroes and the apparatus of war, in a direct response to the Russian threat. Alongside the traditional flowers, wildlife and geometric patterns, now sat tanks, landmines, artillery and aircraft. Thought to have been made initially as expressions of anger at the invasion, their popularity soon ensured that they were manufactured more widely for the tourist market. Nowadays, they incorporate images of more recent conflicts culled from magazines and TV, including the stricken Twin Towers in New York and the war machinery associated with the American invasion of 2001. Perry vividly recalls the first time he came across these rugs on a friend's floor and was immediately seduced by their anarchic mix of ancient tradition and hyper-modern technology (p. 93). He subsequently collected a number himself, and the rugs' stylistic imprint appears in many of his works, including in the background design for his vase *The Names of Flowers* (pp. 92–93), and in the tapestry, *Vote Alan Measles for God*, an indictment of war-mongering religious extremism (p. 116).

The conflicts that Perry reflects upon may be based on those of his own lifetime, but his wars are not exclusively those of the real world. Indeed, war

has a particular hold over his imagination less because of the realities of actual conflicts than because it acts as a potent metaphor for other, more emotional, struggles, in particular those of his childhood. His family background was, as he describes it, 'fairly typical, with a bit of violence and a lot of dysfunction'. In particular, his parents' break-up when he was a young child came as a major blow, and Perry now considers his father's leaving to have been the single most important event in his early life. Soon afterwards, his stepfather moved in, a man he describes as 'dangerous … flashy … a poor man's Tom Jones'.[1] A naturally combative character, he worked occasionally as a nightclub bouncer and spent his weekends practising amateur wrestling. He and Perry did not get on, their differences becoming all the more apparent when, in the autumn of 1967, the first of Perry's two half-brothers, described by him as 'the golden boy',[2] was born. Impressionable, sensitive and intelligent, the young Perry felt rejected by both his mother and father, and under constant threat from a bullying stepfather who took little pains to understand him. Home became a battlefield, and Perry turned, in his own words, into a 'cipher of a boy'.

His response to these upheavals was to retreat into an elaborate fantasy world, a universe fuelled by war.

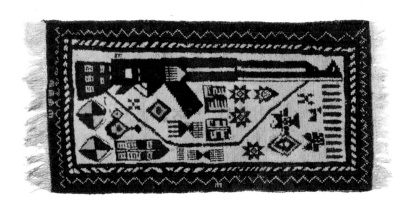

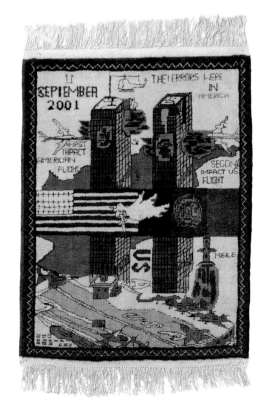

Perry's earliest childhood had been infused with the glamour and romance of battle, his father an RAF armourer-turned-engineer who encouraged his son's passion for war-themed comics and plastic Airfix model aeroplanes. Now, with the arrival of his stepfather, Perry's boyish love of war games fused with real-life conflicts, and he began to map an imaginary battlescape within the safe haven of his bedroom, a war waged between the forces of darkness and light. Chief protagonist was his faithful teddy bear, Alan Measles, given to him for his first Christmas and named in honour of the next-door neighbour's son and Perry's own recovery from a bout of the childhood illness. A godlike figure, Alan Measles was assigned the role of guerilla resistance leader, spearheading Perry's fictional rebel troops against the invading Germans – a lightly veiled, if unconscious, reference to his stepfather, the enemy who had so brazenly invaded Perry's home.

Casting himself as Alan Measles's bodyguard and protector, Perry describes his teddy bear as 'my surrogate father, the leader of my imaginary world, a benign dictator and an invulnerable war hero all rolled into one'. As almost the only surviving artefact of Perry's childhood, the bear has since been invested with a powerful, almost sacred, significance. He has come to feature prominently in Perry's work, appearing variously as totemic male god, symbol of protective fatherhood, and, in *Alan Measles on Horseback*, as the victorious warrior who successfully led him through the battles of childhood (p. 117).

When Perry has turned his attention more broadly to the subject of children and childhood, it is these images of conflict and strife that persist. While traditional representations of children in art more typically denote cherubic goodness, innocent *naïveté* or harmless mischief, Perry's visions are the antithesis of the sentimental or saccharine. His children play in needle-ridden streets, flee from their abusive parents, get bullied by text message or die impoverished and neglected. The family is exposed in his work not as the defender of social values but as the source of misery and trauma (pp. 106–107 and p. 119). Similarly, the toys that appear in vases such as *Refugees from Childhood* and *Dolls at Dungeness* are not innocent playthings but scarred survivors (p. 104 and pp. 112–13). Dragged through the war zone of childhood, they are a testament both to the perpetual conflicts and struggles of family life and to our ability to endure them.

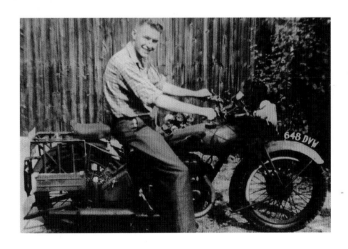

Opposite | Afghan war rugs from Grayson Perry's collection
Above | The artist's father, *c.* 1952
Right | Alan Measles

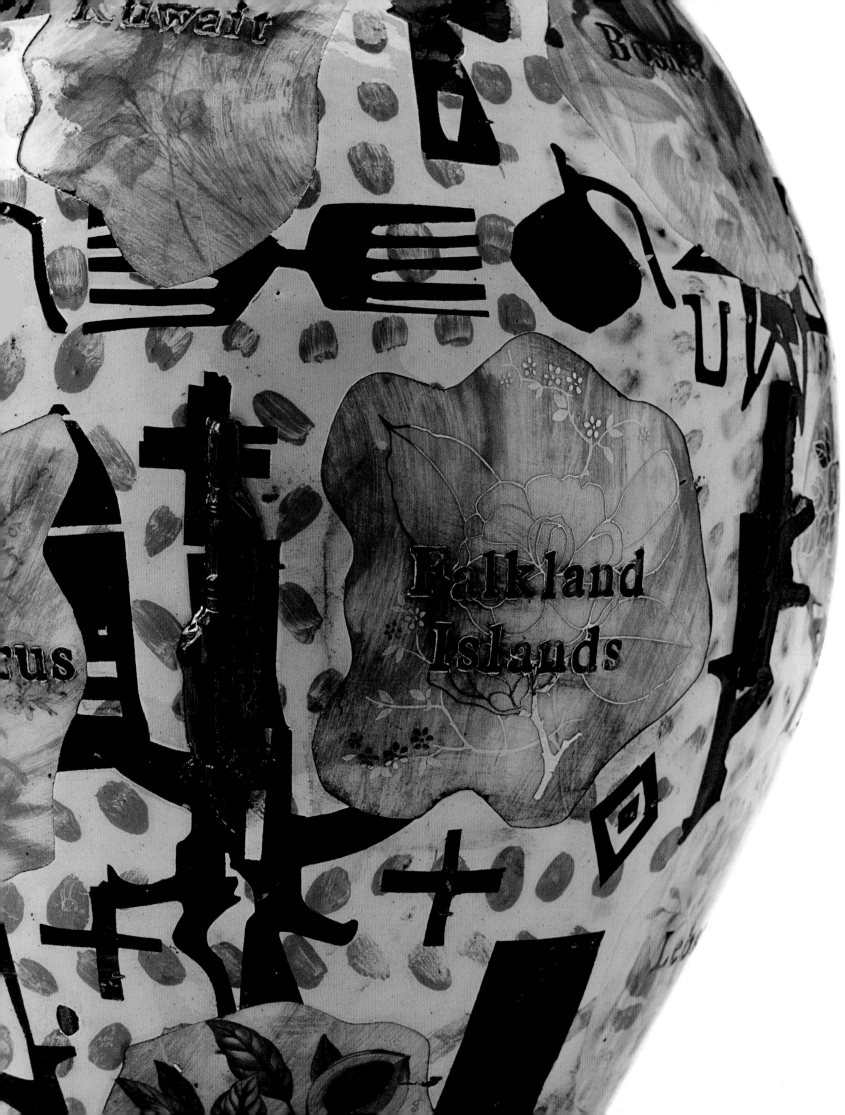

This pot started with the background imagery, which I did in the style of Afghan war rugs. I first came across these rugs in the early 1980s on the floor of my friend and dealer James Birch. To begin with, I thought I'd been drinking too much. I said, 'Is there a helicopter in that rug?!' And James said, 'Yes, it's a map of Afghanistan.' I thought it was fantastic; I've since bought a few myself.

The inspiration also came from the flower patterns you find in open-stock transfer catalogues from the pottery factories in Stoke-on-Trent. They reminded me of seed or wallpaper catalogues. I always liked the names given to different varieties of rose, like 'Ice Cream' or 'Lady Diana'. Here, I named my flowers after wars that have happened in my lifetime, making the connection between memorials and flowers.

This pot was bought by the Stedelijk Museum in Amsterdam. For a while it lingered in the basement of the museum until the curator Marjan Boot was rummaging around and came across it. She went on to buy a few more pieces, and later took me out for a drink and asked if I'd like to have my own show at the museum. That was a very happy moment. The exhibition, which took place in the summer of 2002, led to my nomination for the Turner Prize – so this pot is a very important piece for me.

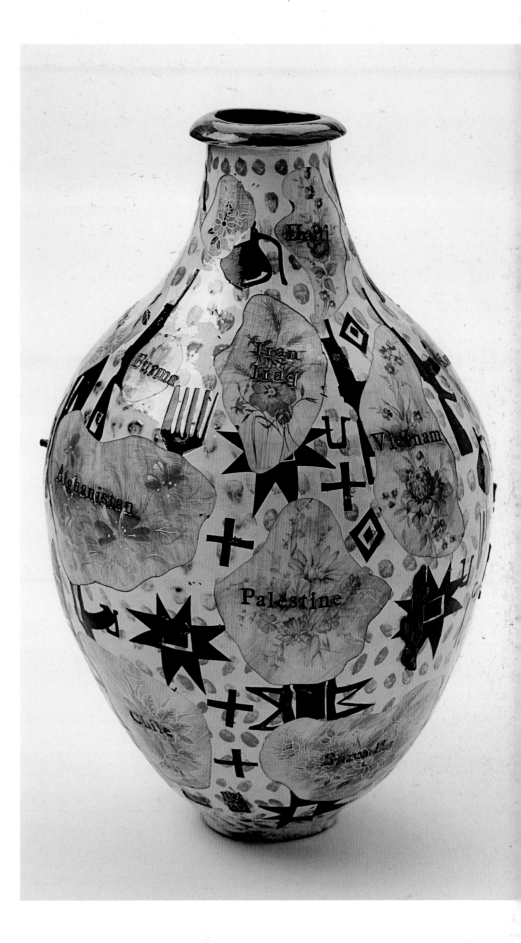

the names of flowers | 1994

Glazed ceramic, 42 × 28 (16½ × 11)

slave ship | 1998

Cotton and rayon, computer controlled embroidery, H. 150 × W. 250 (59 × 98⅛)

"

I've always liked flags in churches and historic buildings, so I began to think about making my own one. The most obvious was a version of the St George's Cross: there was a rash of these at the time because of the World Cup, hanging from every window and transit van.

My design comes from a number of sources. I was looking at an exhibition catalogue of Asafo flags from West Africa. There are groups in Ghana called regiments that are like social clubs, organized along the lines of the British military with clubhouses, military pageants and formation marching. They have special flags made with the symbols of their regiments to wave at parades. They usually include a crude Union Jack in the corner, a bit like old colonial flags, along with illustrations of proverbs. They're very colourful and beautiful.

I was thinking, too, about slave ships and that famous illustration of how to pack slaves into a ship's hold. I was also interested in the recent tradition in Ghana of making 'fantasy coffins' that reflect the trade of the person who has died. The flag is woven, in African style, with rows of coffins in a cemetery. Made from cotton, it is a multi-layered reference to England and the enormous wealth it gained from slavery, cotton, and trade with Africa. There are also references in the embroidery to modern-day consumer goods like TVs and cars. I've heard some people call Britain 'America's biggest aircraft carrier'. In a way, that's true: we're slaves nowadays to the shops. There are military references like the gold edging braid, but my flag is an anti-jingoistic, non-triumphant military standard.

'No one can defeat us except God', Asafo (people's militia) flag, Ghana, West Africa

American School, *Stowage of the British Slave Ship 'Brookes' Under the Regulated Slave Trade Act of 1788*

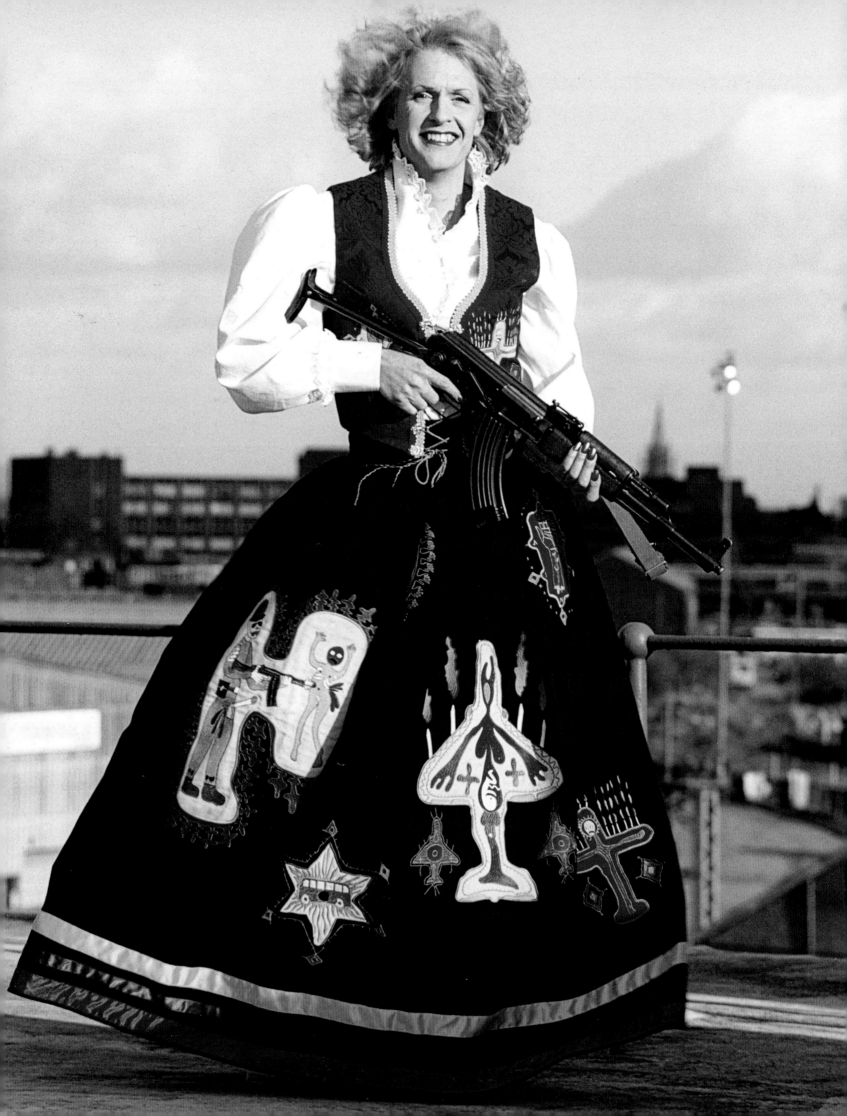

claire as the mother of all battles | 1996

Photographic print, H. 71 × W. 48 (30 × 18⅞)

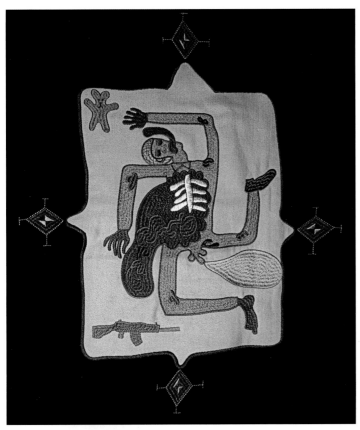

Details from *Mother of All Battles*, 1996. Cotton and rayon, computer controlled embroidery, H. 152 × W. 91 (59⅞ × 35⅞)

"This was the first embroidery I ever made. I was asked to design a piece for an exhibition called 'Techno Stitch' at Oldham Art Gallery. The outfit was made at an embroidery factory that uses a computer programme to sew out the design via enormous machines. The appeal for me is that embroidery has a precious quality to it, like gold. I wanted to make something in embroidery that was as traditional as a vase.

The phrase 'ethnic cleansing' was being used a lot at the time, in relation to the Bosnian conflict. Folk costume is an essential element of ethnic identity, and I started thinking about how the Balkans have many different folk costumes while Britain doesn't really have any. If you go to certain parts of Europe, on high days and holidays many people still wear traditional costumes; in Japan, too, you see people going out to dinner in a kimono. But folk culture and costume has almost entirely died out in Britain, probably because we had the Industrial Revolution so early. So this was my imaginary folk costume. Its appliqué motifs are powerful images of war: an eviscerated soldier, a bound and gagged rape victim, a soldier with an erection killing a child, a bombed-out bus at the centre of a Star of David. I had this photograph taken of me on the roof of my studio with a Kalashnikov, pretending it was Sarajevo.

angel of the south | 2005

Cast iron, 15 × 29 × 78 (5 ⅞ × 11 ⅜ × 30 ¼)
EDITION OF 3 PLUS 1 ARTIST'S PROOF

❝ **The title of** this work refers to Antony Gormley's huge steel sculpture in Gateshead, the *Angel of the North*. I see his gargantuan winged man as a celebration of the triumphant industrial might of Victorian England, forged in the cities of the north and sent around the world to hammer out an empire. I made *Angel of the South* as a monument to all the people who got the down-side of that – for the most part, people in the developing world, sometimes called the South, and very often children. It is a child's coffin, a non-triumphal monument to the countless victims of empire building and the North's technological dominance. Victorian England saw high levels of child mortality; we still see the skinny babies of peasant farmers dying today, but now it's in very poor African countries.

My piece is made from rusty cast iron, older, cruder and more fragile than steel. It has a formal resemblance to the brass plaques from Benin that you see in the British Museum, one of the more shameful imperial lootings of Africa. The sides of the coffin are decorated with designs taken from cathedral floor tiles, and some of the images also relate to medieval tombs of knights and bishops. The nails that are driven into it have a kind of voodoo feel, which connects to the idea of folk charms and talismans.

Brass plaque showing Oba sacrificing leopards, 16th century

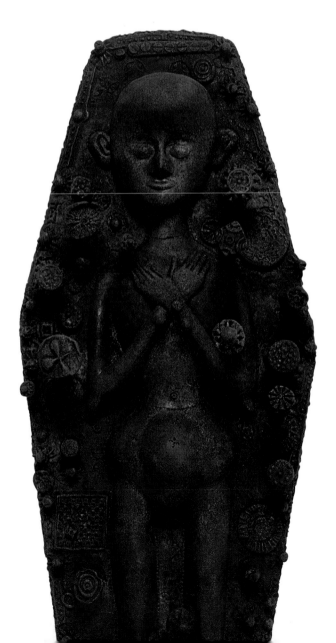

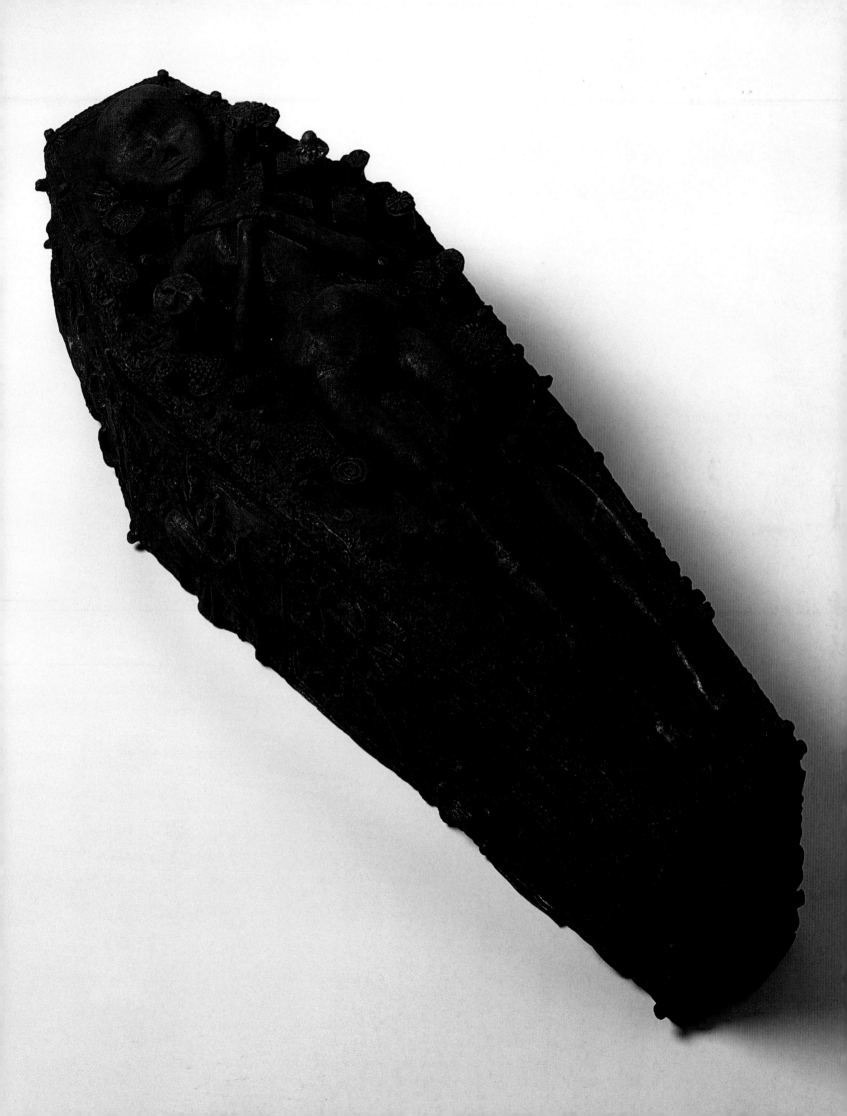

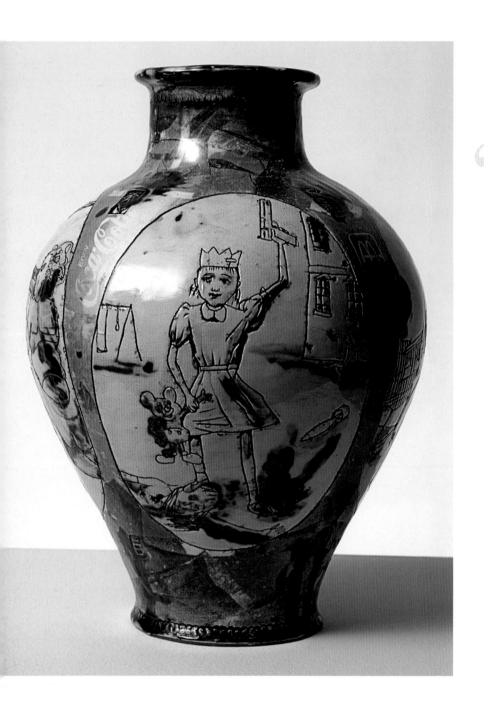

"The imagery on this vase is of people murdering each other: a young girl in a home-made paper crown with her foot on the head of someone she has just shot, a housewife with a rocket launcher, a boy holding up a severed head. I was watching the news during the Balkan conflict and the collapse of the former Yugoslavia. The report showed refugees trudging down a road in the mountains. The journalist was trying to show that these people weren't from some unknown part of the Third World – this was happening in Europe. He said something to the effect that these weren't impoverished tribal people: they'd come from homes with fridge-freezers! As if fridge-freezers were a symbol of advancement and our shared culture.

The report was trying to draw on our common humanity but in fact it did the opposite for me. Of course, I don't know what I would do in that extreme situation, although I do remember thinking: these people are massacring each other, they're not like me. We may both have a fridge-freezer, but I'm not going to go around killing my neighbours because they believe something different from me.

peasants with fridge-freezers | 1995

Glazed ceramic, 30 × 23 (11¾ × 9)

the frivolous now | 2011

Glazed ceramic, 47 × 32.8 (18½ × 12⅞)

Museum curators love objects that tell a story about the time and place in which they were made, so I thought it would be interesting to make a pot that was very much about the here and now, for my 2011 show at the British Museum. I drew in my sketchbook one night while the news was on in the background, and then as I was working on the pot in my studio the radio was on, so things came out of the ether. I got the title from an article in the *Guardian* or *Observer* which was about the voracious news agenda that's here one minute and then immediately gone. Nothing lasts. The fact that this is a pot, perhaps the most enduring medium, is quite funny.

I picked buzzwords that were in the air at that moment: Big society, YouTube clips, Cyber-bullying, Product launch, LOL, Headscarf ban. One of the more obscure words was Sket-site. Sket-sites are websites where boys who've been spurned or who have split up with their girlfriends post humiliating photographs of their ex-partner as a kind of cyber-stocks. Then other people write derogatory comments underneath it. They're not nice, but they're very 'of the moment'. It was these tiny nuggets of contemporary culture that the pot revolved around.

untitled | 2004

Watercolour, crayon, pen and collage on paper, H. 41.5 × W. 59 (16⅜ × 23¼)

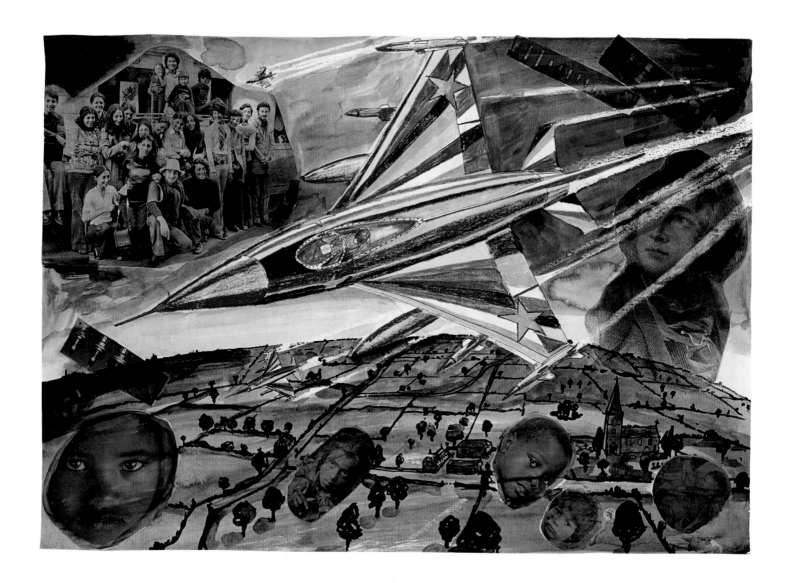

" **This drawing is** about aeroplanes as decorative objects. It shows a jet plane in pretty, playful colours, with images of African children across the landscape below. I can get swept up in the glamour of fighter planes, and it's easy to forget the horrible, messy reality of what they are able to do to people. We can look up in awe at air displays and forget that these things are really made for chopping people into bits.

arabic stealth bomber | 2007

Glazed ceramic, 50 × 50 × 4.5 (19¼ × 19¼ × 1¼)

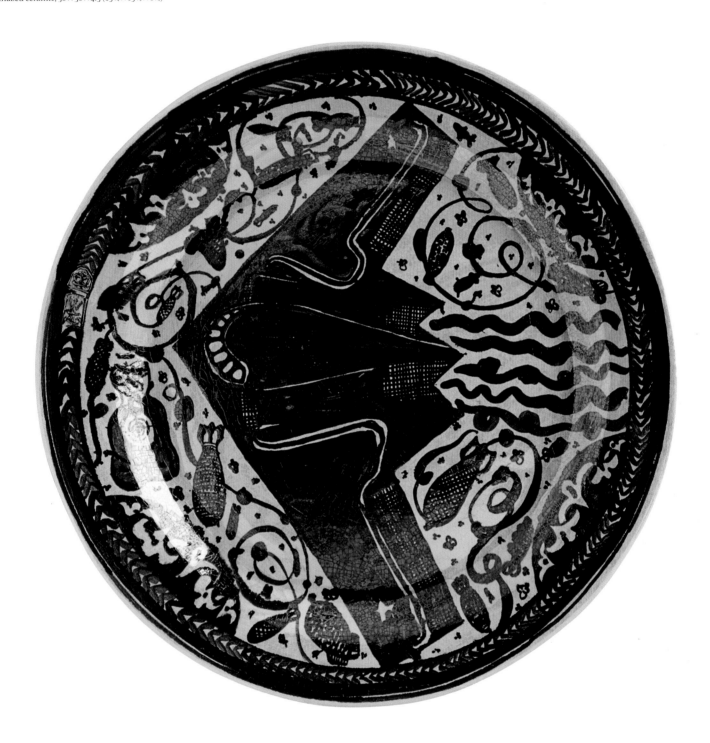

"Islamic lustreware of the twelfth and thirteenth centuries, and the Hispano-Moresque tradition that followed, excelled in large, elaborate heraldic plates. They often featured a coat of arms, an image of a warrior on horseback, or a big ship. I wanted to make a stealth bomber into a motif for a plate, and I saw the plane as an equivalent to one of those big Islamic ships. I gave the plate the lustrous, pearlescent finish typical of a lot of Islamic ceramics. There's an irony, of course, in having a great symbol of American power on an Islamic-style plate.

I think stealth bombers are superb. I love their graphic shape and their silhouettes. They're fantastically brooding, very menacing and sci-fi, like black holes in the sky. Almost invisible from the side, they're like origami carrion crows swooping down on their prey. The aesthetics of weaponry is fascinating, and very consciously done. From time immemorial, what warriors look like has been almost as important as how effective they are. Fantastic battleships from centuries ago and jet fighters today are frightening, thrilling things. Sometimes at night on my Harley, I fantasize I'm a bomber pilot heading for Dresden.

refugees from childhood | 2001

Glazed ceramic, 50 × 35 (19¼ × 13¾)

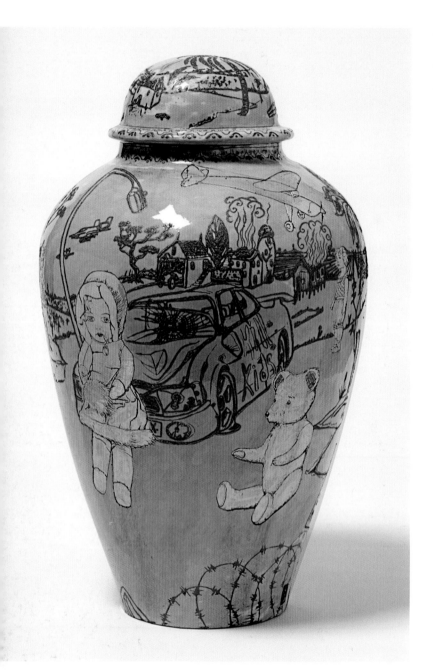
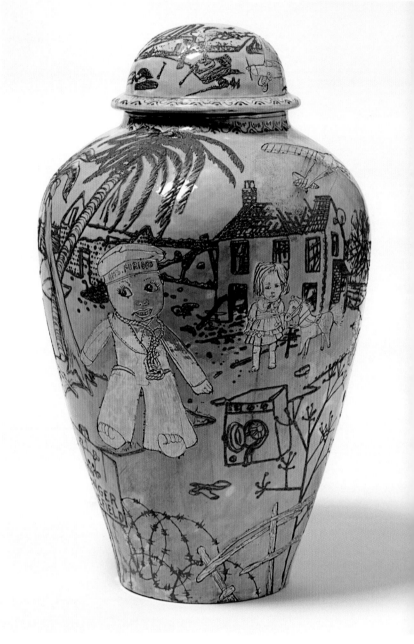

"This vase refers in its form and colour to a large Italian majolica jar from the eighteenth century. Quite often when I'm copying a vase I take just the shape, but at other times I use the style of a flower, a bird or some vegetation, lifting a motif straight off another pot to use as source material. This piece shows a war-torn landscape with planes, tanks and blown-up buildings. The Balkan conflict was still in my mind when I made it, and I used the metaphor of childhood as a war zone. All of the refugee figures are toys that I sourced from a historical book about dolls. I was playing with the idea that your stuffed toys are somehow with you, that they've escaped alongside you.

Technically, I was very pleased with this vase. I used copper-oxide slip as the inlay and it slightly 'bloomed', welling up and spreading so that it bled the red lines and made them slightly raised, which I think is very attractive.

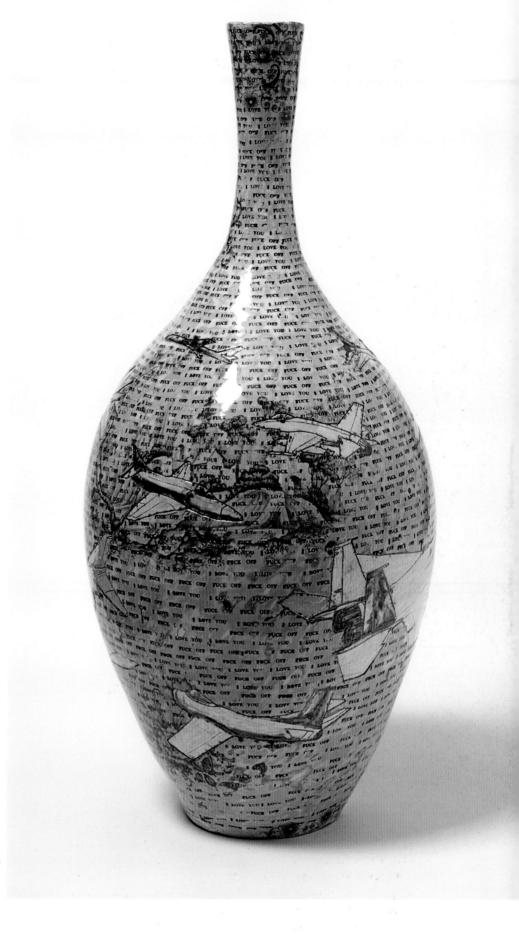

"My father was in the RAF and my mother had hopes that I would also go into the air force or join the army, returning one day in a sports car to rescue her from her unhappy situation. That's an interesting fantasy to communicate to your teenage son. So this pot was saying, 'Look Mum, I'm a jet pilot' – that is, I'm not, and this is as near as I'm going to get to it.

It has aeroplanes and lines of text that go around the vase to imitate the throwing lines made by the fingers on a traditional pot. These lines would normally be the mark of a hand, but here they are the mark of the mind. It's one of those pieces I think of as a landmark in my work, when I solved a problem for the first time in what I saw as a satisfactory way. In this case, it was how I put the imagery together, and how it hovers over the text.

look mum, i'm a jet pilot | 2000

Glazed ceramic, 56 × 24 (22 × 9½)

we've found the body of your child | 2000

Glazed ceramic, 49 × 30 (19¼ × 11¾)

PIETER BRUEGEL *Hunters in the Snow*, 1565

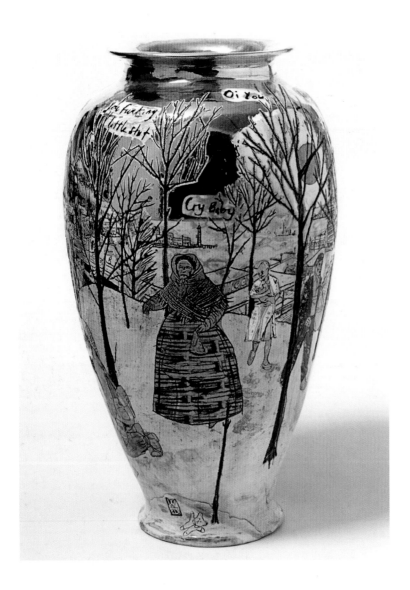

" **I made this piece** around the time of the Sarah Payne investigation, when 'paedo-mania' broke out in the UK media, following the disappearance and murder of an eight-year-old girl. There was a real press hyper-frenzy, which resulted in a paediatrician's house being mistakenly vandalized – people thought the doctor was a 'paedo'. But on the same day as you would read pages and pages about the Sarah Payne case, there would be a little three-line article somewhere in the back of the paper, saying something like, 'Child battered to death by stepfather'. I read somewhere that around ninety to ninety-five per cent of all child murders are committed by the parents. In the context of the tabloid distortion of 'stranger danger' and the mysterious lone paedophile living down the street, I thought that was interesting.

I was looking, too, at a number of Bruegel paintings, including the *Hunters in the Snow*, whose composition provided the inspiration for this pot. I wanted ambiguity, so there's a woman with the dead body of her child in front of her, surrounded by figures, some of whom look like soldiers. Is she being arrested, or is she being comforted? I also had in mind the Tom Waits song 'Georgia Lee', a ballad sung by a father for his child who is found dead in the woods.

The phrases on the pot are things that many parents find themselves saying: 'Never did me any harm' or 'Never have kids', which my own mother used to say a lot. These phrases are the thin end of the wedge of child abuse: they're about the way we don't take children seriously or treat them as equals.

This has become one of my better-known works but it was odd, because most people didn't actually look at it. It just became the 'paedo-pot'. Even to this day, I meet journalists who say: 'Oh, you're the one who does the paedophile pots.' But in fact this is the only pot I've ever made that refers to child killing.

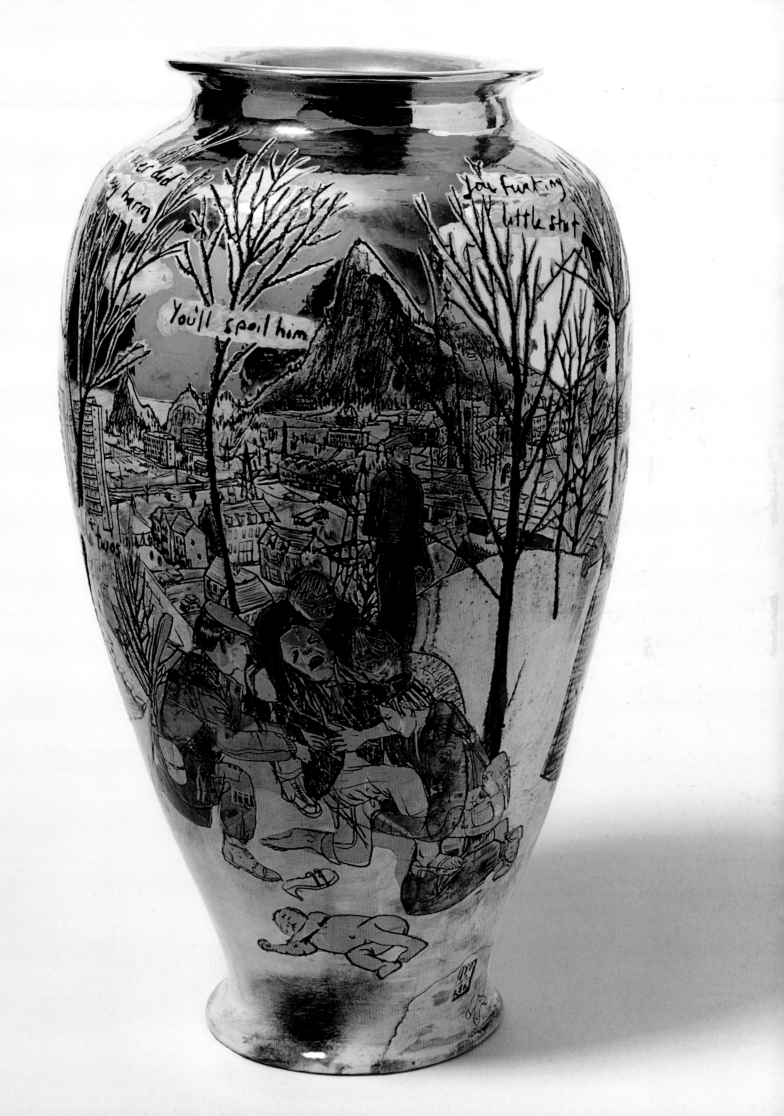

print for a politician | 2005

Etching from three plates, H. 67 × W. 249.5 (26⅛ × 98¼)
EDITION OF 59 PLUS 10 ARTIST'S PROOFS

"This large etching had a number of starting points. One was traditional Chinese scrolls, which account for the style of the mountains in the background. Another was the American Outsider artist Henry Darger's paintings of a similar proportion and shape [p. 200]. My print is also what I would call a playscape, the sort of imaginative universe you spread out in front of you as a child, like a model-railway set. Car windscreens and movie screens have the same shape, that sort of slot vision onto the world.

I made the print for a show I had in Venice. I was interested in the history of the city and its geography, with the Grand Canal splitting it through the centre. That was the starting point for the layout of my battle, which has a loop across it like the canal. Everyone is at war. There are sides but they're pretty indistinct: it's a free-for-all. I made a long list of groups, from Christians, Nazis and Satanists to paranoid conspiracy theorists, animal rights activists and male chauvinist pigs, and then added each group to the drawing at random. Everyone can probably identify with at least one group on here, if not several; it might make them think about who they are and which side they fall on. There's no such thing really as 'us' and 'them'.

As soon as one group feels like they have a monopoly on righteousness we are in trouble.

From the very beginning, I had a fantasy of the print hanging on the wall of a politician's office. He might sit thinking, 'Yeah, we're going to get those people!', but then he'd look up at it and realize that it wasn't that simple. It's deliberately multicultural and cross-temporal, so there are elements of battles from different ages: galleons, men on horseback, First and Second World War aeroplanes and jet fighters. It's nice that one of the prints did end up in the House of Commons art collection and has now been seen by lots of MPs.

Chinese painting, *Home in the Mountains*, c. 1550

troubled | 2000

Glazed ceramic, 44 × 25 (17⅛ × 9⅞)

Sometimes I think political struggles get used to cover up more basic prejudices such as race or class. The Northern Ireland 'Troubles' gave certain people licence to vent their innate aggressive instincts in the name of a political cause. Once the struggle with the government and the British Army stopped, it wasn't as if the problems of class and crime went away.

There's a Billy Bragg song called 'Northern Industrial Town', which has a line about how there are only two teams in this town and you have to support one or the other. I find that sort of partisanship rather repellent. It seems appalling to me that men are willing to turn to violence because of differing views. I've got a complete, pathological hatred of violent men.

There's also an anti-art thing going on, which for me is connected to class struggle, with two guys firing at a sort of 1960s art college. The other side of the pot shows the gable end of a house that's been bombed, covered in wallpaper and religious imagery. In the foreground, there's a hatchback with an Islamic-style sunshade. This was around the time when gangs of second- and third-generation Asian youths in London started to cause problems. One of the first times I ever saw one of those roadside shrines of flowers was when there was a white kid murdered by an Asian gang in Somers Town, in Camden. It was ethnic violence, but going the other way.

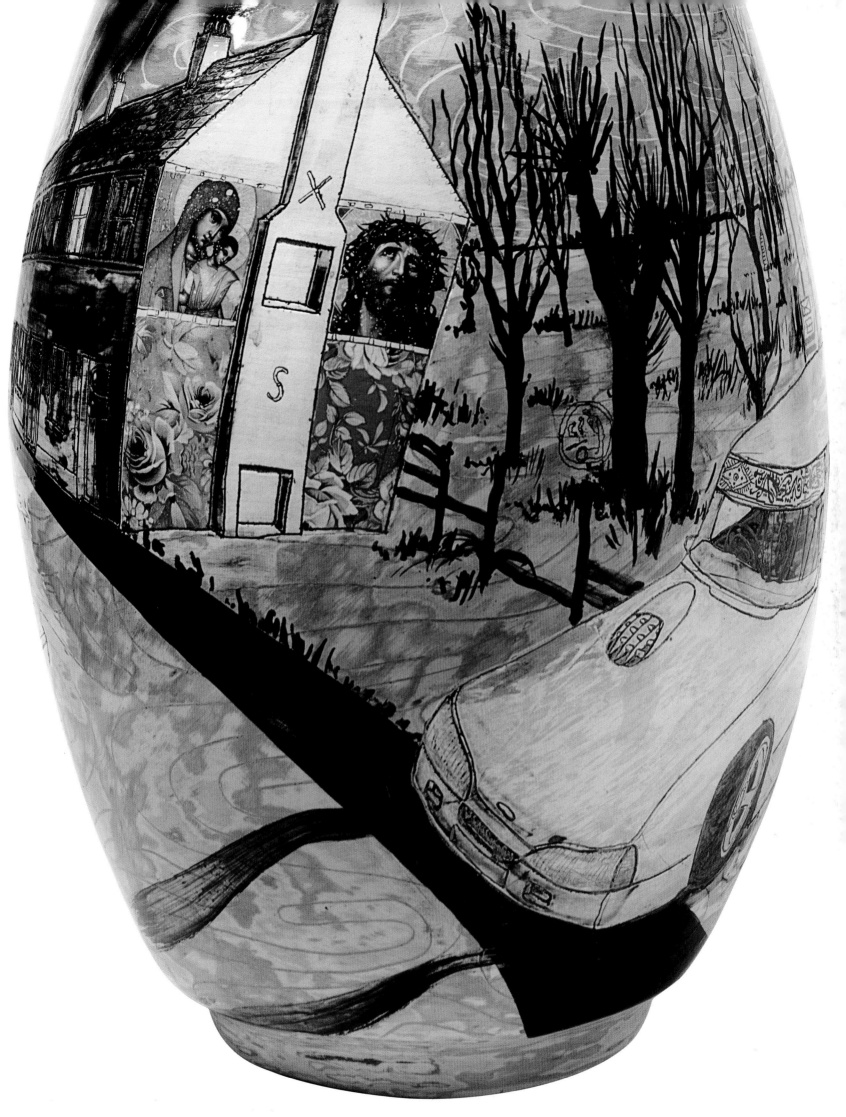

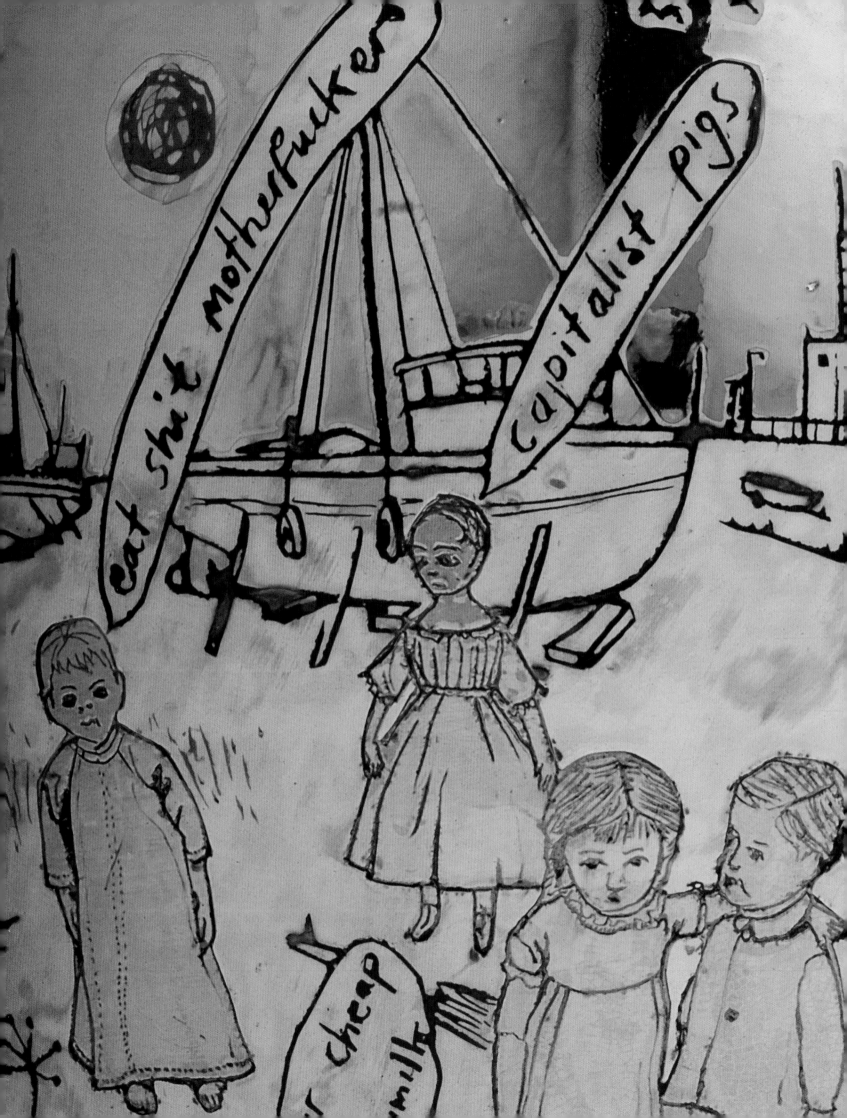

Like the John F. Kennedy assassination, everybody remembers where they were and what they were doing when they heard about the attacks on the Twin Towers in New York on 11 September. I was in a group-therapy session. The next day, when I went back to work, all the newspapers were full of it. It was an event with such a huge impact and my thoughts were dominated by it, so I wanted to make a piece immediately in response. I was halfway through this vase, so I just altered it. Originally, it was going to be *Dolls at Dungeness* and it was full of the bleak, strange landscapes of that part of Kent, but I added the text to reflect the thoughts, feelings and prejudices that were flying about at the time. The characters are saying things like, 'no more beards' and 'our prostitutes are best'. I was looking at both the American and Islamic sides and trying to be provocative, turning their respective ideas on their heads to show them up for the prejudices they really were.

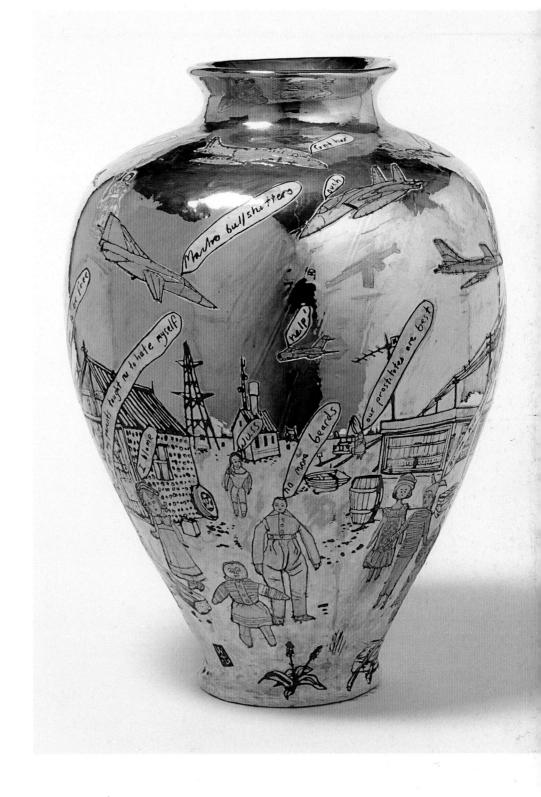

dolls at dungeness, september 11th, 2001 | 2001

Glazed ceramic, 53 × 35 (20⅞ × 13¼)

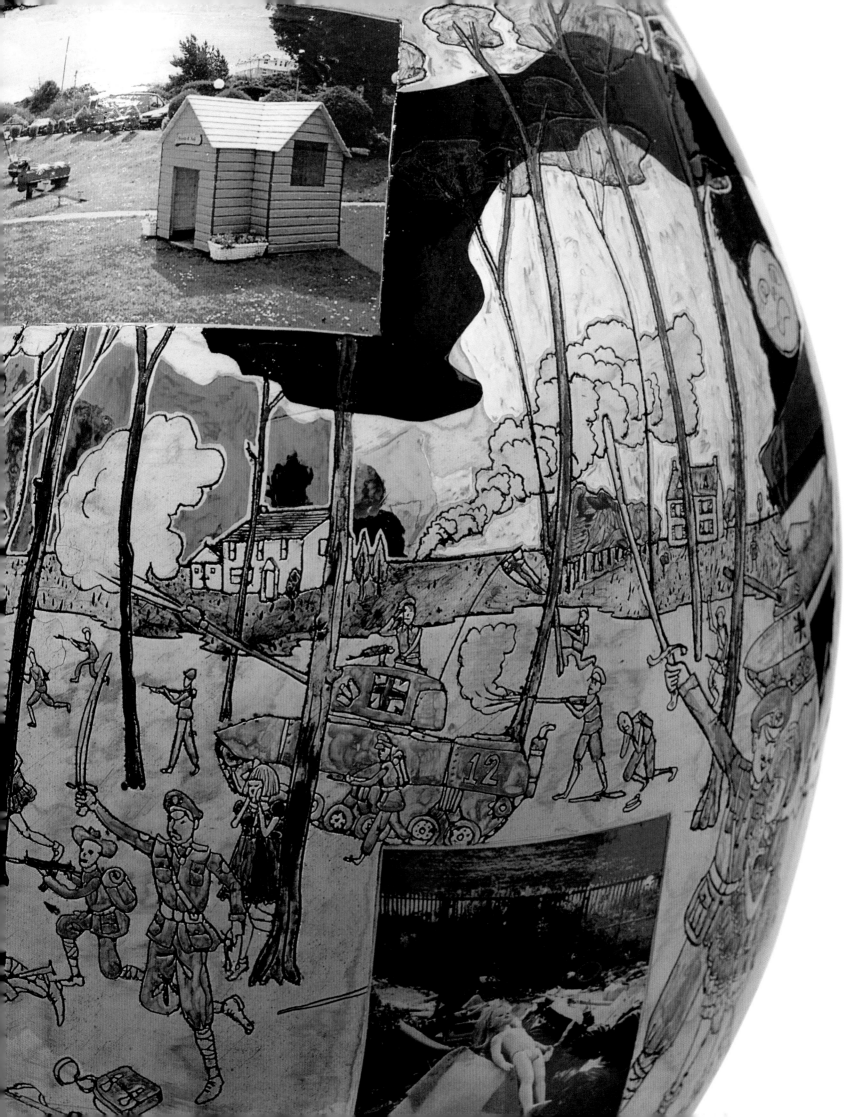

us against us | 2004

Glazed ceramic, 45 × 34 (17¾ × 13⅜)

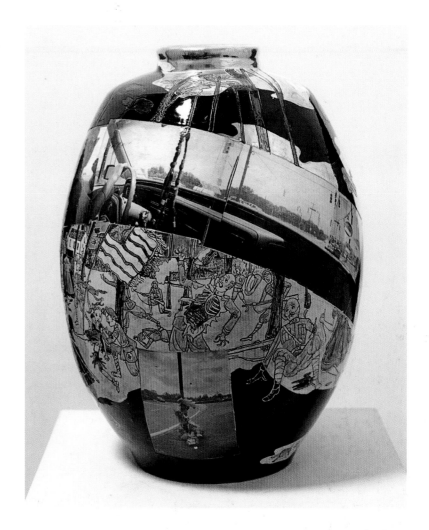

"**On this pot** there is a battle taking place with soldiers and little girls, but the two genders are fighting on the same side. It is about our internal worlds. It's related to the paintings of the American Outsider artist Henry Darger whose work was a grand, lifelong metaphor for what was going on within himself. War was one of Darger's most common metaphors, as it is mine. His imagined war, the one that loomed large for him, was the American Civil War. Mine was the Second World War, but it was also the war played out between me and my stepfather.

The circular nature of a vase is such that if you draw one force attacking another, they end up coming round behind themselves. You can never find out who is fighting whom. It's a metaphor for the fact that if we all admitted that evil exists inside each of us, we would be less polarized. In the end, we are all fighting ourselves – our own internal natures.

HENRY DARGER Untitled, date unknown, from *In the Realms of the Unreal*

vote alan measles for god | 2007

Handmade wool tapestry, H. 248 × W. 175 (97⅝ × 68⅞)
EDITION OF 5 PLUS 3 ARTIST'S PROOFS

" I was asked by a rug company that makes
bespoke, handmade carpets if I would design
a tapestry for a project they were planning.
Mine has a primitive, carpet-weaving look to
it and a lot of the symbols come from Afghan
war rugs. I love their *naïveté* and their childlike
drawings which show weapons of terror and
horrific trauma. They're powerful examples of
survivor art. At first they were a spontaneous,
traumatized reaction to the 1979 Russian
invasion, but they turned very quickly into
tourist souvenirs, often incorporating words
and phrases in English. The story goes that
they were sold to Russian soldiers and,
ironically, the money was used to help
fund the Afghan resistance fighters, the
mujahideen, against the Russians. There is
a dissonance in them between imagery and
medium that I like enormously.

For me, Alan Measles was the arch rebel
underground leader, so he would identify
with the guerrilla fighters of today. It was
an obvious analogy for me. The whole 'war on
terror' is symbolized here, from the Pentagon,
the London Underground and the Israeli wall
along the West Bank to Osama bin Laden, body
bags, the Twin Towers and suicide bombing.
I wanted it to look a bit like a Third World
political banner. We take political freedom for
granted in the developed world and are often
apathetic about it, but elsewhere people are
fighting hard for representation. Democracy
and certain styles of religion are of course
antipathetic. The idea of voting for God is itself
quite provocative, though in many ways it's
what we do. 'My god's better than yours!', 'No,
mine's better than yours!' – well, for goodness
sake, have an election then, rather than a war!

alan measles on horseback | 2007

Cast iron, 86 × 69 × 20 (33⅞ × 27⅛ × 7⅞)

I've always liked old lead soldiers, particularly their two dimensionality. I wanted to make my own version using Alan Measles, the great leader who led me through the war of my growing up. He's like one of those equestrian statues you see in Trafalgar Square: if they gave me the empty fourth plinth there, I'd put this up, life-sized. He's a celebration of the imaginary friends who help us through hard times. In my childhood games, my stepfather was the invading Germans and Alan Measles was the brave resistance hero. I grew up in the aftermath of the Second World War, which my parents' generation would talk about a lot.

I made this in cast iron as an approximation to the lead of a toy or the bronze of a statue.

I also like iron as it rusts, acquiring a marvellous patina suggesting age and heritage. I'm increasingly drawn to the fakery of that. In Japanese culture there is a reverence for age, and they've got no qualms about faking it: they make replicas of famous statues, even copying the detail of the weathering on them.

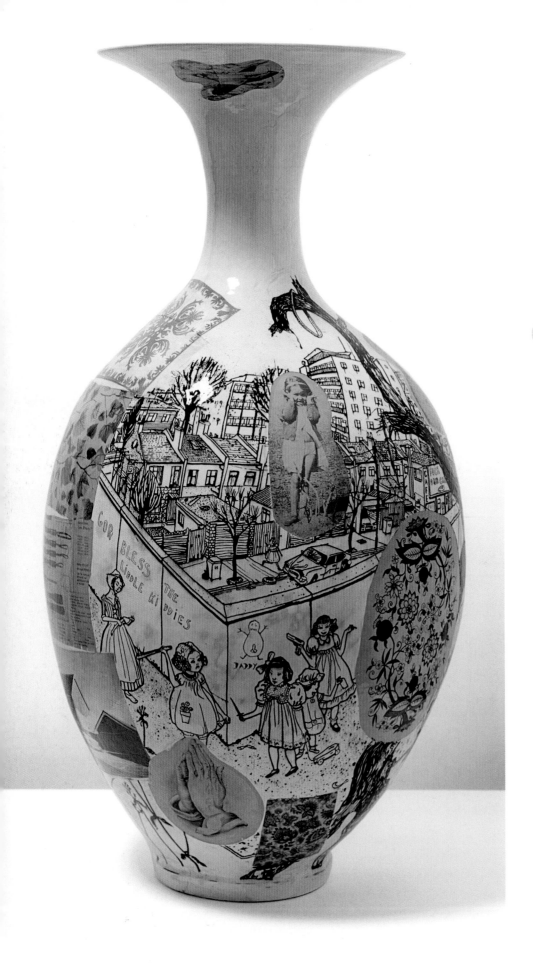

"This pot shows a London landscape around my studio, near the North Circular Road in Walthamstow. It's in part a homage to where my studio is and to the landscapes that have inspired me. It's also about the way we sentimentalize children on the one hand and demonize them on the other. The media likes a black-and-white image, not subtle shades of grey.

It's about the horrors of growing up and how, if you've got any kind of sensitivity, peer pressure is a horrible thing that'll beat it out of you. It shows those places beyond adult supervision where children are the bosses: the alleyways with burnt-out cars, damp mattresses and broken glass. There are idyllic little children in their 1950s dresses doing all the things that we fear children get up to, like taking drugs, stealing cars and killing each other. There's a twisted tree, the stock Japanese image, but here it's deformed by children who've been swinging on its branches.

plight of the sensitive child | 2003

Glazed ceramic, 101 × 54 (39¼ × 21¼)

a tradition of bitterness | 2002

Glazed ceramic, 43 × 37 (16⁷/₈ × 14⁵/₈)

The title refers to the way we hand down dysfunction through the family. Family tradition is held up as an icon of wellbeing but in fact it can also be the font of trauma. I went to a Barratt estate and took shots of a couple of dead ordinary houses. The style of the pot is folky, like embroidery or appliqué images, or the sort of thing you might see impressed on a celebratory loaf of bread. The silhouettes are mini fairytales of dysfunction: the son coming down on Christmas morning to find his father hanging; the man discovered wearing his wife's clothes, being attacked in fury by her. People often ask me, 'What kind of background do you come from?', and I say, 'Oh, normal – the normal amount of mild mental illness, violence and divorce.' That is what the family is. Traditions are great, but the heritage of trauma needs to be recognized as well.

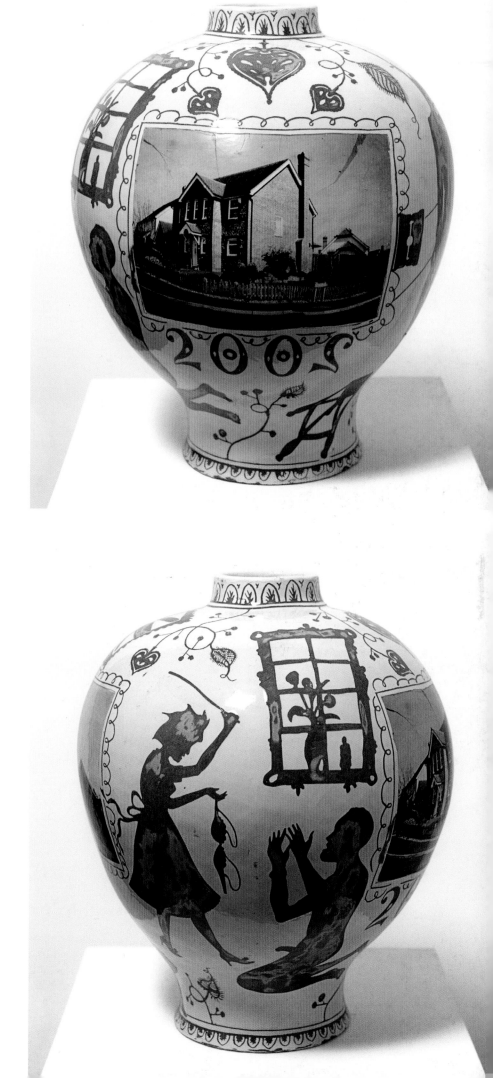

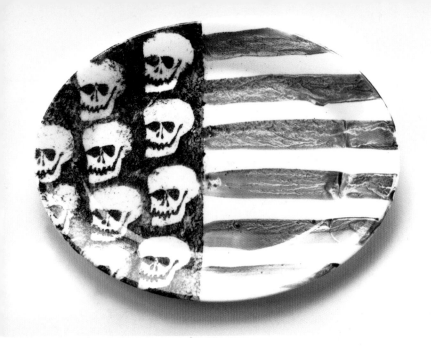

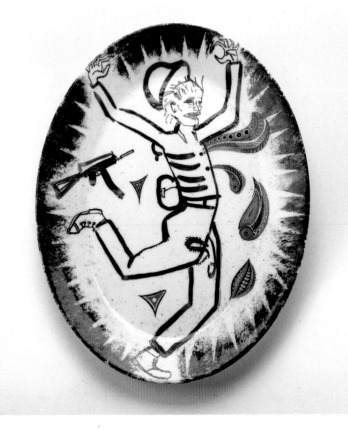

“ **A friend gave** me a load of unglazed blank plates that were left-over props from a TV production company, and I used them like sketchbook paper. The first Gulf War was going on at the time, and one of the things I made was a twelve-piece dinner service, painted quickly in blue and white with little touches of colour. They are among the most obviously political pieces I have made. There are emblems of the Stars and Stripes, but instead of stars I painted skulls and instead of stripes, running blood. Another one features a skeletal Uncle Sam riding a Harley Davidson with skulls pouring out of the exhaust pipe, like a political cartoon in some Eastern European newspaper. CNN reporters crop up too, as well as jet planes dropping phallic bombs and soldiers with their guts spilling out in the form of decorative paisley cartouches. There is a military general with dark glasses whose willy hangs out of his trousers. The plates have a studenty feel to them, but they were great fun to make.

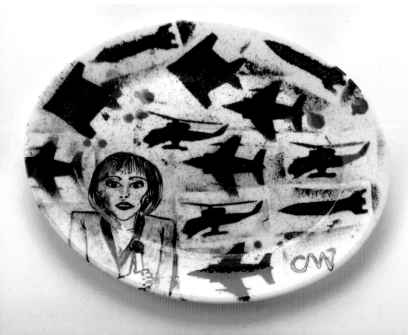

gulf war dinner service | 1991
Underglaze painting on porcelain factory blanks
Each 26 × 34 × 2.7 (10¼ × 13⅜ × 1) 3 PLATES FROM A SET OF 12

for faith in shopping | 2008

Struck copper, 6.8 × 6.8 × 0.6 (2⅝ × 2⅝ × ¼)
EDITION OF 51 PLUS 2 ARTIST'S PROOFS

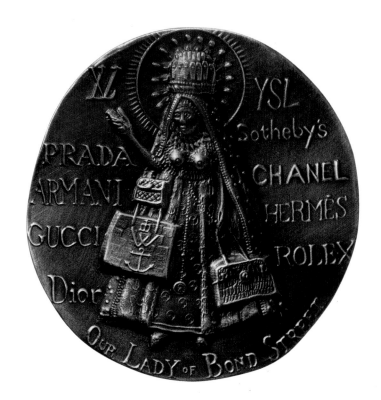

"There's a long tradition, going back to the sixteenth century, of satirical medals that take the mickey out of figures of authority like religious leaders and politicians. They were often used as badges of allegiance to particular causes at times of political upheaval such as the English Civil War or the French Revolution. The British Museum asked me to design my own 'medal of dishonour'. Two big issues in the air when I made this were the Iraq War and the environment, and I started thinking about what might link them. I think it's about the need to supply the developed world with things to satisfy our adrenalized craving for consumer goods; the fact that we want more and new stuff. I designed this medal in 2007 before the credit crunch added weight to its message.

On one side it shows 'Our Lady of Bond Street', a Madonna figure with a couple of designer handbags, alongside what I call the top ten 'airport brands'. She's wearing a hat with coffins all over it, a dress patterned with Mercedes logos and a cape with dollar signs. On the reverse is a design that was inspired by a timpanum above a cathedral I saw in northern Spain. Instead of Christ in judgment as an adult, I put him on as a child. The child is the ideal consumer because he lacks willpower, judgment and experience. The basic forces of consumerism will always push us towards the easy, the simple and the fast, and away from the slow, the hard and the complex, so I've got 'Easy Simple Fast' as the resurrected people who are allowed into Heaven, and 'Slow Hard Complex' as the people damned into the mouth of Hell. The Christ child is 'Born to Shop'. It's quite crude, like some sort of badge or token you might have seen along a pilgrimage route in the Middle Ages. They were the medieval equivalent of 'I went to Lourdes and all I got was this bloody T-shirt'.

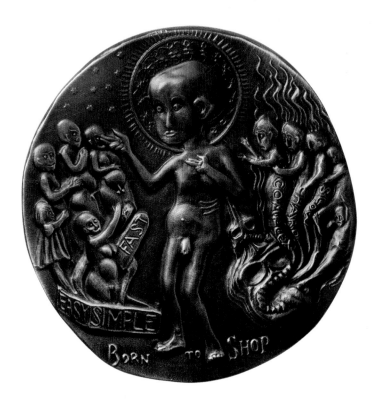

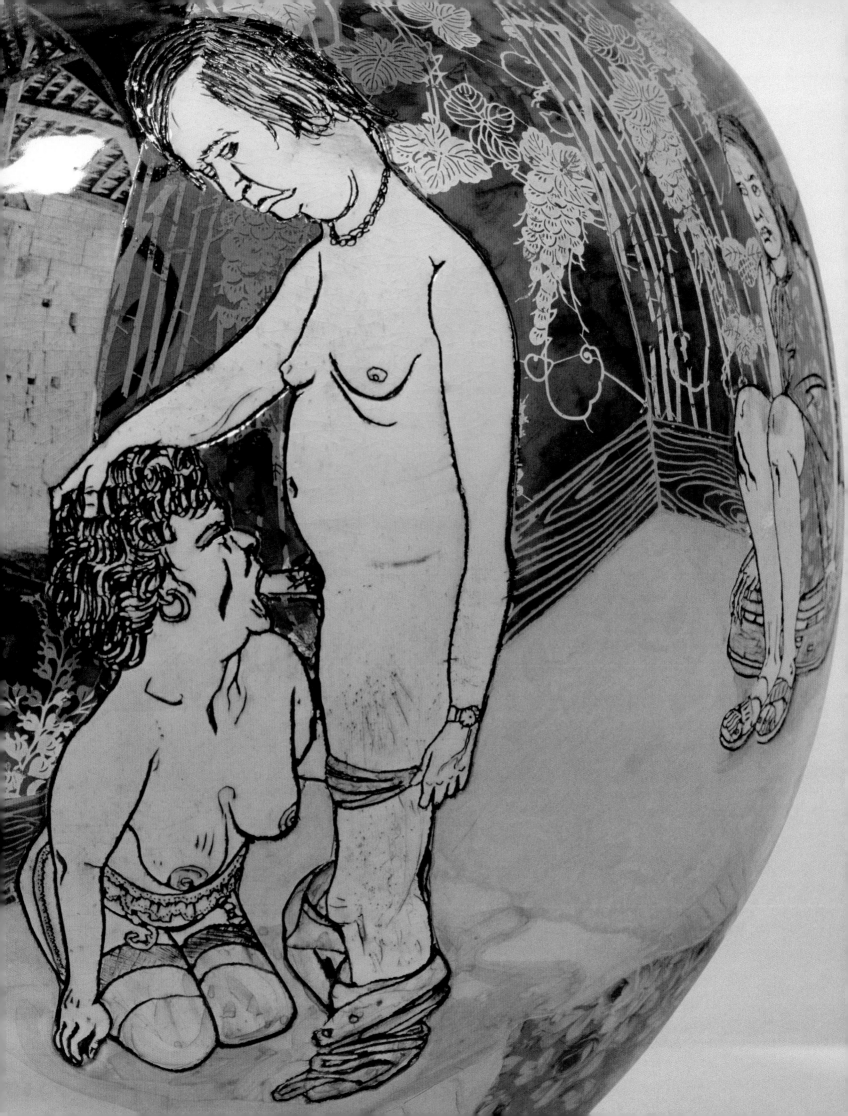

chapter 5 sex and gender

'In life, as in art, I have been dusted with the perversion brush.'

In the catalogue to one of Grayson Perry's early solo exhibitions the artist described his first pottery lesson at school, at the age of eight. 'To protect our clothes we were made to wear long sleeved smocks made of light blue rubber. I can vividly recall mine being too small as the pretty teacher did up the snap fasteners down the back. I became very excited at the feeling of the tight smooth material. In this state I made my first ever pot, an ashtray for my dear mother.'[1]

Perhaps no other moment of Perry's life weaves together so seamlessly his major interests and singular obsessions. This formative fetishistic experience began what for him has become a lifelong affair with the more deviant aspects of sexual behaviour. He is intoxicated by the worlds of kinky sex and sadomasochism, and both feature regularly in his work. Among his diverse sources of inspiration are the fetish shops of London's Holloway Road and S&M porn magazines, in which he seeks out not just titillating images but also, as he perceives them, fascinating insights into the human psyche. Perry admits to having enjoyed a range of kinky sex practices himself, from auto-strangulation and suffocation to rubber fetishes, plundering these experiences as fruitful territory in his work. He finds S&M a thrilling diversion, 'a bittersweet cocktail of emotional damage and sexual excitement', whose roots lie in the psychological dynamics of his distant childhood – as he relates in one of his pots, *Strangely Familiar* (p. 150). It is also, he says, one of the great unacknowledged forces of human behaviour, for even the most 'vanilla people have very dark chocolate sexual fantasies'.[2]

Perry's own sexual fantasies have made their mark on the public consciousness, most notoriously, through his cross-dressing. His transvestism began during puberty, when the twelve-year-old Perry asked to borrow some of his sister's clothes to dress up in. The pink satin and blue velvet ballet dresses she lent him would leave a lasting imprint in his memory – even if at the time he understood little of what drove him to try them on. Perry's experimenting continued, and by the time he was fifteen he was ready to step out of the front door and troll around the local village, decked out in a polyester blouse, dog-tooth checked skirt and a cut-price wig ordered from the back pages of a newspaper. It was around this time, too, that he stumbled across an article on transvestism in his stepfather's *News of the World*, discovering, with relief, that his secret activities were not only a widely recognized phenomenon but were practised by many men – gay and heterosexual alike.

Early on, Perry's transvestite persona needed a 'fem name' to use at trannie clubs. She came to be called Claire, on the advice of a girlfriend who thought the name suited her look and character. In her earliest manifestations (and the connections to Perry's own mother can hardly be overlooked), Claire was the very embodiment of an Essex housewife, as Perry describes it – 'heading up to town to do a spot of shopping, the sort of woman who would go to Debenhams'. In the 1980s and 1990s, Claire often appeared with coiffured blonde hair, prim suit, headscarf and pearls – part Margaret Thatcher, part Camilla Parker Bowles.

A major shift in Perry's thinking about, and expression of, his transvestism came in 2000 when he was invited to design a ritualistic object for the touring exhibition, 'A Sense of Occasion'. The commission came in the midst of Perry's course of psychotherapy, when he was exploring and beginning to make sense of his complex and competing gender identities. As a result, he decided not only that his chosen ceremonial artefact would be a bespoke dress

but that its debut would form part of his very own 'coming out ceremony' (pp. 138–39). The event, which took place on 30 October 2000 at the Laurent Delaye Gallery on London's Savile Row, marked the beginning of a new phase for Claire, who now emerged in the radically different guise of a little girl. Her short puffy dresses with Peter Pan collars, flat Mary Jane pumps and Alice bands were a very public expression of Perry's sudden realization that his dressing up was not about wanting to be taken for a woman but about desiring and provoking certain responses from those around him. Perry describes the subgroup of transvestites who love to dress up as little girls as 'the crackheads of the trannie world. For us, it's the pure drug; we don't mess about pretending to be women.' The exaggerated, frilly femininity of the new dresses he began to make were self-consciously ridiculous and, for a grown man, knowingly humiliating, thereby fulfilling for Perry a key part of his dressing-up fantasy. They also had the effect of transforming him

Left | Cover of *The World of Transvestism*, Vol. 17, no. 9
Right | Claire in a photobooth at Euston station, 1983
Far right | Claire at a transvestite weekend in Bournemouth, *c.* 1999

into an object of affection, something immediately lovable, adorable and precious: just the sort of focus of others' attention that he had never been as a young boy. As Perry was discovering, the affectionate gaze based on one's appearance above all else is not one normally directed to young boys or men – and it is this which lies at the heart of the thrill he feels in dressing up.

As his explorations into his own sexuality and identity deepened, Perry began to look more closely at the history of transvestism, in particular the Victorian period and early cross-dressers such as Ernest Boulton and Frederick Park, characters who would later appear on two of his commemorative plates (pp. 144–45). Exploring society's attitudes towards gender and self-expression more broadly, Perry has arrived at his own theory about transvestism, seeing it as a manifestation of sexism in society – but sexism directed against men rather than women. Despite ongoing discrimination against women in some arenas of modern life, they are, so Perry argues, granted greater leeway than men in the range of their emotional expression. He has developed this line of thinking in his work and, more explicitly, in the 2005 TV documentary he made, 'Why Men Wear Frocks', in which he suggested that the gender identities available to women in most developed societies are far more varied and nuanced than those typically allowed to men. Where women can choose to be anything from the sex kitten to the tomboy, boys and men who show their vulnerability are regularly taunted as unmanly 'sissies'.

Perry himself now happily embraces the two aspects of his own personality, expressing his feminine side in his flouncy frocks while also enjoying stereotypical blokeish pursuits such as mountain-bike racing and high-speed motorbike riding. Men's roles, masculinity and the symbols of male power have been the subject of much of his work. In both *Y-Fronts and Roses* and *Floating World* he confronts the diminishing of traditional male values in modern Western society and seems to lament the

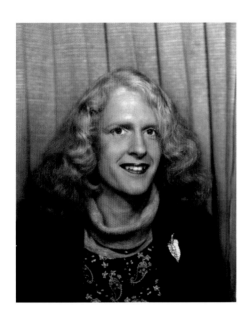

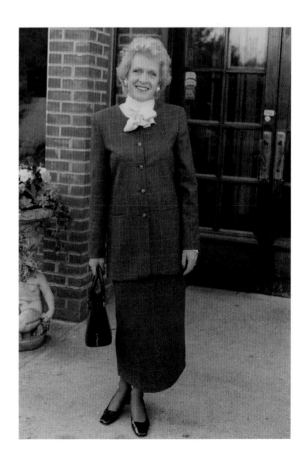

emasculation of modern man (pp. 128–29 and p. 146). His elegiac tone is not, however, straightforwardly sentimental, for he also repeatedly recoils from the aggression and bravado that certain men display. In particular, his campaign, as he puts it, to 'decriminalize the penis' is about reclaiming that powerful symbol of potential male aggression for more innocent purposes. In his *Coming Out Dress* and elsewhere, Perry attempts to re-present the male member as simply a charming decorative symbol, in a bid to make it an emblematic motif as popular and inoffensive as the flower (pp. 138–39). In proposing such a thing, Perry is, of course, mounting a challenge, directly confronting received attitudes and social conventions. In one work, *Moonlit Wankers*, he even attempts to recast masturbation, a subject usually well beyond the realms of art and culturally polite society, as an opportunity for romantic contemplation (p. 151). Such subject matter, as well as the taboo-breaking instinct that underlies it, allies Perry's work with that of the English illustrator Aubrey

Beardsley, an artist whose grotesque erotica Perry much admires. Like Beardsley, Perry presents in his drawings sexually explicit imagery – in particular, images of male genitalia – in a satire both of male potency and of society's deep-seated taboos about sex.

Since the early 2000s, Perry's cross-dressing has at times been a similarly provocative embodiment of sexual cliché and deliberate subversion. While Claire still regularly appears in babydoll garb or Little Bo Peep ensembles, she has also dressed in more explicitly sexualized oufits, including a black leather bondage dress and a pale pink fleshly concoction of satin hidden under a sheer black negligée, mimicking the coyly-concealed vixen familiar from cinema and pornography. A number of Perry's most flamboyant panto-dame-cum-geisha-girl outfits have originated in the 'Design a dress for Grayson' project that he established in 2005 for the fashion print students he teaches at Central St Martins College of Arts and Design. Over the five-week course, the students each make Perry a dress, with his favourites then being

Left | AUBREY BEARDSLEY *The Examination of the Herald*, from Aristophanes' *Lysistrata*, 1896
Right and far right | Claire, 2009, from 'Grayson Perry: The Artful Dresser', *Art World* magazine

purchased and worn by him. Whatever Claire's style, however, she is now a central part of Perry's identity, and for every one of his pots, there exist many hundreds of pictures of him dressed up. Claire even has her own bedroom in Perry's home, complete with tasselled curtains, satin cushions, dressing table and toile de Jouy wallpaper.

Like a handful of other modern and contemporary artists, such as Marcel Duchamp and the photographers Cindy Sherman and Yasumasa Morimura, Perry undoubtedly plays the dressing-up card as part of his artistic act. As he readily admits, the image of the transvestite potter in the guise of an adorable young girl or outré sexbomb has become a well-publicized element of the 'brand' that is Grayson Perry. Some critics have, as a result, taken Claire to be an artwork in her own right. Interviewers and commentators trying to find a context for Perry's cross-dressing have often looked to the traditions of the drag act and pantomime, explaining Claire away as a vaudevillian sideshow. But it is perhaps more true to

read her various reinventions as signs of Perry's own, more personal, emotional development. His sporadic recasting of Claire is always a means of expressing through dress what he calls 'the heraldry of my subconscious'.[3] Where his dressing up differs from that of many other artists, and stops short of being a mere artistic device or marketing ploy, is in its unnerving authenticity. Emphatically, Claire is not an alter ego for Perry: she is simply him in a dress. The power, pathos and oddness of his transvestism lie not in its status as performance. This is no mere stunt: instead, his is a publicly played-out compulsion – one rooted in rejection, unhappiness and the need to be loved simply for being oneself. As Perry said in the speech he gave at his 'coming out ceremony': 'A lot of people find [cross-dressing] funny, something to be mocked. I acknowledge that no matter how accepted it becomes, a man in a frilly dress can still be a ridiculous spectacle. So please imagine, for a moment, what it is like to feel compelled to put yourself in that position – and maybe it's not so funny.'[4]

y-fronts and roses | 1988

Glazed ceramic, 41 × 25 (16 × 10)

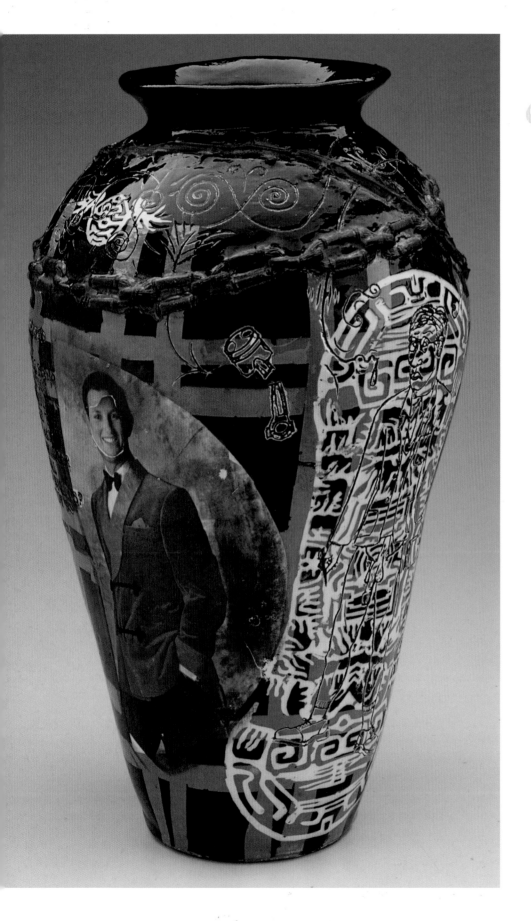

"**This work is about** emasculation. Y-fronts make me think of the caricaturist Steve Bell, who famously drew the British prime minister John Major wearing his underpants on the outside of his suit, parodying Superman. They are the symbol of unthreatening, domestic, non-sexual man. Roses for me are symbolic of the tacky romanticism often used by men that makes me want to vomit. So 'Y-fronts and roses' summed up for me the nightmare scenario for men.

There are some barbed rose stems around the top of the vase, as an allusion to the double-edged nature of relationships. There's a large white phallic shape on the side, made from a paper-cut stencil, with a drawing inside it of a man with no trousers on but wearing a jacket and tie. The pink and blue is a sort of tartan made up of the two clichéd gender colours. I've included a broken sword as a symbol of emasculation. There is also a text on the vase that says, 'If machismo dies, will the silks and satins of spirituality replace the sword and supercharger as sexual status symbols?' What a load of tosh!

The transfers of Charles and Diana have their faces swapped. This was long before they got divorced: for me, switching their faces was a way of expressing how men are living nowadays in a woman's world. The modern workplace is increasingly becoming a place where women thrive more than men, because they have better communication skills and empathy. A lot of male attributes don't have a place in the modern world: male evolution has been outstripped by technology and nowadays you don't need to be strong and aggressive to get on. I've got a particular bias against aggressive male posturing.

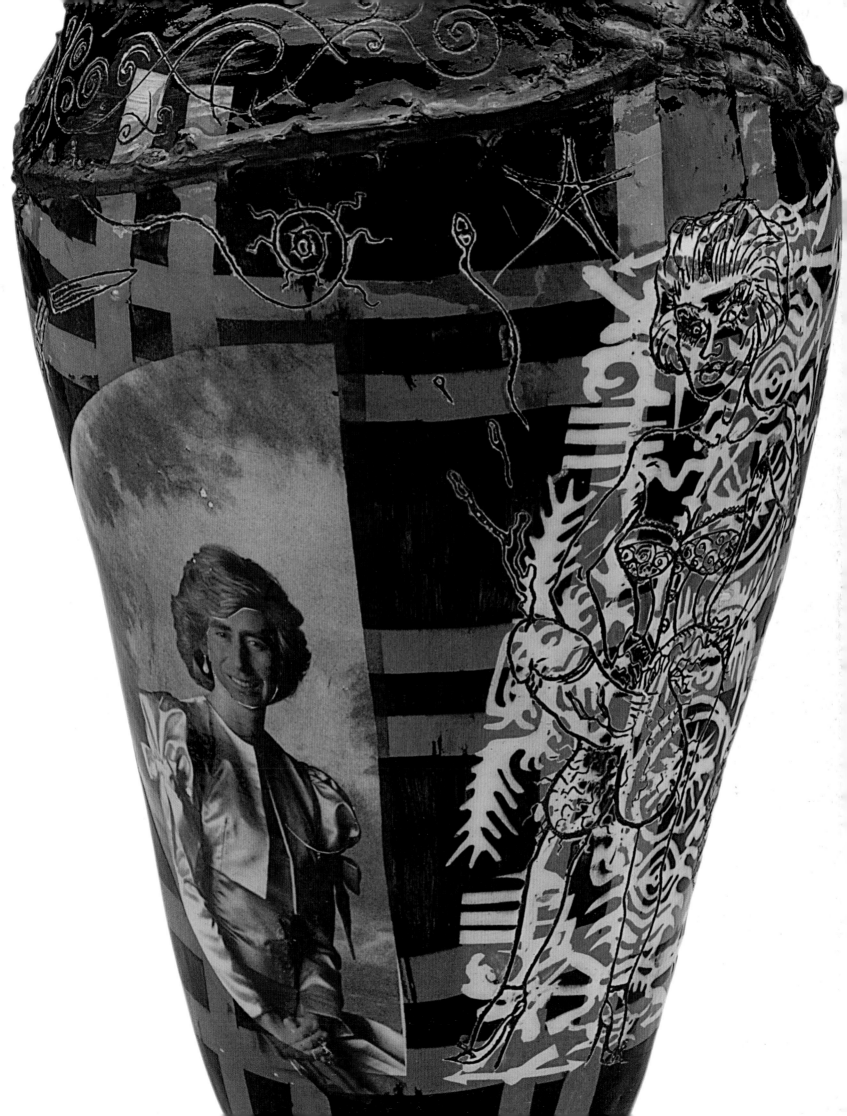

This was my first quilt piece. My major source of inspiration was a quilt made by a woman in Kentucky in the mid-nineteenth century to help deal with her grief over the death of her two young sons. She stitched a series of fabric coffins around the quilt's edge with the names of her family on them and unpicked them one by one as the people died, re-sewing the coffins at the centre inside a graveyard.

Traditional American quilt patterns often have biblical-sounding titles like 'Jacob's Ladder', and I thought 'Tree of Death' would have a similar ring. The Tree of Life is of course a very common embroidery motif. I was thinking, too, of the quilts made in the US in the mid-1980s, in memory of people who had died from AIDS. They'd been sewn together into a massive quilt thousands of feet square. It was a political act, as well as linking to the old American quilting tradition.

Here, the main motif is a repeating pattern of phalluses ejaculating into anuses, with foliage made up of atomic explosions, coffins, medicine capsules, and veins with needles going into them. Everything relates to death, particularly death from AIDS. The foliage design came from a Japanese kimono, but instead of the little seeds in this flower I put swastikas: I wanted a shorthand symbol for 'badness'.

The quilt is made from a hundred separate embroidered panels sewn together, done on computer. Each one has about 60,000 stitches: there's a total of around six million stitches. I wanted to make something very opulent and sumptuous about a not very domestic subject. I used an industrial process to make it because, as much as I love traditional folk crafts, I couldn't really countenance the idea of having little old ladies sewing it for me.

ELIZABETH ROSEBERRY MITCHELL Graveyard quilt, 1839

tree of death | 1997

Cotton and rayon, computer controlled embroidery, H. 250 × W. 250 (98¼ × 98¼)

right to life | 1998

Cotton and rayon, computer controlled embroidery, H. 200 × W. 250 (78¼ × 98⅜)

" **The American tradition** of quilt-making is especially strong in the Bible Belt, the kind of places where people are violently anti-abortionist and attack medical clinics. Here, I've superimposed embroidered foetuses and blobs of blood on the classic 'tumbling blocks' pattern of 3-D cubes.

Ambiguity is said to be one of the defining characteristics of contemporary art. This quilt is quite an ambiguous piece: it sits on the fence of the abortion debate. You could read it as a kind of inanimate DNA pattern, suggesting that foetuses don't have personalities or any life to them. Alternatively, it could suggest the way in which we often try to straightjacket the organic into the empirical. There's a contrast between the pattern of the foetuses and the very rigid geometry of the traditional pattern, reflecting how we sometimes decide that a new life doesn't fit conveniently for us into our financial or social systems.

rumpleforeskin | 2005

Glazed ceramic, 58 × 38 (22⁷/₈ × 15)

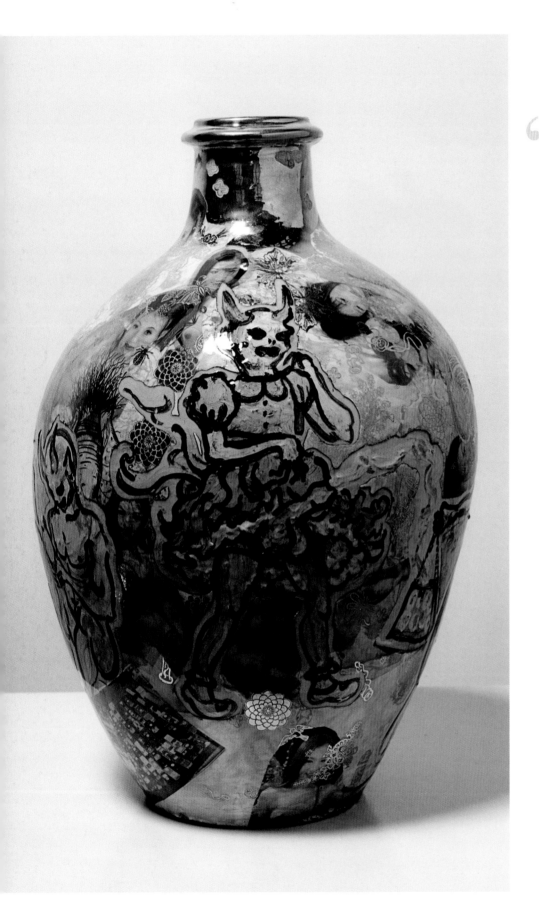

66 **I like words,** and titles are very important to me. A title is an entrance into what the work is about, as well as having the potential for humour and mischief. More often than not I decide on titles after the work is finished, when I'll brainstorm a list and choose the one that hits it on the head.

This work is quite freeform, showing a small, impish devil character masturbating. I like the idea that there are different forces tugging on you when you're looking at a pot like this: am I meant to be seeing it as a sublime piece of work, is it a joke, is there a historical reference, or is it some sort of intellectual exercise? Humour is for me a very creative force. It's instinctive, like sex, I think. Something either turns you on or it doesn't; something either makes you laugh or it doesn't. It's about supplying two electrodes and hoping that a spark will be triggered between them.

This pot has open-stock transfer imagery of fighter planes and Native Americans. It's interesting to me that those collections of generic decorative images are incredibly gendered to this very day. Boys still want cars on their shirts and girls want flowers. My imagery shows a fantasy of male suppression and humiliation. There are S&M scenarios with boys being treated as dogs, and there's a reference to a Native American initiation ceremony. There was a film made in 1970, *A Man Called Horse*, in which Richard Harris played a kind of wannabe Native American. There's a famous scene where he gets sticks thrust through his chest muscles and he has to endure being hung up by them, so there's a reference to that in the various tortures depicted on the pot.

I've made a lot of vases using this combination of techniques. There's sgrafitto drawing with copper oxide, transfers and then finally platinum or gold lustre filled in. This combination gives me the freedom to make relationships between the transfer images and my own drawn pictures. It looks like the transfers are the last thing to be applied, but in fact they're the first thing to be chosen, because I have to demarcate the area where they're going to end up to make sure that I don't draw or paint over it.

growing up as a boy | 2000
Glazed ceramic, 40 × 18 (15¾ × 7⅛)

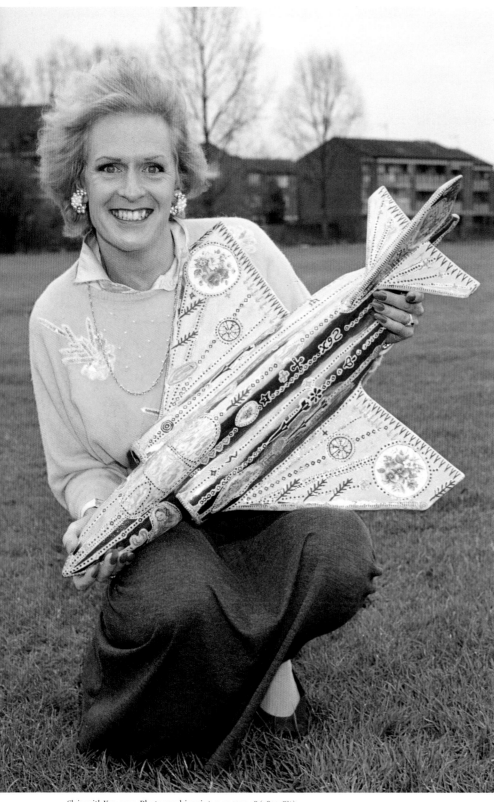

Claire with X92, 1999. Photographic print, H. 71 × w. 48 (28 × 18⅞)

66 **I was very interested** in radio-controlled cars, and I remember going into an Oxfam shop and buying a pile of old model-aeroplane magazines. On the cover of each one was a wife holding her husband's model aeroplane. She'd have her best jumper on and a bit of lippy. I thought they were such surreal photographs that I decided to do one myself.

I built my own aeroplane as a prop for Claire to hold in the picture. X92 reads as 'sex' backwards. It is a kind of woman's aeroplane, a hybrid between a model jet plane and a knick-knack that would be dusted along with the brasses. The imagery includes kittens and flowers alongside rockets and missiles of the sort you might see on Afghan war rugs.

X92 | 1999

Glazed ceramic, 18 × 58 × 84 (7⅛ × 22⅞ × 33⅛)

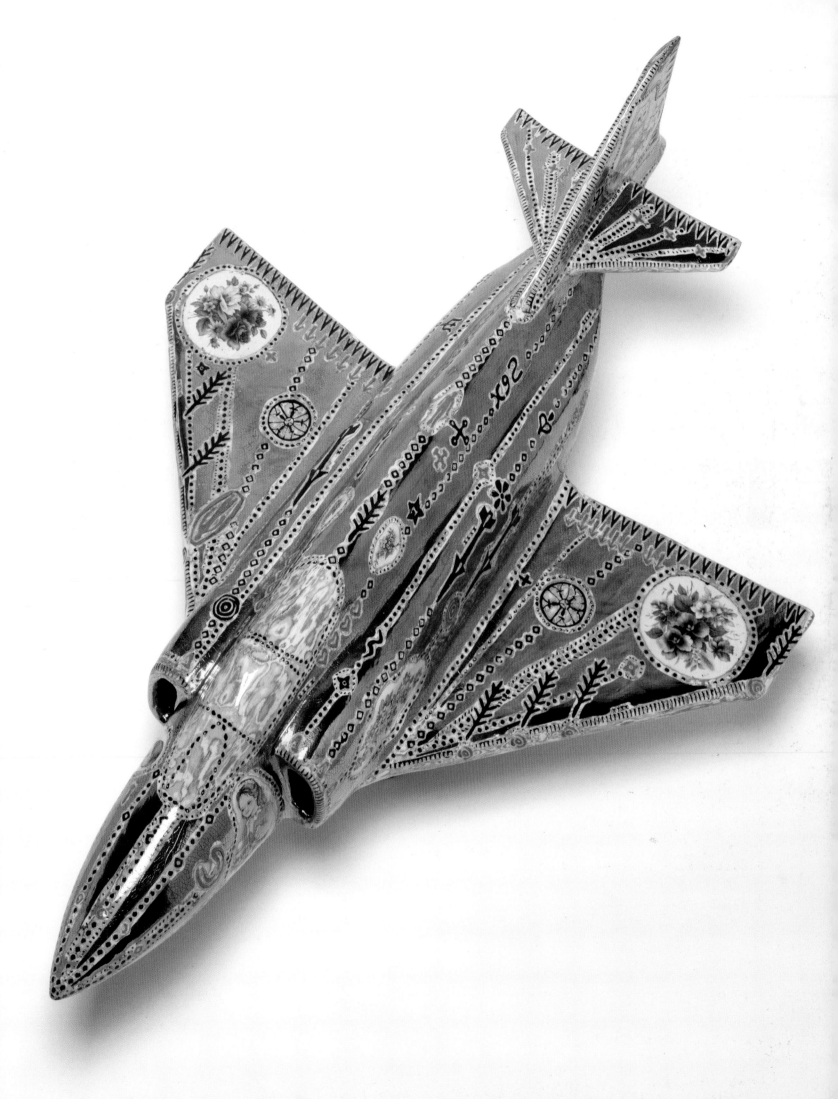

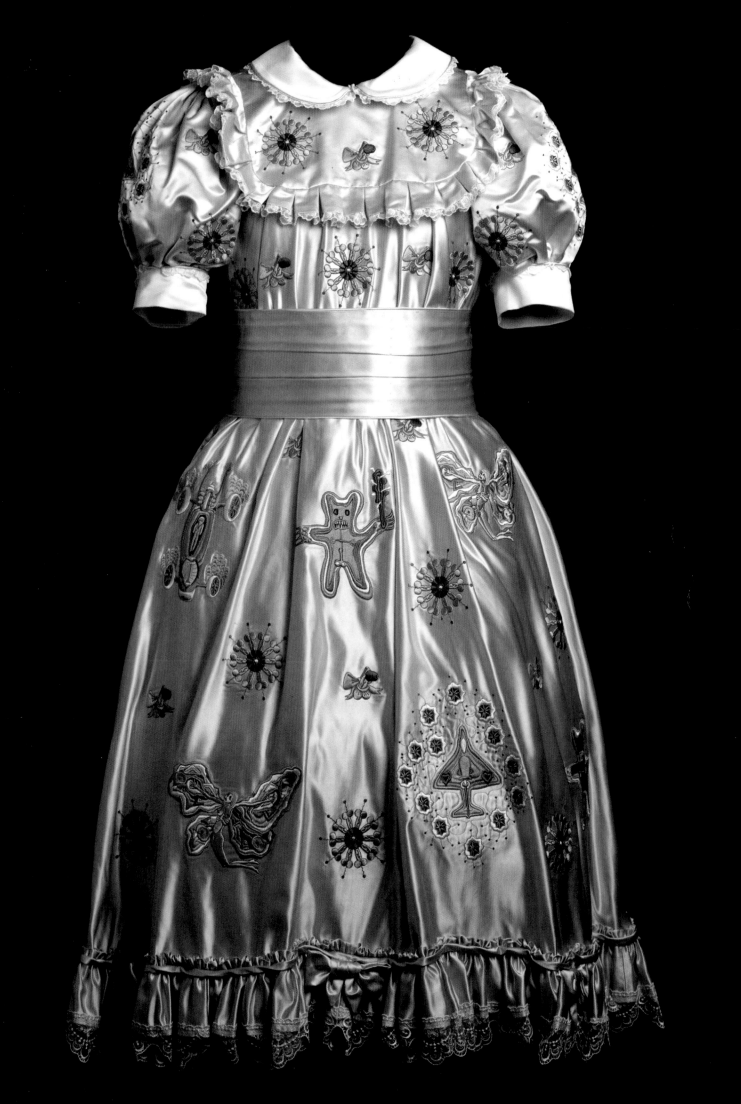

claire's coming out dress | 2000

Silk satin, rayon and lace, H. 125 × W. 80 (49¼ × 31½)

"**This dress has got** what I call the Liz Hurley factor: it's been so documented that it's hard to wear it twice. I made it for an exhibition called 'A Sense of Occasion' which was of objects made for specific ritual purposes. As a transvestite, I thought the obvious thing to make would be a dress. I was going through some major upheavals at the time in my personal interior life. I had a kind of epiphany in 2000 when I realized that being a transvestite wasn't about pretending to be a woman. It was about me putting on the clothes that gave me the feelings that I wanted, and I would get the most concentrated hit of those feelings from something frilly and flouncy. The style of this dress was very important to me, because it was taking me back to the absolute distilled essence of femininity that I realized I had been somehow reaching out for as a child. Classic little girl dresses are for me the ultimate in frilliness and sissiness – the absolute antithesis of the macho.

The images on it are about my childhood, including Alan Measles as an avenging primitive god, and a struggling butterfly, symbolic of the transvestite coming out of the cocoon of puberty. The penis with the little bow around it is about trying to decriminalize the penis. A red penis is seen as a threatening image so I wanted to make it look somehow cute, like a sweet little bird you could nurture or a motif you might see on a child's dress, like a pair of cherries. The dress itself has very pretty sugary colours and is a real mix of gender stereotypes.

I organized an actual 'coming out ceremony' at the Laurent Delaye Gallery in October 2000, with me wearing the dress, coming through an archway of balloons around the door. I made a little speech to a selected group of friends and family, and showed a slideshow of the history of me as a transvestite. It was a real occasion, not something staged as an ironic performance piece.

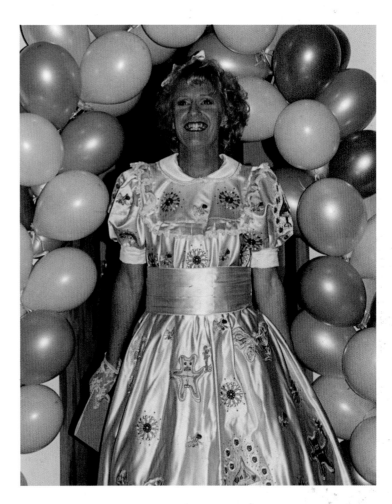

Top | Claire at her 'coming out ceremony', Laurent Delaye Gallery, 30 October 2000
Above | Detail of *Claire's Coming Out Dress*

untitled | 2002

Pen and coloured pencil on paper, H. 21 × W. 30 (8¼ × 11¾)

"A lot of my drawings are about sexual fantasies. This one shows a woman in bed eating chocolates. I have lots of daydreams about what it will be like being an ageing transvestite, one of those women who doesn't get up until she is ready for lunch, and who stays in bed taking phone calls.

In my fantasy, I imagine being employed in a doll shop. For a while I was obsessed with dolls; I still like them very much. They are at once fetish object, toy, artwork and gender signifier. There's a universal element to them too: all cultures have dolls.

My fantasy woman would probably live in a little village in the country. My ideal hamlet has little phallic churches, farmhouses and village halls. It's that Ruritanian idea of a folk culture – traditional but in my case highly sexualized – that connects back to my early sketchbooks from college.

The drawings I've done since the early 2000s put me in contact with how I started, and with my childhood world. That for me is a big part of drawing. It links to the idea that the world of my imagination has its own culture. I'm continually returning to that comforting feeling of creating an interior landscape through drawing, and having glimpses into a mythic space where my emotions create societies.

untitled | 2002

Pen and coloured pencil on paper, H. 42 × W. 30 (16½ × 11¾)

untitled | 2004

Pen and pencil on paper, H. 21 × W. 30 (8¼ × 11¾)

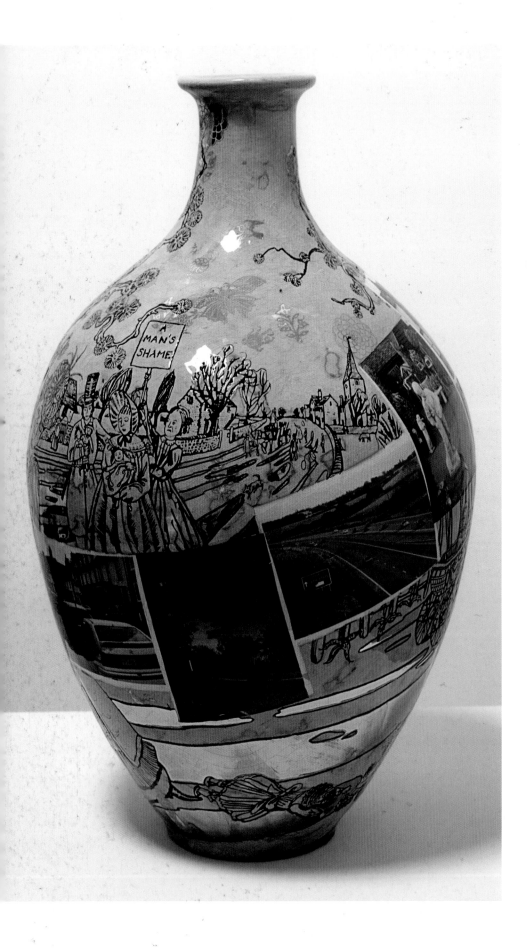

" **This piece was inspired** by going to a village-hall watercolour exhibition. The locals' paintings bore no resemblance to the village they were being displayed in, although they purported to be of that very place. There were no cars or road signs, no satellite dishes or pylons. My pot contrasts the idea of an imaginary, sexualized Victorian village with a real, modern village. I juxtaposed my fantasy with a collage of photographs I took in the area around where I used to live. It is heavily built up and has a motorway running past it; every street is lined with cars and the local shops sell lottery tickets. It's the kind of place where the garden centre is the most active part of the village.

This is a theme that goes right back to my earliest works. I made a piece early on called *The Countryside is Modern Too* – because in art the countryside is so often portrayed as old-fashioned. The rural idyllic past is a myth: farmers use sat nav nowadays to guide their tractors when they plough their fields.

fantasy village | 2006

Glazed ceramic, 56 × 33 (22 × 13)

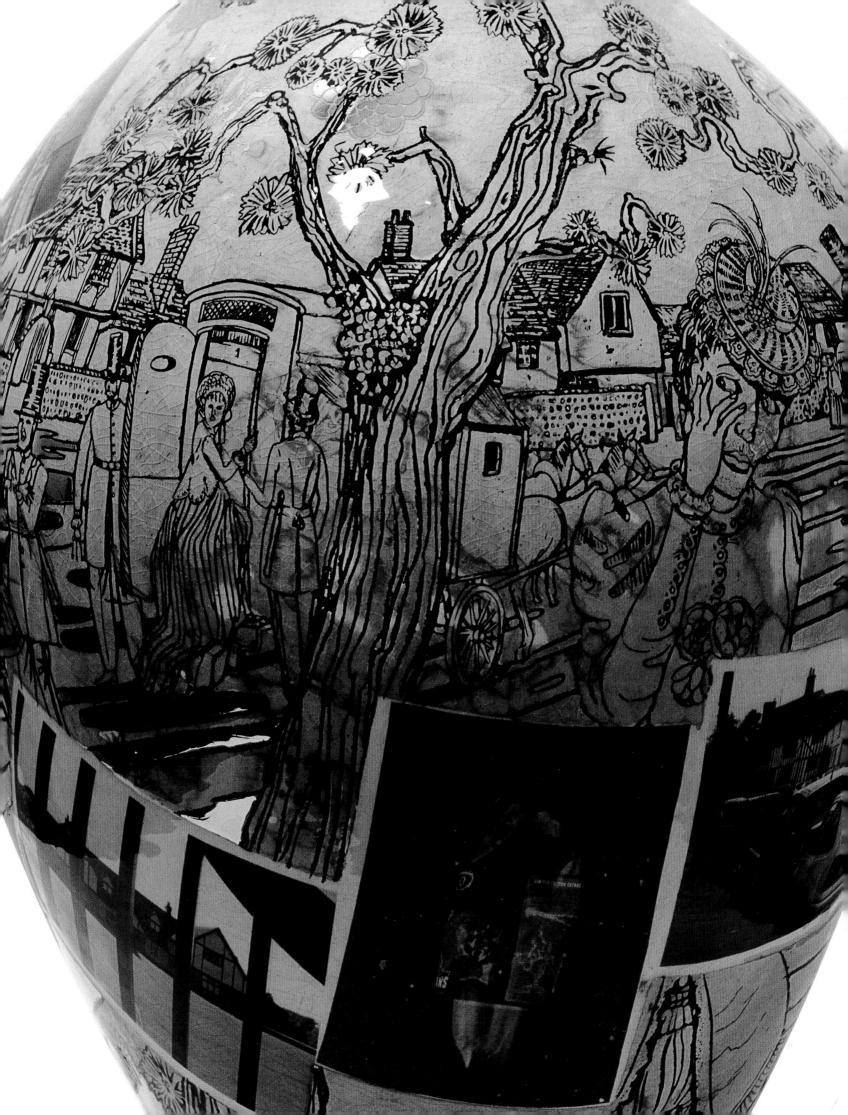

mr ernest boulton | 2006

Glazed ceramic, DIAM. 51 (20⅛)

Ernest Boulton and Frederick Park, c. 1869

" Ernest Boulton and Frederick Park were probably the most famous Victorian transvestites. I made these commemorative plates to them as if they were folk heroes of the sort you might see on sixteenth- and seventeenth-century pottery. The pair used to swan about London in the full rig. Interestingly, transvestism was seen then as something eccentric but not sexual: this was pre-Freud. It wasn't necessarily encouraged, of course, and Boulton and Park did once famously get arrested, but they were never charged because there wasn't a law against dressing up. This was the time of the earliest studies of 'Eonism', as it was then called, named after the most famous historical transvestite, Chevalier d'Eon de Beaumont.

If I was going to be transported back in time, then the late Victorian era would be a great period to be a trannie, costume-wise. It's when female style was at its most impractical and kinkiest. Up until that point, men's dress was still quite ostentatious, but in Victorian times there was a divergence of male and female dress, partly because of a rebirth in religious morality and partly for practical reasons. 'Men of action' who went out into the world couldn't be elaborately dressed anymore. Women, however, had very different dress codes: they were almost pieces of furniture and could hardly move. So quite often trannie societies have a Victorian evening, because everybody aspires to swan around in a corset, a big dress and a bonnet. I'm a sucker for it myself.

Transvestism looks instinctively for things that delineate roles like this. Transvestism is a marked symptom of sexism in that it fetishizes the difference between women and men. I mean sexism in both ways, in that it denigrates women by saying that certain sorts of 'feminine' behaviour are humiliating and bad, but it also restricts men's roles, saying that certain behaviours are not allowed for men. Being treasured for how you look can be positive though, and is not something usually available to men.

mr frederick park | 2006

Glazed ceramic, DIAM. 51 (20⅛)

floating world | 2001

Glazed ceramic, 56 × 44 (22 × 17⅜)

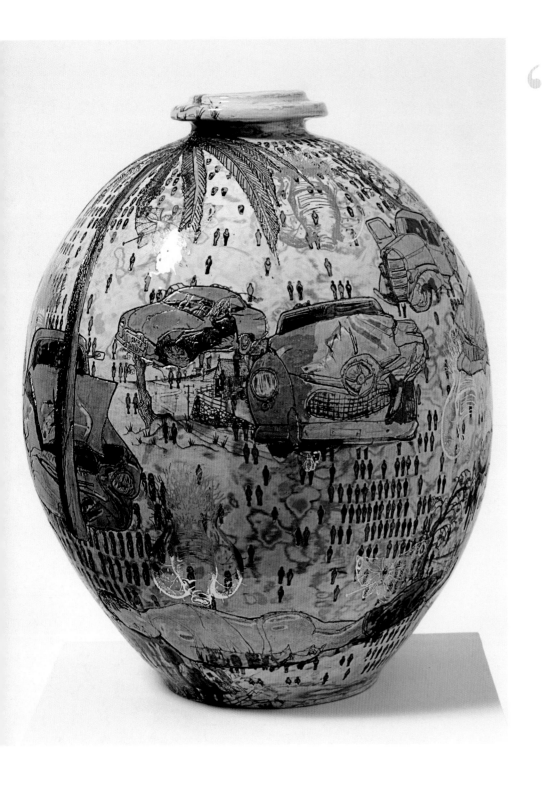

" **I'm fascinated with** all things Japanese. *Ukiyo-e*, or floating world, refers to the Japanese world of pleasure: the geishas and taverns of old Japan. My pot is about maleness. The background has gold drawings of my willy and red landscapes with a little idealized hamlet. A phallic tower stands at the side of a workshop with an abandoned racing car that has the words 'Alan Measles' written on its side. The dominant images are car wrecks, which I saw as flaccid, post-coital penises, with the crumpled foreskin like the front of the car as it collapses after sexual congress on the highway. The road is where men nowadays play out their hunter-gatherer instinct. The male role has a dwindling relevance to the modern world. There's a kind of poignancy in that for me: it's an end of an era, at least for the modern, Western, developed world.

One of the things I strive for technically is to get my imagery to float. I use various techniques to lift images apart from one another, such as colour or the style of line. Marbling has an out-of-focus quality that fades towards the background, whereas gold will always leap forward. I like that sort of shifting. Apparently if our eyes are kept dancing we are calmed, which is perhaps why we love pattern. It's like a form of hypnotism. I'm a great believer in pattern and ornateness. I was never into minimalism. There's something inhumanly anal and denying of the animal about it: it's all intellectualism. It aspires to remove itself from the mess of reality. My own style is more human.

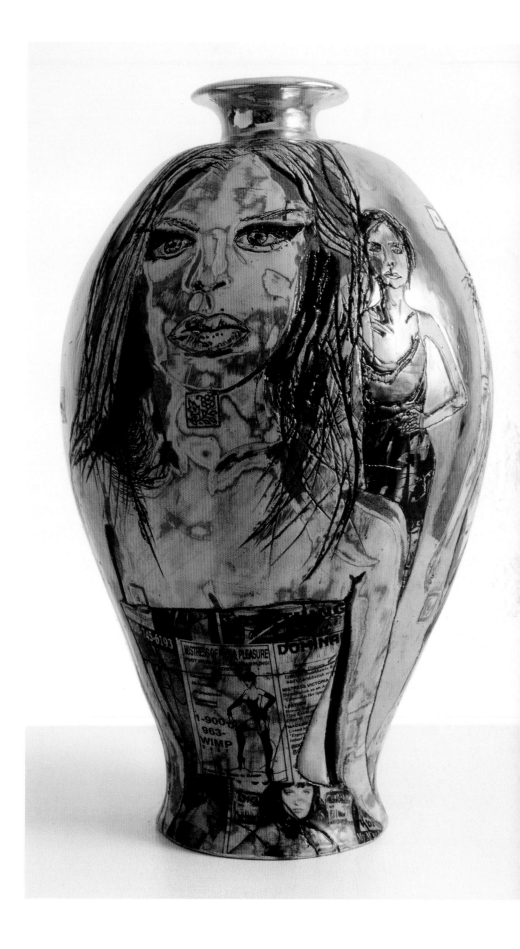

This title is a direct quote from a transvestite writing in a trannie magazine. He was a satin fetishist, quite a common fetish, and I remember he wrote: 'Satin, somewhere between Saint and Satan.'

The pot is a straight indulgence in sexy femaleness. It's a kind of trannie version of the Madonna/whore fantasy. There's an aggressive, bold, dominatrix vision of female sexuality. One woman's dress is made up of S&M small ads. It's quite a simple, one-shot idea, but a pleasing vase all the same. I don't always aspire to great narrative, or to intellectual, social or political heights; sometimes I just make something in pretty colours.

Many of the things I like about my own work are pure craft things, like a texture, a combination of colours or the proportion of a line: the old-fashioned stuff. Those instant decisions can often be where the organic, spontaneous sensitivity is – where the art is.

saint, satin, satan | 1999

Glazed ceramic, 45.5 × 27.8 (17⁷/₈ × 11)

in praise of shadows | 2005

Glazed ceramic, 80 × 50 (31½ × 19¾)

I was asked to make a piece about Hans Christian Andersen, the Danish writer of fairytales, for an exhibition marking the two hundredth anniversary of his birth in Aarhus, Denmark. I chose one of his stories that I like very much, called 'The Shadow'. It's about a man whose shadow leaves him and goes off and has a life of its own. Then one night the guy is in his apartment and there's a knock at the door: his shadow's come back. Their roles are slowly reversed and the shadow ends up leading a successful life while the man slowly fades away. He is eventually imprisoned and executed whereas his shadow marries the king's daughter. It's a very sinister story about our dark side. Hans Christian Andersen had a dark side too. He was probably gay and quite tortured sexually. He never had a partner in his life, and used to put a cross in his diary every time he masturbated.

The title of the pot comes from a Japanese essay, written in the 1930s by the novelist Junichiro Tanizaki, in which he lamented how Western electric lighting was destroying the aesthetic of traditional Japanese interiors.

He talks about things glittering in the warm candlelight and how the West is constantly in pursuit of more light and technology whereas people in the Orient can be happy immersing themselves in the beauty of darkness. I have two modes of presentation of my own work in terms of lighting. One is to put as much light on things as possible so that people can see every detail, and the other is to do something more atmospheric, using the drama of a museum display that might show treasures or historical exhibits. I like the sense of discovery in that.

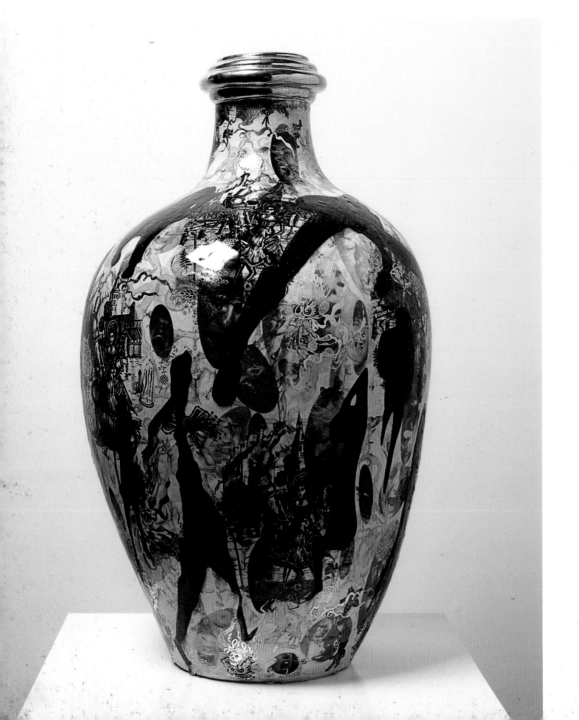

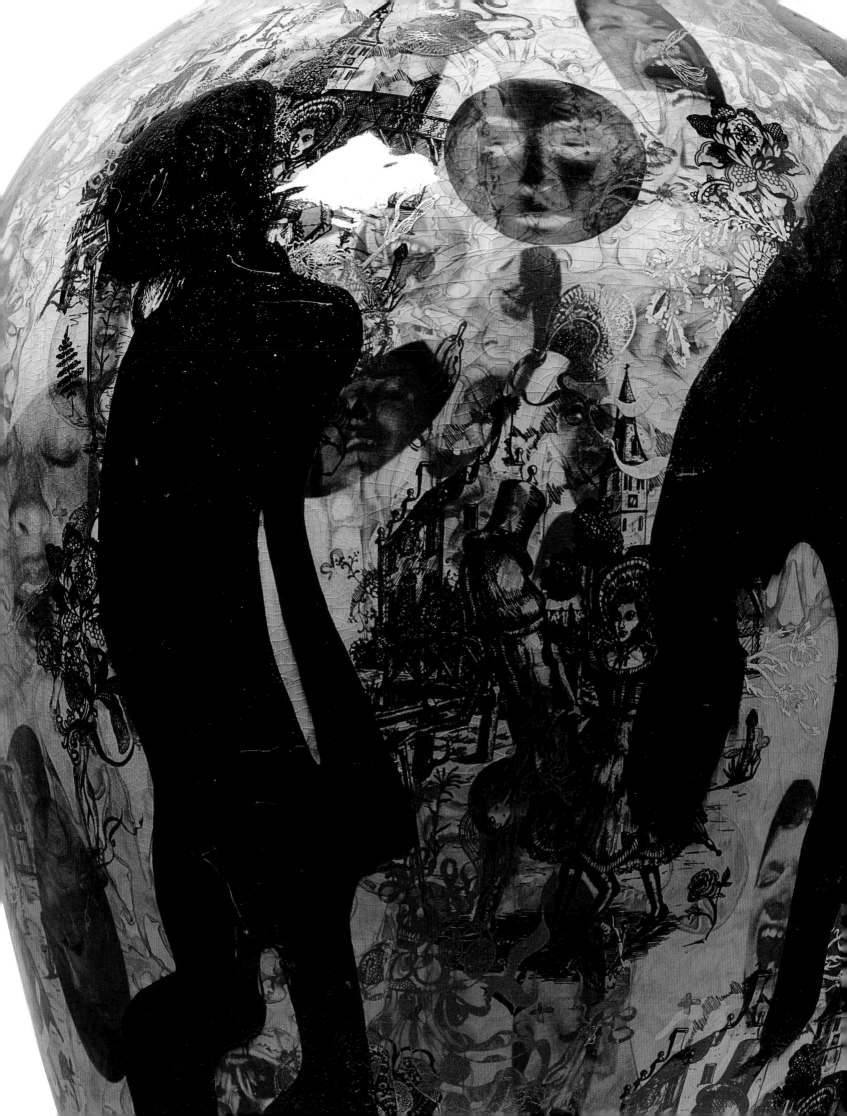

66 **On this pot**, layers of decoration correspond to layers of awareness or the unconscious. The surface layer shows people playing out S&M scenarios; below that are images of suburbia, as a skin of respectability; and below that, harder to read, is this text, the layer of the unconscious like a voice from childhood saying, 'Daddy don't hit me', 'Mummy stop him'. The text forms lines going around the pot, almost as though they're bound into its construction, like throwing lines.

The shape was taken from a Bernard Leach pot: quite sturdy, sort of respectable old English. The dominant brown colour is superficially wholesome. The title comes from the fact that in S&M scenarios we are revisiting an emotional experience which, though we may not know it, we went through in childhood: so it's strangely familiar.

strangely familiar | 2000

Glazed ceramic, 39.7 × 24 (15⅝ × 9½)

moonlit wankers | 2001

Glazed ceramic, 66 × 35 (26 × 13¾)

"**This is a piece** about masturbation. It harks back to a particular wank I had when I was about eighteen. There was an empty Victorian mansion up the road from where I lived and I used to store my secret cache of women's clothes in one of its outbuildings. I would sneak off there and try the clothes on, disporting myself about the large grounds.

I remember one particular moonlit evening with dew on the grass. I had the idea that it was like a self-dating experience, which could in fact almost be romantic. 'Wanker' is normally an insult, and yet most people masturbate. Relax and it can be quite a thrilling and romantic thing. So this pot presents an arcadian vision with people masturbating all over it against the backdrop of a clichéd rural sunset.

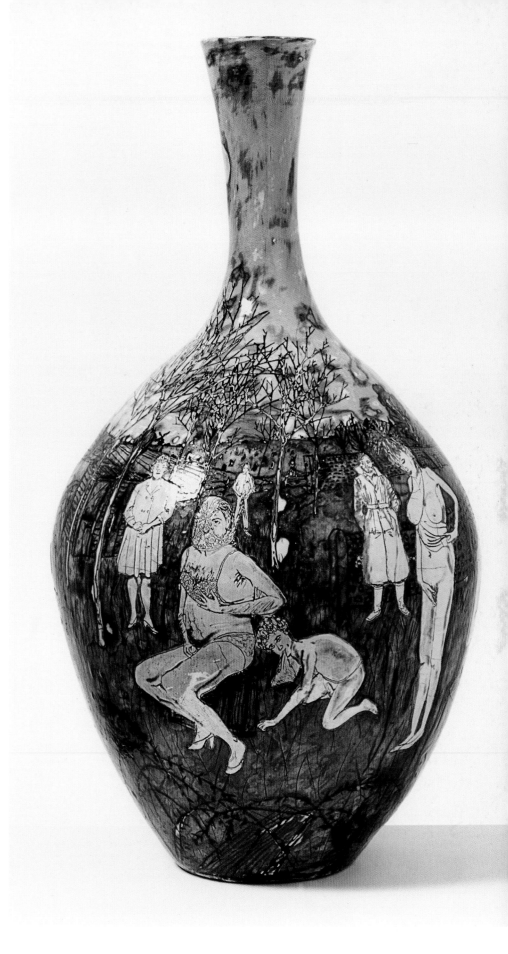

lacroix | 2005

Pen, crayon, watercolour and collage on paper, H. 59 × W. 42 (23 × 16½)

untitled | 2003

Pen and coloured pencil on paper, H. 30 × W. 21 (11¾ × 8¼)

People often assume that I must be really interested in contemporary high fashion, but in fact I'm more passionate about clothes and style, culturally and historically. I'm as fascinated by folk costumes as I am by the latest trends: it's the material culture of clothes that intrigues me, and the idea of clothes as social signifiers. As a transvestite my interest is heightened, of course. I enjoy clothes on a heavily sensual level, and I'm always looking out for designs that snag with my personal fetishes. I often draw to experiment with ideas

for my own outfits. My drawing of a man in a little girl's dress, for example, was partly a design fantasy for thinking about my own dresses. He's got his bag with 'LGW' on it as he's off to Little Girl World.

I enjoy going to fashion shows too. In 2005, I was commissioned by the fashion magazine *Spoon* to cover the haute couture catwalks in Paris for that year's autumn/winter season. I went along to most of the big shows and did a series of collages. This one features a Christian Lacroix coat. While I was in Paris, the 7 July

bombings happened in London and they totally coloured my experience of everything I was seeing. I remember coming out of the Chanel show and someone telling me about what had happened. My family was back at home in the middle of a terrorist attack and I spent the next few hours desperately trying to contact them. So I collaged the fashion drawings with photographs of newspaper stands and crime boards. This one shows a headline from the *Evening Standard* about the bombings, from a photograph I took near King's Cross.

Behind this work is the idea of a phallic symbol. It's me in a mid-life crisis: I was just turning forty when I made it. I was interested in American stock cars so there are two racing cars, one with 'Mid-Life' written on its side and the other sponsored by prostitutes. There's a graveyard, too, symbolic of the end of youth and a look at one's mortality.

This pot is one of a series using a similar composition and colours. I quite often work in series: if I find a combination of colours or techniques that work well together, I'll do three or four vases in a similar style, trying to refine it. But I'm not interested in churning out a formula, so I either get bored or feel it's gone as far as it can go and I stop.

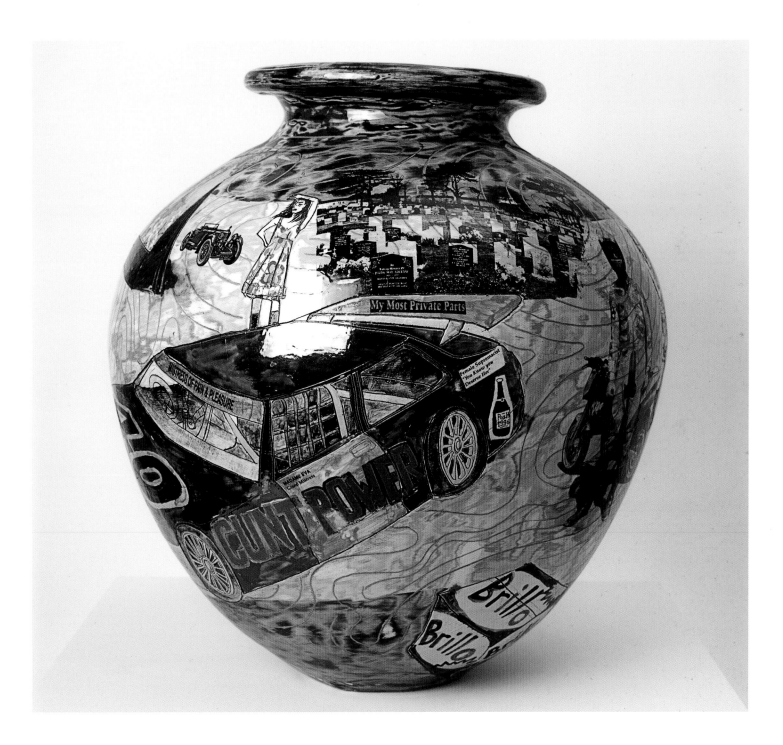

driven man | 2000

Glazed ceramic, 39 × 31 (15³⁄₈ × 12¹⁄₄)

pot based on twenty-year-old collage | 2006

Glazed ceramic, 45 × 46 (17¾ × 18⅛)

Untitled (sketchbook page), 1985. Mixed media on paper, H. 29.6 × W. 41.2 (11⅝ × 16¼)

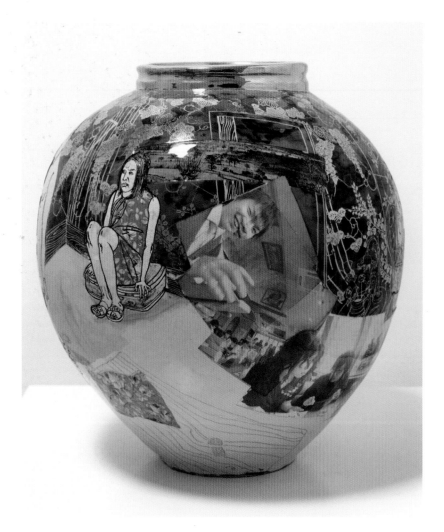

"I've spent a lot of my career trying to reproduce the look of my early sketchbooks on the surfaces of my pots. It took me the better part of twenty years to reach a point where I felt confident and knowledgable enough to be able to reproduce in ceramics the variety of treatments that you get with a collage.

This pot was an attempt to replicate some of my early collages in terms of composition, colour and techniques, using the ceramic equivalents for watercolour, pen, and cut-out images from magazines. My collages were often violently sexual and I wanted to capture something of my early, rather unpalatable imagery of the relationships between men and women, particularly the subjugation of women. The pot was made for my 2007 exhibition in Kanazawa, and it has a Japanese feel with the gold paper-cut design on the wallpaper and the panorama from a Japanese version of McDonalds that we visited.

I may have done the original drawing in a day, but the pot took three months. When you stick a photograph on a piece of paper it takes a matter of moments, but when you put a transfer on a pot it's a long process. You have to plan how and where it's going to go, so you can't be that spontaneous. Pots are not throw-away things.

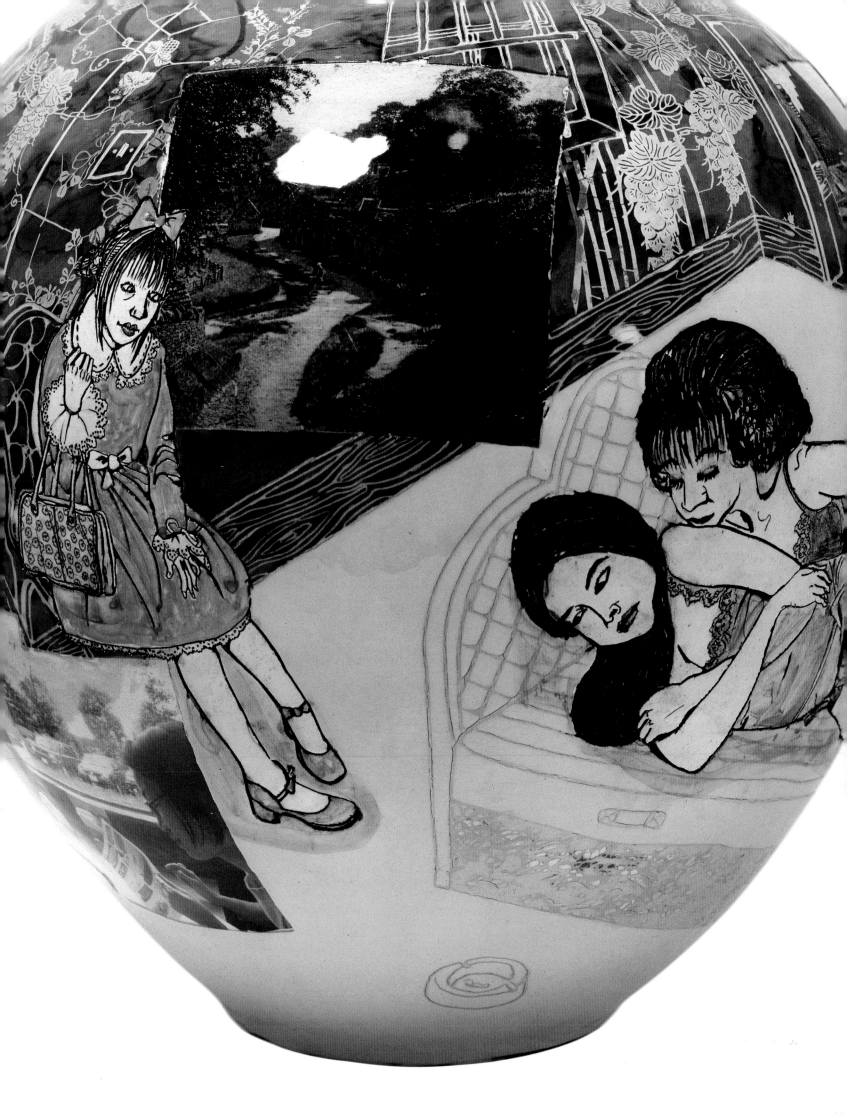

sissy | 2008
Screen print on Liberty Tana Lawn cotton

cranford | 2008
Screen print on Liberty Tana Lawn cotton

"I was invited by the London department store Liberty to make some fabric designs for them. I've used Liberty prints in a number of my outfits so I was very excited. I doodled in my sketchbook and took my drawings along for their designers to decide which they liked. Then I went away and designed them up as patterns. Someone at Central St Martins, who I teach with on the fashion course there, taught me how to do the repeats.

There are four designs, each in four colourways, for use in commercial clothing or for sale to the public. One design called 'Philippa', after my wife, has a tangle of bicycles. Another one is called 'Cranford', after the 2007 BBC TV adaptation of Mrs Gaskell's novel. It's populated by ladies in bonnets congregating like mussels on a rock, in a sort of psychedelic Edvard Munch pattern. Some of them are smiling and some are screaming: it's Liberty with a twist. Then there's the 'Flo' design, named after my daughter, of pollution in toyland. It was inspired by a Japanese screen but instead of the cloud patterns I drew oil slicks and pollution. There are allotments and windmills, dollies, factories, aeroplanes, cars, prams and little gravestones.

'Sissy' is the fabric I'd really want to wear myself. I started with the idea of something very babyish, so there are toys all over it, but as I was thinking of gendered toys I made it more aggressive, adding weapons, knuckle-dusters, daggers and grenades alongside the rocking horses, babies' dummies, football boots and bonnets. It looks like a reinvention of the paisley design using boys' and girls' symbols.

I loved working on this commission. I could quite happily become a fabric designer."

flo | 2008
Screen print on Liberty Tana Lawn cotton

chapter 6 religion and folk culture

'I love religion – it's just the belief bit I have a problem with.'

Contemporary art and religion do not often make easy bedfellows. When they have mixed – for instance in Maurizio Cattelan's sculpture of Pope John Paul II struck by a meteorite, or Chris Ofili's images of the Virgin incorporating elephant dung – controversy and outrage have invariably followed.

Even when artists have not set out to shock, we can still see what might keep contemporary art and religion apart. Religion has a sense of permanence upheld by patriarchal belief systems, a firm sense of community, piety and reverence; it usually stands for deeply conservative values, at times even being on the extremes of right-wing politics. Art, on the other hand, is typically seen as egalitarian, liberal, driven by market values and based on fleeting fashions. It glorifies identity politics, intellectual provocation and the cult of the individual.

For Perry, though, religion has provided rich soil for his artistic imagination. Certainly, he questions, as many do, the assumptions and doctrines on which religious faiths are founded. Highly sceptical of spirituality or 'belief', he defines himself as a 'Christian atheist', abhorring fanaticism of any sort and placing his own faith, such as it is, in rationalism,

fact and a pragmatic humanism. Nonetheless, Perry finds in religion much to applaud and inspire – not least its ritual, pomp and ceremony. He is captivated by its physical trappings, the material culture he finds vividly brought to life in religious artefacts and sacred buildings. A number of his pots have taken direct inspiration from religious works of art, including *The Lincoln Diptych*, a two-sided vase that makes reference to a fourteenth-century panel painting in London's National Gallery (pp. 182–83). He has even made his own set of mystical robes, modelled on the vestments of Japanese Buddhist monks (pp. 174–75). Perry loves the aura that surrounds precious icons and altarpieces, even if such art's moral message or iconography might fail to move him. The exquisite craftsmanship of these artworks inspires awe in him, their minute detailing and strong narrative content mirroring his own aesthetic – and among his favourite paintings we find Grünewalds, Van der Weydens and Bruegels.

Perry also delights in the kinkiness that he finds in religions the world over. He sees a connection between crucifixes and chastity belts (both instruments of torture) and the fetishism of other traditions: Hindu sadhus pulling along carts by chains attached to their genitals; the Islamic and Hindu tradition of purdah which insists on the concealment of women; the wearing of wigs by Orthodox Jewish wives. For him, such traditions not only make for fascinating case studies in ritual but are piquant examples of religion's intimate – if repressed – relationship with sex and sexual fetish.

Perry sees a religious aspect elsewhere in human activity and culture too, often in apparently secular places. He is fascinated by the process of deification and canonization that seems to linger on in our communal rituals – rituals connected, for the most part, to the cult of celebrity or our impulse for memorialization. In the post-9/11 commemorations in New York, the tributes to Princess Diana that sprung up around the world following her death, and the impromptu roadside 'shrines' for the victims of car accidents which have appeared in recent years, Perry detects a sort of modern-day, displaced religiosity. Princess Diana, indeed, was a recurring character in his early plates and vases, partly for the practical reason that commercial transfers of her were readily available but also because she signified for him both an ideal of womanhood and the archetype of the contemporary, popularly elected saint. Early in the Diana craze, shortly after the royal wedding in 1981, Perry made a work that deftly underlined the veneration in which the Princess was held. *The Reliquary of St Diana* was a commode-cum-coronation-chair modelled on the historic throne in Westminster Abbey. In place of the Stone of Scone, the ancient artefact that resided beneath the chair for many centuries, Perry put under his seat a ceramic turd, apparently a relic left behind by the royal saint herself and now preserved for eternity.

Another character who looms large in Perry's litany of contemporary saints is his teddy bear, Alan Measles, the private god for whom he has created a throne and a temple-like shrine, the latter bedecked in ornamental offerings (p. 184). A shrine, of course, implicitly points to a community of devoted believers who pay homage in its sanctuary. It is with this sense of community in mind and the enduring importance of shared experience, as well as recognition of what he calls 'the God-shaped hole' in modern society, that Perry has developed plans for his own life-sized shrine. His *Temple for Everyone* would be a space not only for marriages and funerals but also a pilgrimage site of sorts, a monument to communal experience and memory – complete with its own café and gift shop (pp. 194–95).

Community ritual and shared belief also lie at the core of Perry's explorations into folk culture. Ever the social anthropologist, he sees in people's symbolic objects and behaviours the markers of their broader communal culture. He adores the folk history and aesthetic traditions of Asia, in particular Japan, to which he has travelled a number of times. But his fascination is, for the most part, with the familiar, if vestigial, folk

Left | MATTHIAS GRÜNEWALD The Isenheim
Altarpiece, *c.* 1510–15
Above | PIETER BRUEGEL *Procession to Calvary*, 1564

cultures of his native country. He casts his eye most acutely over the English, whether in Essex or London, Sunderland or the Cotswolds, reflecting these cultures back to his audience as something seemingly strange and exotic. This anthropological instinct was most clearly expressed in Perry's exhibition-as-artwork, 'The Charms of Lincolnshire'. In the show, described by him as 'a poem written with objects',[1] he wove a dark tale of Victorian life centred on the harsh realities and superstitious rituals surrounding death. For Perry, the 'charms' were less the county's natural beauties than the talismans and spells that shrouded the local community. Selecting from Lincolnshire's museums a hidden store of potent artefacts, including a Victorian hearse, grave-markers and a punt gun designed for shooting ducks from a boat, he surreptitiously added his own bogus piece of indigenous material culture, a 'hunt post' that seemed entirely credible but pointed to a local custom that in fact never existed (p. 180). Elsewhere, in the ceramics and sepia photographs he made for the exhibition, he called attention to the dark side of communal life. In *A Sense of Community*, for example, he transformed the seemingly decorative emblems of a village house and church into the sinister shape of a swastika (p. 181).

Another exhibition of Perry's, this time exclusively of his own work, seamlessly brought together these ideas about belief, community, religion and art. In 'My Civilisation', Perry's 2007 show in Kanazawa, Japan, he created an entire world culture based around the ubiquitous figure of Alan Measles, who cropped up as everything from aggressive war-mongerer to Buddhist mystic. Intriguingly, though, Perry described the works in the show as being akin to the 'relics of a saint, the after-effects of my life'.[2] The artist was himself, of course, ultimate creator, his imagination the giver of life to these teddy-bear totems. Such an idea connects back directly to the age-old notion of the artist-as-shaman. And Perry's pots do have something of the aura of religious relics about them, especially when displayed (as they so often are) under glass, on clean white plinths, their flashes of gold or silver occasionally catching the light. Yet he wards off any tendency to self-aggrandizement, presenting us with a vase that knowingly mocks the cult of the artist. In his *Personal Creation Myth* we see Perry giving birth to Alan Measles in a manger, a motley stream of admirers and devotees looking on (pp. 186–87). Less a contemporary god, the artist is in fact a teasing, self-satirizing myth-maker.

Left | GRAYSON PERRY *The Reliquary of St Diana*, c. 1984.
Mixed media, c. 33 × 10 × 12 (13 × 3⅞ × 4¾)
Above | 'The Charms of Lincolnshire' exhibition, installation view from the Victoria Miro Gallery, Wharf Road, London, 2006

st claire (thirty-seven wanks across northern spain) | 2003

Glazed ceramic, 84 × 55 (33⅛ × 21⅝)

In 2003, I went on a two-week cycling trip in northern Spain along the pilgrimage route to Santiago de Compostela. The title is a joke of sorts: I'm an inveterate masturbator, but it's also reminiscent of those Richard Long works with titles like *A Seven Day Walk across the Andes*.

Religion and kinkiness tend to go together, and the vase is about my sexual fantasies. It was based in large part on religious art, in particular those polychrome wooden altarpieces that often look a bit knocked about. I tried to create the ceramic equivalent of this, the look of worn paintwork, in the figures that are in low relief. Alongside some of my kinky iconography – me in a chastity belt, Claire as a saint with a halo, and a bizarre transfer I found of Santa Claus in a dress – there are drawings based on the landscape I'd seen, including the Santiago cathedral which appears in the background.

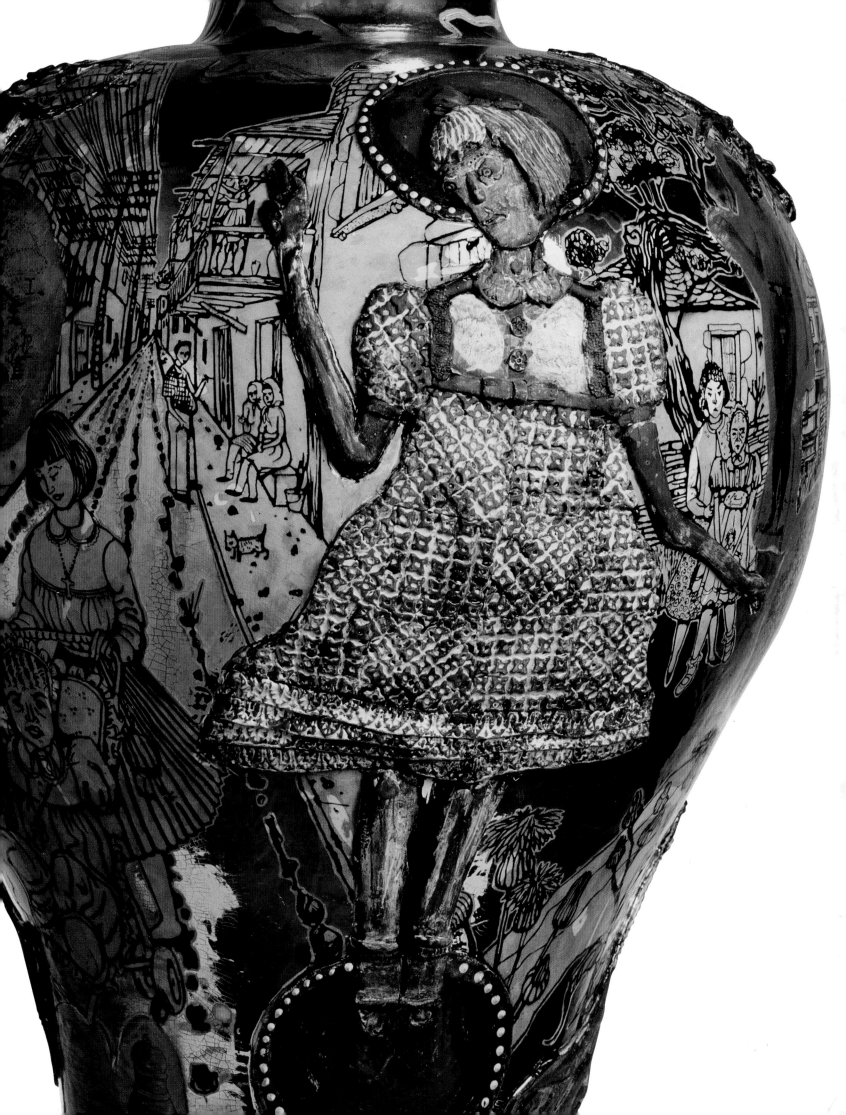

claire and florence visit shrine to essex man | 1998

Photographic print, H. 42 × W. 64 (16½ × 25¼)

" **When I was young,** I often had dreams about cars and motorbikes, but there would be something wrong, usually with the handlebars. After I started having therapy, I began to have similar dreams, the cars now a symbol of my life moving on. I dreamt several times about vintage models. One dream in particular I remembered vividly. It was of a Tang Dynasty racing car with the word 'Dad' written on its side. To me it was obvious: the car was this rather attractive but ineffectual thing, like having an absent father. It was such a clear image that I decided to make the car to the exact scale that it had been in the dream, and I went along to the British Museum to research their Tang Dynasty bronzes.

Then a friend who had a chateau in France asked me if I wanted to do an installation in her garden. I made a small thatched shrine in homage to the ones that you see at the sites of fatal crashes, made from bunches of garage flowers and cuddly toys tied to lampposts. My elaborate version sheltered the bronze car and was strewn with golden ceramic offerings. Next to it I included a pot that was a copy of a Greek grave-marker to suggest a folk tomb or memorial. I wanted to reference Essex, because my father was an Essex man. The county hasn't got a great cultural identity, of course. Its popular culture is still seen to be Ford's of Dagenham, boy racers and their hot cars.

I wanted people in France to think that Essex had a thriving folk culture, and that they might encounter a shrine like this if they wandered down one of its country lanes.

The photograph shows me and my daughter, Flo, dressed in vaguely European folk costume. The style of the photo relates to Arthur Mee's *Children's Encyclopedia*, which was given to me by my uncle, and was one of the first books I remember reading with pleasure when I was young. It was started just before the First World War and had lots of little sepia photographs from around the world. It fed my love of nostalgic images of places, people and traditions long gone.

Page from Arthur Mee's *Children's Encyclopedia*

Dad No. 1, 1999. Bronze, 23 × 26 × 76 (9 × 10¼ × 29⅞)

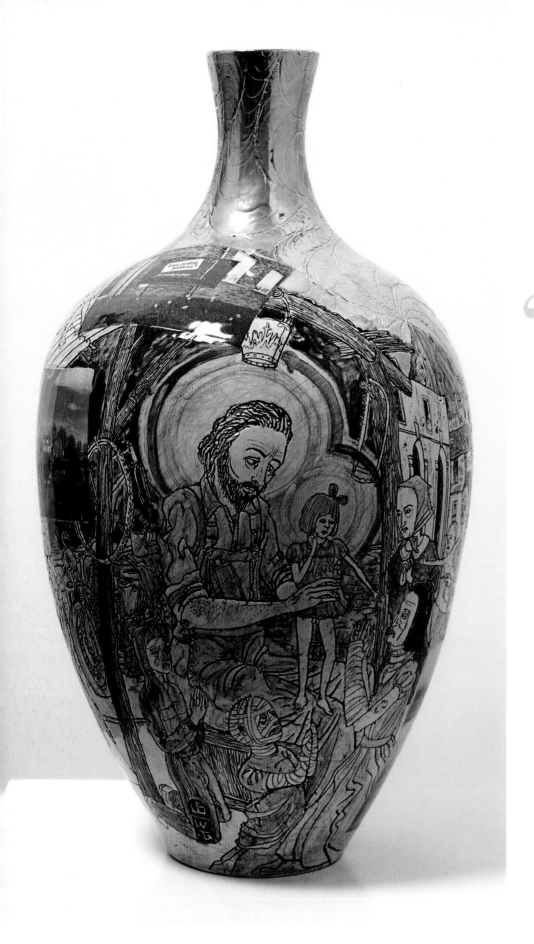

"This is my mix-up of the Nativity story, where the child is with his father instead of his mother. It is a kind of counterpoint to the traditional view of Jesus. It touches on the fact that there might be an alternative version of maleness that isn't triumphant. I think humility and being prepared to fail are important aspects of Jesus – maybe of being human, in fact.

Being non-triumphal is central to my work. This is one of the things that draws me to vases, which are usually small-scale. They have a humility: they whisper rather than shout. Successful male artists can tend to get a bit up themselves and become addicted to priapic gigantism, to the detriment of the quality of their work. Pottery is often regarded as feminine and so my work is implicitly about questioning male superiority, and questioning art's habit of falling into rigid categories.

he came not in triumph | 2004

Glazed ceramic, 53 × 30 (20⅞ × 11¾)

village of the penians | 2001

Glazed ceramic, 50 × 24 (19⅝ × 9½)

"On this vase we see a culture obsessed with penises. The panorama is of a quaint fairytale village that is vaguely European and historical. There is a phallic car, a woman with a phallic headdress who is holding bread in the shape of phalluses, and a little girl holding a phallic candle. Even the trees are trained into phallic shapes. Arrayed around are a number of open-stock transfers including a curious one of a Native American on a horse holding a staff that looks like a strangely deflated red condom. There's also a big Spitfire with its red knob-end.

I wanted to play with the idea of a community whose folk religion was based on worship of the phallus in place of the crucifix. Religious symbols often become invisible to us, but when you think about it, the crucifix that we see in some cultures on every street corner is actually a torture instrument.

At the time I made this pot, I was leading a campaign to decriminalize the penis. The erect penis is the one image that we don't see in the popular media. It's as though it's a dangerous thing, like a bomb that will go off if we see it.

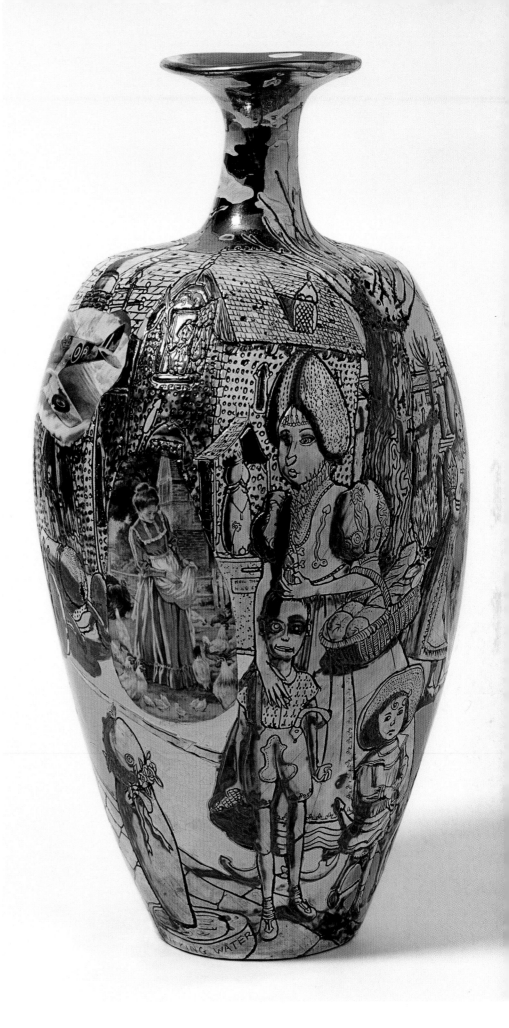

crown of the penii | 1982

Bronze, steel, leather, ceramic and found objects, 10 × 22 (3⁷/₈ × 8⁵/₈)

“ **This work is based** on a famous medieval relic, the Iron Crown in Monza Cathedral, near Milan. The iron in it was supposed to have been beaten out of one of the nails used at the Crucifixion. This was my version, made while I was at college. The pieces are all set into little bronze plaques with bits of seashell as decoration. The band is steel and it has a leather centre; the little attachments are either ceramic or found objects like toys.

I called it the *Crown of the Penii*: it combines ideas about maleness, religion and monarchy. It has lots of phallic imagery and many of the ingredients of my early work: a space shuttle; a Celtic cross; a kind of Willendorf Venus; an American car; a knife; and a pistol. The first space shuttle mission had been launched in 1981 and I'd taken a great interest in it; we all thought it would blow itself into smithereens.

I made this piece in response to the bronze sculptures by William Turnbull and Eduardo Paolozzi in the Arts Council Collection. I wanted to make my own bronze lump for the exhibition I was curating from the collection. It was about the time that Damien Hirst's *For the Love of God*, the diamond-encrusted skull, was getting lots of publicity, fuelling a fascinating debate about art, value and death.

The show I was putting together was about the intangible visual language of Englishness. There has been much talk in the media for some time now about national identity. It's very hard to pin down: there isn't an instant, easy answer to what Englishness is. We no longer have a clear folk identity, so when we talk about ethnicity it's always about non-Englishness, about the 'other', whether it's about immigrants or the Scots, say.

So I made this piece about England's past and the giant of maritime power that was the British Empire. It looks like something that's been dragged out of the sea: a wartime mine encrusted with the desiccated, boiled-down essence of empire in the form of tourist tat. I had it cast in bronze to give it the air of an archaeological treasure or ethnographic artefact, like something you'd find at Sutton Hoo or in the British Museum. There are Union Jacks, the three lions of the English football team, Routemaster buses and kings and queens, Beefeaters, the Post Office, the famous architecture of Tower Bridge and Buckingham Palace. Most of the sprigs were made from moulds of souvenirs that I bought. They are the all-hallowed tribal symbols of England, barnacles on *homus anglicus*.

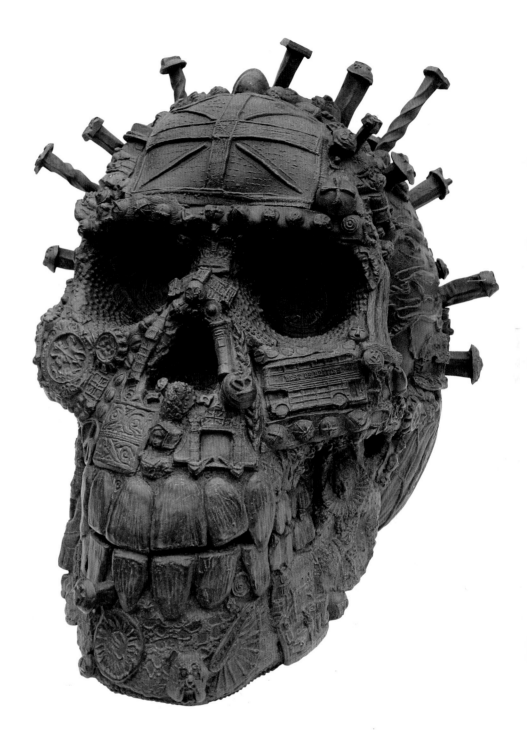

head of a fallen giant | 2008

Bronze, 40 × 35 × 50 (15¾ × 13¾ × 19⅝)
EDITION OF 5 PLUS 1 ARTIST'S PROOF

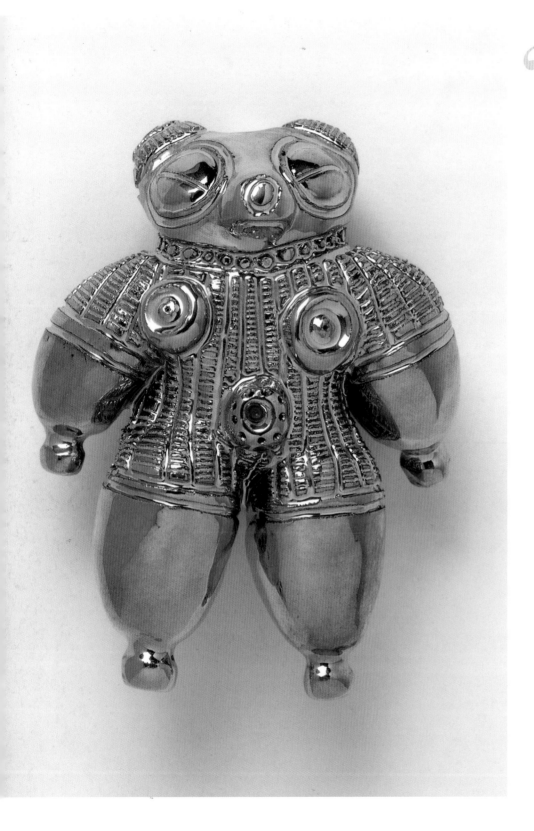

This small figure connects to a pot entitled *Personal Creation Myth* [pp. 186–87] and to my 'High Priestess outfit', a kind of cape with phallic birds set on a branch, embroidered in Japanese style. I wore it at the opening of my exhibition in Kanazawa, with a corset underneath, on the front of which was this precious gold artefact. I wanted people to get a flash of gold, like a hidden sculpture.

At first I had made a small gold phallus with testicles but I wanted it to be more appropriate for the exhibition, so I made it into a teddy-bear shape. I was looking through a book of Japanese ceramics and there was a very early Jomon period figurine that looked a bit like my sculpture. The arms and legs of the primitive figurines resembled flaccid bell-ends or foreskin, which was a bizarre coincidence. So I made this new version, which emphasized the relationship between the figurine, the teddy bear and the phallus. I saw it as a kind of ceremonial artefact, something that would have been handed down from priestess to priestess throughout the cult of Alan Measles. Seen on its own, not with the outfit, it's a bit like seeing a breastplate in a museum that's a remnant of a suit of armour.

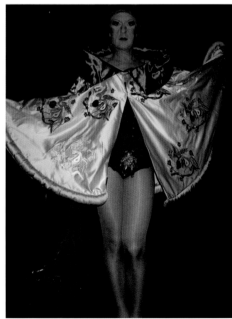

Perry wearing his 'High Priestess outfit', London, 2009

prehistoric gold pubic alan | 2007

Glazed ceramic, 12.8 × 10 × 4.8 (5 × 3⁷/₈ × 1⁷/₈)

grumpy old god | 2010

Glazed ceramic, 71 × 44.6 (28 × 17½)

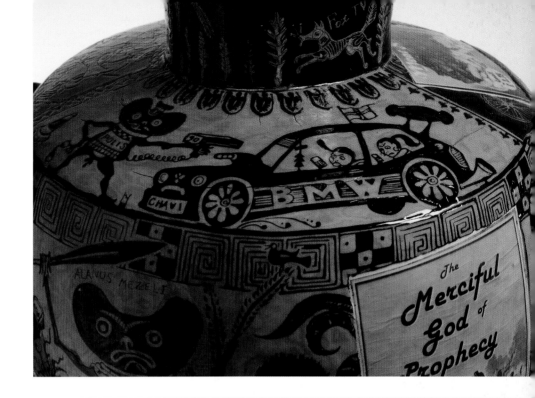

> **I've always shied** away from Greek vases because they are a cliché of the narrative vase. But when I started working with the British Museum on a big exhibition there for 2011, I thought I just had to make one, given their huge collection of classical vases. My pot is about god coming down to Walthamstow. Alan Measles would of course be my first choice of god, so here he is as a mythical figure in the Greek style. On one side, he's being ignored by everyone on their mobile phones while being attacked by 'canus chavi'; on the other side, he's being blinded by people taking photos of him on their camera phones. Both reactions make him grumpy.

This was a vase showing the god's mythic story, but it's being 'disrespected', so people are putting flyposters on it. Funnily enough, I went out in Walthamstow to take some photos of flyposters and found that they don't exist anymore. I looked and looked but it's impossible to find them – they're an anachronism! You used to see great swathes of them around, but they've totally disappeared. That's quite a change for my post-war, punk generation. Flyposting happens now on the Internet or on your mobile. If you want to let people know about a club, you just send out a mass email.

The pot also has a picture on it of Ian Jenkins, senior curator of Greek and Roman art at the BM, who I got on with very well. He helped me understand the museum's history. He also tried to get me interested in classical art, but he couldn't do it.

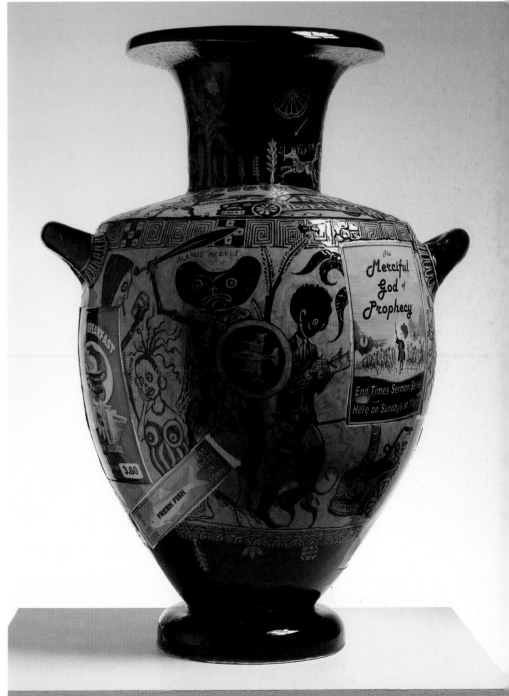

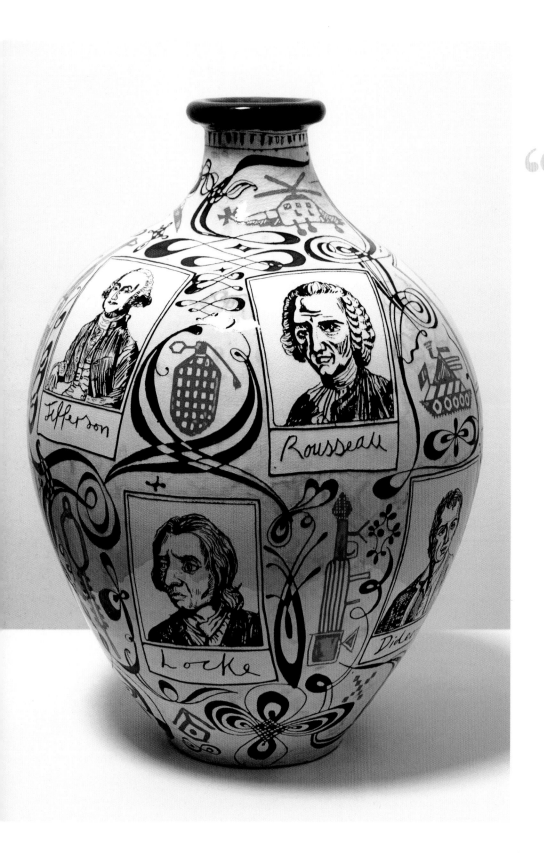

This pot makes a direct reference to the incident in Denmark in 2005, when derogatory cartoons about Muhammad were published in a newspaper, causing an international furore. It was about the Islamic attitude to representative imagery. The debates of recent times have often pitted religious extremism against the West, presenting Enlightenment values as the antithesis of radical Islam. I read an interesting article in the *Guardian* by the journalist Madeleine Bunting, who pointed out that, in fact, most of the leading Enlightenment thinkers were Christian believers. The proselytizers who put forward the Enlightenment as a great beacon of Western idealism and democracy were just as bound up with a belief system as the Islamic fundamentalists of today.

There's a part of all of us that wants to believe the religion question is all tidied up: there's no God and we don't have to worry about it anymore. I don't think it is that easy or clear cut. Here, I drew portraits of the leading figures of the Enlightenment, showing them as prophets – prophets of a certain mind-set, that is. They look a bit like cigarette cards of sporting heroes. We in the West have no hang-ups about portraying people who are sacred to our beliefs. I interspersed them with images of weaponry taken from Afghan war rugs, a craft tradition from within the Islamic community. The rugs are generally abstract in design because of Islamic prohibitions on representational imagery, but in recent times war has brought to the fore images taken from real life.

portraits of our prophets | 2006

Glazed ceramic, 60 × 40 (23⅝ × 15¾)

mr and mrs perry | 2005

Linocuts on handmade paper, each H. 52 × W. 38 (20½ × 15)
EDITION OF 21 PLUS 3 ARTIST'S PROOFS

" **These prints relate** to American primitive folk art. I was looking at those jobbing portrait artists who went around the country in the nineteenth century, usually making really bad portraits. They were interesting in their *naïveté*. In response, I did two portraits in linocut of myself and my wife as Victorians. I printed them on what looked like old wallpaper because I wanted to hint at the idea that we didn't have any paper apart from these odd scraps.

They are a celebration of the naïve folk tradition, putting me into the story. These things were totems of people rather than real representations because they were on the whole such poor likenesses. I'm not a great portrait painter either – I'm happy to admit that. Mine weren't intentionally bad though: they just came out pretty crude. But I was trying; I'm always trying my hardest. As I often say, sincerity is the new shocking.

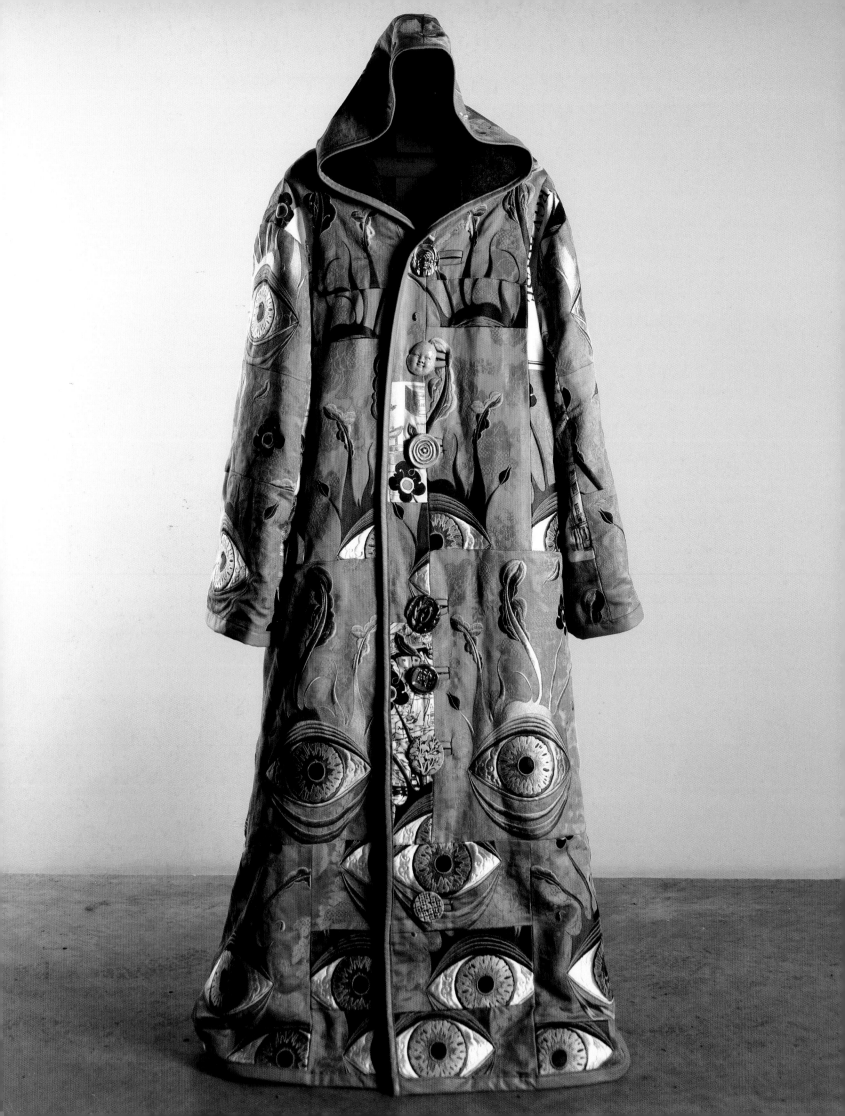

I love the look and design of old Japanese kimonos. I am also interested in artists being like members of a medieval guild. An artist is a combination of wise man, witch doctor and Mason. I imagined wearing the official robes of my guild, so that if I was walking down the street people would say, 'Oh, look, there's an artist!' I was thinking, too, about the Japanese Buddhist monks who had shawl-like garments called kesa. The first monks were poor wandering wise men who wore rags. As Buddhism became a more established religion, the monks' robes would have little flapping pieces of fabric attached, to imitate those rags. This custom gradually became more formalized, until the robes were made from very expensive fabric that was cut into squares and reassembled in a patchwork to look as if it was made from old rags. I loved that notion of a crafted formalization of poverty.

I used that idea to construct my own robes, which I made to look old and slightly worn. I went to a furniture shop and bought this incredibly expensive silk brocade, which I had embroidered with an eye, the most obvious motif for an artist. I also bought tea towels from National Trust properties and had those incorporated into the patchwork. I saw the National Trust as the formalized heritage we have in Britain; I wanted to suggest that I was somehow woven into British culture. On my first visit to Japan I wore the robe as my winter coat, and people loved it. I was there as a kind of visiting ambassador of British art.

Buddhist monks wearing kesa, second half of the 19th century

artist's robe | 2004

Embroidered silk brocade, leather, printed linen
and ceramic buttons, H. 179 × W. 70 (70½ × 27½)

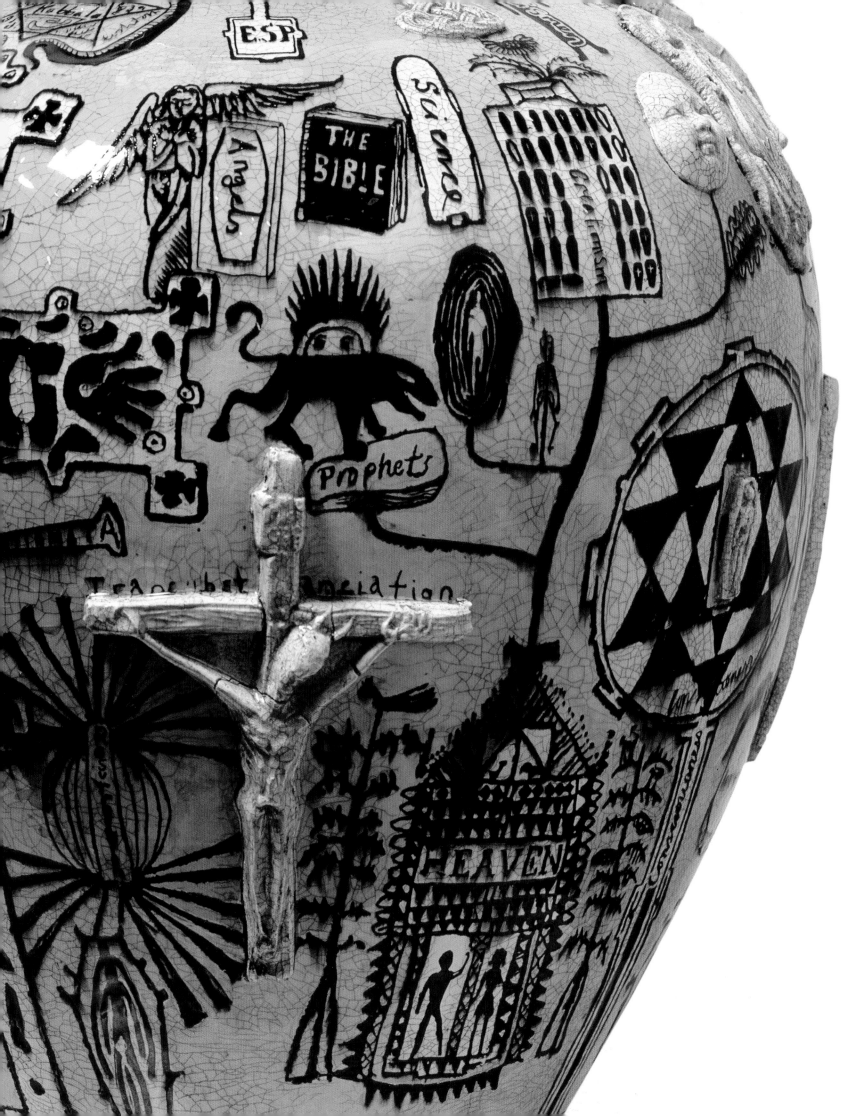

There is a character on the lid of this vase, a kind of beast with a human head. I don't know if it was deliberate or accidental, but curiously he looks a bit like Sigmund Freud. I suppose he could be a Greek philosopher as well: in any case, I wanted him to look like a thinker. He's sitting on top of a tomb that has the word 'credo' on it.

People believe in all sorts of things, everything from aliens to Jesus. Actually the two are not so unrelated in many people's minds. The *Cemetery of Beliefs* is like a map of a sort of internal cemetery or a map of my own mind. I was in one of my 'angry with religion' phases. People are welcome to believe what they like, but I get really aggravated when they get their beliefs muddled up with facts. The reason there's so much heat in the whole notion of belief is that the only thing that supports a belief is emotion. There are no scientific proofs – so when you insult someone's beliefs they get hot under the collar, because you're attacking something that they've invested a lot of emotion in. Whenever people ask me what I believe in, I say 'gravity'. I believe in it but I can also prove it, so I don't need to invest it with emotion. The belief in religion is like keeping a ball aloft by blowing it: if you stop blowing, it falls to the ground.

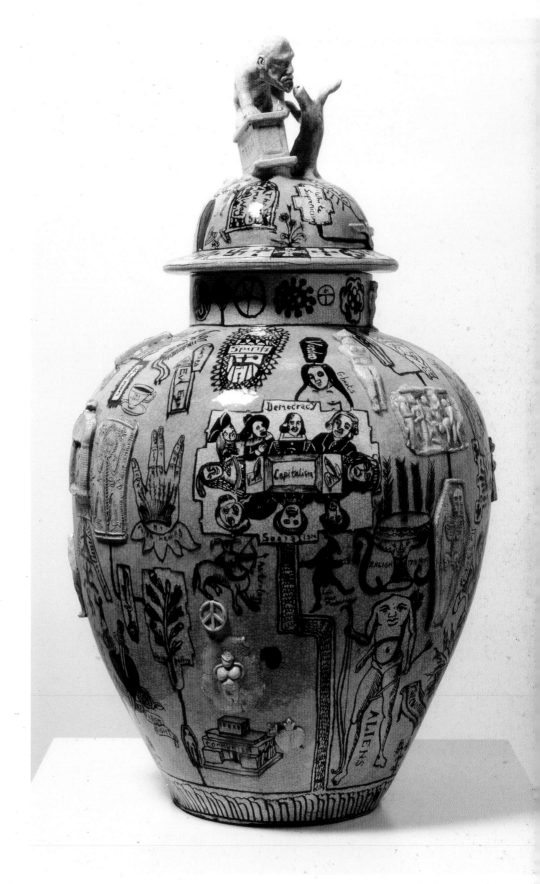

cemetery of beliefs | 2005

Glazed ceramic, 84 × 48 (33⅛ × 18⅞)

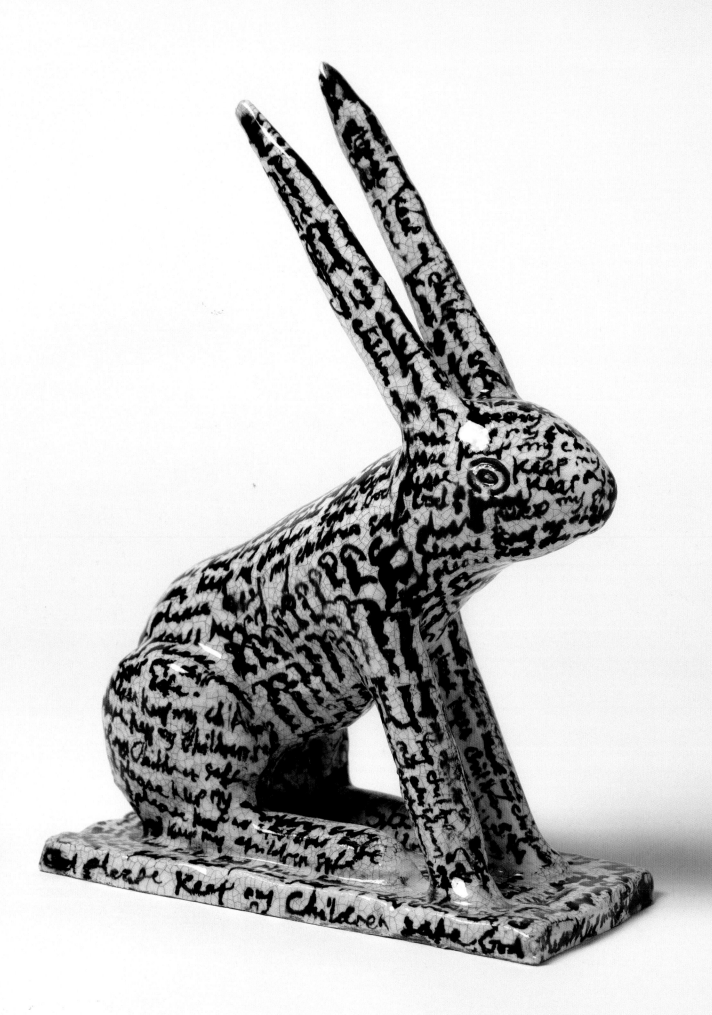

This little sculpture was one of the central pieces in my 2005 exhibition, 'The Charms of Lincolnshire'. It was the first thing I made, because my initial idea was that the exhibition would have more of a deliberate narrative in it. I imagined a story of a woman who was sent mad by the death of her children. Huge numbers of children died in Victorian England, so I made this piece as a strange outsider-ish expression of a woman's grief. Written all over it are the words 'God please keep my children safe' in old ink. It has the feeling of a folk artefact imbued with personal grief.

I displayed it next to two little glass vials, bottles to keep tears in, and there was also a tiny beaded baby's cradle. It became almost the most authentic-looking thing in the show: it was strangely central, and everything else related to it.

I also exhibited a group of nineteenth-century photographs of things like threshing machines, gleaners and tumbledown old windmills. In response to these, I set up a few photographs of myself and a friend posing in Victorian costume, and included in the photographs artworks I had made for the show. I wanted there to be some confusion in the audience's mind as to the provenance of the things they were looking at.

Photograph taken for 'The Charms of Lincolnshire' exhibition, 2005. H. 25.4 × W. 20.3 (10 × 8)

god please keep my children safe | 2005

Glazed ceramic, 23 × 8 × 15 (9 × 3¹/₈ × 5⁷/₈)

hunt post | 2005

Cast iron, H. 90 × W. 80 (35⅛ × 31½)

"In the Lincoln exhibition, I mixed together artefacts of social history with my own work. There was a real temptation to think about how I could blur that boundary and blend my work with the historical collection. I wanted people to start doubting some of the objects, so I made something that might be seen as an old artefact. Hunting was a central theme in the show, which got me thinking about the idea of a marker that might be used to delineate the boundary of the hunt.

My hunt post was roughly based on an eel-hunting fork. I imagined that a blacksmith might have forged it, so I made it out of iron. It had this look of some rusty old thing pulled out of a hedge. I took a picture of my friend Johnny, dressed as a Victorian farmer with a shotgun, standing next to it, to look like an old photograph. In the accompanying notes I described the piece as 'A rusting relic of an ancient ritual found in a hedgerow', and lots of people did think that it was genuinely old.

a sense of community | 2007

Glazed ceramic, 50 × 50 × 4.5 (19¾ × 19¾ × 1¾)

"This plate is about the double-edged sword of community. The pattern comes straight out of the quilting tradition, that repetitive silhouette of a village scene with a little house, but here it has also got a church so that the whole design forms a swastika.

A religious community can be very supportive but it can also have a negative aspect in that it doesn't like outsiders. We have to strike a balance between having a strong sense of communal identity and yet remaining open to external influences.

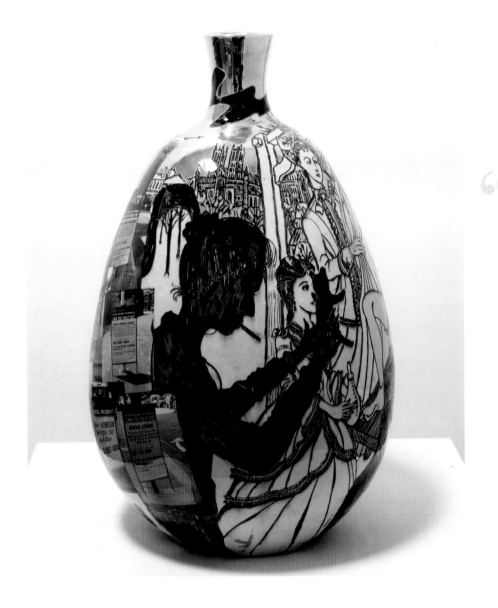

With my vases I've often made use of two distinct sides, a front and a back, so the idea of a diptych was a play on that. Old portable altarpieces, of which the Wilton Diptych is perhaps one of the most famous, have a front and a back. There's a long tradition of updating classical Bible stories, of course: think of Stanley Spencer.

The starting point was those roadside signboards that the police put up announcing major crimes. They seem to have spread like a rash over the last few years: I used to pass three or four of them just on my way to the studio. I started taking photographs of them, which I made into transfers. I collected about a dozen different ones, getting the whole set: robbery, murder, rape, traffic accident and so on. The signs were blue and yellow but I saw the yellow as gold, so they reminded me a bit of angels, particularly the ranked angels on the Wilton Diptych.

On the other side I've drawn a Nativity scene. There are silhouettes of people in hoodies and baseball caps with fags, offering things to the Christ child who looks like a wizened old man, as he often does in medieval representations. But my ranked angels are more like ranked demons for a modern-day altarpiece: in place of shepherds and kings, it's the Adoration of the Chavs.

The Wilton Diptych, 1395–99

the lincoln diptych | 2006

Glazed ceramic, 60 × 40 (23 ⅝ × 15 ¼)

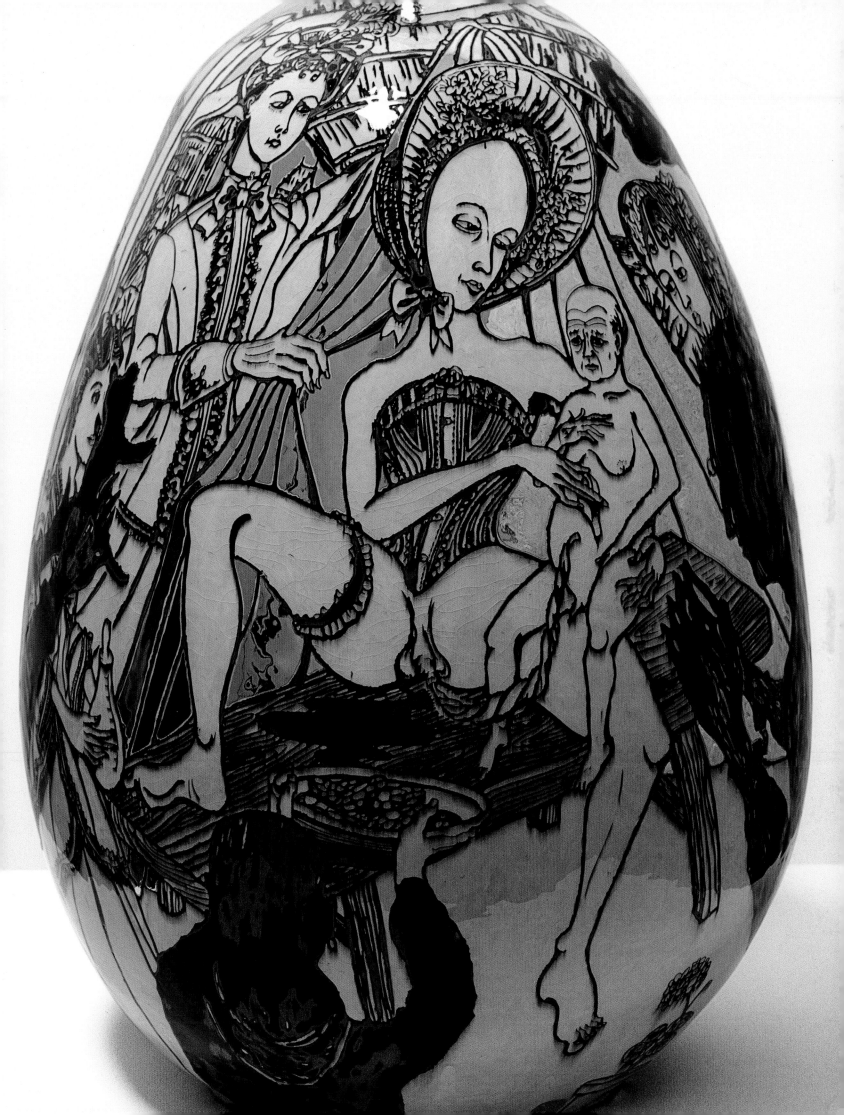

shrine to alan measles | 2007

Glazed ceramic, 72 × 66 × 52 (28⅜ × 26 × 20½)

My exhibition in Japan was built around the idea of my own civilization which adhered to the religion of Alan Measles. I wanted to incorporate the idea that this religion, like all world faiths, was influenced by others. Religion is not something clean and hermetically sealed: most religions bleed into each other at the edges. So as well as a vaguely Islamic-looking Alan [opposite], I did this sort of Buddhist version, making a shrine for him.

On my previous visits to Japan I had encountered dozens of the little Buddhist or Shinto shrines that you typically see by the roadside. Inside mine there are lots of rough little teddies. Curiously, I was thinking about the artist Lucio Fontana when I was making them. Of contemporary artists, he's probably the most interesting ceramic worker for me, often using sublime textures. I tried to replicate the crackle and stain of his ceramics, and found a way of getting a combination of shiny and matt, bleeding and crackled that I was very pleased with. The teddies look aged in a very sensual way, which was appropriate when you think of how the whole Shinto religion uses patina and age. They actually destroy the shrines every twenty years as a form of purification, completely disassembling them and rebuilding them. I think the Japanese attitude to ageing and creation is very interesting, and quite different from our Western obsession with newness.

The shrine also has a picture of the Twin Towers in New York and another of Lady Di, as a nod to the numerous memorials that have been set up to her. I remember going to Kensington Palace just after she died to see the mega-shrine. I also included an old black-and-white photograph of the Lake District – the sort of lyrical cloudy landscape you might see in a Japanese shrine, placed there to set a contemplative tone, of something divine and quiet.

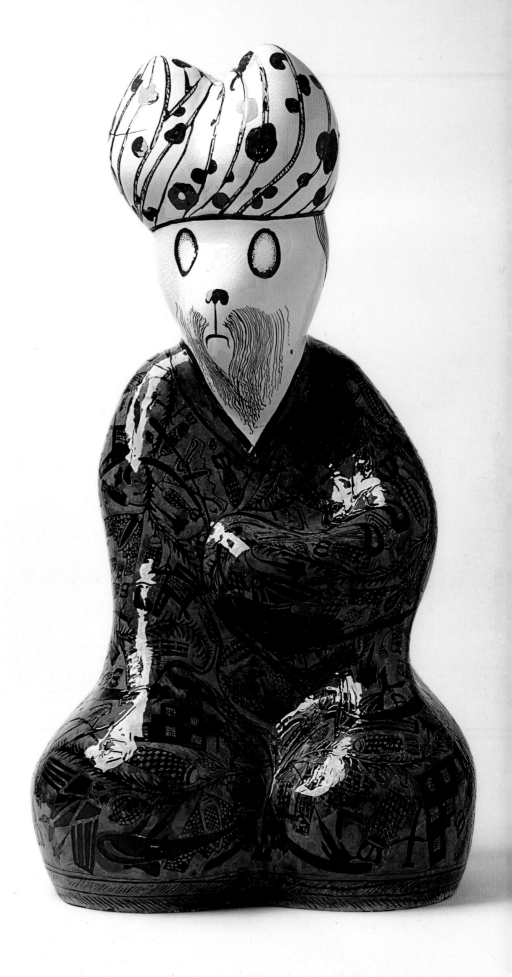

> I wanted to make an Islamic Alan Measles so I was looking for a figurative image, something that's hard to find in Islamic art. The piece was inspired by a little bottle of a wise man that I saw in the Victoria & Albert Museum. I decided to make something large and totemic out of this rudimentary form. Rather than it being accurately sculptural, my piece is a blobby, strange shape. The robes are decorated with patterns of bombs and stealth bombers: this is Alan as the guerrilla fighter.
>
> I built the piece freehand, coiling it. After I'd made the base-plate up I realized that in order to keep everything in proportion it was going to get very big. It was actually pushing the top of the kiln but luckily it just fit.

wise alan | 2007

Glazed ceramic, 97 × 56 × 45 (38¼ × 22 × 17¾)

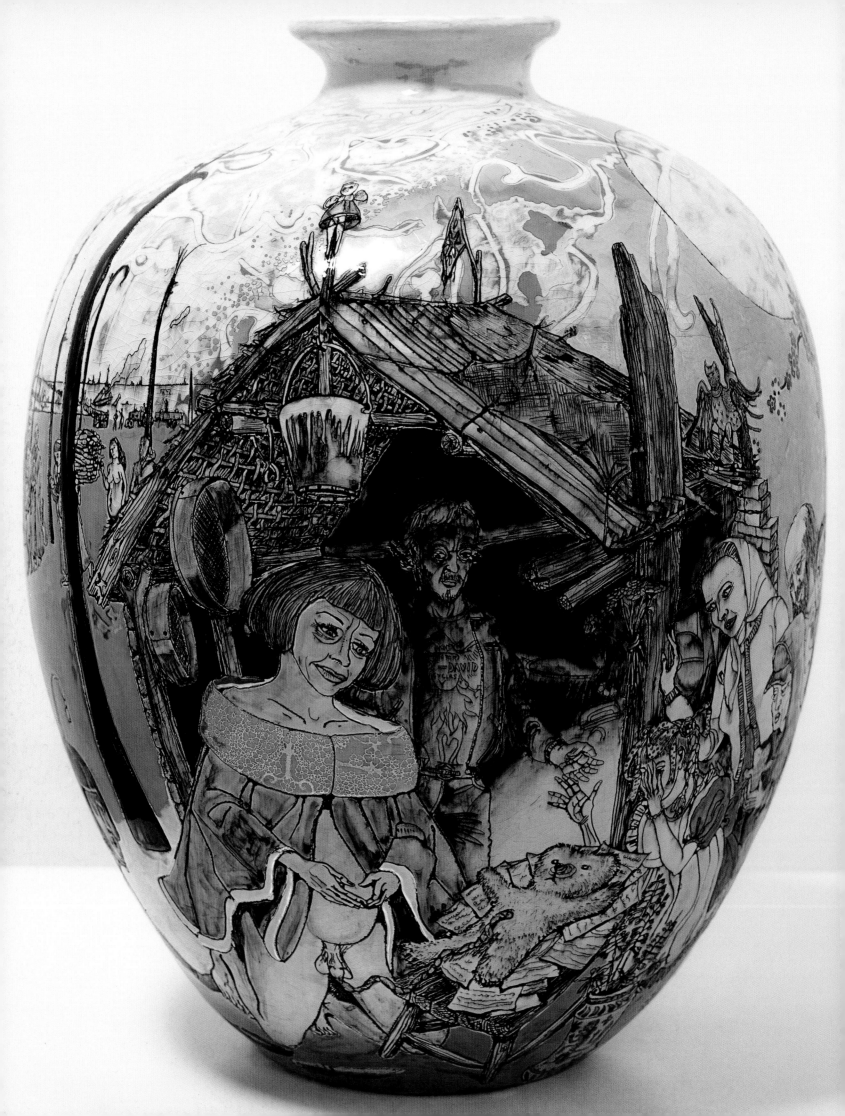

> **The idea for** this pot was lifted straight from the Nativity. It shows me giving birth to Alan Measles through my willy, touching on the idea that we make ourselves and our own internal imaginative landscapes. Internalizing the religious impulse is part of ourselves: religions don't come from nowhere, but from us and our needs. We look around for things that fit and do the job: if we need a story to believe in then we make one up. So here I am with a queue of worshippers lining up to pay homage. It shows a pilgrimage with people from all different periods, eras and religions. I trawled through photo books to find interesting-looking people, so there's a couple of Muslim girls, a strange Catholic penitent boy, a swooning woman and somebody speaking in tongues at a religious festival, holding up her Alan Measles. They're all wandering through a battle-scarred landscape. The Nativity stable as shed is a central motif and something that I've used several times.
>
> For my 2007 show in Japan, I made a costume that I call my 'High Priestess outfit' and which relates to this pot [p. 170]. The title of the pot and the outfit slightly jibe at the idea of the great Modernist artist. I'm perhaps more self-conscious than some artists of the mechanisms that make me who I am. They're happy to ride the waves of their lives but I want to see how the waves work.

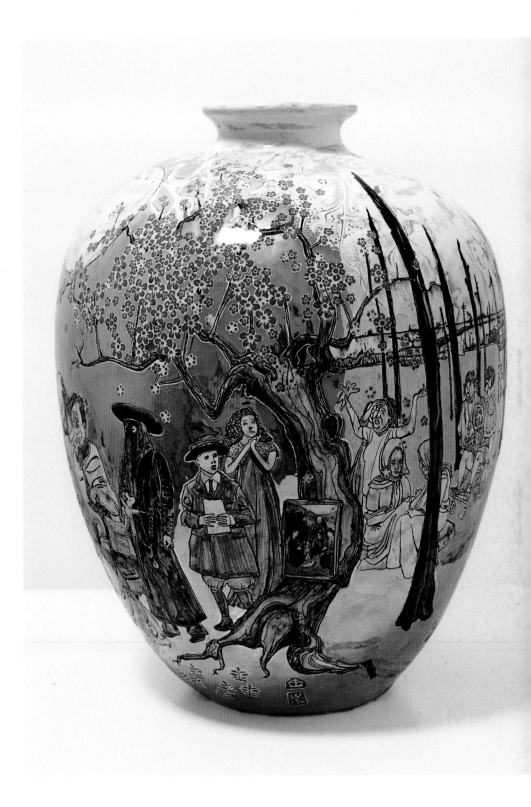

personal creation myth | 2007

Glazed ceramic, 49 × 39 (19¼ × 15⅜)

map of nowhere | 2008

Etching from five plates, H. 153 × W. 113 (60¼ × 44½)
EDITION OF 68 PLUS 6 ARTIST'S PROOFS

GERVASE OF TILBURY Ebstorf Map, c. 1240–90 (destroyed, 1943; reproduction)

" **The starting point** for this print was Thomas More's *Utopia*. Utopia is a pun on the Greek *ou topos* meaning 'no place'. I was playing with the idea of there being no Heaven. People are very wedded to the idea of a neat ending: our rational brains would love us to tidy up the mess of the world and to have either Armageddon or Heaven at the end of our existence. But life doesn't work like that – it's a continuum.

The print has a stormy quality to it. I don't like the plate being wiped too clean in the printing process; I like it to have a sort of antique, dirty look. The basic formal design came from a German mappa mundi called the Ebstorf Map, which was destroyed in the Second World War. It showed Jesus as the body of the world. My daughter often accuses me of setting myself up as God, so I made the lakes and rivers into my body. The whole idea of alchemy and a spiritual body fascinates me.

I wrote place names on the map with references to modern-day things like 'Internet dating' and 'Binge-drinking'. There are lots of jokey references to ecology and green politics. In the middle of the map is 'Doubt', because a philosopher once said: 'Doubt is the essence of civilization.' The image of a skeletal child is like an early anatomical drawing but here the child is covered in bigotries: he has 'Racism' on one hand and 'Sexism' on the other. 'Fear' is in his guts, because all bigotry starts with fear.

A light shines out of my bottom hole, down onto a monastic building on the mountainside. The landscape around it shows a pilgrimage scene with people in religious garb carrying funny dolls and backpacks. The map is very flat but the drawing at the bottom has a 3-D quality: it's like the difference between the realms of the spiritual and the human, or the split between mind and body.

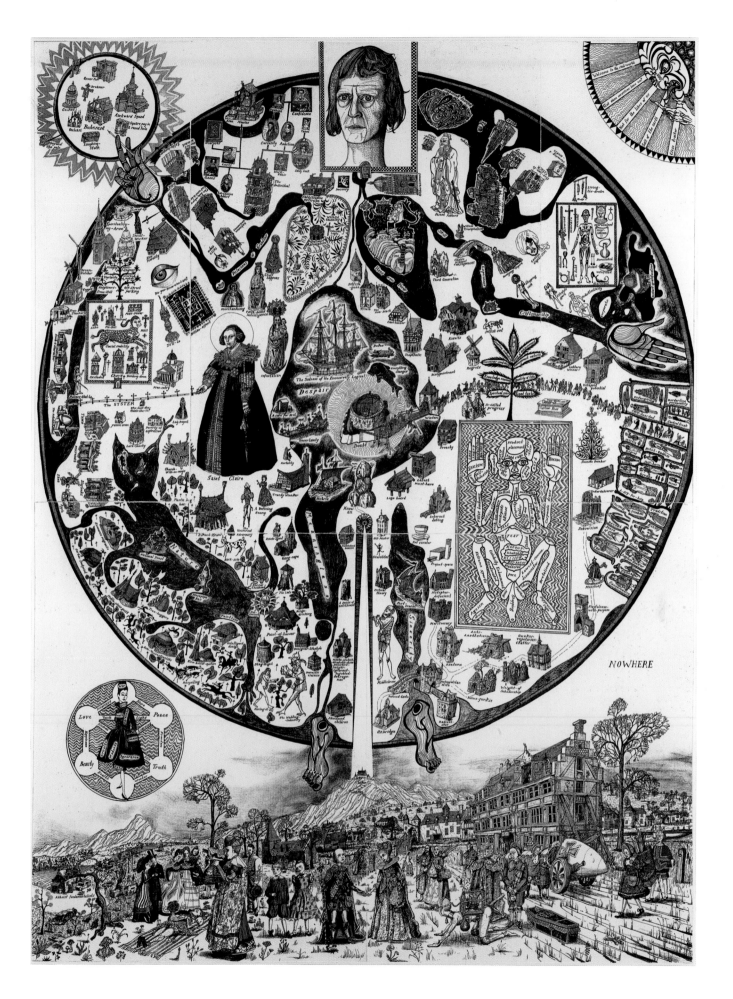

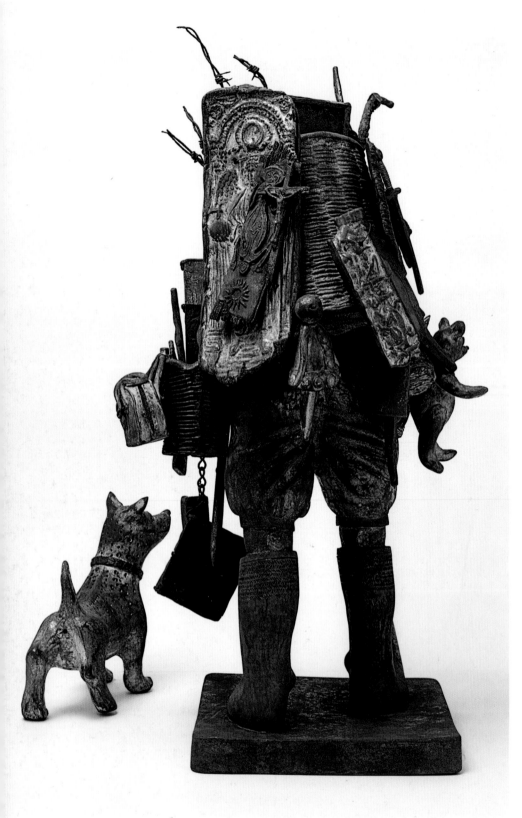

I find the idea of pilgrimage very interesting. Going through a ritual physically is very important. Often we talk about religion in terms of spirituality and ideas, but I think that actually doing it is probably the most significant thing.

I see *Our Father* as a kind of pilgrim or saint, a man on the road of life. He is a monumental utility man, a figure of maleness, like the men of my father's generation who worked in industry and had manual skills. I made him from cast iron, which I see as symbolic of that sort of industry. He's carrying a bunch of metaphors around with him, a kind of literal cultural baggage: everything from an iPod and a Hindu frieze to skulls and icons. In his hand he has a chain with two books hanging from it, a Bible and another vaguely religious tome. He carries lots of the symbols of religion, including Jesus and crucifixes, as well as bits of Islamic-style decoration.

There's a combination of the sacred relic and the sci-fi about him, like something out of *Star Wars*, in that weathered-traveller-through-the-universe way. I like the fact that he's difficult to place, a sort of everyman. He's vaguely Asian-looking and is smiling in a Dalai Lama-ish way. His boots could be Scandinavian or Dutch, and his pantaloons could be medieval. He's got dynamite and an Evian bottle, and he's carrying a laptop in his backpack: what's he about? He could be something dark, like a terrorist, though I see him as a positive character.

This was my first piece to operate on a slightly different level from my usual work. I bypassed any narrative and just went with my instinct. It took me back to making Airfix models as a kid – doing something purely to please myself.

our father | 2007

Cast iron, oil paint and string, 80 × 60 × 52 (31½ × 23⅝ × 20½)
EDITION OF 5 PLUS 1 ARTIST'S PROOF

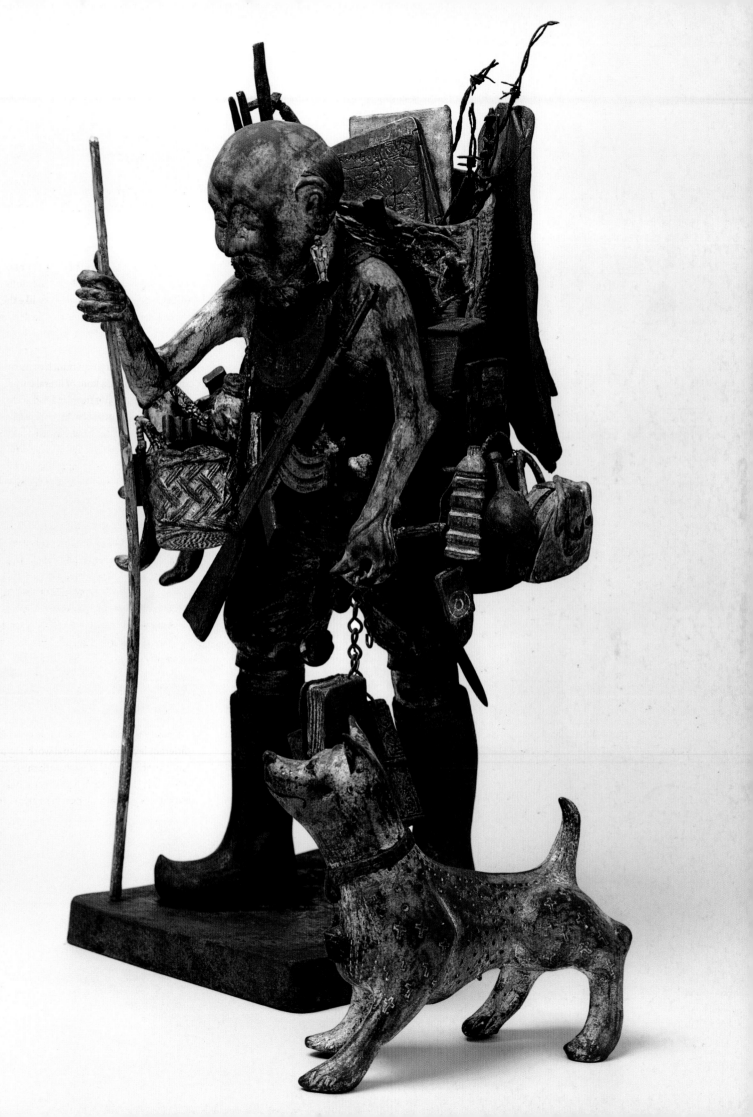

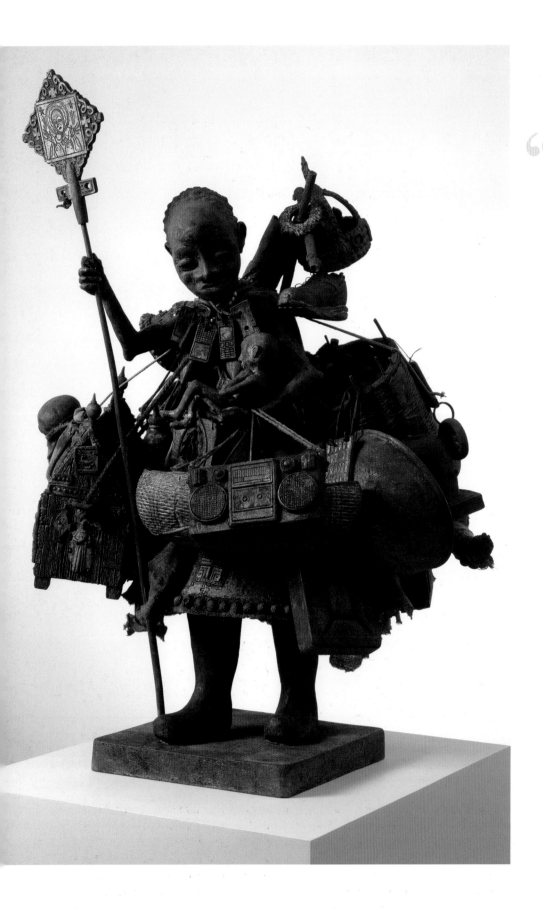

“ I made this a couple of years after *Our Father* [pp. 190–91]. I was pleased with how that work had been received, and it gave me the confidence to make this second piece. The obvious pairing to make was his wife, but I wanted to ramp it up. She is more of a refugee than a pedlar, carrying all of her possessions with her, including a chair and a little shanty-town house. There are four children in various states of life or death attached to her. The dead child was based on a photograph in one of my books showing women and their children after a famine in Africa. I wanted to put in symbols from different cultures as well as images of domesticity and female labour, so she has a basket of fruit, a jerry can for water, a trainer and sewing machine.

Her baggage is a symbol of the baggage we all carry with us, though I supppose I also wanted to make a feminist point, that the woman has more baggage than the man. I got very carried away with the detail on her, to the point where I compare myself to the guys who carved the gargoyles on cathedrals; there's a level of detail no-one will ever see! It was a waste of time in terms of man-hours, but I wanted the sculpture to give off that essence of abundant toil.

This is the most popular artwork I've ever made. People said again and again when they saw her in my show at the British Museum, paired with *Our Father*, that these two sculptures were their favourite things. They are among my most open artworks in terms of interpretation; they're not linked to one particular time or theme. I was playing quite joyfully when I made them, and seeing where it went.

our mother | 2009

Cast iron, oil paint, string and cloth, 84.5 × 65 × 65 (33¼ × 25⅝ × 25⅝)
EDITION OF 5 PLUS 1 ARTIST'S PROOF

recipe for humanity | 2005

Cotton and rayon, computer controlled embroidery, H. 48.5 × W. 36.5 (19 1/8 × 14 3/8)
EDITION OF 250 PLUS 10 ARTIST'S PROOFS

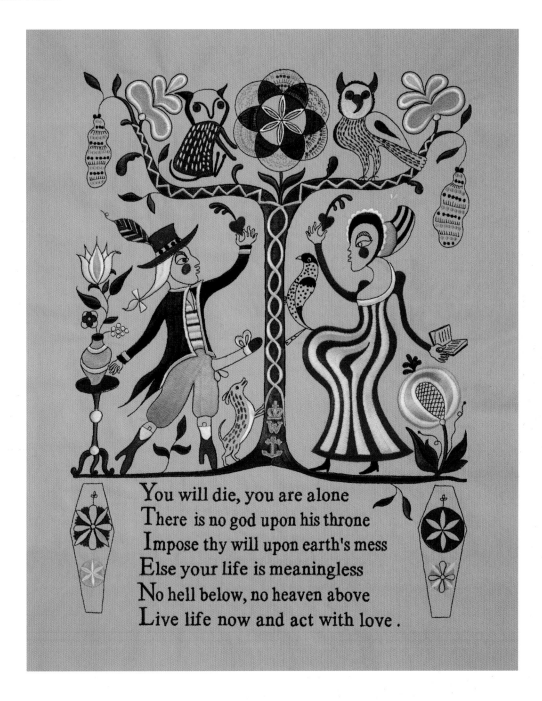

> You will die, you are alone
> There is no god upon his throne
> Impose thy will upon earth's mess
> Else your life is meaningless
> No hell below, no heaven above
> Live life now and act with love.

One of the groups of objects in my Lincolnshire show was samplers, usually made by children to help them learn how to sew. They would often include a text like a little poem; quite often they were memorials. One I remember was for a dead brother; another was dedicated to Leonard Salter, a little boy 'who exchanged worlds on the twelfth day of July in his seventh year'.

Samplers were usually moral or religious in tone, so I made my own atheist version. The idea for my text came from a book I was reading by a famous psychotherapist called Irvin D. Yalom: *Love's Executioner*, a fantastic collection of case studies and amazing stories. He argues that there are four givens of existence that you can rely on: you will die, you are alone, there isn't a god, and life is meaningless apart from the

meaning you give to it. You can't argue with those really – well you can, but you can't prove your side of the argument!

It was a nice, neat set of ideas to oppose the piety that is often shown in a traditional sampler. I've got an Adam and Eve on mine, very common symbols in folk art, but there are also two coffins. All the symbolism and style comes straight from American folk art, which I'm a big fan of.

model for 'temple for everyone' | 2008

Glazed ceramic, 77 × 50 × 65 (30⅜ × 19⅝ × 25⅝)

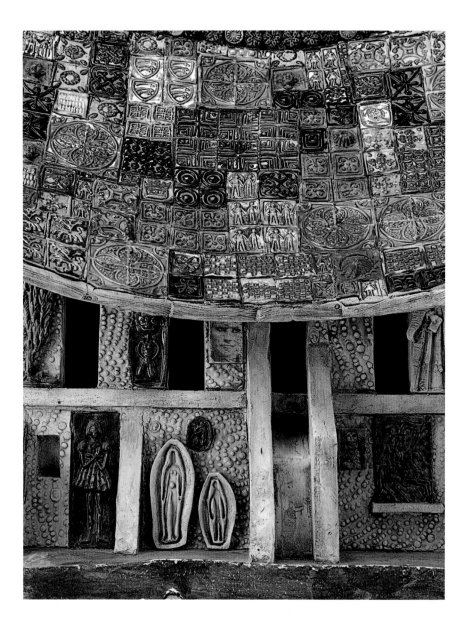

"I love visiting churches and religious shrines. The community side of religion, its pastoral and social aspects, are a big plus I think. You go to church every Sunday because that's the ritual, but the real stuff is happening in the background: meeting people, forming social connections, having a support network and shared touchstones.

I've always been interested in the idea of building a small chapel myself, in the tradition of other artists like Henri Matisse or Mark Rothko, a permanent thing to stand as a monument. If it goes ahead, it would have to be somehow humble, cute and lovable – though that's very hard to do with architecture. It would be a non-denominational building where people could marry, conduct funerals or enjoy ritualistic celebrations. It would be a collage of community commemoration with reliefs and pictures, statues and plaques from the donors, celebrities or local people who have died.

I wouldn't want it to be identifiably of a particular culture, so in my design the lantern and chimney look like minarets, but there's also something of the Buddhist shrine to it. The roof is covered in heraldic tiles that have an olde-English feel, though they're a mixture of Islamic and Christian motifs. Inside, I imagine it being tiled with murals on the walls and Church brasses set into the floor. There would be little shrines dedicated to pets or the armed forces. I like the idea that it would grow organically, having things added to it all the time, like candles or cuddly toys. There would be a resident counsellor who'd be available for people to talk to, a local priest without the superstition.

I would love it to be built in one of the new developments of bland housing in the Thames Gateway, looking as if it had been there already for centuries, or like an ark or spaceship that had just landed in their midst. People would be able to make pilgrimages to it on the weekend: they could have a look round, get a cup of tea and buy a T-shirt at the gift shop before going home.

As it happens, I have plans afoot for a closely related architectural project in Essex, which would be more of a holiday let. I'd be thrilled if it becomes a reality.

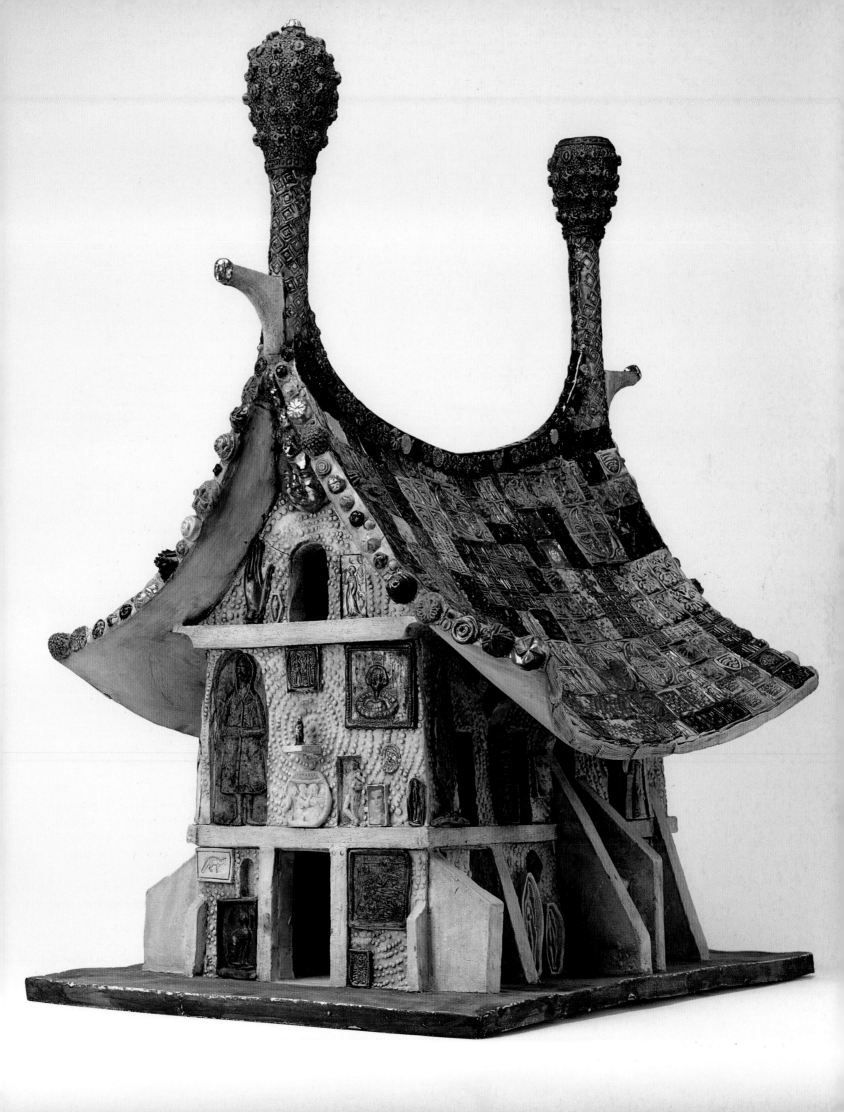

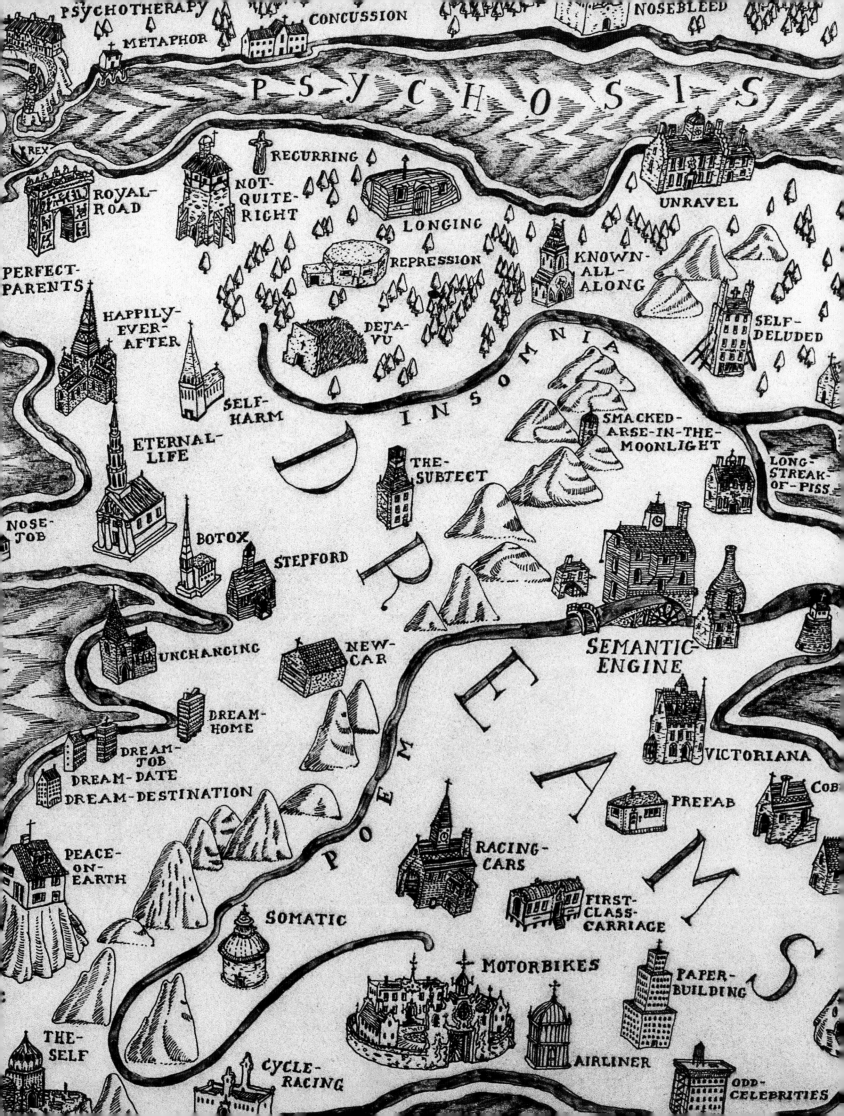

chapter 7 inner landscapes

'As Plato said, "The unexamined life is not worth living." Looking at ourselves is, I think, the most fascinating thing.'

Some of the most compelling and admired artists of the modern age have shared a single common trait: an almost obsessive need to create art from the extremes of their personal experience.

The list of artists famed for making work that foregrounds their psychological and emotional vulnerability runs from Van Gogh to Virginia Woolf, Franz Kafka to Sylvia Plath, Francis Bacon to Tracey Emin. Invariably, we read much of these artists' lives in their work, their tumultuous inner landscapes scored into paper or daubed on canvas.

Grayson Perry's own volatile life has similarly coloured his work. Through his teens and twenties he found the emotional baggage of his childhood impossible to shake off. As well as struggling with bouts of depression, he was also sexually confused by his emergent transvestism – challenges that threatened, at times, to destabilize him. From the first, art was Perry's escape, as he eloquently expressed in his vase *Mad Kid's Bedroom Wall* (p. 203). His emotional upheavals impressed themselves on the surface of every pot and plate, and his earliest pieces often voiced a barely concealed rage, a nagging neurosis or a confusion about his place in the world.

While at art college, Perry was aware that the difficult autobiographical content of his work set him apart from his contemporaries. His fellow students also mined their own lives for inspiration, but their work seemed critically detached and conceptual, whereas his plumbed more dangerously personal depths. It was clear to him, too, that his finely wrought, highly detailed and near-obsessive style was distinctly out of kilter with most of the art around him.

In 1979, these differences were brought into stark relief when he went with some friends to an exhibition of Outsider art at the Hayward Gallery in London. For Perry, it was a revelation. Here he saw for the first time the work of mediumistic artists like Madge Gill and self-taught obsessives such as Scottie Wilson, whose dreamlike, imaginary worlds he immediately understood. These were artists working outside any professional art system, unschooled 'primitives' whose work was often touched by disturbing emotional experience. Much of it was fantastical, highly personal and richly codified, and Perry saw in it aesthetic sensibilities closely akin to his own.

Of all his encounters at that exhibition, by far the most resonant for Perry was his discovery of the work of Henry Darger. Darger was a loner, a solitary man born in Chicago in 1892 who worked for most of his adult life as a hospital janitor. It was only a few months before his death in 1973 that Darger's landlords discovered a staggering treasure trove of forty years' worth of reclusive art-making in his cramped second-floor apartment. Among the collection was a 15,000-page manuscript in fifteen volumes, illustrated with more than 300 pictures, that told the disturbing, epic tale of the fictional Vivian sisters. Known as *In the Realms of the Unreal*, Darger's encyclopaedic fantasy

Opposite | *Map of an Englishman* (detail), 2004 (pp. 210–11)

world was filled with transgendered little girls, violent soldiers, battle-scarred landscapes and scenes of war and adventure, images that were by turns charming and harrowing. Darger had himself suffered a desperately unhappy childhood, culminating in his incarceration at the age of thirteen in a punishing children's asylum. For Perry, the similarities of both imagination and experience were stark. He felt at once that he had, in Darger, discovered a kindred spirit.

Later, Perry encountered the work of two other Outsider artists who were to become favourites of his. Walter Flax (1896–1982) had been refused entry to the US Navy as a young man, and subsequently spent much of his life in a solitary one-room cabin in Yorktown, Virginia. Here, deep in the woods, he painstakingly built his own fleet of model ships fashioned from scraps of wood, empty soup cans, old toasters and other assorted debris. The elaborate naval kingdom he created was one to which Flax both emphatically belonged and benevolently reigned over in a way that he never could in the real world. His fashioning of an alternative, imaginative universe strongly appealed to Perry, who found similar qualities in the work of the sculptor and photographer Morton Bartlett (1909–92). Bartlett's work had an added dimension of particular significance for Perry:

a fixation with children and childhood. His hand-made, anatomically accurate dolls, mostly of girls aged between six and sixteen, were photographed by Bartlett in a range of everyday scenarios. Dressed in clothes that he custom-made for each doll, they were seen reading in bed, scolding toy pets, or playing on the beach. Bartlett's obsessional attachment to his fetish objects, and their obvious Lolita-like quality, made his particular brand of Outsider art especially attractive to Perry.

The shadows of figures such as Darger, Flax and Bartlett have continued to linger in Perry's imagination, and slowly they have become a more explicit presence in his work. Pieces such as *Revenge of the Alison Girls*, for example, made in 2000, directly reference the horrors and obscenities of Darger's fictional world (p. 209). For Perry, this intensified interest in the psychologically charged creativity of Outsider art was sparked by a pivotal event in his own life: the beginnings of a journey into the recesses of his own psyche. In 1998, he began a course of psychotherapy after his wife, herself training to be a psychotherapist, suggested that it could be an invaluable tool in dealing with his ongoing depression. Perry found psychotherapy suited him well, and the conversational, dialogue-based treatment soon became a regular fixture in his week (he continued therapy for some

Left | Henry Darger's room, 851 Webster Avenue, Chicago, photographed in 1999
Right | Walter Flax with his fleet of model ships
Far right | MORTON BARTLETT *Girl with Stuffed Animals*, c. 1955/2006

six years). Perry admits unabashedly that he enjoyed the process, in part because it put him centre stage: 'I found it,' he says, 'like going to a good weepy movie every week, where I was the star.' Therapy also began to give him greater access to his imagination and a more nuanced expressive language. In fact, while he had initially been reluctant to undertake therapy – fearing, as many artists do, that it would somehow disturb his creative drive and dissipate his urge to make art – he found it had quite the opposite effect. Rather than ironing out his 'kinks', it gave him a more profound understanding of their origins. 'Psychotherapy for me was like someone coming into my mental tool shed and tidying it up. It's not like they took away the tools, it's just that now I can find them more easily.'

One thing that certainly came more easily was an understanding and acceptance of his transvestism. Claire came out more confidently and assuredly into the world than ever before – babydoll dress and all (pp. 138–39). A decisive shift also took place in Perry's work, and he now recognizes therapy as having been one of the most significant factors in his artistic development. From around 2000, his art took on a new energy and a more sophisticated emotional vocabulary. In pieces such as *Interior Conflict* he began to confront head-on the battling aspects of his personality (pp. 200–201). Many of his works from this time use the metaphor of the map or instruction manual to pull apart the complex world of thoughts and feelings, including *Assembling a Motorcycle from Memory* and Perry's first print, *Map of an Englishman* (pp. 218–19 and pp. 210–11). This part-fictional, part-autobiographical mind map, a work he would later describe as 'the most sophisticated bit of art therapy I've ever done', showed how a previously chaotic emotional landscape had now become comprehensible and navigable terrain.

Unsurprisingly, psychotherapy itself has also become the subject of Perry's work. Early in his therapy he had even undertaken, albeit briefly, some psycho-therapeutic training, taking a series of classes in the discipline in a bid to understand its fundamental principles. Yet in works such as *I am My Own God* and *Anger Work*, Perry's attitude towards therapy is far from reverential (p. 213 and p. 220). Indeed, he appropriates these titles from phrases heard on the therapist's couch in a wry nod to the perils of therapy-speak and psychobabble. Always playful, he is alert to the reality that psychotherapy is intimately associated, for many, with middle-class self-obsession. Ever the satirist, he does not hold back from quizzing and mocking even the most revered of his own beliefs and habits.

interior conflict | 2004

Glazed ceramic, 43.5 × 35 (17⅛ × 13¾)

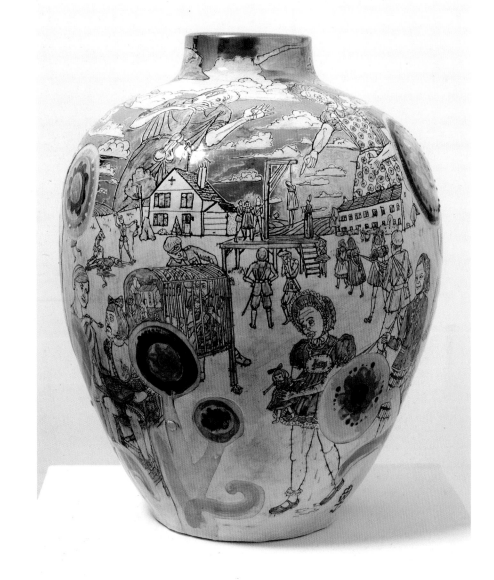

"The principal associations for me in this pot were the more barbaric pictures by Henry Darger. It shows a scene where little girls are being rounded up and hanged by soldiers. The flowers are a direct copy from Darger's paintings.

There's a pun in the title, because in a lot of my pots the perspective points to the inside of the pot. All of the vanishing points are within the pot, so there's this idea that all of the action is somehow going on inside. The interior conflict in this case also relates to the two sets of characters. You could see the soldiers and the little girls as two different sub-personalities of me: the macho, violent, aggressive part and the vulnerable, cute, sissy part. It's about the ambiguous relationship between the two factions, if you like, in my own mind.

HENRY DARGER Untitled (detail), date unknown, from *In the Realms of the Unreal*

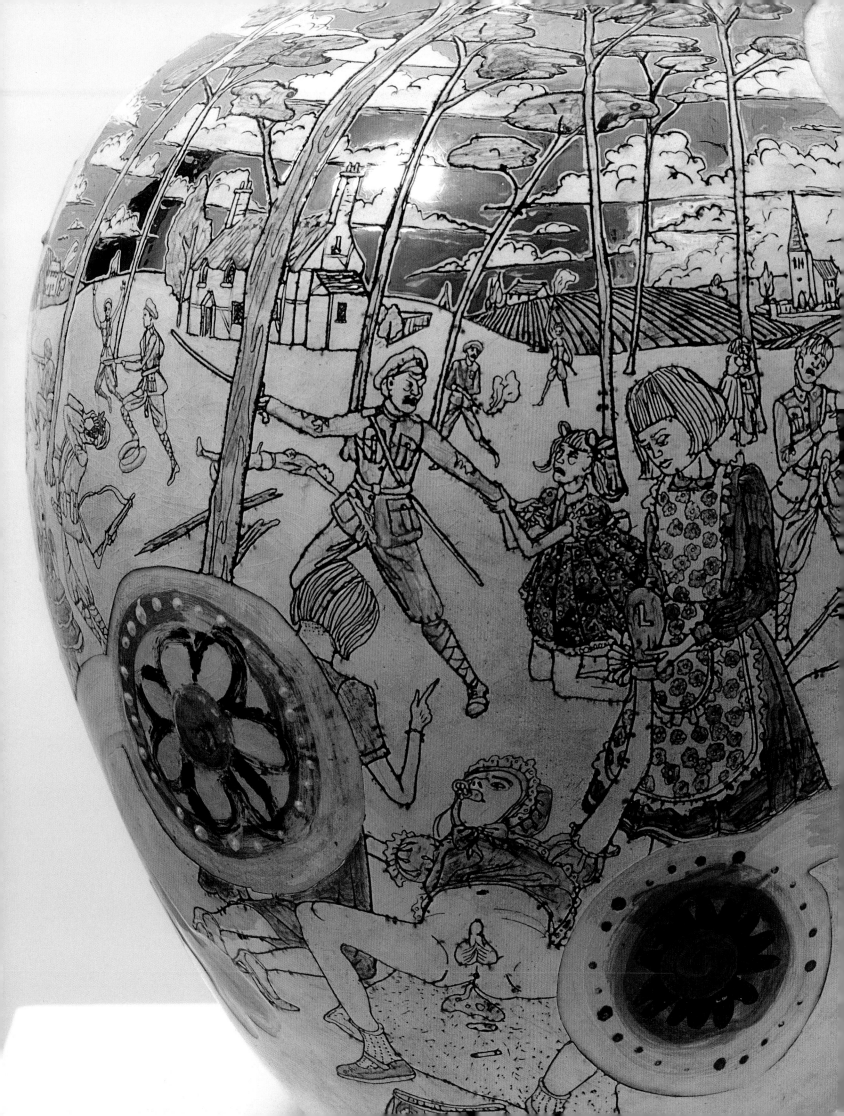

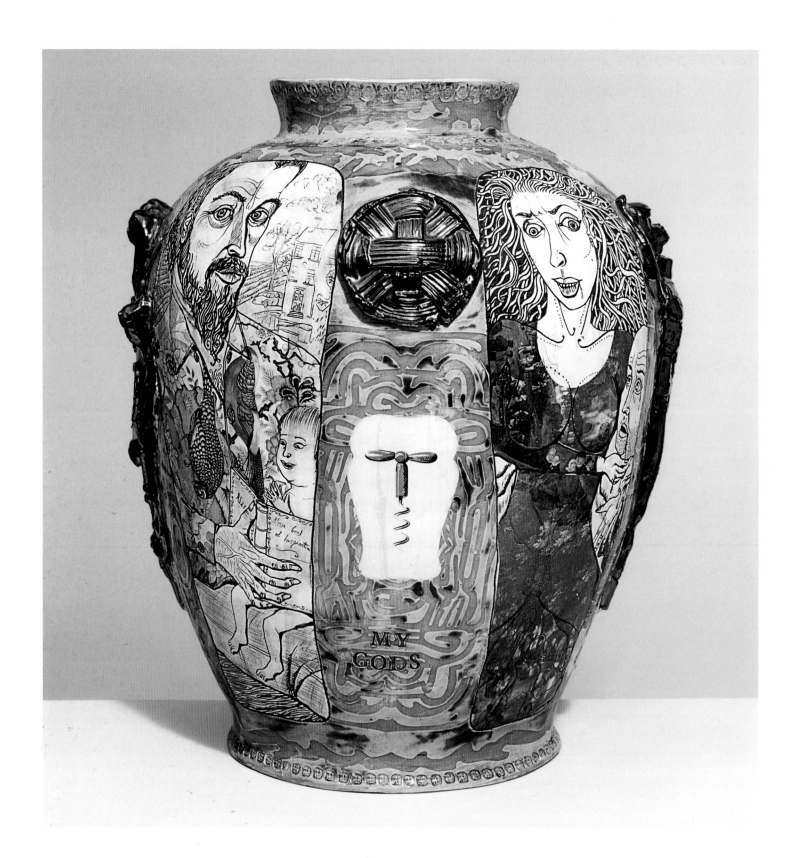

my gods | 1994

Glazed ceramic, 40 × 34.5 (15¼ × 13⅝)

❝ **When you're a child,** your gods are whoever you're told they should be. I was looking back to my past and inventing my own gods. I've included a rather wrathful female god and a guy in decorative chinoiserie leathers. An innocent child worships gods that have aspects of its parents in them: there's a sort of projection of parent onto god. Some people have a very screwed up idea of god: if you have a vengeful parent you probably have a vengeful god. The corkscrew on the pot is a fairly innocuous object, but in this context we can project onto it the image of a crucifix and also the hint at parental alcoholism.

mad kid's bedroom wall | 1996

Glazed ceramic, 41 × 43.1 (16⅛ × 17)

"I used to write a lot of poems. My early sketchbooks are littered with terrible poetry. The final lines of the one on this vase read: 'I was a mad kid and now I ain't. I got out 'coz I could paint.'

It was the idea of a screwed-up working-class boy feeling like a cuckoo in the nest, not being understood by his parents, and about art being a fantastic escape. The history of the arts is littered with people like that; it's a very common dynamic. If you think of the 1960s particularly, the David Baileys, the Albert Finneys, the filmmakers: many of them were angry working-class people or sensitive plants who had grown from rough soil.

As a child, your room is usually just seen as a mess by your parents. This pot was triggered by something I read in the paper about the bedroom being a kind of sanctuary, or like the interior of your head. All the little appliqué-style figures were copies of things that my daughter, Flo, had made. She was four at the time and I remember her coming to the studio and making all sorts of little clay things, including a figure with long hair.

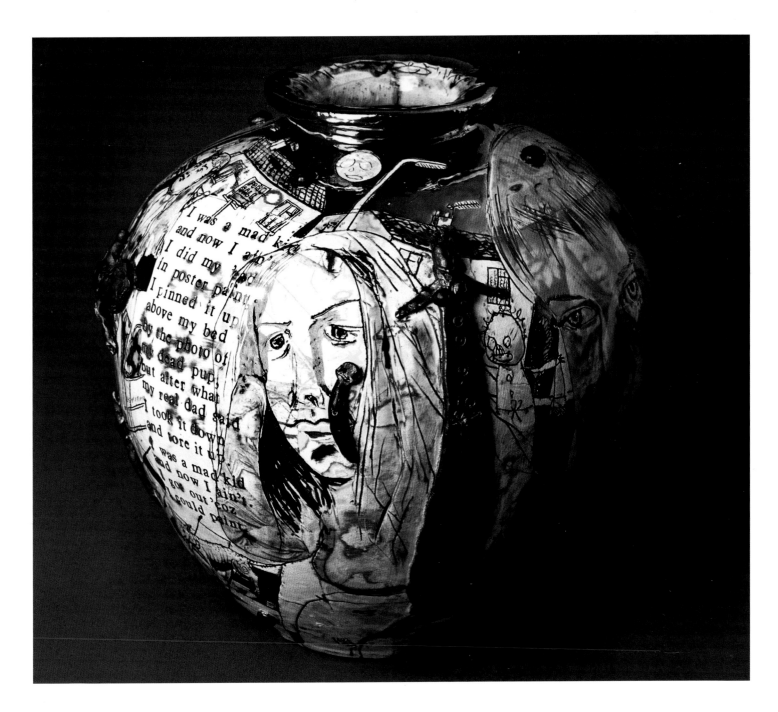

cycle of violence | 1992

Two pages from the novel, each H. 21 × W. 13.4 (8¼ × 5¼)

66 **When I was thirteen,** the first artwork I drew was a series of cartoon strips featuring a character called Riff Raff, an idealized father figure I suppose. As I went through puberty, his adventures became more sexualized. The strips haven't survived, but practically everything in those stories is mirrored in *Cycle of Violence*.

The idea for making a graphic novel came at the invitation of Alastair Brotchie who runs Atlas Press. I made *Cycle of Violence* slightly in reaction to comic art. I've never liked the superhero comic very much. I find a lot of them self-indulgent: whole pages with no words, like storyboards for movies. In my book, I wanted every picture to push the narrative along. I enjoyed enormously the discipline of black and white: it was liberating for me, and it's something that has fed into my work ever since.

The story is elliptically autobiographical, like a dream of my childhood rather than being based in reality. The principal characters have elements of my mother, father and stepfather in them. The sexual violence is an exaggerated version of what was going on in my head at the time, and the cross-dressing in the story is completely wrong – not at all my experience. Very rarely does cross-dressing come about by having to wear dresses when you were a child! But all the cars and bicycles and clothing in the story are still things that resonate with me now.

This was pre-therapy and it was really my unconscious speaking. I was working out a lot of my issues on the page. My wife was training to be a therapist so I got a lot of the therapy stuff second-hand through her. But I was sceptical of therapy and slightly pooh-poohed it at the time.

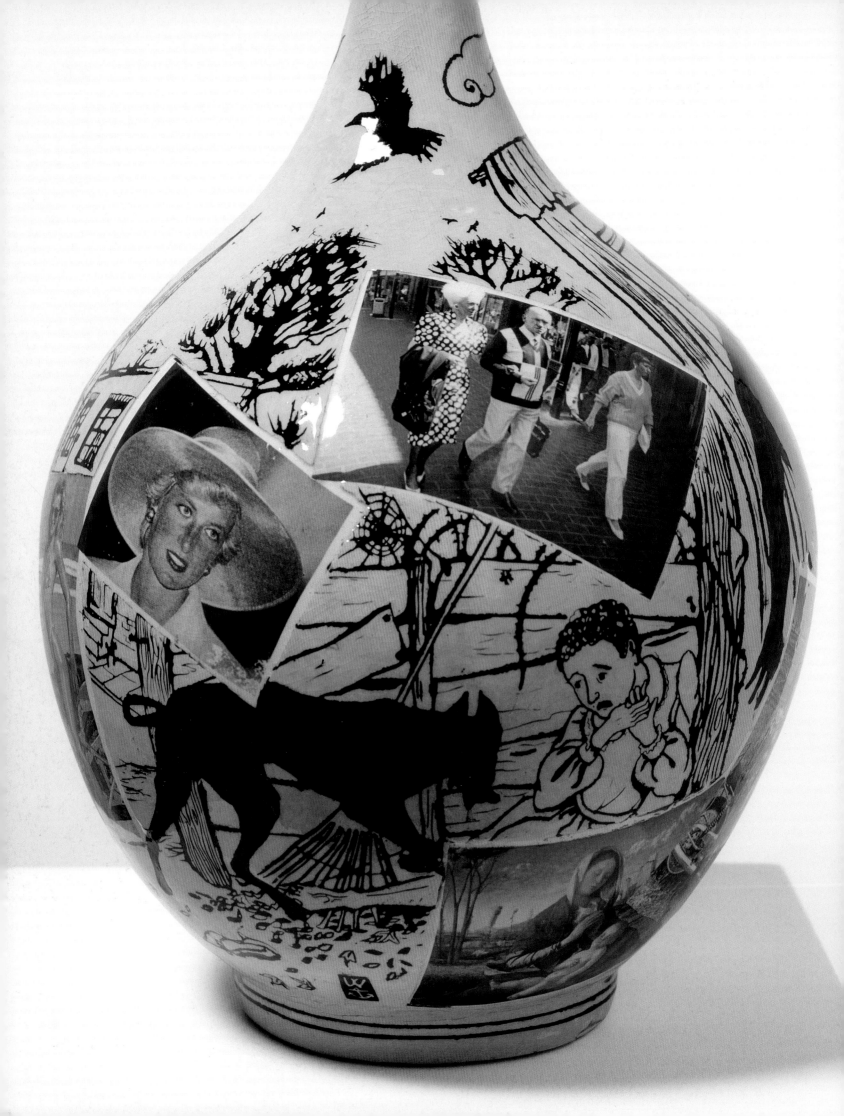

black dog | 2004

Glazed ceramic, 52 × 33 (20½ × 13)

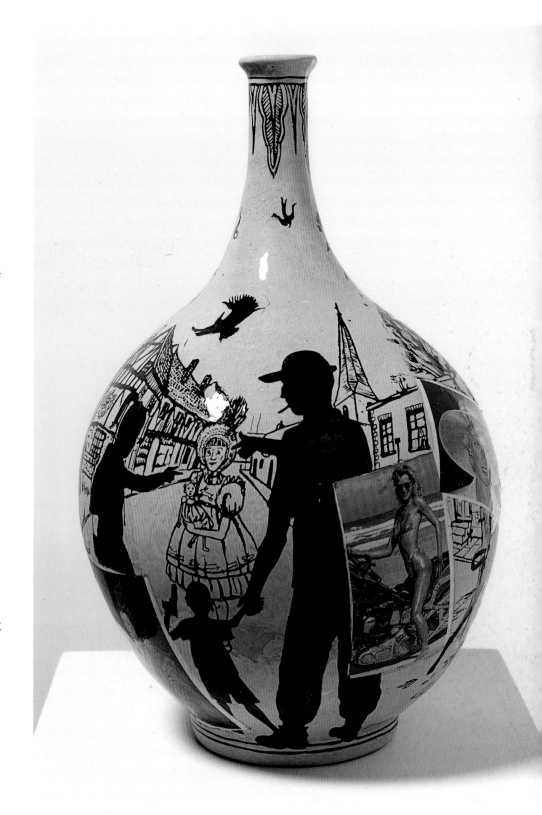

"

'Black dog' is the name Winston Churchill used for his depression. This piece is about the roots of depression: emotional trauma and turmoil. Some of the drawn scenes are from my childhood. One of them is an autobiographical incident that I jokingly referred to because there was a dog involved. I was dressing up in the grounds of an abandoned Victorian mansion up the road on a summer's afternoon. All of a sudden I heard voices, so I quickly retreated into a little summer house and hid. There were people wandering about the grounds and they had a dog with them that came bounding in. I was terrified of being discovered, so I was desperately saying, 'Go away, get away, get out of here!' The dog was sniffing around, and here I was cowering in the corner of a summer house in a badly fitting dress and some slingbacks.

The drawn images also show a boy in a dress with an authority figure and a girl pointing at him. I put the photographs in as a contrast: biker babes, Princess Diana, Blackpool, the Madonna of the Meadow. They're all gender stereotypes being played out. It's about emotional, as much as physical, contrast.

I suffered from depression myself before having therapy. I used to have really down periods for a couple of days, if not longer.

vase using my family | 1998

Glazed ceramic, 60.5 × 32 (23⅞ × 12⅝)

 This vase is about family units, and about bringing yourself into your work. In 1998, my daughter was six, and we were a pretty close unit. This was just before I started therapy, and lots of questions about childhood were being brought up for me by having a child myself. So there are images of my daughter when she was very young and there's Alan Measles, my heroic teddy bear, in his much-damaged overalls from many dogfights. My wife is on there too, as am I, looking like a Victorian dandy leaning on a tomb, a picture we took in Highgate cemetery. There's a packet of crisps, as part of the general homely flavour.

The pot was a transcription of a North African vase, in its colour and decorative style. It triggered a whole series in a similarly limited colour scheme with black-and-white photographs and just a touch of metallic. Some of my early vases have quite violent colour schemes; I wasn't sure how the colours would work, so I made them really strong to be sure they'd come out bright. But this work marked my increasing confidence with the subtle control of colour.

"This was made at an interesting point in my career, when I just started to rekindle my interest in Henry Darger. I made this pot before I'd done any research into him. But I remembered the girls in his paintings who all had little willies, and I thought they were called the Alison girls. On my pot, I have them taking revenge on their parents in a kind of revolution, which was actually a close approximation to Darger's story, even though I didn't know it at the time. The sisters in his story – actually called the Vivian girls – lead a child-slave rebellion against the repressive army of the Glandelinians. I was quite surprised when I read more about Darger to see how closely his stories reflected a kind of psychological template that I carried myself. I feel a strong kinship with him: the way he used his imagination bears close similarities to how I use my own.

revenge of the alison girls | 2000

Glazed ceramic, 65 × 26 (25⅝ × 10¼)

MAP
OF AN
ENGLISHMAN

"I had never thought of making prints until I was at a friend's house and saw a print by an artist who'd drawn a map of the world from memory. It was a large etching in a glass frame and I really liked it as an object. I realized that this was a subset of objects that I was interested in: something on a domestic scale with a long tradition, like those framed maps of counties that posh houses often have in their loos.

I didn't do any preparatory drawings. I started at the top left-hand corner, so as not to smudge it. I don't know how intentional it was that it ended up looking like the two parts of the brain but by the middle of it that was how it was panning out. I didn't want to work on an etching plate of that size because it would be terribly impractical to carry around, so I drew instead on a clear film which is used as a positive to expose the photo-etching. It comes out in the same orientation: where it's black, it's black.

I was thinking of a map of my mind, almost like an exercise you could set in a therapy course. Philippa and I listed all the emotions we could think of, and those became the counties and towns. I used things such as 'fear' and 'love' as mood signs for how I would characterize particular areas of the map. It was a stream-of-consciousness process with word associations. All the different feelings are churches of the sort you might see in those old Dutch maps. I liked that idea because each word suggests a little belief.

Until I finished it, I thought the print was terribly kitsch and a bit hobbity, that twee and nostalgic side of myself that I wrestle with. This is the mischievous part of me, the punk, starting to align forces with the hobbit. But it's among the most popular works I've ever made. There were fifty prints made, and they sold out in three days.

map of an englishman | 2004

Etching from four plates, H. 112 × W. 150 (44⅛ × 59)
EDITION OF 50 PLUS 10 ARTIST'S PROOFS

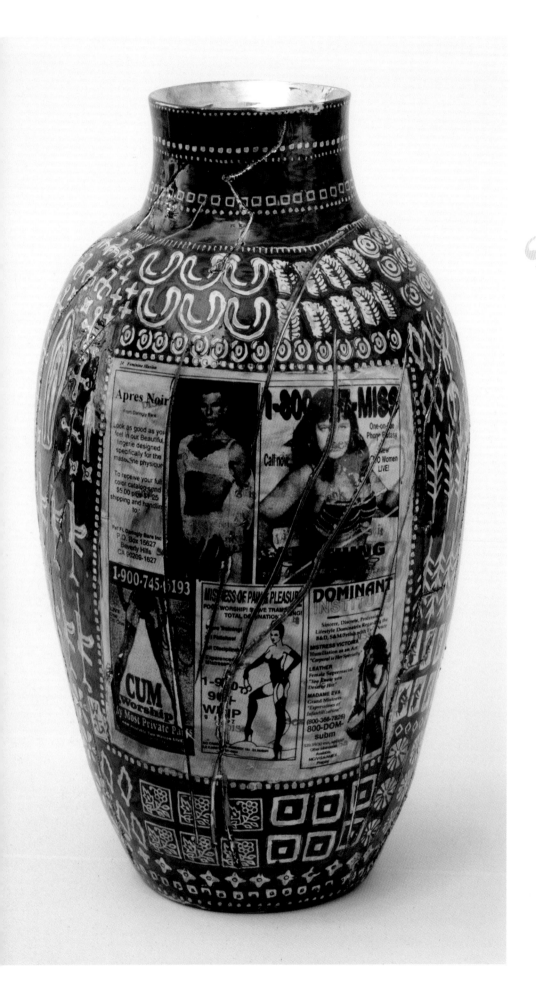

" **In Japanese ceramics,** valuable Edo teaware is very much prized. They can be quite humble pieces but if they break, they're often mended with gold lacquer, so you see these cracks and chips in-filled with what looks like gold. Ever since I saw that, at the time I first became interested in ceramics, I always loved the idea. It's about reverence and showing respect to the object through the way it has been repaired.

I think that psychologically I have got an awful lot of mileage out of my own faults and scars. So I made two pots with slashes symbolic of this damage, to draw attention to it. In *Sublime Hatred* I inlaid gold into the cuts, echoing the Japanese teapots. I was striking out at my demons with self-inflicted slashes but at the same time it suggests how the therapy of my art practice has helped to heal the splits in my personality. I've revered my damage in a way.

sublime hatred | 1999

Glazed ceramic, 40 × 20 (15¾ × 7⅞)

i am my own god | 1998

Glazed ceramic, 110 × 70 (43¼ × 27½)

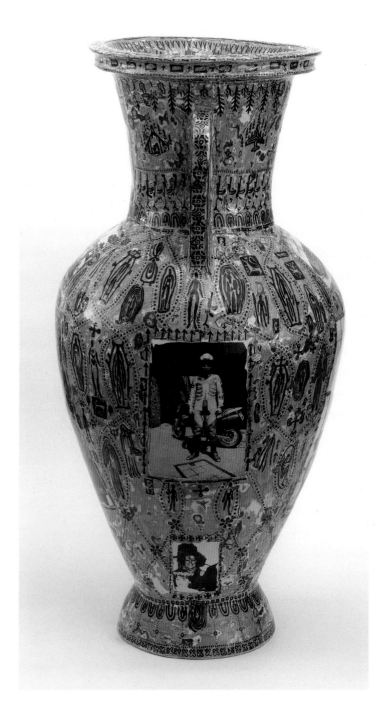
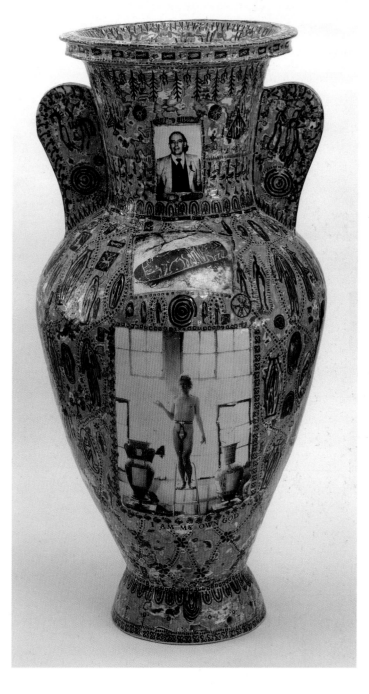

> **This is a copy,** taken from a book, of a large Greek pot that would have been used as a grave-marker. I was having an exhibition in Greece, and I thought it would be interesting to take some coal to Newcastle.
>
> The vase is about constructing personal myths, so it includes photographs of the main players in my own saga. There's me as

a fourteen-year-old; with my motorcycle in my 'Essex Man leathers'; and posing in the studio in my stainless-steel chastity belt as a kind of classical statue. I'm surrounded by my own Madonna (my wife), my father and mother, as well as my stepfather – a sort of Hades, King of the Underworld. All around are primitive-looking figures in coffins or little graves.

A lot of people imagine that I must like that ancient Greek pottery with rude pictures on it, but I've never been a fan of Greek pots. I don't like the texture of them: they have a matt, lumpy quality and look a bit like they've been made with poster paint. Greek vases are now also such a cliché. I can't look at them without seeing tourist tat.

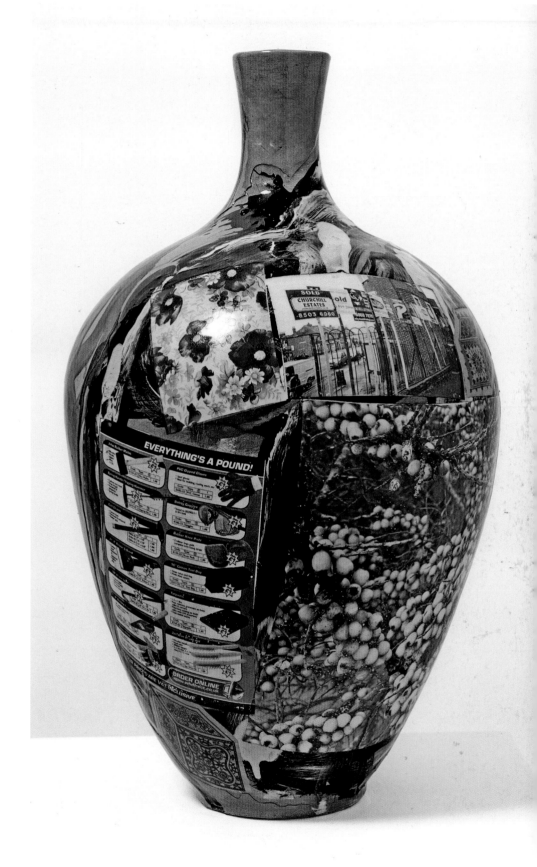

> This work touches on the nature of ugliness. It plays on the convention of what a pot is expected to be: a beautiful object. Things can be at once beautiful and ugly I think, and you can make anything look attractive by placing it on the surface of a pot.
>
> On one side, there is a load of estate agents' boards that caught my eye. In many ways they're horrific but on the other hand they form a sort of rainbow. The photographs I chose are of mundane things, both beautiful and ugly. On the other side, there's a portrait of me where I've literally poked the eyes out, right through the walls of the pot. It's partly about how the ugliness of the world sometimes makes you want to poke your eyes out. Also, I've always associated painted self portraits with not knowing what to paint. They're lame, something that you do in sixth form. Over the centuries there have been some incredible self portraits, of course, but nowadays if you want to make someone's portrait, take a photograph.

self portrait with eyes poked out | 2004

Glazed ceramic, 55 × 34 (21⁵/₈ × 13³/₈)

i hate you, i hate myself | 2000

Glazed ceramic, 31 × 20 (12¼ × 7⅞)

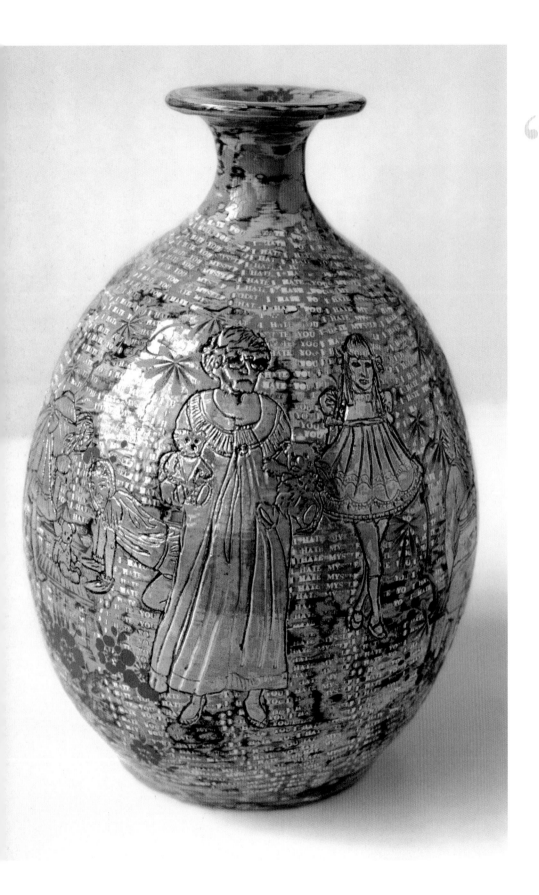

66 **This pot, which shows** scenes of kinky sex, is about denigration and humiliation. Self-hatred is often a part of sadomasochistic scenarios: they often replay moments from your past when you felt put down or humiliated. People who are violent or who are turned on by sexual violence towards other people frequently have a very poor view of themselves.

In a lot of S&M scenarios, people are quite happy to be the master or the slave. What's appealing about it is the emotion that's in the air: I think it's about the smell of power. When I look at sadomasochistic pornography, at one point I'm wishing I was the person tied up and at another point I'm thinking I'd like to tie that person up.

Once you've had a bit of therapy, you can understand why certain things turn you on. It doesn't stop them turning you on, though. My sexual fantasies slightly appal me sometimes: I think, Why do you want to put yourself in that position? Have some dignity Grayson! And yet the opposite of dignity is what turns me on.

golden ghosts | 2001

Glazed ceramic, 65 × 39 (25⅝ × 15⅜)

"**One of the things** that therapists often tell you is not to be so hard on yourself, to have a bit of sympathy for the young person that you once were. During my therapy, I became very empathetic about the plight of children around the world, in part from the experience of looking back on my own childhood. The pictures on this vase show the spectrum of childhood experience from poverty and war to privilege. There's a girl I imagined damaged by the Chernobyl blast, one who has had her hands chopped off in the terrors of Sierra Leone and another damaged by Agent Orange, alongside American pageant princesses. A coffin pattern goes over the whole pot, representing all the millions of little deaths.

The 'golden ghosts' of the title are the ghosts of our childhood. The floating images are akin to the mental pictures that waft around our imaginations. The pot has a kind of pearliness about it and a cherished feeling. My own past was very enriching to me as an artist; my golden ghosts are a precious part of myself. It's quite a sentimental piece but that's how I was then, in the middle of my therapy. I still am quite sentimental; I don't see that as a bad thing. I think the word is often thrown about as an insult – but I'd rather live in a world that's in touch with itself than somewhere that's buttoned-up and repressed.

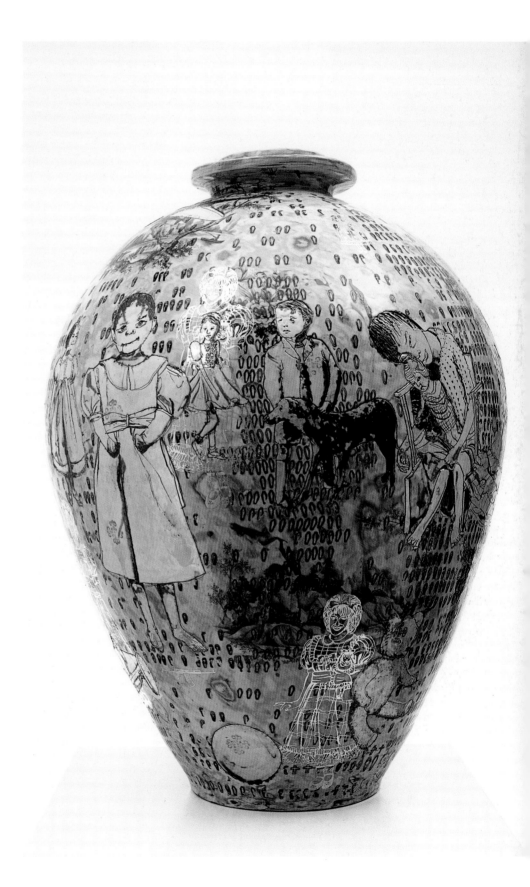

assembling a motorcycle from memory | 2004

Glazed ceramic, 74 × 45 (29⅛ × 17¾)

> **There's a famous** pair of Hogarth prints called *Before* and *After*. In the first image, a man is beseeching a woman to be his lover, and in the second, afterwards, the woman is begging the man to stay while he's hurriedly buttoning up his trousers. That was one of the starting points of this piece: the idea of men and orgasms, and what they do to our psychology. I sometimes feel post-orgasm that it's like the clouds clearing at the beginning of 'The Simpsons'. All that sexual drive, the fog of lust, passes and suddenly men have a clearer vision. I remember joking with Philippa once, 'I feel like mending a watch!' – something completely unemotional and mechanical. Men are much more at home with machines than they are with human relationships, preferring to deal with something like the internal workings of a motorcycle engine rather than messy relationships and contrary, irrational people.

I've lived a large expanse of my life tinkering with machines, model aeroplanes and the like. This pot is about my nerdy side, since I could draw a disassembled motorcycle from memory. I've labelled each of the components with deliberately emotional dialogue, mainly from biographical sources. One I always remember is a quote from my mother, something she once said to Philippa: 'You must be desperate, to marry a transvestite.' All the phrases are from various highly emotional points in one's life, like birth and death; those charged moments with the most uncomfortable feelings that men sometimes have problems dealing with.

I wouldn't have been able to make a work like this before I had psychotherapy, because it pulls apart my own thought processes and feelings. It relates to a very particular aspect of self-examination.

WILLIAM HOGARTH *Before* and *After*, c. 1736

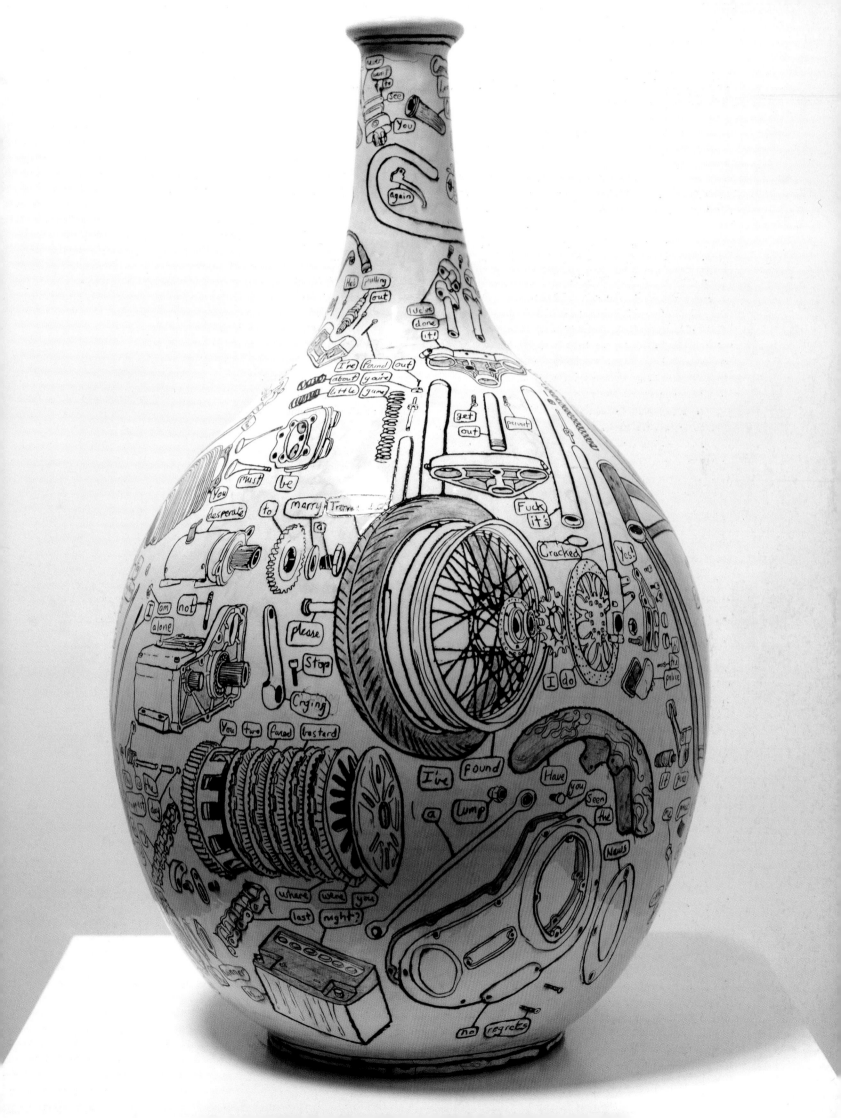

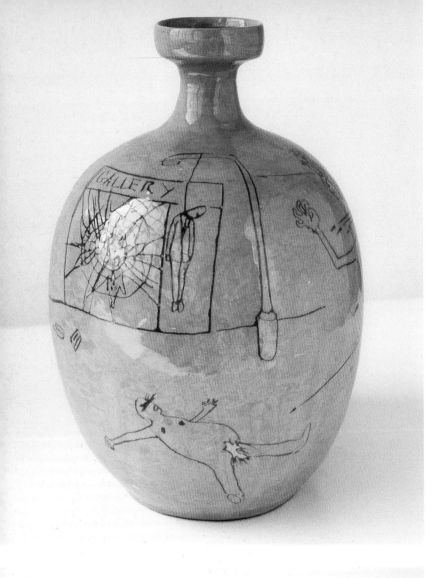

anger work | 2000

Glazed ceramic, 35 × 20 (13¼ × 7¼)

❝ **I was going** through a sort of divorce with the Laurent Delaye Gallery and it was making me really angry. In the course I took on therapy, we did a lot of 'anger work' to channel our feelings, like hitting cushions or pretending to shout at whoever we were annoyed with. My way of dealing with my feelings was to make a pot about it all, so I did a drawing of me with a machine gun killing Laurent Delaye.

It was a quick, crude pot. With anger, you don't sit around. It's also a humorous piece: the fact that you're doing 'anger work' on a pot is rather ridiculous. Anger work is about abandoning yourself to rage in a safe environment, letting it rip. Of course, you can't ever do that with a vase: vases are smashed during angry outbursts, not made. Pottery is incredibly controlled and delicate, so there was a dissonance in the idea of an angry pot.

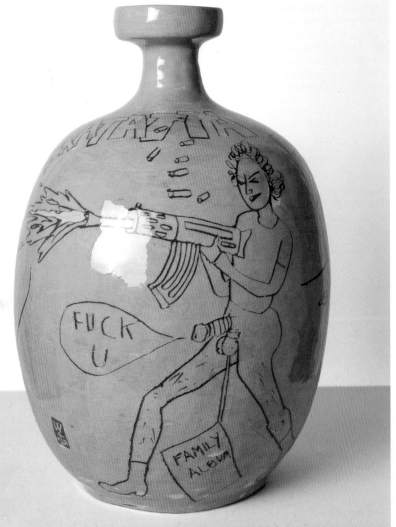

This is one of a series of pots based on some collages I had done in my sketchbooks twenty years earlier. It was about the crux point of my adolescence: those lonely afternoons wandering through the hot cornfields, full of suppressed, perverted lusts. I would hang out in concrete World War II pillboxes. I had a thing for them, and I'd go off on my bicycle around the countryside searching for them. They were always incredibly seedy inside, full of discarded porn or the remnants from where a tramp had slept. There's also a picture of a man with a glider, that slightly nerdy hobby. I was a fifteen-year-old with urges to wander about the fields in a summer frock and yet I was still interested in model aeroplanes. I wanted to get out of there pronto, but had no idea where I was going. It wasn't the happiest time of my life: hence the title. But this pot was also about me reacting to my own indulgence in the therapy world. You can become obsessed with the past, with being a victim, so there's a slightly jokey aspect to it.

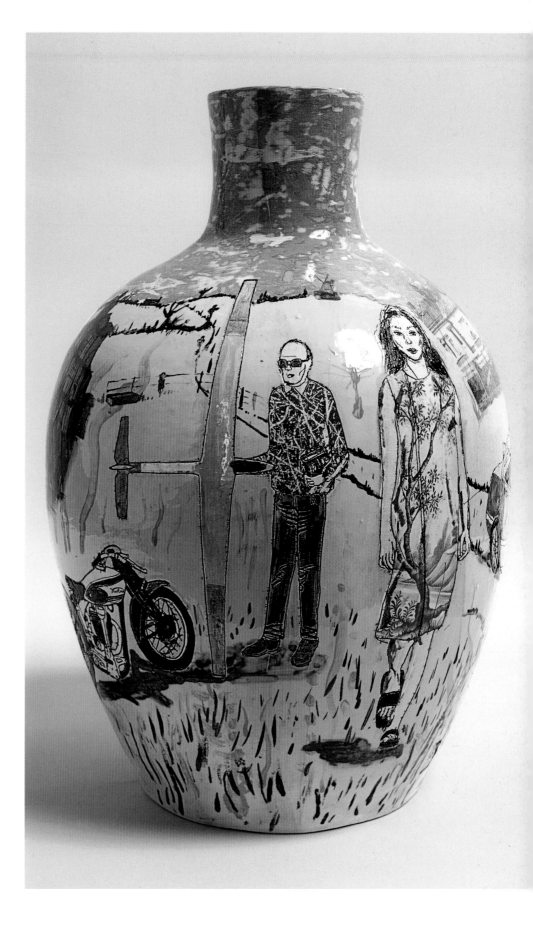

nostalgia for the bad times | 1999

Glazed ceramic, 43 × 28 (16⅞ × 11)

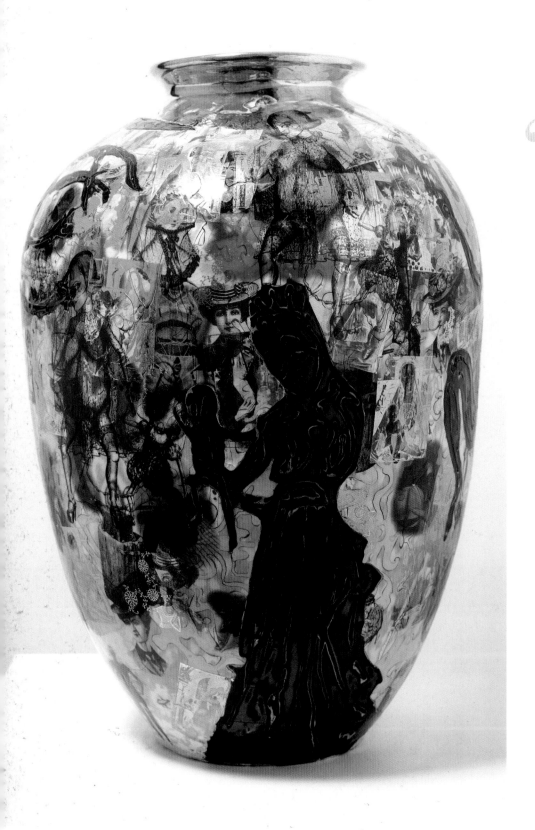

66 **The layering on this** vase is incredibly dense and hard to decipher. All of the images relate to the relationship between mothers and sons. The large silhouette shapes are like primitive parents: a woman giving birth, a kind of Madonna, a drawing of a woman in a polka-dot negligée with a strange demonic child connected to her by an umbilical cord. On top of this there are gold images of the Madonna and Child taken from Northern Renaissance altarpieces. The drawings underneath are of Victorian women: fruit sellers, straight-laced ladies and knife-wielding maniacs. Finally, below that, there are images of transvestite porn, with trannies showing off their willies.

The pot is about the multifaceted relationships between men and their mothers, much of which is connected to my experience with my own mother. It's quite negative and dark, not the happiest celebration of the mother-son bond.

mothers and sons | 2007

Glazed ceramic, 67 × 50 (26 ⅛ × 19 ⅝)

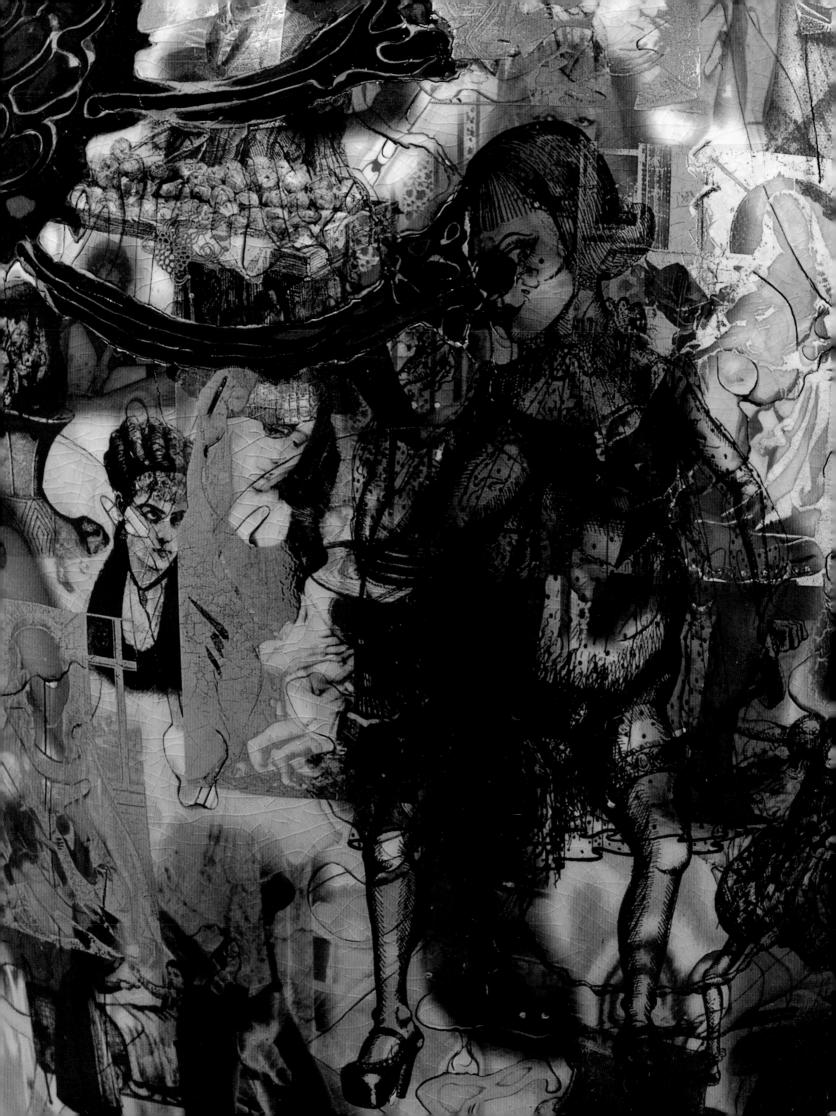

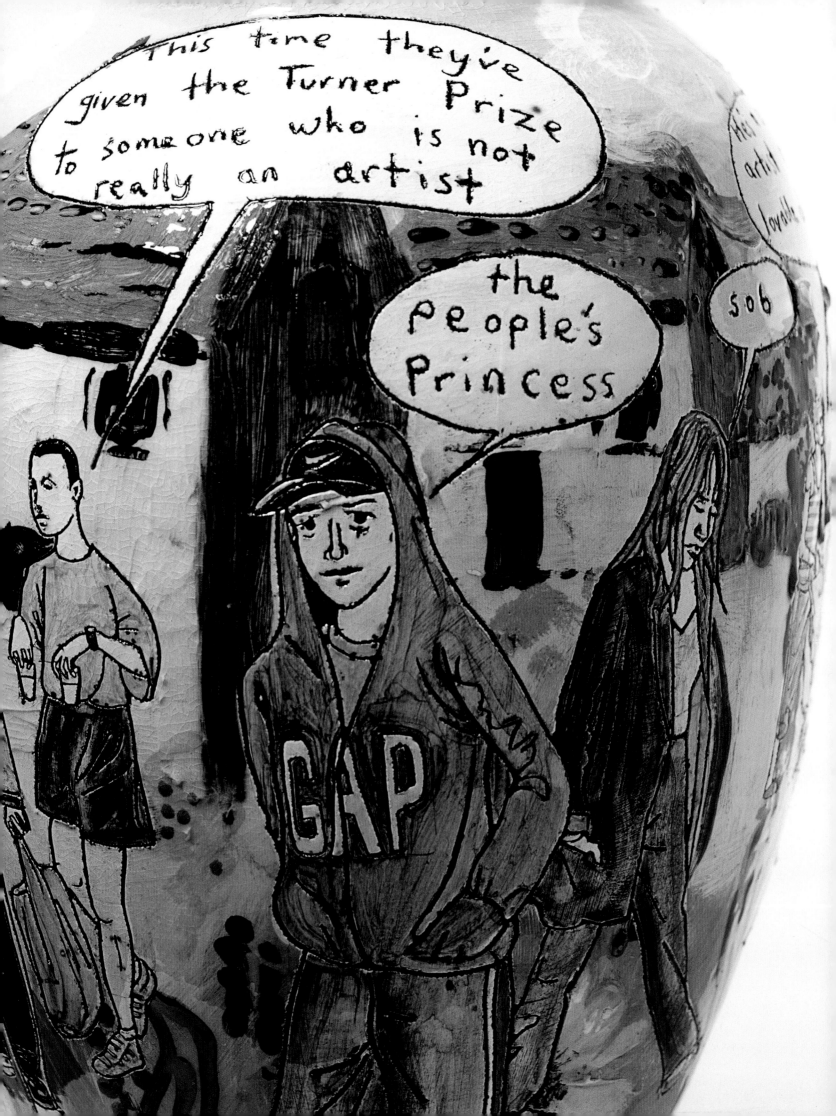

chapter 8 the art world

'The art world is a distinct, tribal micro-culture, a little village of witchdoctors who make artworks about their belief system and their concerns.'

On 7 December 2003, wearing a lilac satin babydoll dress, frilly socks and red pumps, Grayson Perry stepped up to the podium in Tate Britain's grand Duveen galleries to receive one of the art world's most coveted accolades, the Turner Prize. It was a moment of apotheosis.

Pipping the bookies' favourites, Jake and Dinos Chapman, to the post, Perry's seductive pots had captured the imaginations not only of that year's judging panel but also, seemingly, the public at large. The comment boards at the Tate were filled with positive responses to his work, and he was the popular favourite, dubbed, to his delight, the 'People's Princess'. Almost overnight he had been catapulted into the public consciousness, his place at the centre of the British contemporary art world assured.

Perry subsequently made a series of works reflecting on his experience of winning the illustrious prize. Chief among them was a piece entitled *A Network of Cracks (The Turner Prize Award Dinner 2003)*, which commented directly on the nature of being an 'insider' in the art world (pp. 236–37). A colour-coded map of the seating plan from the award-ceremony dinner, it presented both a snapshot of the UK art world at that moment and Perry's personal view of his place within its labyrinth of social networks and relationships.

Taking the art world as his subject was, though, nothing new for Perry. His very earliest works reflected a fascination with the contemporary art scene: its dealers, curators and collectors, its trends and proclivities, its openly declared as well as its unspoken codes and conventions. His stance was, and remains, one of intimate understanding of the art world's inner workings, poised between critical distance and warm affection. One recurring theme in Perry's work is his conviction that the art world, often criticized for being elitist and self-regarding, should in fact be viewed as a sort of folk culture worthy of protection and celebration. The analogy is apt: the art world, after all, has its own language, rituals and ceremonies, its dedicated places of pilgrimage, its tribal leaders and faithfully worshipped gods. It can, he admits, 'be very introspective, and its concerns are not necessarily those of regular people – but you wouldn't accuse Australian Aborigines of being self-obsessed because their art is all about their gods, their interests and their traditions'.

While he defends the art world and its insularities, however, he does not shrink way from exposing some of its flaws and pretensions. One of the main subjects of Perry's critique has been the art market and its coterie of collectors. A quick glance at the titles of some of his works – from early pieces such as *Trendy and Proud*, *Exportware* and *I Know This One Will Sell* to later ones like *Boring Cool People* (p. 241) and *As Sold by the Anthony d'Offay Gallery* (p. 230) – gives a vivid picture of how openly Perry has mocked the aspirations of those who buy his work. For him, the art market, at its worst, is driven by the vain pursuit of status, by a numbing conformity

and a herd mentality to follow fashion. Many of his pieces are also wry comments on the nature of money and possession, revealing a subversive anti-consumerist strand in his thinking. The vase *I Promise Nothing* is perhaps the most direct of these: an acerbic, if playful, comment, in the vein of Andy Warhol's signed dollar bills or American artist J. S. G. Boggs's fake money, on art as pure investment vehicle (p. 243).

Perry's relationships and alliances with a number of art dealers have also helped to shape his attitudes to the contemporary art world. His earliest exposure to the dealings of a commercial gallery was in the mid-1980s, when he showed with James Birch. His first flush of commercial success brought out a nascent ambivalence to the art market. A number of works from the time incorporated pound or dollar signs within their design, or made less than flattering allusions to their owners' roles within a corrupt capitalist system of patronage. One work, bought by Birch himself, was embossed with the words, only half teasing, 'Fascist Boss Man'. Through Birch and his business partner Paul Conran, Perry also showed occasionally with New York ceramics dealer Garth Clark, before moving to David Gill, whose smart Chelsea antiques gallery in London accommodated Perry's pots among the other

decorative *objets*. But it was when he moved in the mid-1990s to the big-hitting establishment dealer Anthony d'Offay that he made some of his most potent work about the art market, continuing to delight in biting the hand that fed him – whether art collectors or the dealers themselves. D'Offay dealt for the most part in high-profile, internationally established artists, but took on Perry at the encouragement of his budding young curator Sadie Coles, soon to become a well-respected gallerist in her own right. Responding to this new exposure to the high end of the contemporary market, Perry made a number of works referencing d'Offay himself who, despite being something of a father figure to him, nonetheless did not escape his caustic wit (p. 231). Laurent Delaye, Perry's dealer from 1999 until his acrimonious split from the gallery in 2002, came in for more severe treatment in pieces such as *Art Dealer Being Beaten to Death* and *Anger Work* (p. 220). And if recent years have seen a spate of less vitriolic works, it can at least in part be attributed to the sage Victoria Miro, whose slickly run but unflashy operation in north London has served Perry happily since 2003.

As his own work has been increasingly exhibited in public galleries, so Perry has turned his attention to another key institution on the cultural landscape: the

'Psst. Before you go any further, that's the bloke who won the Turner prize.'

art museum. Traditionally the bastion of 'high' culture and keeper of its most treasured objects, the art museum has also become, in recent times, the focus of heated political debate, its exhibitions and education activities apparently a panacea for a host of social problems. Perry questions what he sees as the often ridiculous dictats of government and funding bodies to refashion art museums as champions of local regeneration or centres for social improvement. One pot sardonically announces how, among other things, it will 'promote understanding between different ethnic communities' and 'reduce crime by 29%' (p. 239). Yet while he shows some sympathy for museums and the pressure that they often come under, Perry also sees them as complicit in the drive towards sensationalism and the quick fix. In pursuit of ever larger audiences, he finds art museums favouring large, brash work that gives immediate thrills but, arguably, little lasting satisfaction. For him, the Turbine Hall at London's Tate Modern is a prime example of this phenomenon, 'that desperation for showmanship in order to get the public in. It's more about bludgeoning people with headlines than allowing them any meaningful encounter.'

Alongside the art museum, Perry also sets his critical sights on another major art world target: artists themselves. Most directly in his line of fire are those who create 'art by phone': works that might be witty or intelligent but whose execution lacks any relationship to traditional notions of aesthetic judgment or craft skill. 'I always have the feeling,' he says, 'that Damien Hirst, bless his little cotton socks, and Mona Hatoum, ring up their fabricators and say, "I'd like a great big cock made in gold, twenty feet long. See you at the opening. Bye."'[1] As well as resisting artists who are disconnected from the physical realities of making their own work, he also dismisses much recent conceptual art as no more than the embodiment of juvenile 'sixth-form philosophy'. And if artists themselves bow to trends, so too does the art community at large. Perry's pot *Video Installation* neatly sums up how the contemporary art world, despite its apparent openness and radicalism, is premised on a narrow orthodoxy about what forms of art are recognized and applauded at any given moment (p. 242). It lists, with no small dose of irony, recently prevailing modes such as 'video installation with home-made soundtrack' and 'found objects arranged in a pattern'. In his own work, of course, Perry bucks all these trends. As always, he chooses – quite deliberately – to remain at the unfashionable and ambiguous edge of the art world.

Far left | Grayson Perry at the Turner Prize ceremony,
Tate Britain, 7 December 2003
Left | Mac cartoon, *Daily Mail*, 9 December 2003
Right | CARSTEN HÖLLER *Test Site*, 2006.
Installation at Tate Modern, London

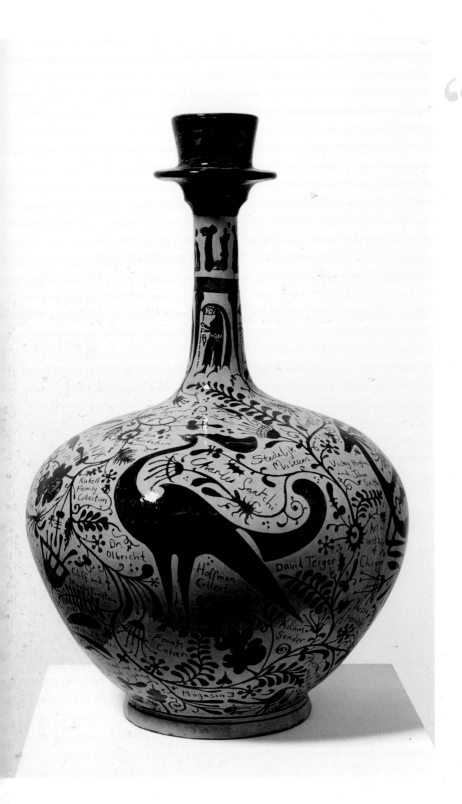

66 **People from outside** the art world often say 'How can you call that art?' I think that's a boring question. Anything can be art, but that doesn't mean it's good art. A much more interesting question is 'What makes something good art?' I see it as a lovely consensus of connoisseurs and art world professionals. An artist gets brownie points as they progress in their career: they have shows; they get reviews; their work makes it into collections – all of this accruing until they become recognized as a successful artist. It can snowball sometimes, and occasionally I think an artist's work is overrated because of their reputation, but on the whole, the checks and balances of the art world are pretty good. This collective value system is really the only way we can judge a work of art. There's no machine that can measure how good art is, although a lot of people talk as if there is.

I asked a friend at the Victoria Miro Gallery which were the fifty most influential museums to have your work in. I deliberately made the pot very decorative, with nice images of animals and flowers, and without what I would call any 'spiky' content. It was about the idea that people buy with their ears sometimes. I wanted people to look at it and say, 'Oh, pretty colours, but oh, look! Reina Sofia, Centre Pompidou, San Francisco MoMa, what does that mean?', as if the pot was whispering, 'Buy this one!' And, of course, it was bought by someone whose name was listed; it's now in one of the lovely fifty collections, and the owner bought it on the mobile phone while he was looking at it in the Turner Prize show. So it works – in a kind of witch-doctory magic way.

lovely consensus | 2003

Glazed ceramic, 60 × 41 (23⅝ × 10¼)

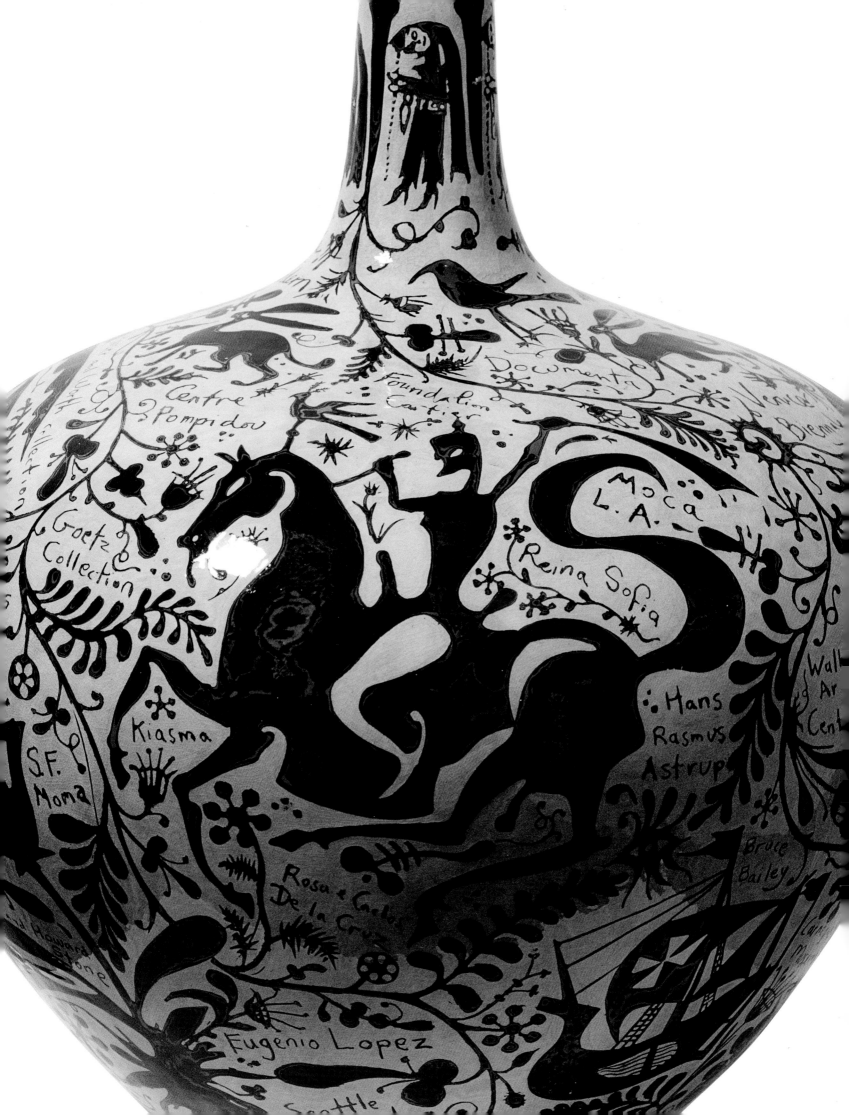

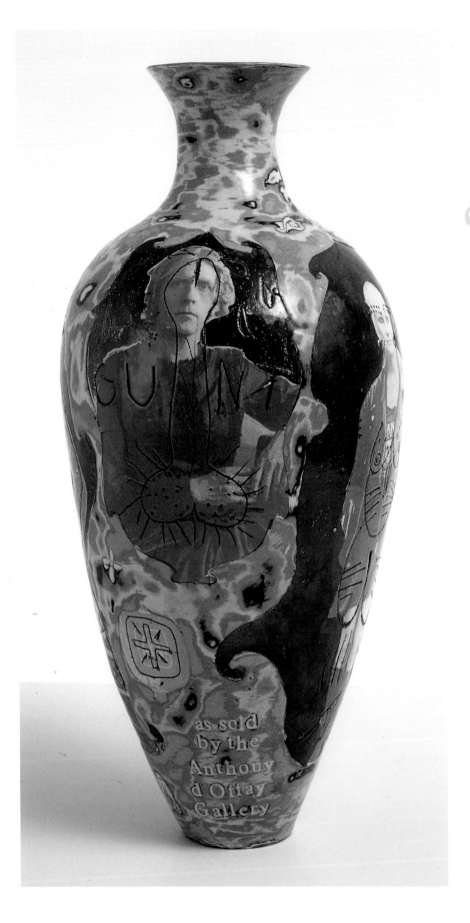

The title of this piece has nothing to do with the content of it; I was just winding Anthony d'Offay up, teasing him by using his reputation, his name and status. When I was installing my exhibition at his gallery in 1994, he came swanning in and said, 'I don't want it looking like a pot shop!' We had the pots arranged on plinths but he didn't think that was right. He wanted it to look like an art installation so he had us put them on little shelves on the wall instead. But it meant you could hardly see some of them, because they were way above head height, and of course you couldn't see the backs of any of them. It wasn't particularly successful as a display, but I suppose on his part it was canny, as he was looking at a way to introduce my work into the orthodoxy of contemporary art. It might have been too much for people to look at craftwork as art.

'Grayson Perry: New Work', installation view from the Anthony d'Offay Gallery, 24 Dering Street, London, 1994

as sold by the anthony d'offay gallery | 1996
Glazed ceramic, 44.5 × 21 (17½ × 8¼)

portrait of anthony d'offay | 1998

Glazed ceramic, left 42 × 13.4 (16½ × 5¼); right 44 × 15 (17⅜ × 5⅞)

"When I joined the Anthony d'Offay Gallery, I thought, That's it, I'm made! Very little happened though, because the gallery wasn't really set up to promote the careers of young artists. I called it the Museum Supply Company: it handled well-established names and helped place their work in museums. I felt that my career wasn't being developed enough there.

I made these pieces at around the time I was leaving the gallery, when I had a lot of emotional pressures coming to a head. I produced lots of work that featured portraits of Anthony d'Offay. He seemed a sort of distant father figure, though I found him frightening at the same time. There were lots of stories floating around about his tastes and eccentricities. He was into alternative therapies and used to go on retreats to Findhorn in Scotland. I'd heard, too, that he had a collection of lingam, ancient Hindu phallic carvings, in his house. So I made a tribal-looking lingam that had the top twenty share prices on it: Abbey National, Royal and Sun Alliance, Marks and Spencer and so on. Somebody saw it in my studio and said it looked like a pepper pot, which made me think I'd make the salt cellar to go with it. The second one listed the top twenty artists whom d'Offay handled. I saw them as somehow representing the duality of his own personality: a very astute businessman but with a spiritual side.

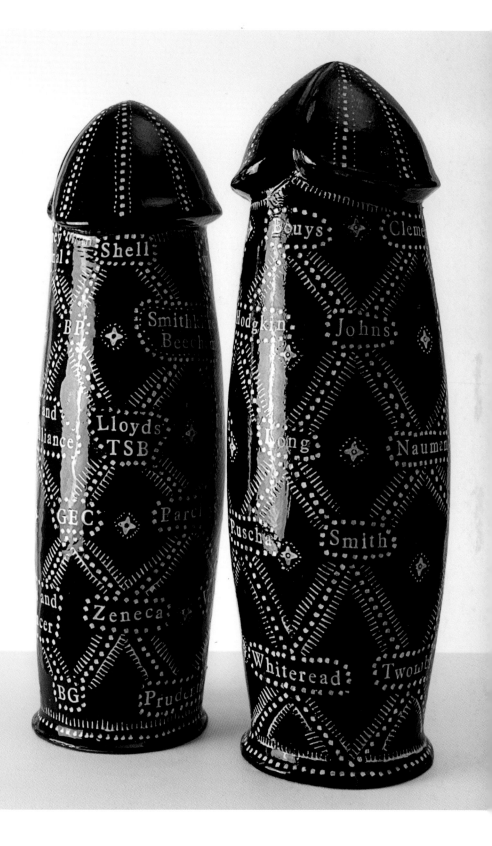

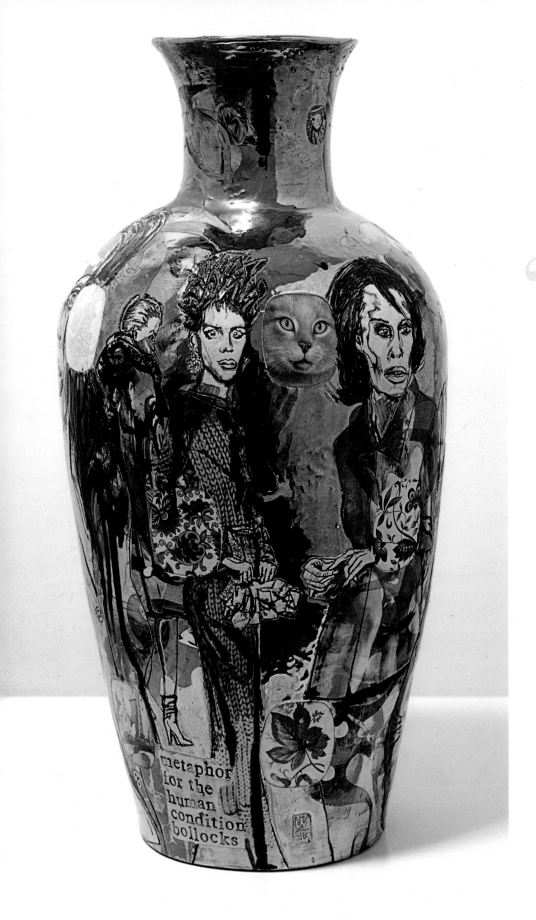

This pot is a joke about the idea of artists wanting their work to be very meaningful. I was listening to the radio in my studio and heard the artist Bill Viola talking about one of his video works. 'Yeah, it's like a metaphor for the human condition,' he said. And I said to myself: 'Bollocks!', because it sounded so crass.

Meaning can sometimes be a hang-up for artists. It has become so important that lots of art is no more than a visual crossword clue. It turns art into something with an on-off switch, where there's no room for a nuanced visual language. There is a profound dignity, though, in just being decorative. Making something pretty – and I use that word advisedly – for visual and sensual pleasure is a worthy thing for any artist to aspire to. I didn't feel as confident in this view when I made this pot, which has on it pictures of models and flowery patterns. I wanted to make pretty things, but I knew that if I just made attractive pots, justifiably they wouldn't be allowed in art galleries because they would be nothing more than craftwork. Only at the last minute did I tend to throw a pinch of salt into my work, in the hope that it would slightly lift it above that.

metaphor for the human condition bollocks | 1996

Glazed ceramic, 54 × 29 (21¼ × 11⅛)

pot designed for a wealthy westerner with good taste | 1994

Glazed ceramic, 38 × 27.5 (15 × 10⅞)

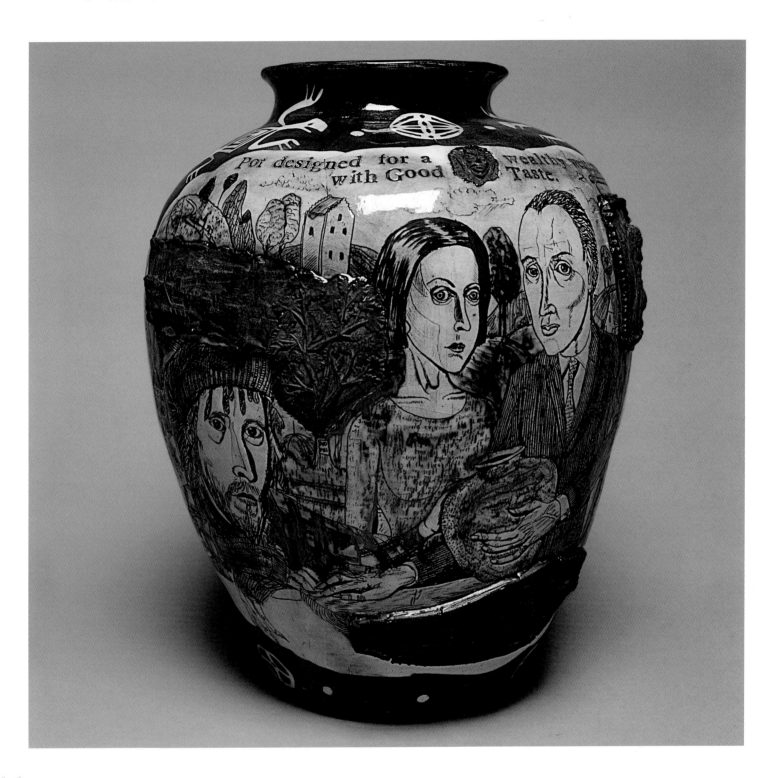

" **My first show** at Anthony d'Offay's gallery was intended to provoke and tease Anthony and the collectors a little. I suspect I was unsuccessful, as nobody self-flagellates as well as the art world. At the forefront of my mind was the fact that I was moving from a little gallery, David Gill, to a well-known one. I was entering a new world. It felt like a big leap, and – as is always the case with me – what was headline in my life became subject matter for my work.

I had a bit of a chip on my shoulder about art collectors at the time, so I drew a couple looking proudly out, cradling the pot they've bought, with their stately home in the background.

There's also a grungy, misbegotten, posh traveller son. On the reverse I drew a simple ethnic pattern, with the idea that it might sit on a west London shelf with the 'polite' side out when guests came round, and the darker side, about the unspoken vanities of the collector, turned to the wall.

gilbert and george in china | 1993

Glazed ceramic, left 38 × 22 (15 × 8⅝); right 39 × 24 (15⅜ × 9½)

James Birch, my first dealer, was organizing an exhibition in China with the artists Gilbert and George, and he suggested that I make a commemorative piece of their trip. They were supposed to be like souvenirs. I was quite desperate for money at the time, and James's idea was that we'd try to sell the piece to them. They didn't buy it in the end, probably because the pots were so rude. George is saying in one of the pictures, 'Arse for all' in place of their slogan 'Art for all'; on the reverse he's giving a blow job to a Chinese dignitary.

I really liked their work at the time – the drawings, photographs and performance pieces – though when they got locked into their stained-glass-window thing I became less interested. They should have changed their style and moved on when computer graphics came along. Nowadays, there is practically a Gilbert and George button in Photoshop.

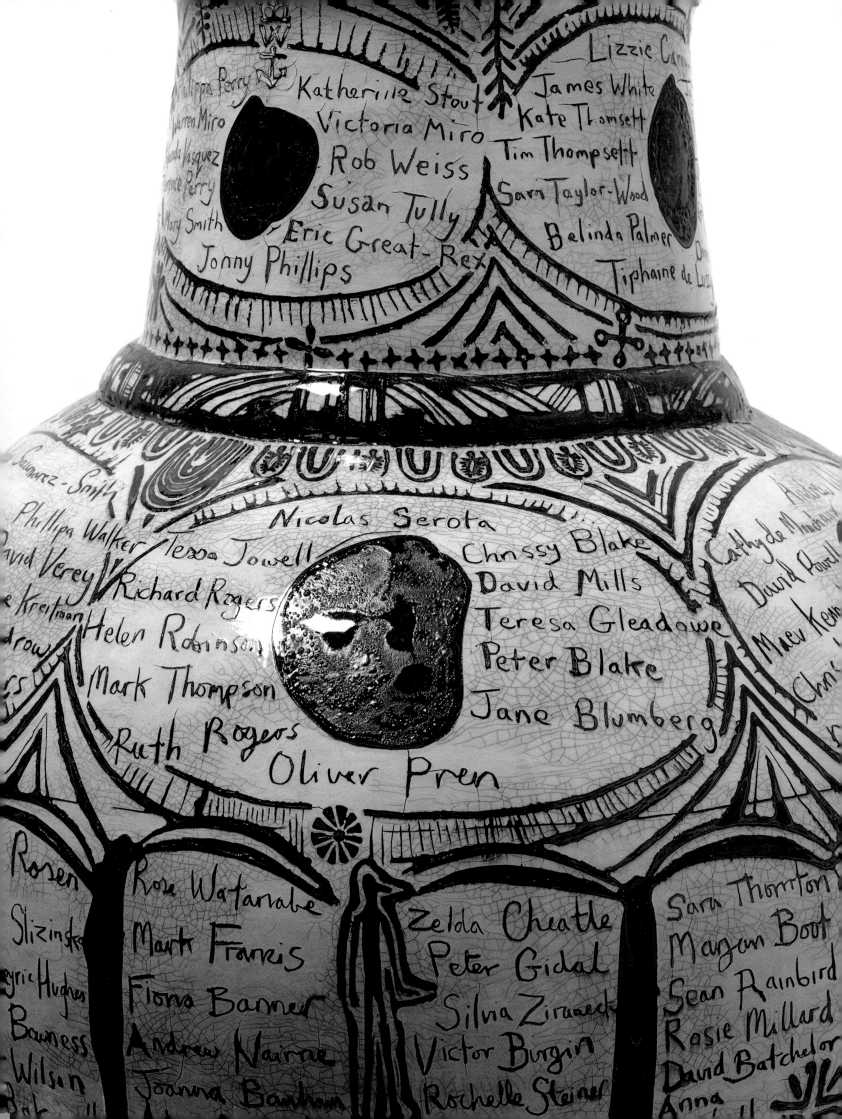

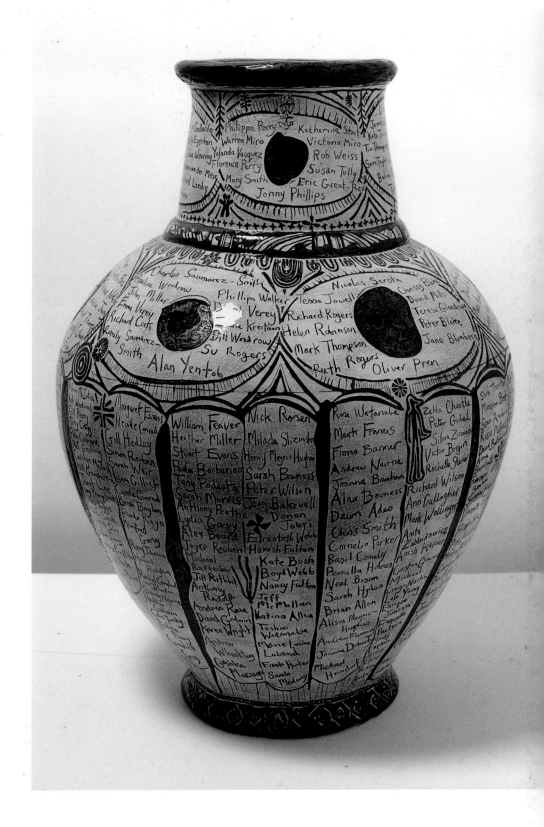

"I was talking to a friend, Sarah Thornton, soon after I won the Turner Prize, and we were joking about the kind of machinations of big institutions like the Tate. The question came up about how carefully planned the seating arrangements were for the award dinner. We were laughing about it: how did they plan it so that wealthy collectors weren't next to private dealers? Did they spread the artists about because they were like pixie dust? So I rang up the Tate and asked them for the table plan, which I then used as the design for this work.

The shape is taken from an Islamic North African design. I wanted to make the pot look ethnic because it was about the art world being a tribe, and the dinner a sort of tribal gathering. The circular spots were like the pits when a bonfire is burnt down, with the tables like the tribes gathered round the fire. It is colour coded, but you can only really see that if you look closely: there is a code on the bottom for the five colours. It goes something like: family and friends; acquaintances; people I've met; people I know by reputation; and people I've never met, which is the majority. I called it *A Network of Cracks* because networking was a key part of the initial idea. I stained the cracklure, the glaze crackling, so that it looked like electricity in the air running between the various people. An historian of the future might be able to interpret the networks via this archaeological artefact.

a network of cracks (the turner prize award dinner 2003) | 2004

Glazed ceramic, 78 × 58 (30¾ × 22⅞)

gimmicks | 1996

Glazed ceramic, 29.2 × 22.8 (11½ × 9)

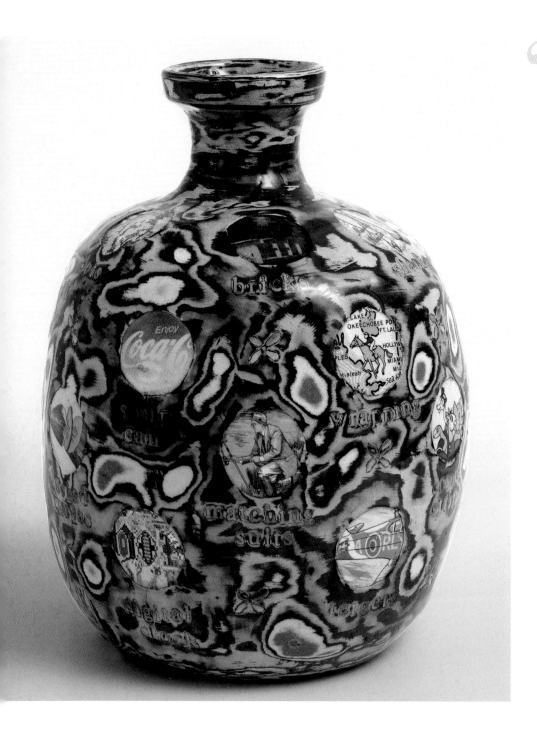

I'm always interested in the 'man-in-the-street' view of art. I was thinking about what the headlines might be for the average person if they thought about famous artists. What would they recognize as each artist's easily identifiable gimmick? For Gilbert and George, they might say, 'Oh, they're the blokes in the suits', or Damien Hirst would be 'the guy who did the shark'.

I made a list of artists and their 'trademarks', and sifted through my open-stock transfers to find an equivalent for each of them. I found someone with glasses who looked like George from Gilbert and George. Luckily, too, I had a Stuka bomber, so I used that for Joseph Beuys. He was very conscious of the myth of the artist: the story of him crashing in a dive bomber, being rescued and wrapped in fat and felt – it was a superb marketing move! It underpins some of the cleverness of his work, and gives even his most esoteric pieces a broad press appeal.

Artists' signatures are interesting, because they leak into the art world. Collectors want 'signature pieces'. If you have a very strong gimmick and then you suddenly make work outside of that, it can turn some people away. They might think, 'Oh, God, I wanted one of his pots but he's now gone and made prints!' For me, it has never happened that way, though: people like the other work I've made, perhaps because many of them didn't know quite what to do with my pots.

" **This vase relates to** a piece I wrote for *The Times* based on a report by the Manifesto Club about the so-called social benefits of art and art galleries. Many people who work in the culture sector believe fully in the regenerative qualities of culture. I think there are social benefits to art, but I don't think these things correlate in the easy way that some people would have you believe. So I made this pot with its cynical title as a joke about how it would promote understanding between ethnic communities, regenerate the local economy, improve schools and even reduce greenhouse gases.

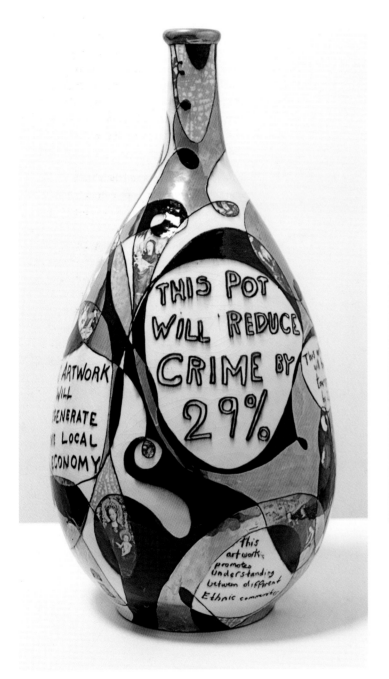
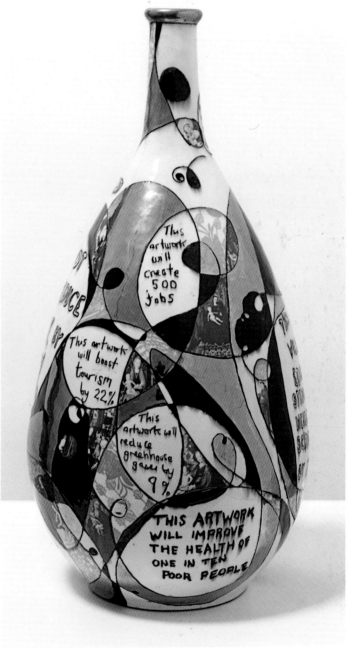

this pot will reduce crime by 29% | 2007

Glazed ceramic, 58 × 30 (22⅞ × 11¾)

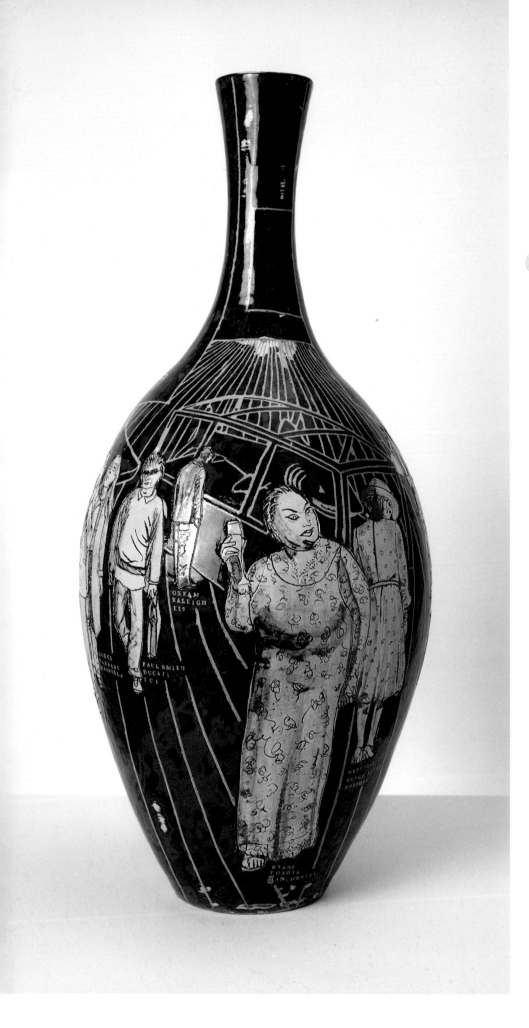

I wanted to make a work about Charles Saatchi and art collecting. There are various characters on the vase who are at an exhibition that could be 'Sensation', Saatchi's 1997 show of Young British Artists. Each person is captioned with what they're wearing, what car they drive and where they live. So there's 'Jasper Conran, Mercedes, sw1' and 'Gucci, Ferrari, Marbella'. Everyone is reduced to their designer label, their car key and their postcode. It was about the rise of the fashionable art collector. This pot is one of a series of quite minimal bowling-pin-shaped vases that started with *Boring Cool People* [opposite]. I was responding to the rise of the 'Britain's got design', stripped-wood floor, modern furniture thing. I saw all that as a blight on aesthetic variation.

I was very pleased when Saatchi saw my work at the 'Protest and Survive' exhibition at the Whitechapel Art Gallery in 2000. I think he saw it on the Saturday morning, went into the Laurent Delaye Gallery on the Saturday afternoon and bought around ten works. He bought another ten or so on a second visit and a few more later, in the end showing twenty-seven pots at his Boundary Road gallery. That was undoubtedly a major boost to my career, but it also meant he had effectively cleaned me out, and had control of over a year's output of my work. I am grateful that he's since returned a number of works to the market, in discreet ones and twos.

we are what we buy | 2000

Glazed ceramic, 50 × 22 (19¾ × 8⅝)

boring cool people | 1999

Glazed ceramic, 63.2 × 26.8 (24⅞ × 10½)

" **What is it about** coolness that annoys me? I see it as a set of values, of ideas about what is right and wrong, and ultimately as a crutch for people who don't trust their own judgment. That's why young teenagers are particularly obsessed with 'cool': they're not confident enough at that stage about their own tastes. It's useful for them to be clear about what trainers or music are considered cool, without having to be sure whether or not they actually like them. But after you're eighteen, you shouldn't be thinking about what's cool. It's a horrible and tyrannical concept, and it's one that's exploited by the commercial world.

The vase shows pictures of fashion models in a blank interior. I'd recently been to a Patrick Caulfield exhibition at the Hayward Gallery, and I really liked the deadpan quality of his minimal works in two colours. I wanted to do something that related to them, so I made what was for me a very understated pot. My work had been getting more and more elaborate up to that point, so this was me really paring it back. I had to fight my instincts to make something so simple.

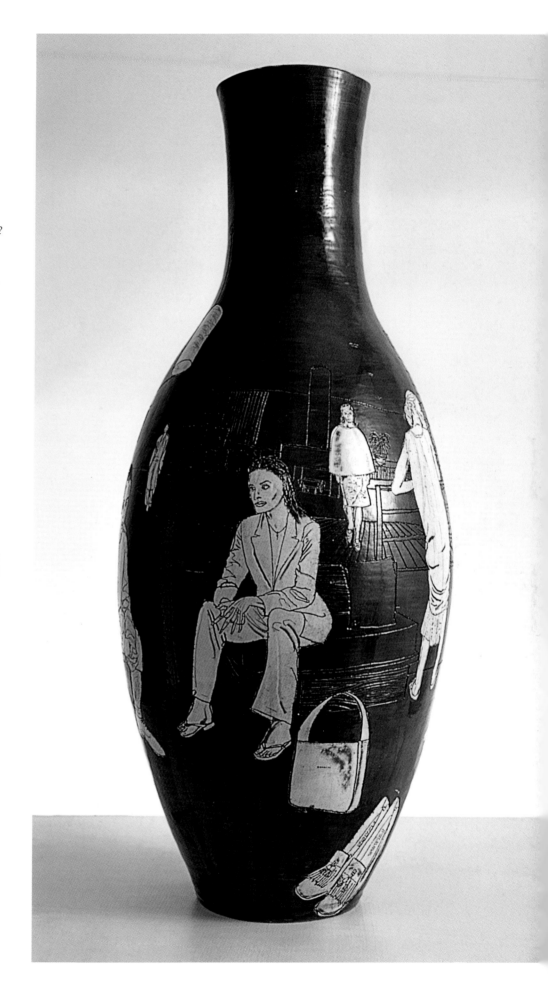

video installation | 1999

Glazed ceramic, 32.1 × 12.1 (12⅝ × 4¾)

"**This pot was made** when I was going through a particularly bitter patch in my relationship with the art world. I was looking at the art being made in London and it seemed to me that even though it purported to be 'anything goes', wild and wacky, actually it had some fairly orthodox attitudes about what categories of object were acceptable as contemporary art. The basic dynamic of the art world is 'good rebellion, welcome in'.

I jokingly listed the ten art categories I regarded as the most common. Top of the list was video installation, along with large ironic paintings, fibreglass figures, neon signs and so on. Neon has become the bronze of the twenty-first century: I've got a real allergy to it because it's just too easy to do. You can have a very slight idea but just add neon, and it's like instant art.

I also gave the pot this title because I thought it would be funny to be listed in a catalogue as 'Grayson Perry, *Video Installation*'. Curiously, the writer Howard Jacobson pointed out that the pot is a similar shape and colour to Marcel Duchamp's urinal. It wasn't intentional, but I liked the idea a lot.

i promise nothing | 2007

Glazed ceramic, 78 × 46 (30¾ × 18⅛)

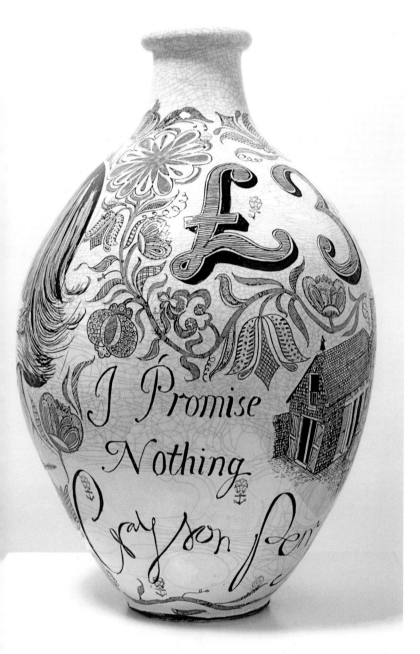

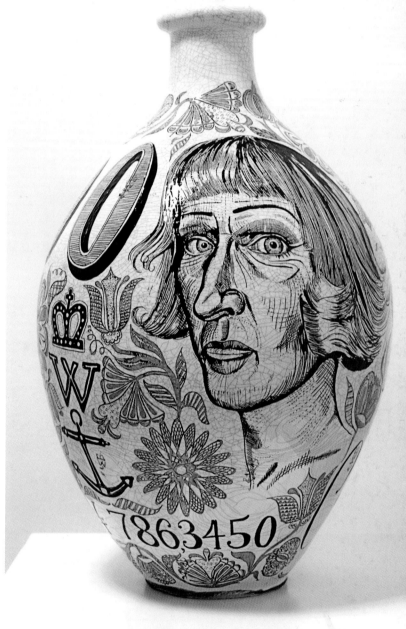

> **Something that's** not always openly advertised in the art world is how much things cost. There's a kind of embarrassment about it and it's seen as crass to ask. So I thought it would be interesting to be really blatant and make a work of art that actually had the price written on it.

When I made this pot it was worth £35,000, so I drew a bank note for that amount with my portrait as the Queen. As I was displaying it in Japan, I put the value in Yen too. I looked at lots of notes in my box of foreign money: they often feature the latest construction project of their country, like a dam, a new art gallery or

a parliament building. Since I'm an artist and had just built a new studio, I put that on. The motto 'I Promise Nothing' relates to 'I Promise to Pay the Bearer'; I wanted to suggest how the value of art is much more fluid than money. The pot promises nothing: it's only really worth as much as you're willing to pay for it.

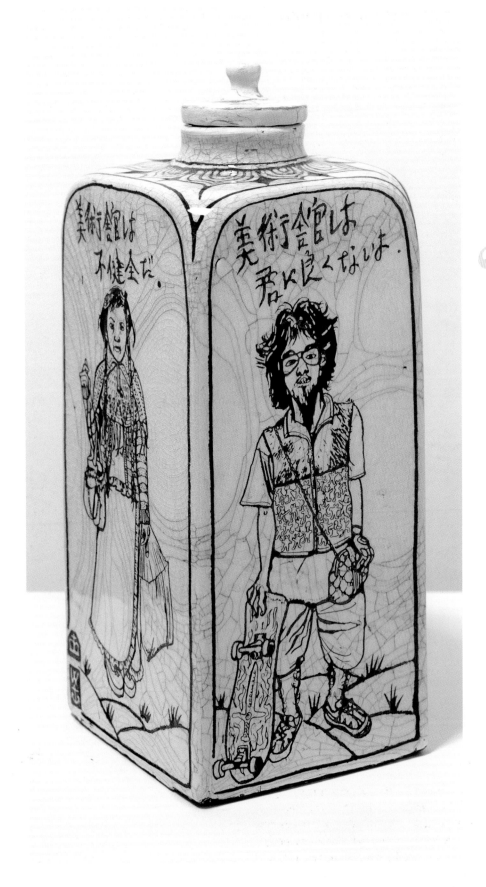

> **One of the things** museums are always desperate for is 'footfall'. Because of this, they are usually in pursuit of the most attention-grabbing objects. The curator of my exhibition in Japan told me that the hardest demographic group to get into museums is young teenagers. It got me thinking about how one way to get teenagers interested in something is to tell them it is bad for them. I deliberately made this pot quite modest and unflashy. It resembles an ancient, crackled tea caddy, exactly the kind of thing that a teenager would walk right past in a museum because it looks like a piece of dull old ceramics. I added pictures of Japanese teenagers in vaguely folky style, and I wrote the title of the work on it in Japanese.

art museums are bad for you | 2007

Glazed ceramic, 35 × 15 × 15 (13¾ × 5⅞ × 5⅞)

welcome to those who hate contemporary art | 2007

Glazed ceramic, 50 × 50 × 4.5 (19⅝ × 19⅝ × 1¾)

" **In Kanazawa, where** I had my exhibition in 2007, they've built a beautiful twenty-first-century museum – a fantastic piece of modern architecture. Then of course there's the old prefecture museum, which is quite dumpy in comparison. The local traditional ceramics, Kutani ware, are very revered in Japan. I copied directly one of the Kutani plates from the local museum, using the figure of Alan Measles as the common character of the wise man. It says in Japanese, 'Welcome to Those who Hate Contemporary Art'. Along with teenagers, people who feel they don't like contemporary art must be another demographic group that's hard to get into art museums. But my work is ideal for encouraging them, because although it's contemporary art, it repeatedly references much older art and traditions.

emotional landscape | 1999

Glazed ceramic, 59 × 32 (23¼ × 12⅝)

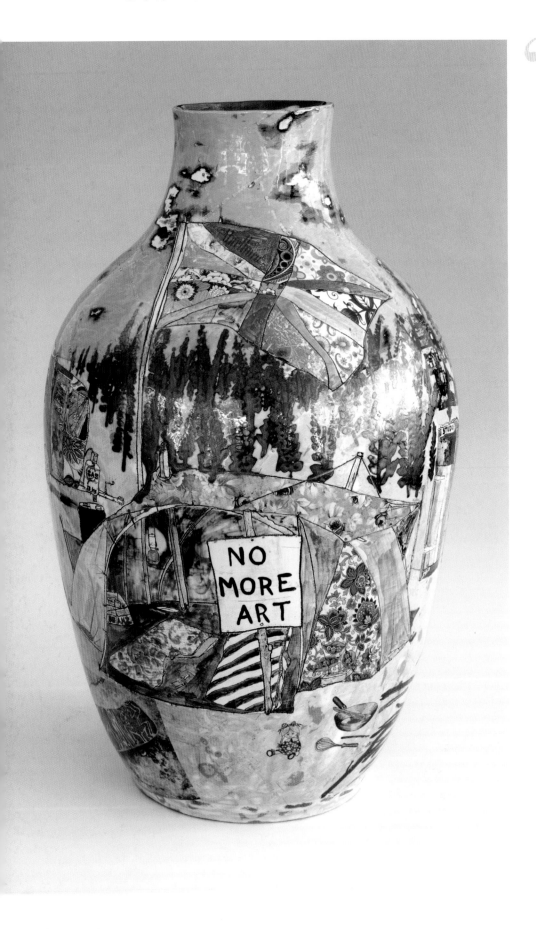

"I had a studio in Leytonstone at the time of the M11 link-road protests in the early 1990s. I was entranced by the imaginative ways people found to protest. One guy booby-trapped his house with secret tunnels and doors that came down like drawbridges. Others would build scaffolding towers out of the top of their houses, with flags flying on them like medieval fortresses. When the police arrived, the protestors would scurry up and padlock themselves in.

I took part in an exhibition in one of the abandoned houses, put on by the protestors. I made a pot for it that got stolen later, when there was another big road protest. This work harks back to that pot. The statement 'No More Art' is key. I sometimes feel that there's too much art, and the problem with such a crowded cultural landscape is that the voices that stand out are the shrill ones. I had a photograph taken, too, with me holding the placard up outside the Tate Gallery. I was being humorous, but there's a seriousness to it as well. Someone once asked me what they should teach in art school, and I said 'less people'. It's true that anyone can make art, but not many can do it very well.

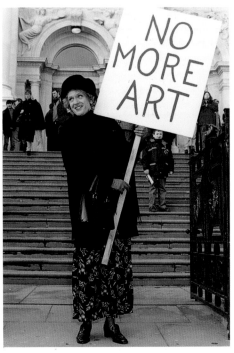

Claire outside the Tate Gallery, 2000.
Photographic print, H. 71 × W. 48 (28 × 18⅞)

"While the Turner Prize show was going on, I collected comments and quotes that stuck in my mind. Being nominated for the Turner Prize suddenly thrusts an artist into the mainstream: you're transported from the art world into the popular consciousness and your work is exposed to the public, as opposed to just the gallery-going public – two very different animals.

For the background of this pot I did a painterly landscape, the cliché of what most people think art is, and I drew characters from the general public making various statements. In fact, the quotes came from many different people, including one of my own and some from friends and critics. There was 'Hairy Potter', which I think came from the TV presenter Jonathan Ross. 'The People's Princess' was very funny, and came from one of my friends. 'Grotesque Goldilocks' was, I think, from the film director Michael Winner. There's a beautiful one from a transvestite website, from this guy who wanted to watch me on the TV broadcast of the Turner Prize award ceremony. He hadn't told his wife he was a transvestite so when she noticed that something was recording and asked him what it was, he said, 'Top Gear', as that was on at the same time! I thought that was absolutely perfect: the most masculine programme was on at the same time that this transvestite wanted to watch me win the Turner Prize.

The Turner Prize publicity machine was massive and I courted it. I was ideal press fodder because I was very media-friendly. The press was not necessarily about the art, though that didn't bother me. In some ways, my celebrity has had a parallel existence to my work. I think a lot of people who've never seen my work in the flesh know who I am, and that's fine. A lot of people know who Seamus Heaney is, but have never read a Seamus Heaney poem. It's the nature of our culture.

taste and democracy | 2004

Glazed ceramic, 41 × 26 (16⅛ × 10¼)

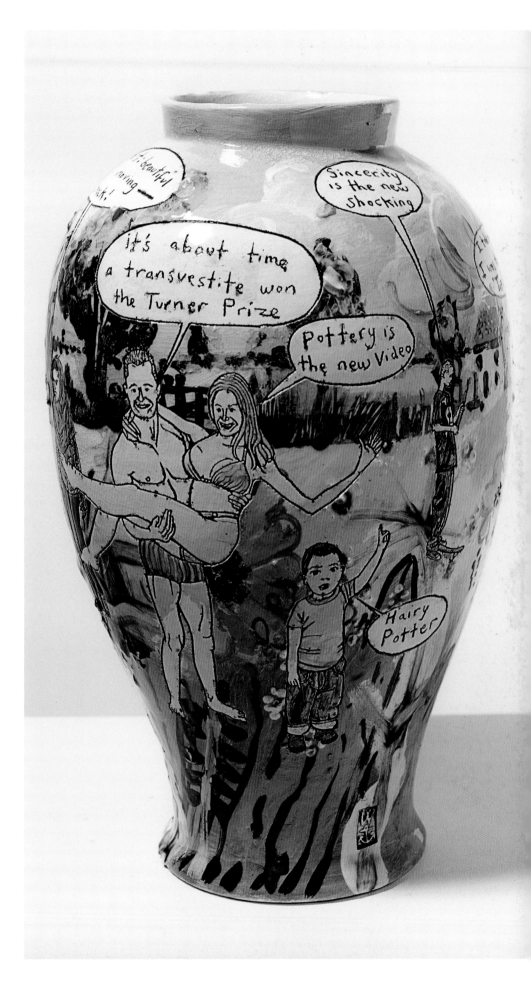

RICHARD OF HOLDINGHAM Hereford Mappa Mundi, *c.* 1300

"**I agreed to give** an art lecture in Hereford because I got it muddled up with Hertford. I'd given talks in both places before, so when I had a letter from a name I recognized I didn't really look closely at the address. When I realized it was in Hereford it was a bit of a pain, because of course it's on the other side of the country from London and meant a day out when I didn't really have the time. In the end, though, I really enjoyed it. I went there on my motorbike and it was nice and sunny.

I went to see the Mappa Mundi in Hereford Cathedral and I was very impressed with it. It's a map of the world as seen by a scholar of the thirteenth century. I decided to do a map of my own universe, as an artist of the twenty-first century, and the obvious transcription was a map of the London art world. It's called *Balloon* as the pot is balloon-shaped, but also because the art world is sometimes full of hot air.

I made all the galleries into churches and the museums into cathedrals, the artists into saints, and the directors and collectors into the clergy. I see a parallel between art and religion: there is the same element of do-goody Sunday afternoons about them both, of being taken to a gallery, like a church, in order to do something 'worthwhile'. So there's Nicholas Serota as the pope, Charles Saatchi as the emperor and the British Council as Noah's Ark. Michael Craig-Martin is a saint turning into an oak tree, St Tracey is in her bed, and Chris Ofili is riding an elephant that's pooing on the Courtauld Institute. Hoxton Square is the Garden of Eden with White Cube as Camelot. I thought of Cork Street as Pompeii, a ruin left over from a previous civilization – the art world of the 1960s and 1970s. I had enormous fun drawing it and thinking about all the parallels.

balloon | 2004

Glazed ceramic, 82.5 × 45 (32½ × 17¼)

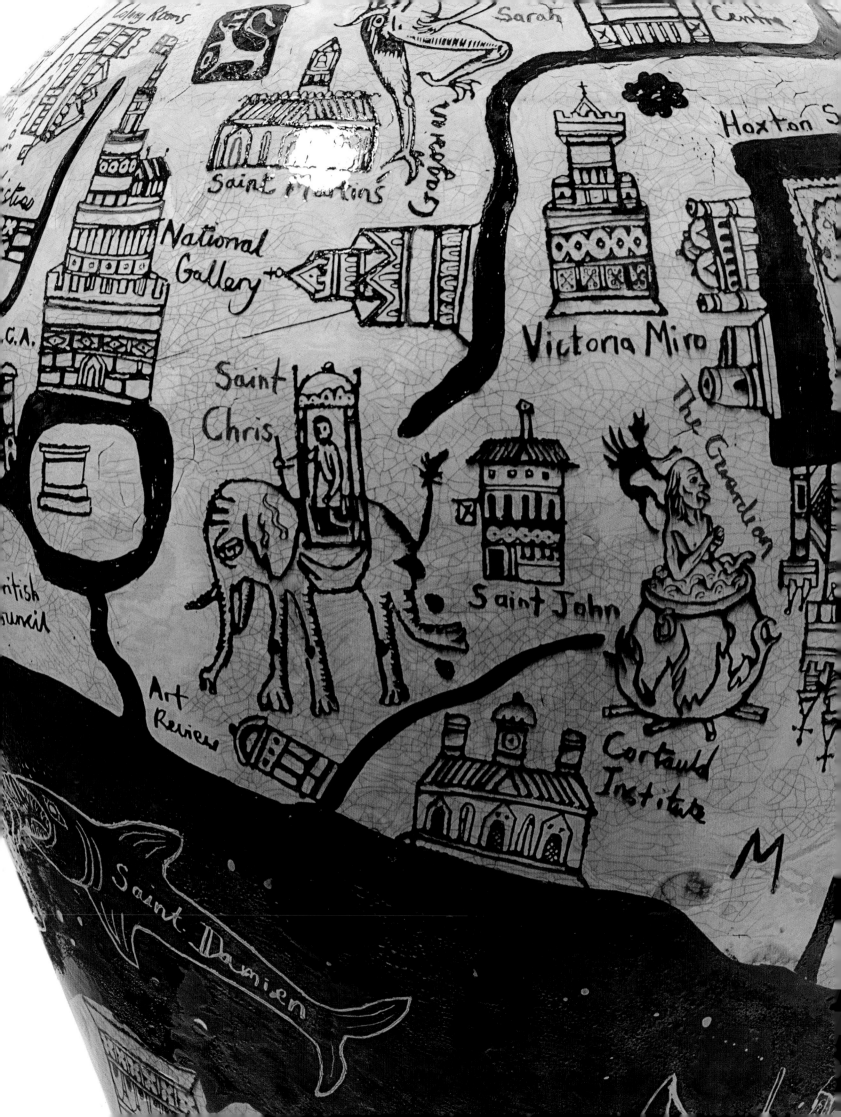

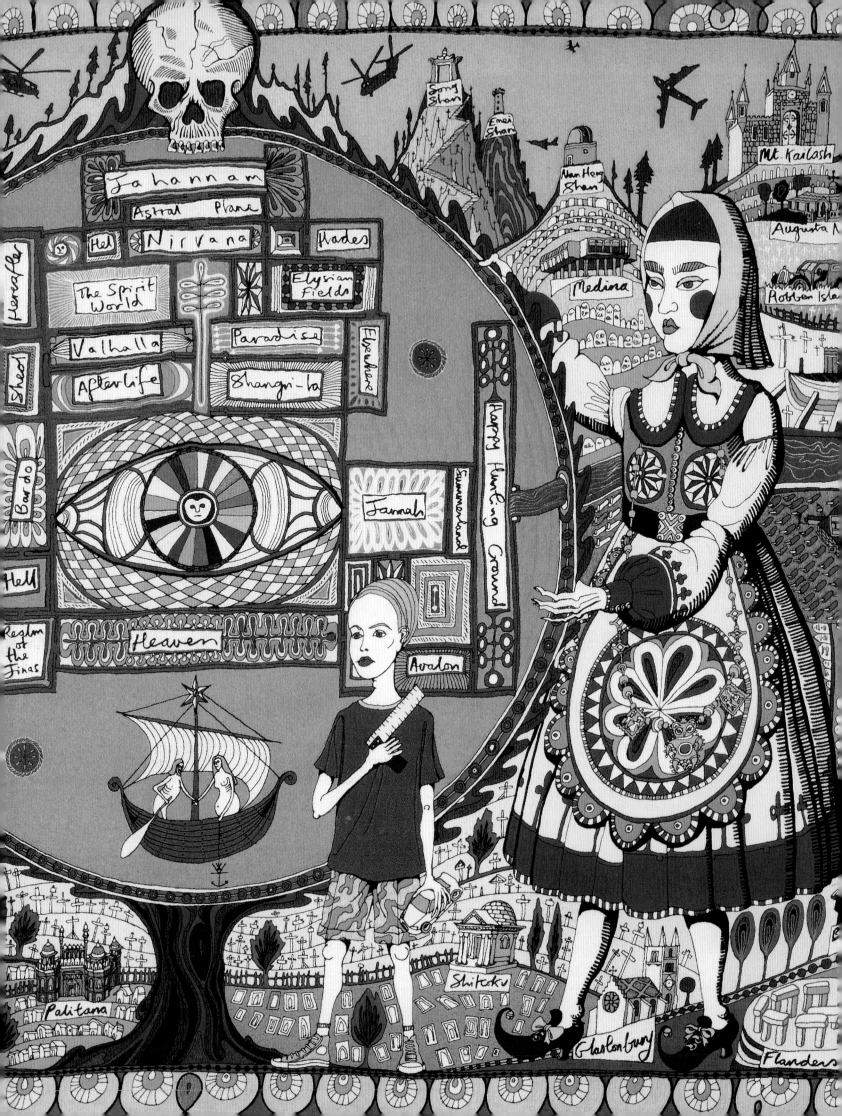

chapter 9 pilgrimage

'Pilgrimage is a vivid physical manifestation of devotion. Part penance, part holiday and part exploration (of the self as well as the world), it's a great metaphor for our lifelong search for meaning.'

Grayson Perry's fascination with the rituals and artefacts of religion has inspired a significant body of work touching on the idea of pilgrimage or spiritual journeys.

From the time of his own first pilgrimage, to the shrine of Our Lady of Guadalupe in Mexico City in the late 1980s, Perry has been fascinated by what it is that gives sacred objects and sites their particular resonance, and by what entices people to 'go to all the trouble of rolling across India or walking across Tibet to be in the presence of a significant object'. As a great lover of the hand-crafted artefact, he admires the human instinct that still yearns, despite the glut of knowledge and visual imagery available in our digital age, to be in the physical presence of an object.

Perry has since embarked on further pilgrimages, cycling in 2003 from Biarritz along the classic pilgrim trail through northern Spain to Santiago de Compostela, and in 2007, again on his bicycle, making the journey from Sussex to Madrid, taking in Lourdes and Chartres, a trip made partly in homage to Kenneth Clark's landmark 1969 television series, 'Civilisation'. For Perry, the arduousness of these expeditions added to their potency and meaning. 'Chartres Cathedral', he points out, 'looks much better when you've cycled there in the burning sun, spying it on the horizon with that great sense of anticipation, than if you'd just stepped off the train.' These real-life journeys have fed back into his art, and alongside Perry's enigmatic pilgrim pair, *Our Father* (pp. 190–91) and *Our Mother* (p. 192), he has created his own souvenirs: a headscarf showing the aspirational career path of the budding artist and a portable reliquary for London's greatest art shrine, Tate Modern, made in tribute to the mementoes and trophies that line pilgrim routes the world over (p. 259).

It was Perry's creation of a customized motorbike, the *Kenilworth AM1*, however, that launched his most intense and prolonged exploration of the practice and symbolism of pilgrimage (p. 258). Named in honour of his teddy bear, Alan Measles, the bike-cum-travelling-shrine was made not only to gently scandalize (its über-kitsch pink-and-blue design bedecked with the ultimate anti-macho slogans of 'Patience' and 'Humility'), but also to take Perry and Alan on their own journey, from his birthplace in Chelmsford to its twin town of Backnang in Germany. The pilgrimage, called 'The Ten Days of Alan' (also dubbed 'Operation Dirndl'), took place in September 2010 and included the rather unorthodox sites of the Nürburgring racing circuit, the castle at Neuschwanstein – featured in the 1968 children's film *Chitty Chitty Bang Bang* – and the Steiff teddy-bear factory at Giengen. Along the way, Perry stamped the guidebooks and pilgrim passports of the travellers he met with an image of Alan as a mini-Pope (p. 261), and charted the voyage and its aftermath through his newly set-up blog and Twitter feed.[1]

Safely returned from its German jaunt, the *AM1* would become one of the central exhibits in a major exhibition Perry curated in 2011 at London's British Museum, the UK's most popular cultural attraction.

Two years in the making, the exhibition carved, as he put it, 'a narrow pilgrimage trail across [the] infinite plain'² of the museum's encyclopaedic collections. The works Perry selected from the institution's stores, chosen chiefly on the basis of the similarities they suggested with his own interests, such as transvestism, teddy bears, tombs and maps, were shown alongside more than a dozen new works of his own and as many older pieces, most of them inspired by the idea of the sacred journey. Among the exhibits were his ink-and-graphite drawing *Pilgrimage to the British Museum* (p. 263), the pot *A Walk in Bloomsbury* (p. 272), mapping Perry's own excursions between his central London home and the museum, and the monumental *Map of Truths and Beliefs*, a vibrantly coloured tapestry plotting mythical, spiritual and earthly sites, from Avalon and Nirvana to Stonehenge and Graceland, which he has described as 'my mad map of pilgrimage' (pp. 256–57).

Perry encouraged visitors to the exhibition, as his opening wall text urged, to consider themselves 'real pilgrims'. He packed the gift shop with a fulsome range of merchandise for the visiting traveller to take home: tapestry kits and pendants, key chains, fridge magnets and another of his headscarves, this one embellished with an Alan Measles-shaped map of the museum floorplan (p. 260). Contributing to everything from the education programmes to the tea menu in the museum restaurant, Perry variously performed as oracular saint, giving talks and lectures, as High Court judge, selecting 'stunt double' bears to sit on the *AM1* for the duration of the show, and as proto-spiritual healer, running an A-level study day and a workshop for the visually impaired. For one of the exhibition sponsors, luxury goods company Louis Vuitton, he designed a special pilgrim's trunk, the *LVAM1*, a sort of leather winged altarpiece made as the ultimate high-end suitcase for the twenty-first-century cultural tourist.

It was in the British Museum exhibition, too, that Perry raised to new heights his earlier, playful idea of a civilization built around the religion of Alan Measles. Now, he revelled in the opportunity to 'insert' Alan into the museum as a fully fledged cultural divinity sitting alongside the dozens of others represented in the collection. Alan appeared not only as a pope but as a Japanese warrior-god, a deity in a folk shrine, an irascible tomb guardian (p. 262) and a crotchety Greek god (p. 171). Encouraging viewers to take their appreciation of his war-scarred teddy bear to the level of cult worship, Perry even gave Alan his own religious mantra: 'Hold Your Beliefs Lightly'.

But religious pilgrimage to revere the world's deities is only one of the forms of spiritual journey that

Above | Grayson Perry on the road to Santiago, 2003
Right | GRAYSON PERRY *LVAM1*, 2011.
Leather, wood, brass and felt, 160 × 120 (63 × 47¼)

has inspired Perry in his work. As he approached his fiftieth birthday in 2010, Perry clearly began to look back over his work and to take stock. In the process, he decided to include in his British Museum show a series of works made at the very start of his career, including his 1983 tower sculpture and a ceramic coffin crafted two years later containing his own ponytail. The journey being narrated here was, at least in part, Perry's own midlife voyage of self-discovery. His work from 2009 onwards started to exhibit a greater sense of ambition, and to reflect his growing sense of self-confidence as an artist. Where viewers had witnessed in his 2007 *Personal Creation Myth* the fanciful birth of Alan Measles (pp. 186–87), now in *World Leaders Attend the Marriage of Claire Perry and Alan Measles,* made in 2009, they were offered the spectacle of Perry's male and female alter egos at last brought together in symbolic union (p. 271). In *The Near Death and Enlightenment of Alan Measles* (pp. 274–75), Perry's stand-in is seen transforming from hot-headed warrior to wandering holy man, a transformation mirrored by the artist himself in his own journey from on-the-fringes rebel to much-loved cultural guru.[3]

This sense of personal evolution has played out in Perry's practice more widely, and a number of his most important works have focused on the notion of life's journey. Among these is *The Walthamstow Tapestry,* an exuberant 15-metre-long tableau navigating the seven ages of man through the consumer brands that endlessly impinge on our collective consciousness (pp. 267–70). *The Vanity of Small Differences* (pp. 276–79), another major tapestry work, similarly marks the journey of a life, telling a story of class mobility through its protagonist Tim Rakewell, a homage to William Hogarth's doomed hero from *A Rake's Progress*. Across six scenes, we move from the front room of Tim's great-grandmother in a Sunderland council house via 'the sunlit uplands of the middle classes' to witness his eventual demise in the gutter after crashing his Ferrari. And the British Museum show itself, named for its central artwork, the *Tomb of the Unknown Craftsman,* told the story of the ultimate journey we must all take, from life to death. Laden with artefacts and reliefs, mysterious bottles and effigies, the sculpture powerfully captured the cluttered detritus of a life (pp. 264–65). Something of a visual pun – the ship 'the craft of the craftsman' – Perry's cast-iron monument also spoke with serious intent of ageing, death and the afterlife. As D. H. Lawrence's poem 'The Ship of Death' – an excerpt of which Perry included in his display – mournfully narrates, 'We are dying, we are dying, so all we can do / is now to be willing to die, and to build the ship / of death to carry the soul on the longest journey.'[4]

Left | British Museum gift shop, 2011
Above | GRAYSON PERRY Desk ornament of
Alan Measles, sold at the British Museum, 2011.
Pewter, 6 × 9 × 3.5 (2½ × 1½ × 3½)

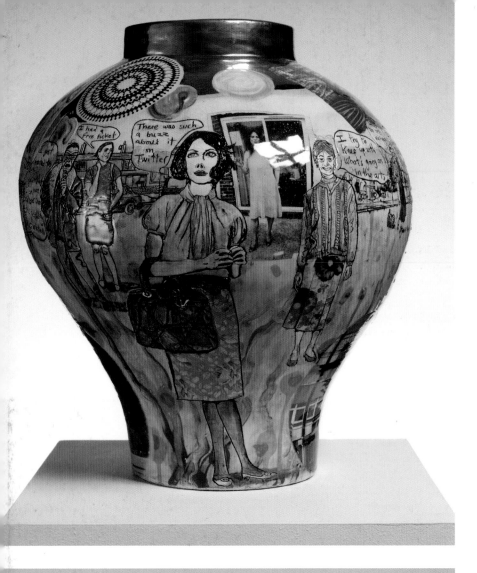

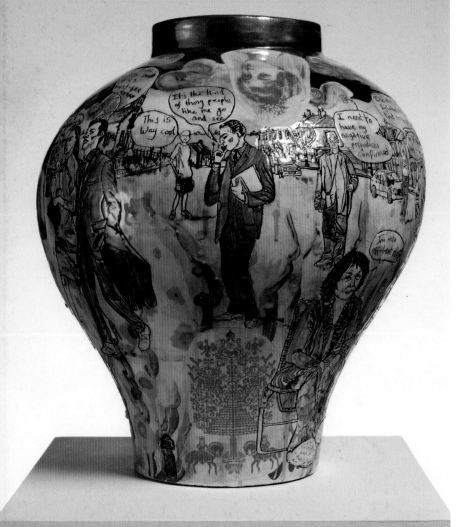

66 **This pot was** displayed at the very start of my exhibition at the British Museum in London, in the autumn of 2011. It was one of the final things I made for the show, and was quite a light-hearted, last-minute thought. It was about making people realize that they were part of the exhibition – and also about pre-empting their possible criticisms! The idea of pilgrimage was implicit. I wanted people to think on one level about how they were making a pilgrimage to the show, and how I was conscious of all the possible reasons why they might have come. Also, it was to say that this wasn't a regular show but was open to interpretation in different ways, so the visitor's interpretation was every bit as valid as mine. And lastly I wanted to flag up that the show you were about to see was a little bit funny. It was a cheeky way of saying, 'I've got your number', but also, 'Welcome, you are part of it!'

There's a guy saying, 'I need to have my negative prejudices confirmed' and a woman who says, 'There was such a buzz about it on Twitter'. But there are also quite innocent things like, 'It's on my A-level syllabus', 'I had a free ticket', and 'I'm into off-beat stuff'. That last one was my favourite, as it so perfectly sums up a section of the audience! But you should never despise your public, of course.

you are here | 2011

Glazed ceramic, 43.5 × 39.2 (17⅛ × 15⅜)

the rosetta vase | 2011

Glazed ceramic, 78.5 × 40.7 (30⅛ × 16)

"One of the first things people saw in the BM exhibition was a wall text saying, 'Don't look too hard for meaning here.' It's a natural instinct that our brains want to understand the world. I'm more interested, though, in supplying clues so that people can join up the dots themselves.

The most famous object in the BM is the Rosetta Stone, which helped to interpret Egyptian hieroglyphics. This vase purports to explain or decode the exhibition, but it was really just a place for me to list mischievous little headings around which the show might or might not be arranged. On one side there's a figure of the artist as a kind of anatomical drawing. Over the heart I've written 'Career Enhancement' to teasingly suggest that the whole thing is intended to move forward my career – which of course it has done, remarkably well! On the other side there is a tree, which is the institution, and little phrases like, 'Hold your beliefs lightly', and 'Craftsmanship in the digital age'. It's got many of the key ideas that held the show together, but not in an easily readable form: in fact, if anything, it's mystifying rather than demystifying.

In many ways I think this was the nicest vase in the show. It was used as the 'lead image', so it was up on the Tube, in magazines, and on banners outside the museum. Right in the middle of the exhibition poster were the words 'Iconic brand', which of course the BM is itself; that was very satisfying to me.

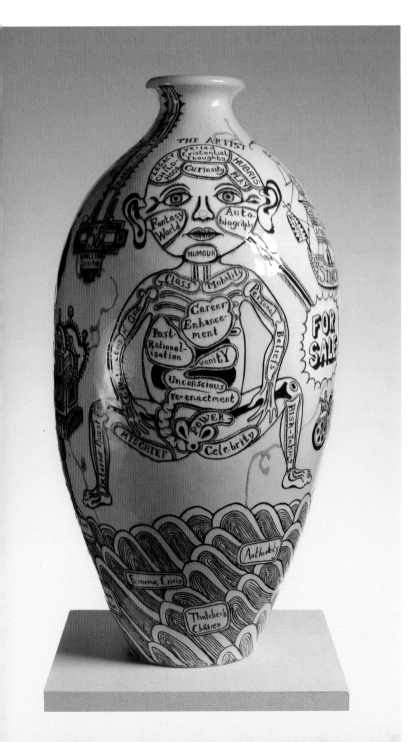

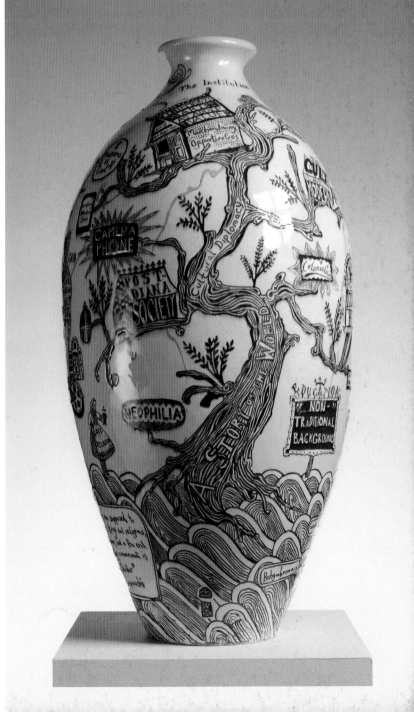

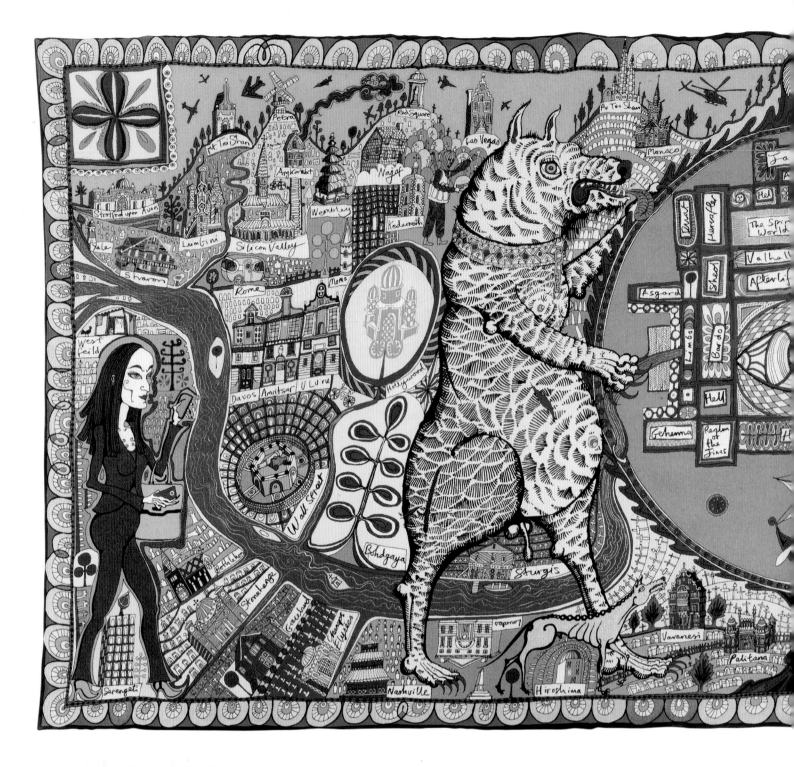

map of truths and beliefs | 2011

Wool and cotton tapestry, 290 × 690 (114¹/₈ × 271¹/₄)
EDITION OF 7 PLUS 2 ARTIST'S PROOFS

"I wanted to make a sort of altarpiece, a map of heaven. I looked at the floorplan of the British Museum as a mandala, and added all the different terms I could find for the afterlife. The charge of it is in the clash of the prosaic and the spiritual. I was thinking of pilgrimage in a wider, non-religious sense, so I included places of pilgrimage that I'd googled. Most are religious but many are historical and secular. In the centre is an eye, where the Great Court of the BM is, which is also where my exhibition was. Alan Measles, my teddy bear, is in the middle of the pupil, as the god.

The female figure at the far left represents the aggressive consumerism of modern life: she has a black trouser-suit, two iPhones and straightened hair. The boy at the centre is innocent logic. He's got his set-square, his toy car and camouflage trousers; he's trying to make sense of the universe. The bear is a wild, emotional vision of the world and the woman opposite in folk costume represents tradition. Between them they hold in balance the two things: raw creativity and

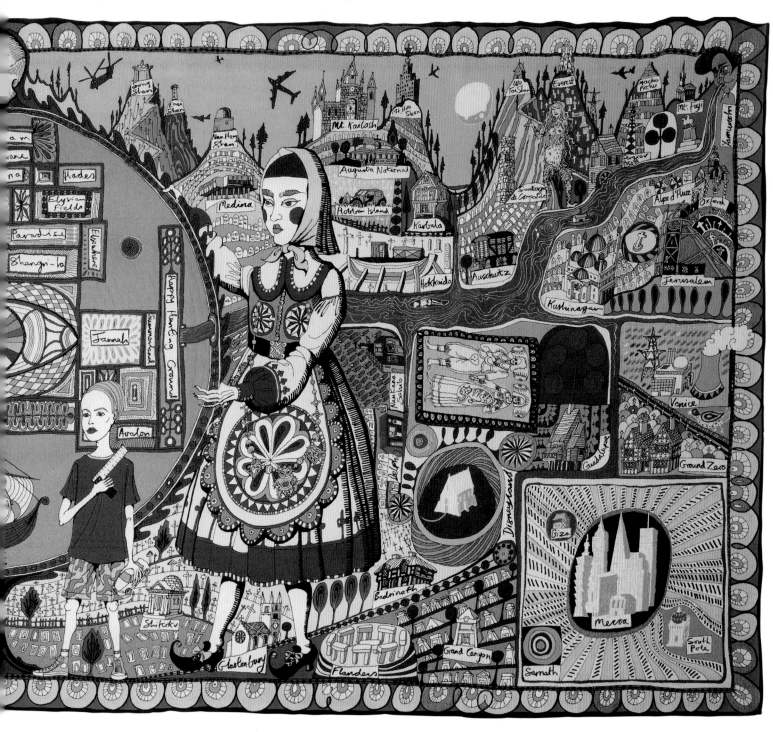

The tapestry contains many embroidered place labels including: Hades, Elysian Fields, Paradise, Shangri-la, Jannah, Happy Hunting Ground, Avalon, Medina, Robben Island, Augusta National, Karbala, Hokkaido, Auschwitz, Mt. Kailash, Mt. Hua Shan, Nan Heng Shan, Song Shan, Wu Tai Shan, Everest, Machu Picchu, Mt. Fuji, Xanadu, Santiago de Compostela, Alpe d'Huez, Oxford, Jerusalem, Kushinagar, Venice, Guadalupe, Ground Zero, Giza, Mecca, Sarnath, South Pole, Disneyland, Grand Canyon, Flanders, Glastonbury, Badrinath, Shikoku, Nan Kara Saihō

sensuous desire, and the rules of society. Together they carry the disc of belief.

The style of the tapestry relates to the Outsider artist Adolf Wölfli, and a picture of his that I saw in a book. The other starting point was a very beautiful embroidered shawl from the V&A collection showing a map of an Indian town.

The Kashmir Shawl (embroidered map of Srinigar), Kashmir, India, late 19th century

ADOLF WÖLFLI *Cambridge, 1,483,000 Souls*, 1910

kenilworth am1 | 2010

Custom motorcycle, 159 × 275 × 126 (62⅝ × 108¼ × 49⅝)

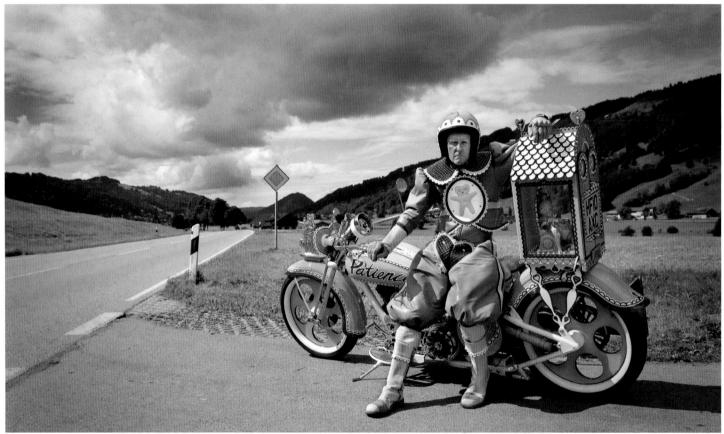

Perry and the *Kenilworth AM1* on the Alpenstrasse, near Füssen, Germany, 2010

" I have always loved custom bikes and in around 2008 I found myself with enough money to have one made. My bike is a sort of mobile chapel to Alan Measles: it's his Popemobile. I wanted it to be slightly antagonistic to normal biker aesthetics, so instead of macho images of flames and nude women I did something pink, girly and playful. The words on the side of the tank, Patience and Humility, are a provocation to the thrusting maleness of biker culture. There are lots of jokes in the bike: so for example, the saddle is like a huge cock-and-balls, and there's a large lacy ejaculation going up the tank. I had lots of fun designing it.

The bike represents a crux moment in my imaginative framing of Alan. At the front, there's a reprise of him as military hero, a mascot of masculinity, as a sculpture on horseback – but at the back he's become a more passive guru or holy man. This is his narrative. It also reflects myself, of course, and my journey from angry young man to older, perhaps slightly wiser, person.

Bodyguard's Jacket, 2010. Leather costume, 77 × 60 (30¼ × 23⅝)

Bodyguard's Helmet, 2010. Polycarbonate, metal and textile, 29 × 26 × 27 (11⅜ × 10¼ × 10⅝)

tat moderne scarf | 2009

Silk, 90 × 90 (35⅜ × 35⅜)
OPEN EDITION

tate modern reliquary | 2009

Display box containing fragment of original work by Grayson Perry.
Relic: 8 × 5.2 × 2.1 (3⅛ × 2⅛ × ¾); display box: 10.2 × 7.6 × 2.8 (4 × 3 × 1⅛)
OPEN EDITION

We look at art in a way that was formed by religion. We go to special buildings where we venerate special objects. So when I was asked to make some gifts for the Tate Modern shop, I approached it like it was the cathedral of contemporary art. Having been to Lourdes and Santiago, I thought about the sort of souvenirs you pick up, such as pilgrim badges, and I wanted to make my equivalent of those. I was keen that the gifts would be easy to carry, so I made a headscarf and a reliquary, both of which you can wear around your neck as a marker to show you've been to this place.

For the scarf I was thinking about a map or journey. In the war, RAF pilots had silk maps sewn into the lining of their flying jackets that could be used to help them escape if they got shot down. That was my starting point. This map shows you how to get to Tate Modern – not geographically, but in your career. So it starts with childhood play and an inspirational teacher, going via teenage pupation and art school, on to group and solo exhibitions, recording all the milestones of an art career. The landmarks along the way are famous artists, each with quite teasing attributes representing their 'brands'. There's a yurt for Joseph Beuys, a urinal for Marcel Duchamp, a spiritual candle for Anish Kapoor, a factory for Damien Hirst, a handbag for Takashi Murakami.

Some of them are more cheeky than others, so I've got Banksy, Beryl Cook and Jack Vettriano living in neighbouring terraced houses. The journey ends at 'Tat Moderne', in the middle.

With the reliquary, I was thinking about artists as the saints of the modern art gallery. Cheekily, you could say that I'm one of the saints myself. So the relic you get is a piece of one of my pots. I took several vases that weren't quite up to my standard but that I still had knocking around the studio and I broke them into thousands of pieces. Then we made little reliquaries for the fragments as pilgrim souvenirs, each with a crude image of Tate Modern stamped on the front.

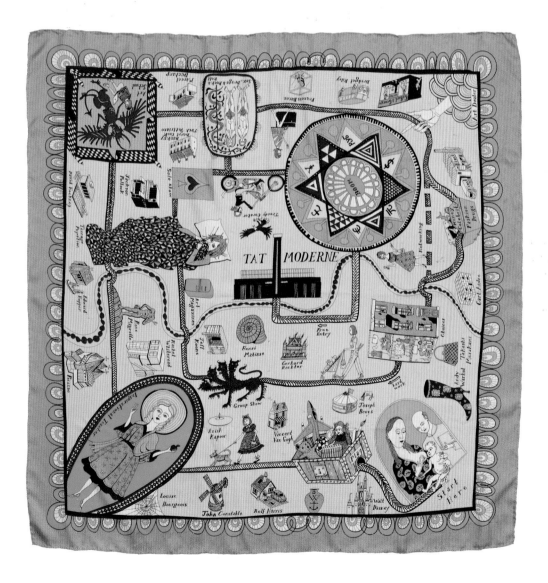

british museum map scarf | 2011

Silk, 90 × 90 (35⅛ × 35⅛)
OPEN EDITION

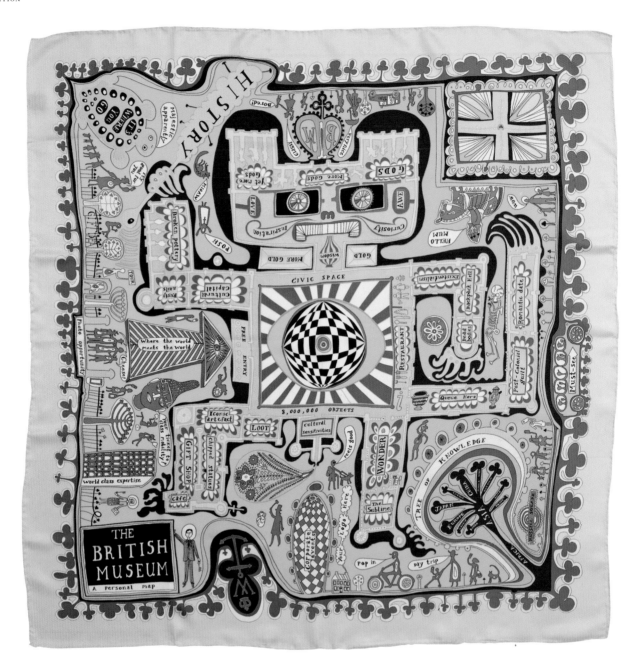

As part of the whole experience of putting on an exhibition at the British Museum, I wanted to play with the context of what a museum show is, to look at what the expectations are, right from the banners outside to the publicity around it and the merchandise sold in the gift shop. So I designed a whole range of things for the shop, from mugs, tea towels and bags to jewelry, badges and a headscarf. The scarf was similar to the one I'd made for Tate Modern [p. 259] but a bit more kind-hearted, as the BM is such a nice place. It's more innocuous than the Tate scarf, too, as it was made for a wider audience – not just students and the art crowd but what I regard as my older, middle England, National Trust, BBC Radio 4 kind of audience.

It shows a map of the BM in the form of a monster Alan Measles. It has little facts about the museum on it, such as '8,000,000 objects', 'Russell Square', 'Dead bodies' and 'Chipped statues', but it includes some cheeky phrases too, like, 'Your ticket to class mobility?', 'Corporate events', 'Backpack hell', 'Photo opportunity', 'Gods', 'More Gods', 'Yet more gods'. There's a tree of knowledge whose trunk and branches are the geographical regions from which the museum's artefacts have come, and a jade tortoise in the corner, which is one of the collection's highlighted objects.

pope alan stamp | 2010

Ink on scrap paper, stamp size 12.5 × 10.1 (4⁷⁄₈ × 4)

As soon as I started to think of my motorbike as an artwork rather than just my 'ride', I knew it had to go on a journey somewhere. I didn't just want it to be a motorbike; I wanted it to be an artefact that had a function. The obvious place to go was Germany, because Alan had fought the Germans in my imaginary childhood games. It was time for a reconciliation.

I could immediately list half a dozen places I really wanted to visit, such as Neuschwanstein, where they filmed *Chitty Chitty Bang Bang*; Colmar, where the Isenheim Altarpiece is; the amazing Rococo Wieserkirche that Kenneth Clark visited in 'Civilisation'; the Nürburgring; the Steiff teddy-bear factory. We made the trip in the autumn of 2010, and I called it 'The Ten Days of Alan'. I took along a Chaucerian band of friends and we set out from Chelmsford, where I'm from, taking a message of goodwill from the Mayor and Mayoress to Backnang, a town near Stuttgart that's twinned with Chelmsford.

I made this stamp for the pilgrimage. I wanted something that could easily be transferred to a scrap of paper or a book, to make a little instantaneous artwork. The trip was literally a cultural exchange because by complete chance we went to Bavaria, where the current Pope was born, at exactly the same time he came to Britain. So here is Alan as a little Pope. The idea came from the Buddha stamps I'd seen at the BM, which were printed on prayer flags in Tibet.

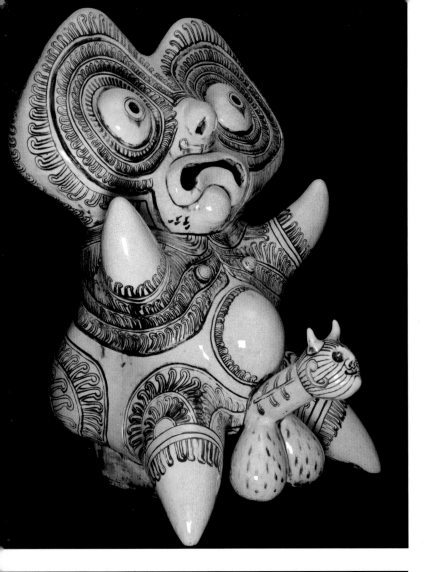

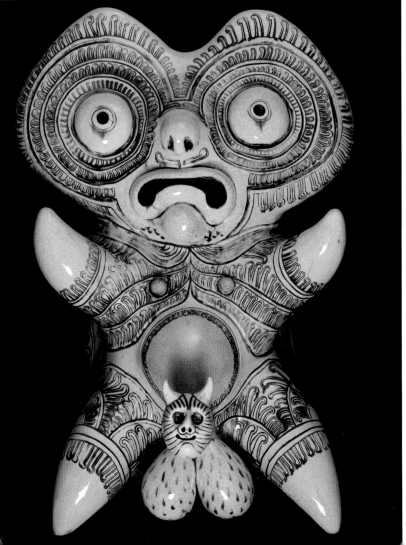

tomb guardian | 2011

Glazed ceramic, 77 × 60 × 60 (30¼ × 23⅝ × 23⅝)

" **My exhibition at** the British Museum was originally going to be in a single room, so I wanted to have a tomb guardian to confront the visitor at the entrance. I was inspired by the large ceramic monk-like figures up in the Chinese galleries. I was also fascinated by Sheela-na-gigs: figures found in early Irish and British churches that show a woman holding open her vulva. They probably come from pre-existing fertility cults, or they might be warnings against female lust. It's interesting that such a blatant sexual image was part of the Catholic Church. Similarly, in ancient Greece, at thresholds they would have pillars called herms with a head on top and a phallus half way down, and people used to rub them or put milk on them for good luck.

It's slightly out of step with what I normally make in terms of scale and aesthetic: it's really large, and I wanted it to look a bit South American or Aztec, so he's feathered. I also slightly stained the cracklure to give it an old look. I thought it was obvious that it was Alan Measles but lots of people immediately assumed it was an object from the BM collection!

One of my friends told me that when they were at the show, there was an old couple looking at this work. They were completely silent, and then the old woman turned to the man and said, 'Lovely smile'. I quite liked that.

Sheela-na-gig, Kilpeck Church, Herefordshire, 12th century

pilgrimage to the british museum | 2011

Ink and graphite on paper, 60 × 60 (23⅝ × 23⅝)

Early on, I thought about a poster for the exhibition. I wanted to come up with an image that encapsulated what the whole thing was about: putting the reality of the museum and its contents into one's imaginary journey. It came to me in a flash: the British Museum as a Tibetan monastery, to which people would make an arduous journey. I liked the idea of the museum as an isolated holy site, rather than a huge cultural institution in the middle of one of the world's major cities. The only access to it was along this precarious path lined with shrines to Alan Measles. The pilgrim in the foreground is carrying some of the objects that were in the show, including a Russian icon, an African fetish figure and the pilgrim bottle I made.

Neil MacGregor, the BM's Director, said afterwards that his 'History of the World in 100 Objects' had located the collection for people in terms of its history and stories, but that my exhibition had located it in terms of the imagination, showing the BM as a place for people to go to in order to imagine things. That idea appealed to me.

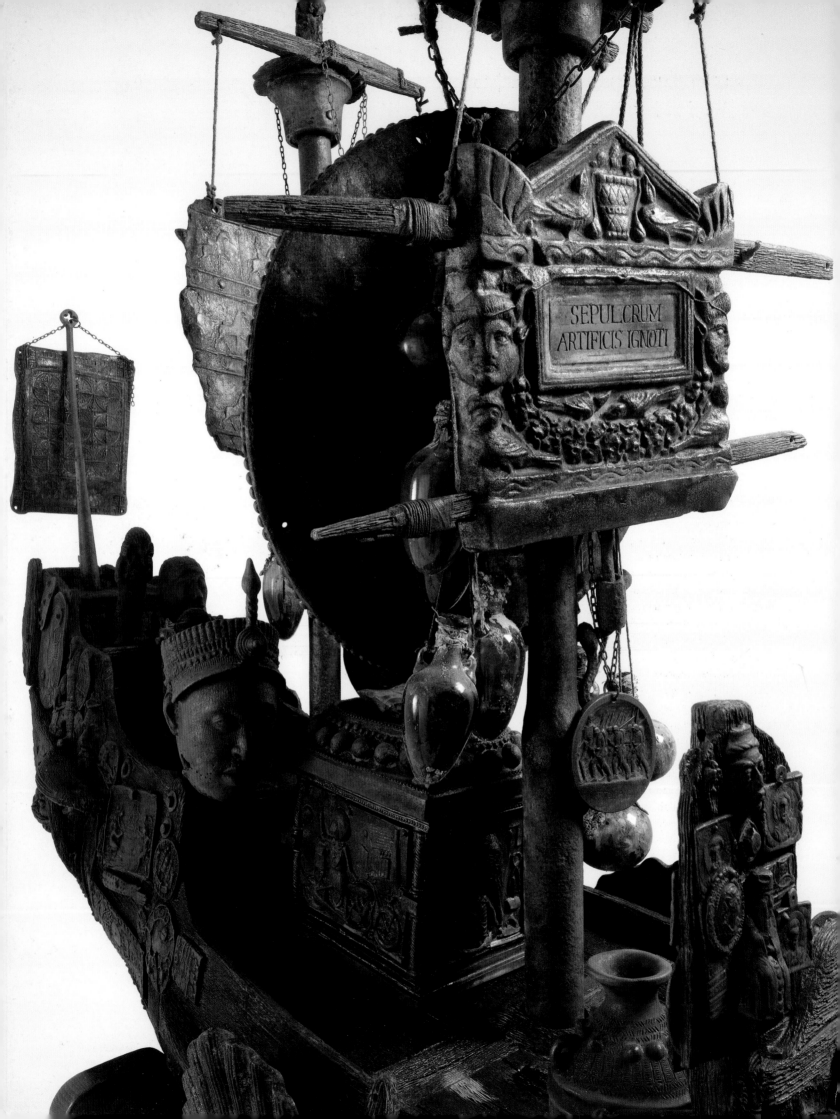

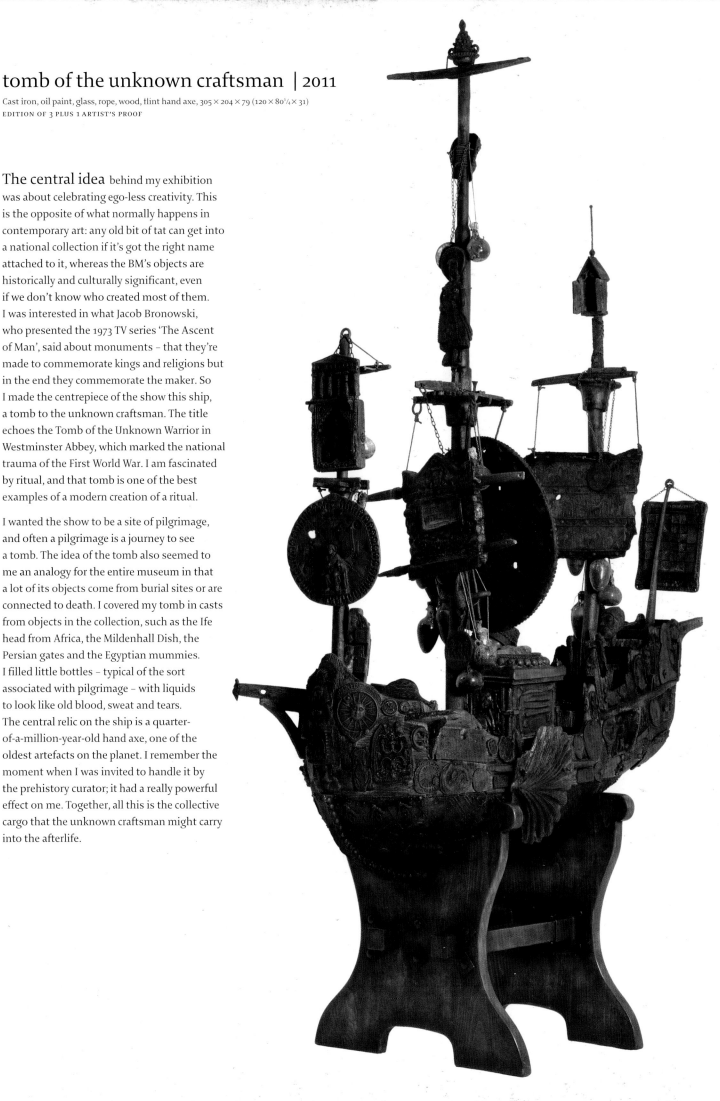

tomb of the unknown craftsman | 2011

Cast iron, oil paint, glass, rope, wood, flint hand axe, 305 × 204 × 79 (120 × 80¼ × 31)
EDITION OF 3 PLUS 1 ARTIST'S PROOF

"The central idea behind my exhibition was about celebrating ego-less creativity. This is the opposite of what normally happens in contemporary art: any old bit of tat can get into a national collection if it's got the right name attached to it, whereas the BM's objects are historically and culturally significant, even if we don't know who created most of them. I was interested in what Jacob Bronowski, who presented the 1973 TV series 'The Ascent of Man', said about monuments – that they're made to commemorate kings and religions but in the end they commemorate the maker. So I made the centrepiece of the show this ship, a tomb to the unknown craftsman. The title echoes the Tomb of the Unknown Warrior in Westminster Abbey, which marked the national trauma of the First World War. I am fascinated by ritual, and that tomb is one of the best examples of a modern creation of a ritual.

I wanted the show to be a site of pilgrimage, and often a pilgrimage is a journey to see a tomb. The idea of the tomb also seemed to me an analogy for the entire museum in that a lot of its objects come from burial sites or are connected to death. I covered my tomb in casts from objects in the collection, such as the Ife head from Africa, the Mildenhall Dish, the Persian gates and the Egyptian mummies. I filled little bottles – typical of the sort associated with pilgrimage – with liquids to look like old blood, sweat and tears. The central relic on the ship is a quarter-of-a-million-year-old hand axe, one of the oldest artefacts on the planet. I remember the moment when I was invited to handle it by the prehistory curator; it had a really powerful effect on me. Together, all this is the collective cargo that the unknown craftsman might carry into the afterlife.

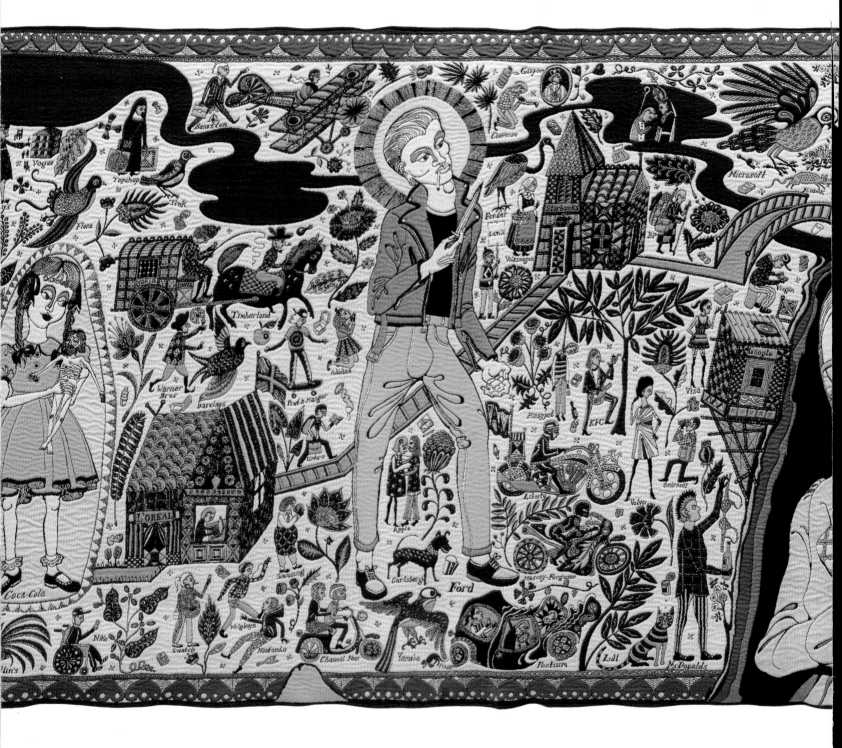

there are lots of jokes in the piece, so for instance Guggenheim is a blind lady being led by Sotheby's as the guide dog; the BBC is an old auntie; Easyjet is someone hanging themselves from a tree, which is what you feel like after you've been on one of their flights. There's a conflict between what you think of each brand, whether there's a good or bad association, and what the image shows.

But it's quite unjudgmental about most of the brands. It would have been easy to make something angry and anti-consumerist, but that wasn't what I wanted.

I was uncomfortable with the idea of someone hand-making another tapestry, as had happened with *Vote Alan Measles for God* [p. 116]. I found out about this technology through Charles Booth-Clibborn, who

publishes my prints. One day he handed me a bit of fabric: it was a section of my print *Map of an Englishman* [pp. 210–11] which he'd put through the loom process. It was a rough scan, but it was enough to intrigue me. He told me about this three-metre loom out in Ghent, and I measured the wall at the Victoria Miro Gallery. The scale was perfect – so that just decided it.

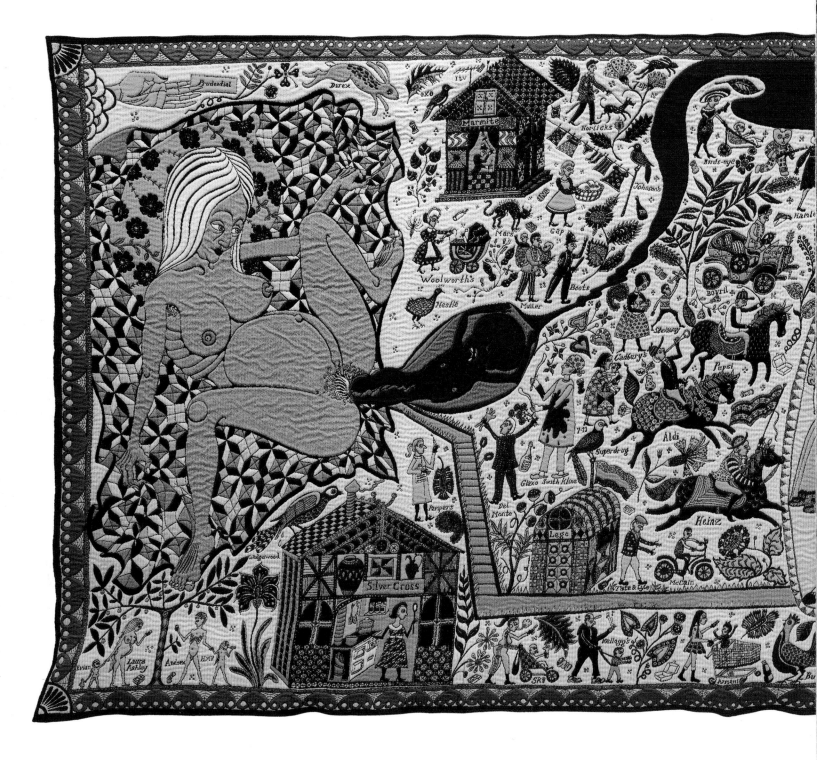

the walthamstow tapestry | 2009

Wool and cotton tapestry, 300 × 1500 (118 × 590½)
EDITION OF 3 PLUS 2 ARTIST'S PROOFS

This was my first really large-scale work. I made it as a sort of backdrop or logo board for the launch of this book. It was a big deal: the first monograph on my work! It sounds trite, but in the past you would have had the heraldry of your lord and master, now you have the heraldry of your sponsor. I was also looking at Giotto and his fresco cycles; I wanted to make something on that scale.

The subject is a take on the journey of life, but seen through shopping. The title references the famous Bayeux Tapestry, which is about the invasion of the Normans. My one is about the invasion of marketing into our heads. It shows the journey from birth to death, via the seven ages of man. Along the way are the brands, like gods, the ubiquitous presences that shape our lives today. I think of

it as the *Guernica* of the credit crunch. I chose the brands that resonate with me, that I feel are impinging on my life, so in a way it's a bit of a self-portrait.

I thought about drawing the brand logos, but I decided to put them all in the same script because then it's a purely emotional, rather than visual, response. Each word is linked to an image, mostly in an arbitrary way, although

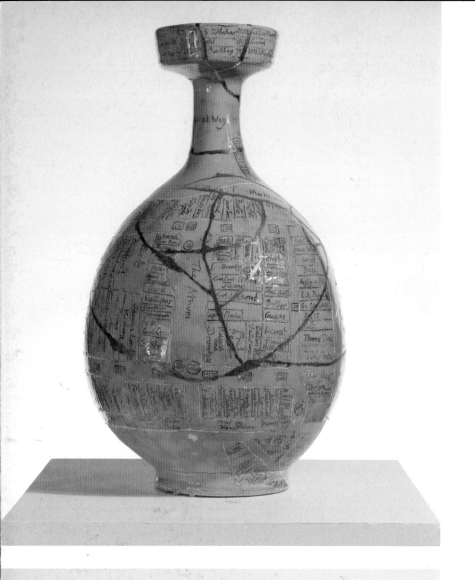

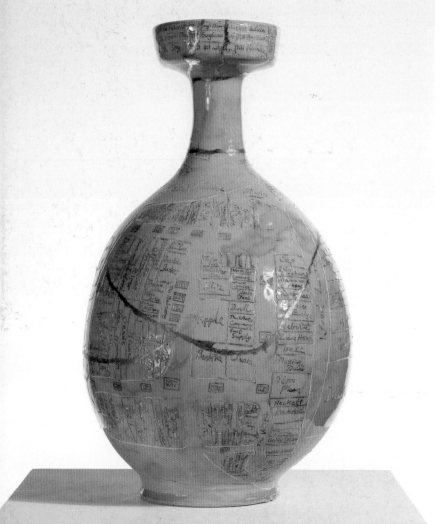

westfield vase | 2009

Glazed ceramic, 67.6 × 39.7 (26⅝ × 15⅝)

 I'd seen a wonderful Chinese or Korean celadon vase at the British Museum, mended with gold lacquer in the traditional way. I love that history of honouring important ceramics. As an object lover, it's great; this is veneration of the object at its most extreme. I wanted to combine that idea with something that really horrifies me. Westfield shopping centre had just opened in Shepherd's Bush, a sort of Death Star of consumerism landed in West London. It opened just as the world plunged into recession; it was beautifully timed. I went along to have a look around. I can remember the first dingy malls in Britain but this was beautifully designed and impressive. It's this very impressiveness that is horrifying and distasteful. It's an enormous sophisticated machine for selling stuff, none of which I would want to buy.

I was also thinking about 'desire lines'. I first heard about this phenomenon talking to someone about garden design. When a public garden is laid out, they often turf over an area and see where the public wants to walk, before putting in a path to follow those lines. I made the pot with a map of Westfield on it, like a circuit board. Then I took it to the studio of my ceramic restorer, Bouke de Vries, where I got a hammer and smashed it. He stuck the pot back together with filler covered in gold leaf. The gold lines represent a kind of alternative map; they are almost desire lines, but desire lines of destruction.

This was by far my favourite ceramic piece in the show I had at Victoria Miro in the autumn of 2009. And I got the gig at the British Museum just when that show opened, so it was a very important time for me.

"This pot was knowingly hubristic. I made it just as I was writing to Neil MacGregor, Director of the British Museum, about having a show there. I was applying to have a sort of one-man culture at the museum, but who am I to do that? That feeling of hubris was partly what informed this pot.

Here are the two very personal symbols of mine: Alan Measles as my positive male self and Claire Perry as my female self. They're getting married: it's like I've finally come to fruition. It's a momentous occasion, and what could mark it better than inviting all the world leaders to come to my folk ceremony? I think I chose the members of the UN Security Council. So there's Gordon Brown and President Obama, Vladimir Putin and Mahmoud Ahmadinejad, Nicolas Sarkozy, Angela Merkel and the Chinese premier, all coming to pay homage. I've got on a folk costume and in the background is a version of the model church I made, and a woman who might be a priestess.

I've got used to being sane. It's been a while since I've had therapy and I'm not the troubled soul I was before. I have much more command of my faculties, and I'm aware of processes and my abilities now. But that can be a double-edged sword; I have constantly to balance out self-consciousness and confidence with being my own worst critic. You've got to do that, however, so as not to just churn out sub-standard stuff. What gives me heart is that when I look back over my work, I quite like most of it! There are very few pieces where I think, I shouldn't have let that one out.

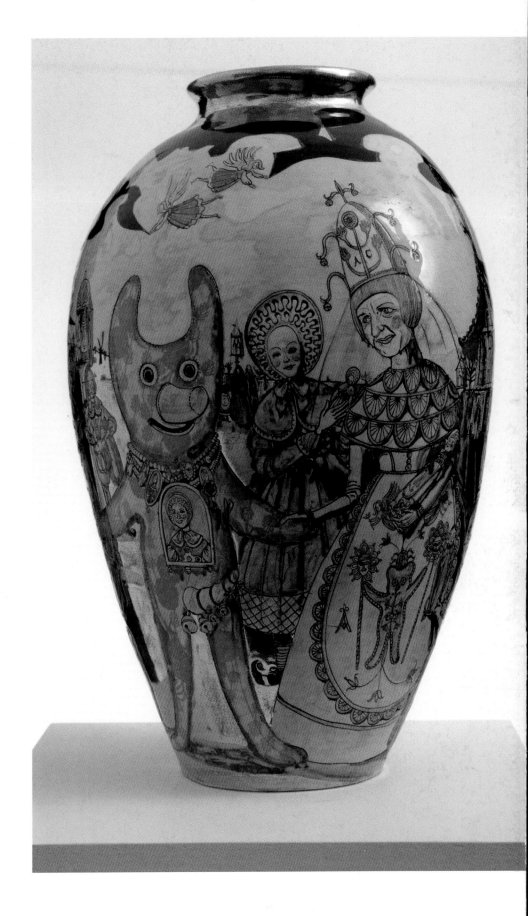

world leaders attend the marriage of claire perry and alan measles | 2009

Glazed ceramic, 52 × 32 (20½ × 12⅝)

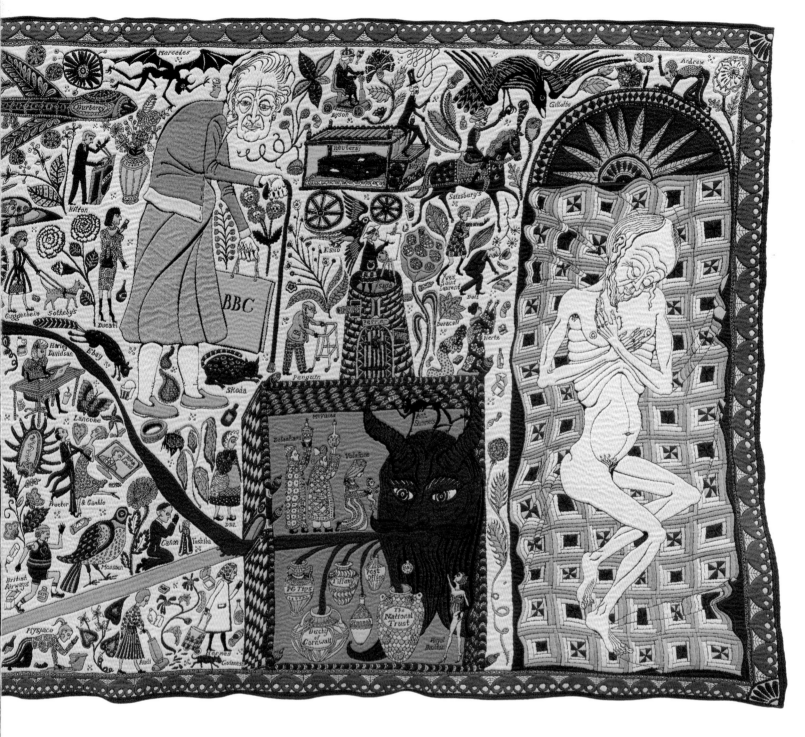

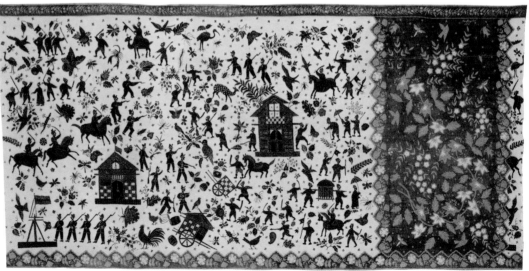

Sarong (detail), signed van Zuylen, Sumatran batik, Pekalongan, c. 1900

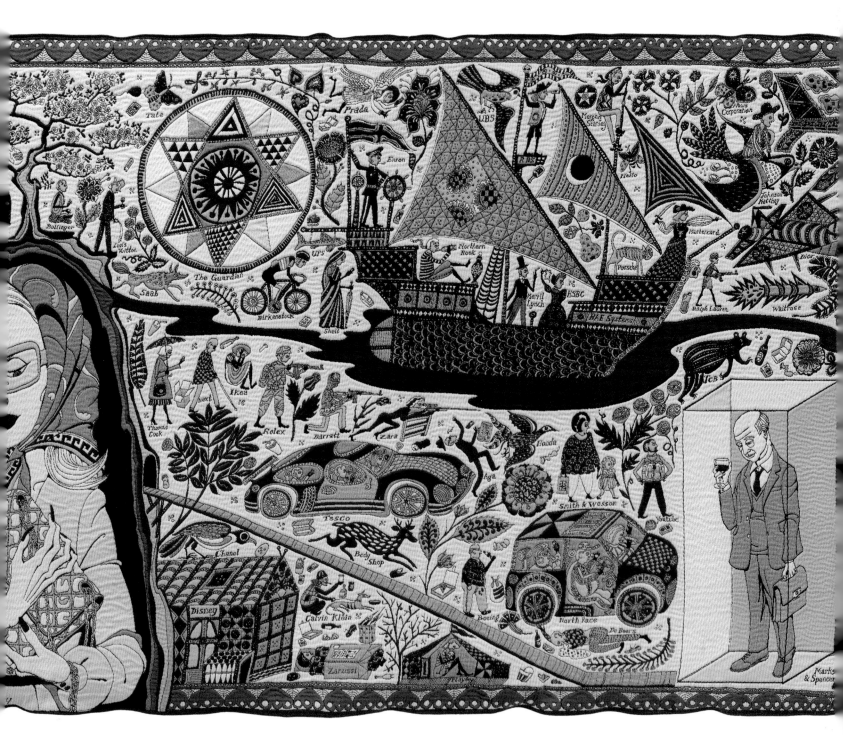

Walthamstow is where my studio is. It's also where William Morris was born, the great champion of things like tapestry, though as handcraft. He would have been horrified by this! Superficially it has the decorativeness of a Morris design, though the composition and style were inspired by Sumatran batiks that I was introduced to by the fashion designer Justin Oh. He showed me a book and one page in particular kicked me off, showing sarongs made in around 1900.

This work had an amazingly good response from the press and the crowds. The number of people who came out to see it at Victoria Miro was incredible; the *Guardian* even wrote a leader piece about it! It's what I call my first 'celebrity artefact'.

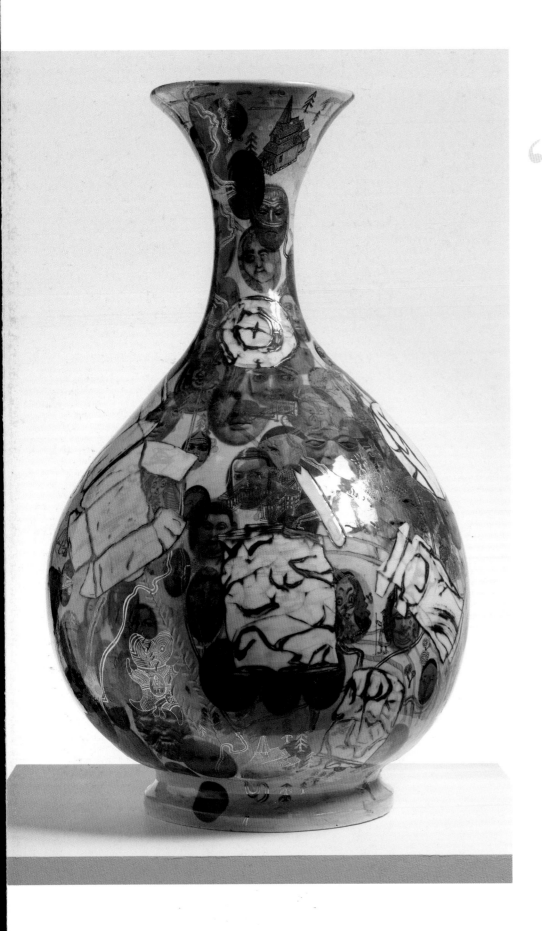

" The British Museum is within walking distance of my house and during the run-up to my show I spent a lot of time travelling there to look at the galleries and stores. Within a few minutes I would go from the litter-strewn streets of central London into a shrine to world culture. This pot is about that journey.

The big white patches are drawings of rubbish; there's a plastic bottle, for example, a cigarette packet and a chip fork. I wanted something that was a useful compositional device but also quite subtle and decoratively rendered. One of the things you realize about the BM is that the minute something gets into the collection it immediately becomes a significant object, even if it's a chip fork or a McDonald's package. So there's an idea that these things are outside the museum and yet the millennia-old equivalent of the same things, within the museum, are revered as sacred. The rubbish dumps of Ancient Mesopotamia have been scoured to create the collection!

The photographic imagery shows the faces of people I've met in this microcosm of the world: they are faces from all cultures and from history, each one taken from something in the museum. I went round snapping the objects as if they were people, and turned them into transfers. On top is a kind of gold map of pilgrimage, with a little drawing of the BM along with churches and shrines, with pilgrims wandering through. The vase represents the different layers of imagination and reality. You've got the literal reality of rubbish and the historical artefacts, and then this fantasy pilgrimage.

The title was the last thing I did. That's a habit of mine; I very rarely work towards a title because I find that unproductive and inhibiting. More often than not, the thing comes into focus and the title is the final thing, the pinhole through which you view the work.

a walk in bloomsbury | 2010

Glazed ceramic, 76 × 47 (29⁷/₈ × 8¹/₂)

i've never been to africa | 2011

Glazed ceramic, 81 × 45 (31⅞ × 17¾)

"I haven't been to Africa, and I feel a bit guilty about that. I'm scared of it, to be honest. In the media Africa is represented as a very dangerous place where you're likely to get shot or kidnapped, get a disease or get lost. Yet it's a place that the British took over, so there's also this post-colonial guilt. I wanted to make a pot that dealt with this difficult issue, because the BM is full of stuff that's been taken from different cultures.

The transfers come from news photographs and old encyclopaedias, and show European visions of Africa. The two sprig-moulded figures are Queen Victoria and Queen Elizabeth II who span the two attitudes to Africa: one ruling in the great period of empire, the other in the era of independence. In the exhibition, we paired this pot with an African tusk carved with figures of Europeans.

These days there seem to be bragging rights for how adventurous you are as a traveller, a sort of tick-box list for the experience junkie. 'Oh, we went white-water rafting on the Zambezi!' 'Oh well, we lived with a Zulu tribe and went hunter-gathering with them!' I only travel for work and thankfully the art world only goes to rich countries; it's nice, comfortable travel. I don't want to eat goat stew out of a rusty pot in the middle of nowhere.

Carved tusk, Democratic Republic of Congo, c. 1901

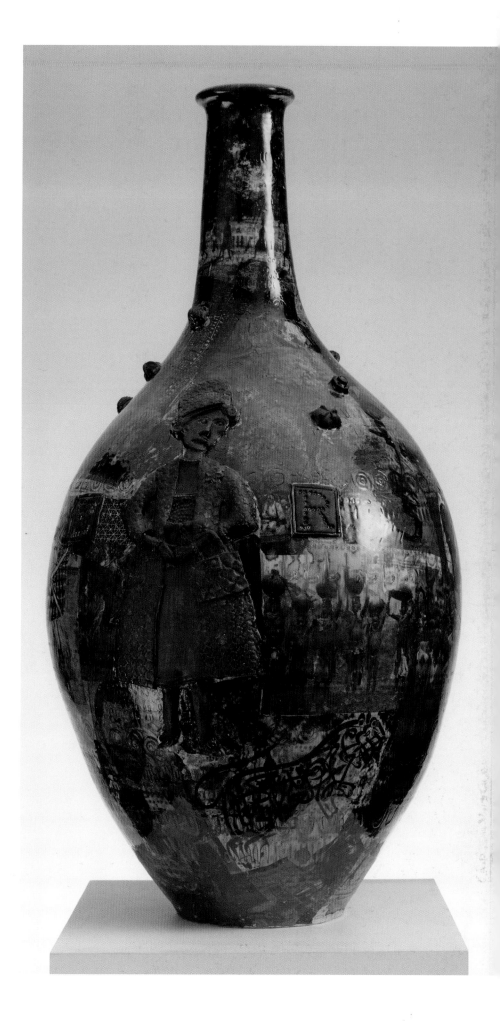

the near death and enlightenment of alan measles | 2011

Glazed ceramic, 42 × 31 (16½ × 12¼)

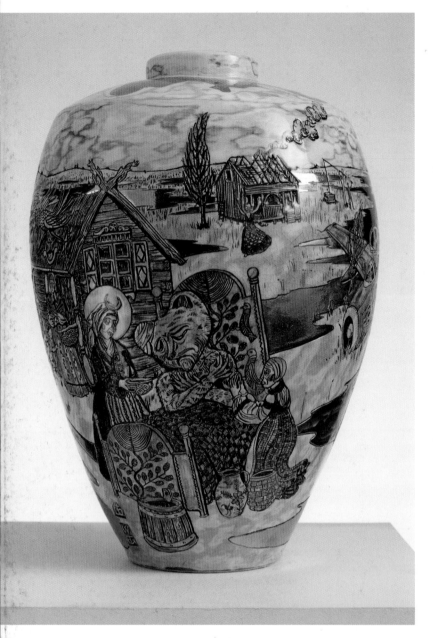 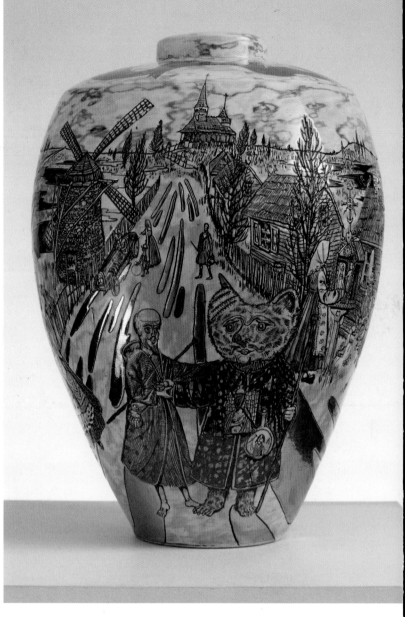

I wanted to document the transformation of Alan Measles on his journey from warrior hero and rebel leader to wandering holy man or living god. I've always been aware that Alan is part of my own self-mythologizing exercise. The greatest self-mythologizer of modern art was, of course, Joseph Beuys, so as a kind of art-world joke I thought Alan should go through a Beuysian moment.

The most famous myth Beuys would tell about himself was that he had crashed in his Stuka in the Crimea during the Second World War. He claimed to have been rescued by Tartar tribesmen who daubed him in fat and felt and brought him back to life. It was only partially true, of course, but it was a great story. So here I have Alan crashing in his jet plane, being pulled from the wreckage by two Latvian

peasant women and nursed back to health by traditional herbal medicines. He's then instructed and enriched by a guru figure before he goes off on his travels around the world as a wandering holy man.

Technically I was very pleased with this vase. I particularly like how the sky turned out, a lovely illusionistic effect that came about by scraping through the layers of slip.

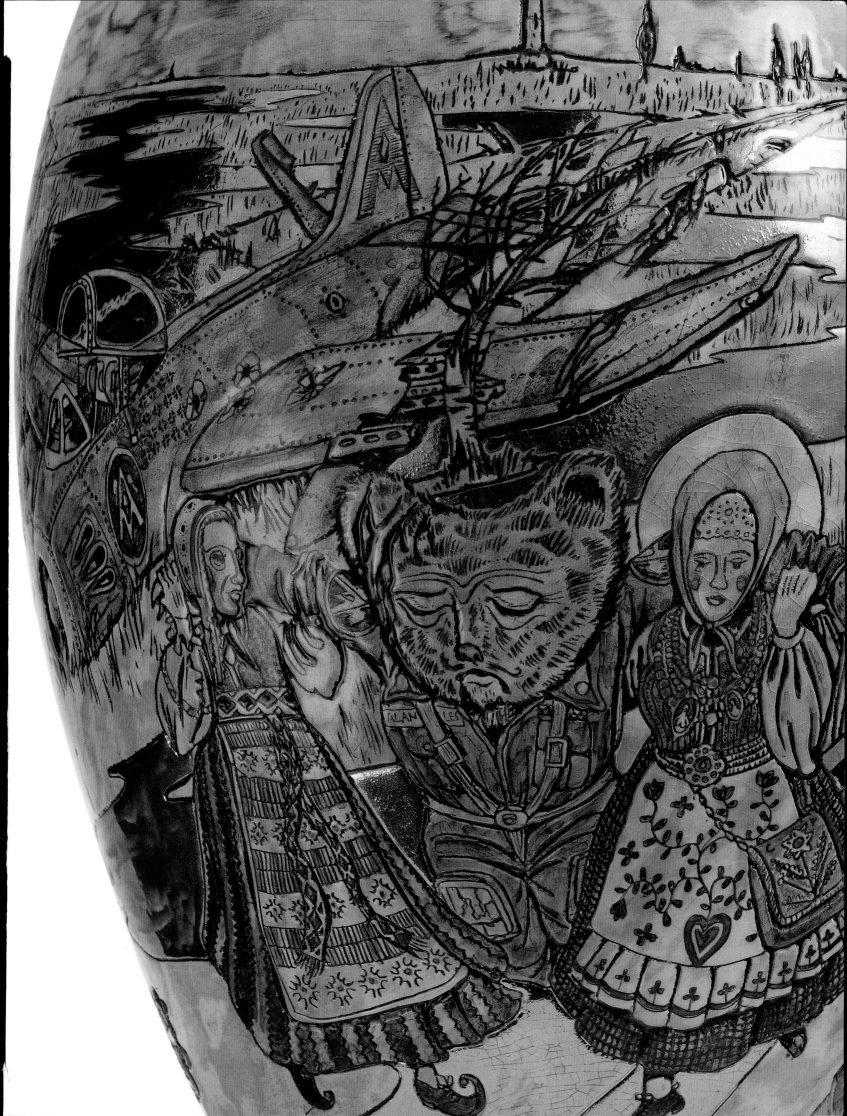

the vanity of small differences | 2012

Wool, cotton, acrylic, polyester and silk tapestry, each 200 × 400 (78¾ × 157½)
SIX TAPESTRIES, EACH AN EDITION OF 6 PLUS 2 ARTIST'S PROOFS

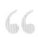

I've made a few documentaries with Neil Crombie over the years including 'Why Men Wear Frocks', about transvestism, and 'Spare Time', about people's hobbies. He'd also shot the 'Imagine' programme about me for Alan Yentob and the BBC in 2011. I have a very good working relationship with him and he's now a close friend. We'd always wanted to make another programme, and taste was something that fascinated us. Channel 4 liked the idea, so we got commissioned to make a three-part series. It was called 'All in the Best Possible Taste', and was broadcast in the summer of 2012.

We divided the three programmes up by class, rather than age or gender, say, because taste is the most potent sign-system within class. Channel 4 were keen that I took authorship of the series, and they wanted me not only to have artistic input into the programmes but also to create an actual artwork. Telly being telly, they wanted it yesterday! But most of the media I work in are very slow and I didn't want to commit myself to a huge long series of works. Tapestries are rich with the resonance of the 'tapestry of life' and they also have the advantage of being a relatively quick way to make fairly monumental works. They are essentially drawings expanded into quite satisfying and substantial objects. I decided on the spot that I would make six tapestries. That seemed like a good number to form a series. The obvious parallel was *A Rake's Progress* by Hogarth, which I've worked with before [see p. 77], and which is also a journey through British society. Hogarth's story is about Tom Rakewell, who inherits a fortune and gambles it away before dying in a madhouse; my story is about Tim Rakewell and his ascent up the ladder of class mobility before he meets his own tragic end.

I filmed the series over the summer of 2011. We went to Sunderland to film working-class culture, to Tunbridge Wells to film middle-class culture and to the Cotswolds for the upper classes. I called it my safari through the taste tribes of Britain. I made a few notes and doodles, and took photographs of things that caught my eye as I travelled around. These notes and pictures were the main source material for the tapestries, and I ended up literally weaving the characters I met into the narrative. When I got back to London I started thinking about the journey of a central character, from birth to death. I wanted each tapestry to have some sort of religious resonance too, so each one is based on a religious scene, some taken from specific examples of Renaissance paintings, including Masaccio's *Expulsion from the Garden of Eden*, Grünewald's Isenheim Altarpiece [p. 160] and Rogier van der Weyden's *Lamentation*. Woven into each tapestry are also bits of text, each one in the voice of one of the characters, and a small dog, a homage to Hogarth's much-loved pug, Trump.

The tapestries tell the story of class mobility. I think nothing has as strong an influence on our aesthetic taste as the social class in which we grow up. I was interested in the emotional investment we make in the things we choose to live with, wear, eat, read and drive. This emotional charge is what draws me to a subject.

I'd nearly finished the first tapestry before I bought my high-tech drawing screen. That's how I tend to do things; I learn on the job. So I did the later ones on this clever draw-on computer screen. It's very easy and natural because you draw with a stylus directly onto the screen, making marks in real time. You can change the width, the style, the opaqueness, everything. Someone from the tapestry workshop came over to tutor me for a couple of days and improve my basic Photoshop skills. I learned how to clean up the black-and-white drawing, because you get a lot of stray pixels, and how to work with layers, which is the basic principle of Photoshop. Before, I would draw with a pen and then colour in the drawing with flat colours, using the programme like a sophisticated colouring book, but now I can work with brushes, paints, crayons, transparency – all sorts of things.

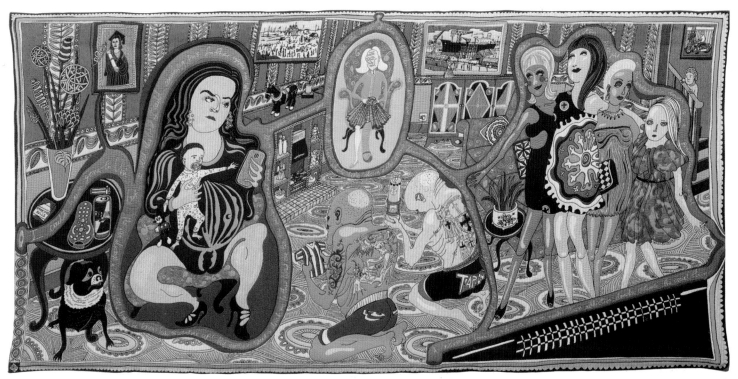

The Adoration of the Cage Fighters

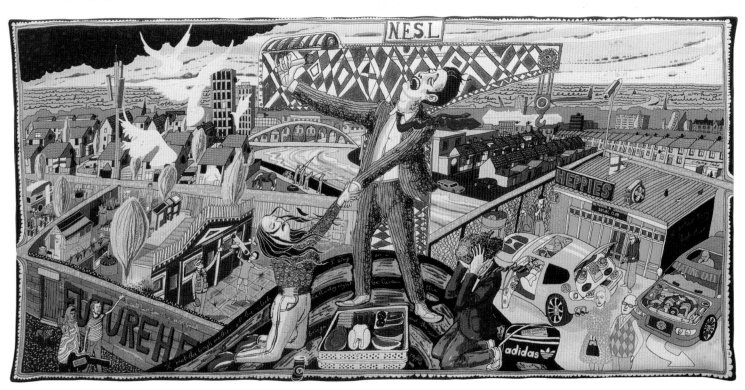

The Agony in the Car Park

The first scene is set in a grannie's front room in Sunderland and shows Tim as a baby with his mother. Her mates have come round to take her out for a night on the town. There's a graduation portrait on the wall, education being the big driver of social mobility, a Lowry painting, a picture of ship-building, Red Bull, fags and the TV remote control. The cage-fighters offer up symbolic membership of the working class in the form of a baby-sized Sunderland football shirt and a miner's lamp.

In the next image, Tim's mother has fallen for a club singer at Heppies, the Hepworth and Grandage Social Club; as he croons away Tim covers his ears in embarrassment. In the foreground there's a meat raffle. There are also allotments; horses grazing round council estates; old miners' cottages; the football ground; and custom cars. The colourful shed at the left is Britain's only listed pigeon cree. The letters 'NESL' stand for North East Shipbuilders Limited, the final incarnation of the shipyards. In the bottom right corner is Mrs Thatcher and a businessman type, pioneering the upwardly mobile society that will enable Tim to climb the social ladder. He's already interested in computers; he's got *Your Computer* magazine in his bag.

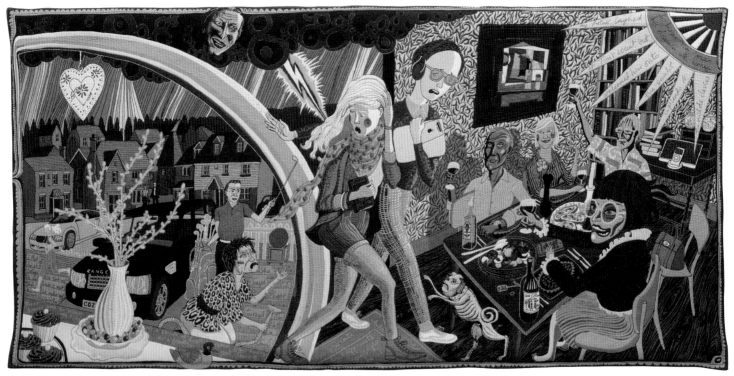

Expulsion from Number 8 Eden Close

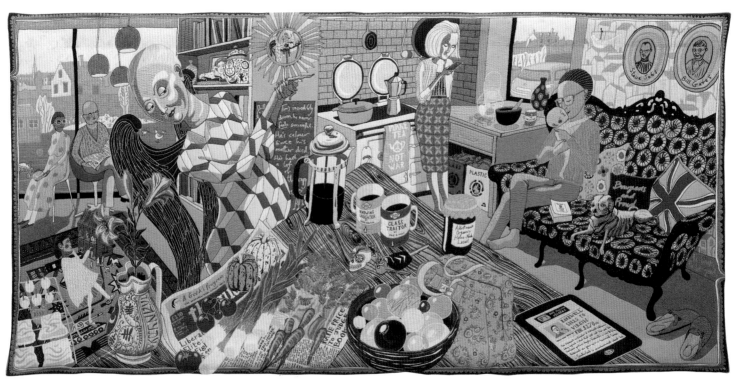

The Annunciation of the Virgin Deal

Here, Tim is expelled from King's Hill, an estate we went to near Tunbridge Wells, after his mother accuses him of being a snob. It was like *The Truman Show*, a complete facsimile of a community. The two words you'd hear time and again were 'convenience' and 'security'. Tim has now been to university, met his nice middle-class girlfriend, and rejects his

former life, turning himself out from the lower-middle-class paradise of cupcakes, jogging and hoovering the AstroTurf lawn. He enters the middle classes via its central ritual of the dinner party, crossing over into the world of olive oil, ciabatta and wine. The wallpaper is William Morris and there's a Ben Nicholson cafetière picture in the background.

In the next scene, Tim and his wife have reached the upper middle classes. He's just sold off his company, Rakewell Computing, to Virgin for £270 million. They're in a leafy suburb, surrounded by their Penguin mugs, recycling boxes, allotment organic, a Cath Kidston bag, a pebble bowl, reusable nappies. His wife leans against the Aga, Tweeting on her iPhone.

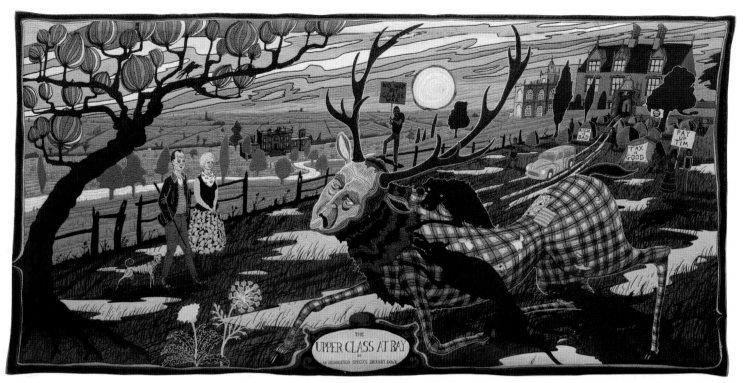

The Upper Class at Bay

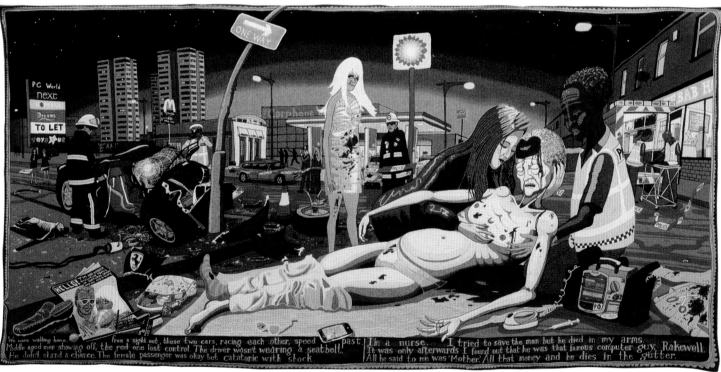

Lamentation

The fifth tapestry shows two stately homes and a vista of land. I had this feeling that the upper-class people I met were like a lost tribe hanging on as the forest is logged around them. Tim is in his Barbour jacket, his wife in her wellies and headscarf. They look a bit like Gainsborough's Mr and Mrs Andrews. He's bought the house off this old aristocrat who's being brought down by

tax, social change, upkeep, fuel bills – they're tearing away at his rather tattered tweed hide. There's a kind of Occupy protest on Tim's doorstep because he's not angelic; the protestors are saying, 'Pay up Tim', and 'Tax is good'.

In the final scene, our hero lies dead in the street. He's had a mid-life crisis, left his first wife and got a younger one, bought a Ferrari.

Showing off, he's rammed the new car into a lamppost in an Essex suburb. A passer-by who's a nurse cradles him in her arms as he dies. Her statement at the bottom says, 'It was only afterwards that I found out that he was that famous computer guy Rakewell. All he said to me was, "Mother". All that money and he dies in the gutter.'

notes

introduction mapping the world of grayson perry

1. Perry's exhibition at the British Museum in the autumn and winter of 2011–12, for example, attracted around 118,000 visitors, nearly 50 per cent more than anticipated by the museum. For references to Perry's column in *The Times* newspaper, see 'Articles by Grayson Perry' (p. 283). Perry's building project, a two-bedroom holiday home intended to be sited in Essex, is a collaboration with the architectural enterprise Living Architecture. Perry was elected a Royal Academician in May 2011.
2. For Perry's major media broadcasts, see 'TV and Radio' (p. 285).
3. Rosie Millard, 'Is this all a joke?', *Radio Times*, 29 October–4 November 2011, p. 18. Jeremy Hunt, Secretary of State for Culture, chose Perry's *Map of Nowhere* from the Government Art Collection in July 2010 and George Osborne, Chancellor of the Exchequer, selected *Print for a Politican* in November of the same year.
4. See, for example, Jonathan Jones, 'If I had a hammer...', *Guardian*, 5 May 2001, and Brian Sewell, 'A touch of smut with a hand from Saatchi', *Evening Standard*, 18 May 2001, pp. 28–29.
5. A profile of Perry was published in *ARTnews* in September 2012 ('Dressing for Success' by Elizabeth Fullerton, pp. 82–87), while a short piece appeared in *Art+Auction* magazine in November 2011 ('In the Studio: Grayson Perry' by Judd Tully, pp. 84–90) and a brief review of his work *The Walthamstow Tapestry* appeared in *Art in America* (March 2010, p. 160). *PARKETT* and *Art World* magazines commissioned longer features on Perry (in 2005 and 2009 respectively) but both focused on his transvestism rather than his work. The exhibition catalogue referred to is *Grayson Perry: Guerilla Tactics*, Amsterdam and Rotterdam: Stedelijk Museum/NAi Publishers, 2002.
6. Interview with Anna Somers Cocks, *The Art Newspaper*, 17 February 2012.
7. Perry is uncomfortable having his tapestries handmade by specialist weavers, since for large-scale works this is a hugely time-consuming and labour-intensive process. Instead, he works with Factum Arte, a technology and conservation company that adapts and cleans up his Photoshop files (made on a Wacom drawing screen using a stylus). The files are then passed on to programmers at Flanders Tapestries in Ghent, Belgium, where they are converted and made ready for transfer to the mechanical Jacquard loom.

chapter 1 beginnings

1. Unless otherwise cited, all Grayson Perry quotations in the book are taken from interviews conducted by the author between October 2007 and June 2008, and in March 2012.
2. Quoted in Louisa Buck, 'The Personal Political Pots of Grayson Perry' in *Grayson Perry: Guerilla Tactics*, p. 94.
3. A glossary of key technical terms is given here:

 Coiling A method of hand building clay forms by squeezing and rolling out lengths of clay which are coiled on top of one another to form a solid wall.

 Sgraffito drawing From the Italian word *graffiare* meaning 'to scratch'. A technique of scratching through one layer to reveal an underlying one, often of a contrasting colour.

 Slip A liquid clay, produced by suspending clay in water, which can be coloured by adding stains or oxides.

 Slip trailing A decorative technique in which slip is used as a medium for drawing, usually applied with a fine pointed dispenser such as a rubber syringe.

 Sprigging, or sprig moulding The application of sprigs, or relief ornaments, to a clay surface. Sprigs are made by pushing soft clay into a plaster or clay sprig mould.

 Transfer A picture or design – fixed to specially prepared transfer, or decal, paper – that can be transferred to a ceramic surface. When wet, the held print slides off and adheres permanently to the surface through firing.

 Open-stock transfer Transfer available to order from a series of commercially produced, mass-manufactured designs.

chapter 2 pottery and aesthetics

1. See, for example, 'Fear and loathing', *artists newsletter (Clay supplement)*, July 1994, p. 30, and 'Off centre: Theme park pottery, Bideford', *Ceramic Review*, no. 167, Sept/Oct 1997, p. 9.
2. Grayson Perry, 'A refuge for artists who play it safe', *Guardian*, 5 March 2005.
3. Quoted in Sarah Howell, 'Sex pots', *World of Interiors*, July 1993, p. 101.
4. Quoted in Lisa Jardine, 'Grayson Perry – very much his own man', in *Grayson Perry*, London: Victoria Miro Gallery, 2004, p. 7.
5. Bernard Leach, *A Potter's Portfolio: A Selection of Fine Pots*, London: Lund Humphries, 1951, p. 16.

chapter 3 class

1. Quoted in Wendy Jones, *Grayson Perry: Portrait of the Artist as a Young Girl*, London: Chatto & Windus, 2006, p. 22.
2. Philippa Perry in conversation with the author, 14 May 2008.
3. Quoted in Maria Alvarez, 'The provocative potter', *Daily Telegraph (Magazine)*, 14 April 2001.

chapter 4 war and conflict

1. Quoted in Jones, *Grayson Perry: Portrait of the Artist as a Young Girl*, p. 12.
2. Ibid.

chapter 5 sex and gender

1. *Grayson Perry: Ceramics*, text by Grayson Perry, London: Birch & Conran, 1987 [p. 3].
2. Quoted in an interview with Emiko Yoshioka in *My Civilisation: Grayson Perry*, Emiko Yoshioka (ed.), Kanazawa, Japan: 21st Century Museum of Contemporary Art, 2007, p. 62.
3. Quoted in Sheryl Garratt, 'Pot art and parenting', *Junior*, April 2004, p. 36.
4. Grayson Perry, video recording of his 'coming out ceremony' speech at the Laurent Delaye Gallery, Savile Row, London, 30 October 2000 (collection of the artist).

chapter 6 religion and folk culture

1. Grayson Perry, 'Essay' in *Grayson Perry: The Charms of Lincolnshire*, Lincoln: The Collection, 2006, p. 6.
2. Grayson Perry in an interview with Gavin Esler for 'Hardtalk Extra: Grayson Perry', first broadcast on BBC World News, 30 March 2007.

chapter 8 the art world

1. Quoted in Fiona Maddocks, 'It's easier to be a tranny than a craftsman...', *Evening Standard*, 17 July 2003, p. 43.

chapter 9 pilgrimage

1. Perry's blog (http://alanmeasles.posterous.com) was started in May 2010 and his Twitter account (http://twitter.com/Alan_Measles) opened the following month. Both are written in the voice of his teddy bear, his Twitter account purporting to come 'From the keyboard of the bodyguard and private secretary to our Beloved and Benign Dictator his Divine Excellency Alan Measles'.
2. *Grayson Perry: The Tomb of the Unknown Craftsman*, London: British Museum Press, 2011, p. 27.
3. In July 2012, following the success of Perry's three-part television series 'All in the Best Possible Taste' for UK network Channel 4, the channel announced that Perry had been signed up for a two-year deal as a celebrity presenter who, as 'artist-anthropologist', would explore and comment on different aspects of contemporary life.
4. D. H. Lawrence, 'The Ship of Death', 1930.

chronology

architectural commission

public collections

All collections are in the UK unless otherwise stated.

21st Century Museum of Contemporary Art, Kanazawa, Japan
Arts Council Collection

Birmingham Museums & Art Gallery
Brighton & Hove Museums
British Council Collection
The British Library (Map Library), London
British Museum, London
Chelmsford Museum
The Collection, Lincoln
Crafts Council
Everson Museum of Art, Syracuse, New York, USA
Gallery of Modern Art, Glasgow
Government Art Collection
House of Commons Collection
Leeds Museums and Galleries (City Art Gallery)
The Mint Museum, Charlotte, North Carolina, USA
Musée d'Art Moderne Grand-Duc Jean (Mudam),
 Luxembourg
Museum of Art, Rhode Island School of Design,
 Providence, Rhode Island, USA
Museum of Contemporary Ceramic Art, The Shigaraki
 Ceramic Cultural Park, Shiga, Japan
The Museum of Fine Arts, Houston, Texas, USA
The Museum of Modern Art, New York, USA
National Gallery of Victoria, Melbourne, Australia
Newark Museum, Newark, New Jersey, USA
Nottingham Castle Museum
The Potteries Museum & Art Gallery, Stoke-on-Trent
Stedelijk Museum, Amsterdam, The Netherlands
Tate
Towner Art Gallery, Eastbourne
Victoria & Albert Museum, London
Yale Center for British Art, New Haven, Connecticut, USA

solo exhibitions

All exhibition venues are in the UK unless otherwise stated.
Dates refer to the year in which each exhibition started.

1984 'Grayson Perry: Ceramics and Sculpture', James Birch
 Fine Art, London
1985 'Grayson Perry: Ceramics', James Birch Fine Art, London
1986 The Minories, Colchester
1987 'Grayson Perry: Ceramics', Birch & Conran, London
1988 'Grayson Perry', Birch & Conran, London
1990 'Grayson Perry: Recent Work', Birch & Conran, London
1991 'Grayson Perry', Garth Clark Gallery, New York, USA
1992 'Grayson Perry: Ceramics', David Gill Gallery, London
1994 Clara Scremini Gallery, Paris, France
 'Grayson Perry: New Work', Anthony d'Offay Gallery,
 London
1996 'Grayson Perry', Anthony d'Offay Gallery, London
2000 'Grayson Perry: Sensation', Laurent Delaye Gallery,
 London
 'fig-1: 50 projects in 50 weeks', 2–3 Fareham Street,
 London
2002 'Guerilla Tactics', Stedelijk Museum, Amsterdam, The
 Netherlands. Toured to Barbican Art Gallery, London
2004 'Grayson Perry: Collection Intervention', Tate St Ives
 'Grayson Perry', Victoria Miro Gallery, London
2005 Galleria Il Capricorno, Venice, Italy
2006 'Grayson Perry: The Charms of Lincolnshire',
 The Collection, Lincoln. Toured to Victoria Miro
 Gallery, London
 'Grayson Perry', Andy Warhol Museum, Pittsburgh,
 Pennsylvania, USA

2007 'My Civilisation: Grayson Perry', 21st Century Museum
 of Contemporary Art, Kanazawa, Japan
2008 'Grayson Perry: My Civilisation', Musée d'Art Moderne
 Grand-Duc Jean (Mudam), Luxembourg
2009 'The Walthamstow Tapestry', Victoria Miro Gallery,
 London
2011 'Grayson Perry: Visual Dialogues', Manchester Art
 Gallery, Manchester
 'Grayson Perry: The Tomb of the Unknown Craftsman',
 British Museum, London
2012 'The Vanity of Small Differences', Victoria Miro Gallery,
 London
 'Grayson Perry: The Walthamstow Tapestry', William
 Morris Gallery, London

selected group exhibitions

1981 'New Contemporaries', Institute of Contemporary
 Arts, London
1982 'New Contemporaries', Institute of Contemporary
 Arts, London
 Neo-Naturists, B2 Gallery, Wapping, London
1983 Standard-8 Films, B2 Gallery, Wapping, London
 'Small Works', Ian Birksted Gallery, Great Russell
 Street, London
1984 Film screening with Derek Jarman, Cerith Wyn Evans,
 John Maybury and Michael Kostiff, Institute of
 Contemporary Arts, London
1985 2nd Leicester International Super-8 Film Festival,
 Leicester
 Film screening, Diorama, London
 Brussels Film Festival, Belgium
 'Artists in Essex', Epping Forest District Museum
 and The Minories, Colchester
 Gallozzi e La Placa, New York, USA
 'Je ne comprends pas la raison', James Birch Fine Art,
 London
 'Curious Christian Art', James Birch Fine Art, London
1986 'Mandelzoom: Controllo e destino nei modelli della
 giovane arte internazionale', various venues near
 Viterbo, Italy (Centro Informazioni Centrale Nucleare
 di Montalto di Castro; Chiostro del Convento di San
 Francesco di Castro; Biblioteca Comunale di Marta;
 Convento del Santuario della Madonna del Monte
 di Marta)
1988 'Two from London/Two from Texas', Read Stremmel
 Gallery, San Antonio, Texas, USA
1989 'Art to Heart', Read Stremmel Gallery, San Antonio,
 Texas, USA
1990 'Words and Volume', Garth Clark Gallery, New York, USA
1991 'Essex Ware', Central Library, Chelmsford. Toured to
 Königsburg, Germany and Amiens, France
1992 'Fine Cannibals: Ideas and Imagery Cannibalised by
 Contemporary Makers', Oldham Art Gallery. Toured to
 Peter Scott Gallery, University of Lancaster; Stockport
 Art Gallery; Warrington Museum and Art Gallery
 'Art 2 Heart Two', Art Incorporated, Gallery of Fine Art,
 San Antonio, Texas, USA
1993 'The Raw and the Cooked: New Work in Clay in Britain',
 Barbican Art Gallery, London. Toured to The Museum
 of Modern Art, Oxford; Taipei Fine Arts Museum,
 Taiwan; Glynn Vivian Art Gallery, Swansea; The
 Shigaraki Ceramic Cultural Park, Shiga, Japan; Musée
 d'Art Contemporain, Dunkirk, France

1996 'Grayson Perry/Tracey Emin/Peter Land', Philippe
 Rizzo Gallery, Paris, France
 'Whitechapel Open', Whitechapel Art Gallery, London
 'Hot Off the Press: Ceramics and Print', Tullie House
 Museum and Art Gallery, Carlisle. Toured to Collins
 Gallery, Glasgow; Wolsey Art Gallery, Christchurch
 Mansion, Ipswich; Croydon Clocktower; Crafts
 Council Gallery, London; Peterborough Museum
 and Art Gallery; Oriel, Cardiff; Harris Museum and
 Art Gallery, Preston
 'Objects of Our Time', Crafts Council Gallery, London.
 Toured to Ormeau Baths Gallery, Belfast; Royal
 Museum of Scotland, Edinburgh; Glynn Vivian Art
 Gallery, Swansea; Manchester City Art Galleries;
 American Craft Museum, New York, USA
 'An Exhibition of Football', Gallery 27, 27 Cork Street,
 London
 'Techno Stitch: Art, Embroidery and Computerisation',
 Oldham Art Gallery
 Indigo Gallery, Boca Raton, Florida, USA
1997 'Craft', Richard Salmon Gallery, London. Toured
 to Kettles Yard, Cambridge
1998 Château de Sacy, Sacy-le-Petit, Picardy, France
 'Glazed Expressions', Orleans House, Twickenham,
 London
 'Over the Top', Ikon Gallery touring exhibition to
 Dudley College; Hodge Hill Girls School, Castle
 Bromwich; Holte School, Birmingham; Bewdley
 Library; The Living Gallery, Stourbridge College
1999 'Grayson Perry and Gillian Wearing', Hydra
 Foundation, Hydra, Greece
 'Decadence? Views from the Edge of the Century',
 Crafts Council Gallery, London. Toured to Harley
 Gallery, Worksop and The Bowes Museum,
 Barnard Castle
 'Contained Narrative', Garth Clark Gallery, New York, USA
 'The Plate Show', Collins Gallery, Glasgow
 '541 Vases, Pots, Sculptures and Services from the
 Stedelijk Collection', Stedelijk Museum, Amsterdam,
 The Netherlands
2000 'Three Decades – 30 Years of British Craft 1972–1999',
 The London Institute Gallery, London. Toured to
 Cleveland Art Centre and Glynn Vivian Art Gallery,
 Swansea
 'Protest and Survive', Whitechapel Art Gallery, London
 'The British Art Show 5', a National Touring Exhibition
 organized by the Hayward Gallery, London, for the Arts
 Council of England. Toured to Edinburgh (Scottish
 National Gallery of Modern Art, Royal Botanical
 Garden, City Art Centre, Talbot Rice Art Gallery,
 Stills Gallery, Fruit Market Gallery); Southampton
 (Southampton City Art Gallery, John Hansard Gallery,
 Millais Gallery, Southampton Institute); Cardiff
 (National Museum of Wales, Centre for Visual Arts,
 Chapter); Birmingham (Birmingham Museum and
 Art Gallery, Ikon Gallery)
 'A Sense of Occasion: Significant Objects Marking
 Diverse Contemporary Occasions', Craftspace Touring
 exhibition. Toured to mac, Birmingham; Harley
 Gallery, Worksop; Cheltenham Art Gallery & Museum
 and Gloucester City Museum; Shire Hall Gallery,
 Stafford; The Design Centre, Barnsley; The Bowes
 Museum, Barnard Castle; 20-20 One, The Visual Arts
 Centre, St John's Church, Scunthorpe; Welfare State

International, Lanternhouse, Ulverstone

'Britisk Keramik: British Ceramics.2000.dk', Keramikmuseet Grimmerhus, Middelfart, Denmark

2001 'New Labour', Saatchi Gallery, London

'Carts and Rafts: New Artisans in Contemporary Practice', Centenary Gallery, Camberwell College of Arts, London

'Looking With/Out: East Wing Collection No. 5', Courtauld Institute of Art, London

'Self-Portrayal', Laurent Delaye Gallery, London

'The Other Britannia/La Otra Britania/L'Altra Britania', Centro Cultural Tecla Sala, Barcelona, Spain (in collaboration with The British Council). Toured to Villa Iris, Fundación Marcelino Botín, Santander, Spain

'Invitation à ... Laurent Delaye Gallery invitée par la galerie Anton Weller', Galerie Anton Weller, Paris, France

2002 'The Galleries Show', Royal Academy of Arts, London

2003 'Hylands Sculpture Trail', Hylands House, Chelmsford

'Great Pots: Contemporary Ceramics from Function to Fantasy', The Newark Museum, Newark, New Jersey, USA

'Micro/Macro: British Art 1996–2002', British Council and Műcsarnok/Kunsthalle, Budapest, Hungary

'For the Record: Drawing Contemporary Life', Vancouver Art Gallery, Vancouver, Canada

'Thatcher', The Blue Gallery, Great Sutton Street, London

'Turner Prize 2003', Tate Britain, London

2004 'Extended Painting', Victoria Miro Gallery, London

'Homeland' (organized by Spacex and Relational Projects), various venues, Exeter

'A Secret History of Clay: from Gauguin to Gormley', Tate Liverpool

'Autumn exhibition', Geedon Gallery, Jaggers, Fingringhoe, Colchester

2005 'The Wonderful Fund Collection', Le Musée de Marrakech. Toured to Pallant House Gallery, Chicester

'Reveal: Nottingham's Contemporary Textiles', Nottingham Castle Museum

'Mixed-Up Childhood', Auckland Art Gallery Toi o Tāmaki, New Zealand

'Fairy Tales Forever: Homage to H.C. Andersen', ARoS Aarhus Kunstmuseum, Denmark

2006 'Eye on Europe: Prints, Books & Multiples/1960 to Now', The Museum of Modern Art, New York, USA

'Designing Truth', Stiftung Wilhelm Lehmbruck Museum – Zentrum Internationaler Skulptur, Duisburg, Germany

'The Compulsive Line: Etching 1900 to Now', The Museum of Modern Art, New York, USA

2007 'Hugh Stoneman: Master Printer', Tate St Ives

'The Neo Naturists: Christine Binnie, Jennifer Binnie, Wilma Johnson, Grayson Perry', England & Co, Westbourne Grove, London

'100 Years of Fashion Illustration', William Ling, Golborne Road, London

2008 'Love', Bristol City Museum and Art Gallery. Toured to Laing Art Gallery, Newcastle upon Tyne and The National Gallery, London

'History in the Making: A Retrospective of the Turner Prize', Mori Art Museum, Tokyo, Japan

'Dargerism: Contemporary Artists and Henry Darger', American Folk Art Museum, New York, USA

'Demons, Yarns and Tales: Tapestries by Contemporary Artists', The Dairy, Wakefield Street, London. Toured to The Loft, NE 1st Court, Miami, Florida, USA; James Cohan Gallery, New York, USA

2009 'Clay Canvases: The Fine Art of Painted Ceramics', Gardiner Museum, Toronto, Canada

'Shout: Contemporary Art and Human Rights: Lesbian, Gay, Bisexual, Transgender and Intersex Art and Culture', Gallery of Modern Art, Glasgow

'Medals of Dishonour', British Museum, London

'Prints Charming', Liberty, London

'Conflicting Tales: Subjectivity (Quadrilogy, Part 1)', Burger Collection, Berlin, Germany

'British Subjects: Identity and Self-Fashioning 1967–2009', Neuberger Museum of Art, Purchase, New York, USA

'Fascination with the Foreign: China – Japan – Europe', Hetjens-Museum, Landeshaupstadt Düsseldorf, Germany

2010 'Quilts: 1700–2010', Victoria & Albert Museum, London

'Magnificent Maps: Power, Propaganda and Art', British Library, London

'Rude Britannia: British Comic Art', Tate Britain, London

'Psychoanalysis: The Unconscious in Everyday Life', Science Museum, London

'Aware: Art Fashion Identity – GSK Contemporary 2010', Royal Academy of Arts, London

2011 'Let the Healing Begin', Institute of Modern Art, Brisbane, Australia

'Penelope's Labour: Weaving Words and Images', Fondazione Giorgio Cini, Venice, Italy

'Measuring the World: Heterotopias and Knowledge Spaces in Art', Kunsthaus Graz, Austria

'From Picasso to Jeff Koons: The Artist as Jeweler', Museum of Arts and Design, New York, USA

curated exhibitions

2008 'Unpopular Culture: Grayson Perry Selects from the Arts Council Collection', De La Warr Pavilion, Bexhill on Sea. Toured to Harris Museum and Art Gallery, Preston; Royal Museum and Art Gallery, Canterbury; DLI Museum and Durham Art Gallery; Southampton City Art Gallery; Aberystwyth Arts Centre; Scarborough Art Gallery; Longside Gallery, Wakefield; Victoria Art Gallery, Bath

2011 'Grayson Perry: The Tomb of the Unknown Craftsman', British Museum, London

selected bibliography

SOLO EXHIBITION CATALOGUES

1987 *Grayson Perry: Ceramics*, text by Grayson Perry, London: Birch & Conran

1999 *Grayson Perry: Hydra*, Hydra, Greece and London: Hydra workshops and David Gill

2002 *Grayson Perry: Guerilla Tactics*, with a preface by Rudi Fuchs and essays by Marjan Boot, Andrew Wilson and Louisa Buck, Amsterdam and Rotterdam: Stedelijk Museum/NAi Publishers

2004 *Grayson Perry: Collection Intervention*, Susan Daniel-McElroy and Kerry Rice (eds), broadsheet with text of a talk by Grayson Perry and interview by Tim Marlow, St Ives: Tate St Ives

Grayson Perry, text by Lisa Jardine, London: Victoria Miro Gallery

2006 *Grayson Perry: The Charms of Lincolnshire*, Lincoln: The Collection

2007 *My Civilisation: Grayson Perry*, Emiko Yoshioka (ed.), Kanazawa, Japan: 21st Century Museum of Contemporary Art

2011 *Grayson Perry: The Tomb of the Unknown Craftsman*, London: British Museum Press

GROUP EXHIBITION CATALOGUES

1981 *New Contemporaries*, London: Institute of Contemporary Arts

1982 *New Contemporaries*, London: Institute of Contemporary Arts

1986 *Mandelzoom: Controllo e destino nei modelli della giovane arte internazionale*, Naples, Italy: Guida Editori

1989 *Art to Heart*, San Antonio, Texas, USA: Bexar County Hospital District

1992 *Fine Cannibals: Ideas and Imagery Cannibalised by Contemporary Makers*, with an essay by Hugh Adams, Stockport: Omega Print and Design

Art 2 Heart Two, San Antonio, Texas, USA: BCHD Development Corporation Charitable Foundation

1993 *The Raw and the Cooked: New Work in Clay in Britain*, Martina Margetts and Alison Britton (eds), Oxford: The Museum of Modern Art

1996 *Whitechapel Open*, London: Whitechapel Art Gallery

Hot Off the Press: Ceramics and Print, Paul Scott and Terry Bennett, London and Carlisle: Bellew Publishing in collaboration with Tullie House Museum and Art Gallery

Objects of Our Time, Martina Margetts, London: Crafts Council

An Exhibition of Football, London: Gallery 27

1997 *Craft*, text by Simon Watney et al., London: Richard Salmon Gallery/Edwardes Square Studios

1998 *Glazed Expressions*, Paul Scott (ed.), London: Orleans House

1999 *Decadence?* [limited edition pack of cards], London: Crafts Council Gallery

The Plate Show, Paul Scott (ed.), Glasgow: Collins Gallery

2000 *Protest and Survive*, London: Whitechapel Art Gallery

The British Art Show 5, London: Hayward Gallery Publishing

A Sense of Occasion: Significant Objects Marking Diverse Contemporary Occasions, Birmingham: Craftspace Touring

Britisk Keramik: British Ceramics.2000.dk, Tanya Harrod, Martin Bodilsen Kaldahl and Lise Seisbøll, Humblebæk, Denmark: Rhodos Forlag in collaboration with Keramikmuseet Grimmerhus

2001 *fig-1: 50 projects in 50 weeks*, Mark Francis, Cristina Colomar and Christabel Stewart (eds), London: Spafax Publishing in association with *tate: the art magazine*

New Labour, London: The Saatchi Gallery

Looking With/Out: East Wing Collection No. 5, London: Courtauld Institute of Art in association with Thames & Hudson

La Otra Britania, Santander, Spain: Fundación
Marcelino Botin

2002 Landscape, London: The Saatchi Gallery

2003 Micro/Macro: British Art 1996–2002, Budapest, Hungary:
Műcsarnok/Kunsthalle
For the Record: Drawing Contemporary Life, Daina Augaitis
(ed.), Vancouver, Canada: Vancouver Art Gallery

2004 A Secret History of Clay: from Gauguin to Gormley,
Simon Groom (ed.), London: Tate Liverpool in
association with Tate Publishing

2005 Revealed: Nottingham's Contemporary Textiles,
Nottingham: Nottingham City Museums and
Galleries
Mixed-Up Childhood, Janita Craw and Robert Leonard,
Auckland, New Zealand: Auckland Art Gallery
Toi o Tāmaki
Fairy Tales Forever: Homage to H.C. Andersen, Aarhus,
Denmark: ARoS Aarhus Kunstmuseum

2006 Eye on Europe: Prints, Books & Multiples/1960 to Now,
Deborah Wye and Wendy Weitman, New York, USA:
The Museum of Modern Art
Designing Truth, Duisburg, Germany: Stiftung
Wilhelm Lehmbruck Museum – Zentrum
Internationaler Skulptur

2008 Hugh Stoneman: Master Printer, London: Tate St Ives
in association with Tate Publishing
History in the Making: A Retrospective of the Turner Prize,
Tokyo, Japan: Mori Art Museum and Tankosha
Publishing Co.
Demons, Yarns and Tales: Tapestries by Contemporary Artists,
foreword by Christopher Sharp, introduction by
Sarah Kent, London: Banners of Persuasion

2009 Shout: Contemporary Art and Human Rights: Lesbian, Gay,
Bisexual, Transgender and Intersex Art and Culture, Glasgow:
Glasgow Museums Publishing
Medals of Dishonour, Philip Attwood and Felicity Powell,
London: British Museum Press

2010 Quilts 1700–2010: Hidden Histories, Untold Stories,
Sue Pritchard, London: Victoria & Albert Museum
Magnificent Maps: Power, Propaganda and Art, Peter Barber
and Tom Harper, London: British Library

2011 Penelope's Labour: Weaving Words and Images, Venice, Italy:
Fondazione Giorgio Cini
Measuring the World: Heterotopias and Knowledge Spaces in
Art, Peter Pakesch (ed.), Graz, Austria: Kunsthaus Graz
From Picasso to Jeff Koons: The Artist as Jeweler, Diana
Venet, New York, USA: Museum of Arts and Design

CURATED EXHIBITION CATALOGUES

2008 Unpopular Culture: Grayson Perry Selects from the Arts
Council Collection, London: Hayward Gallery Publishing

2011 Grayson Perry: The Tomb of the Unknown Craftsman,
London: British Museum Press

ARTIST'S BOOKS

1992 Grayson Perry, Cycle of Violence, London: Atlas Press
(2nd edition 2002)

BOOKS

1994 Paul Scott, Ceramics and Print, London: A & C Black

1995 Garth Clark, The Potter's Art: A Complete History of Pottery
in Britain, London: Phaidon

1997 Louisa Buck, Moving Targets: A User's Guide to British Art
Now, London: Tate Publishing (2nd edition 2000)

1998 David Scott, Clays and Glazes in Studio Ceramics, London:
Crowood Press

1999 Brenda Pegram, Painted Ceramics, London: Crowood Press
Edmund de Waal, Design Sourcebook Ceramics, London:
New Holland Publishers
Josie Warshaw, The Complete Practical Potter:
A Comprehensive Guide to Ceramics, with Step-by-Step
Projects and Techniques, London: Lorenz Books
Eric Yates-Owen and Robert Fournier, British Studio
Potters' Marks, London: A & C Black

2000 Jeffrey Jones, 'Grayson Perry: The pot is the man', in
Julian Stair (ed.), The Body Politic: The Role of the Body and
Contemporary Craft, London: Crafts Council, pp. 96–102

2001 Mark Del Vecchio, Postmodern Ceramics, London:
Thames & Hudson

2003 Virginia Button, The Turner Prize: Twenty Years, London:
Tate Publishing
Ulysses Grant Dietz, Great Pots: Contemporary Ceramics
from Function to Fantasy, Madison, Wisconsin, USA:
Guild Publishing
Sharon Kivland and Lesley Sanderson (eds),
Transmission: Speaking & Listening, vol. 2, Sheffield:
Sheffield Hallam University/Site Gallery
Edmund de Waal, 20th Century Ceramics, London:
Thames & Hudson
100: The Work that Changed British Art, introduction
by Charles Saatchi, text by Patricia Ellis, London:
Jonathan Cape in association with The Saatchi Gallery

2005 Uta Grosenick (ed.), Art Now Vol. 2, Cologne and
London: Taschen
The Wonderful Fund Collection, London: The Wonderful Fund

2006 Wendy Jones, Grayson Perry: Portrait of the Artist as
a Young Girl, London: Chatto & Windus
Etienne Lullin and Florian-Oliver Simm (eds),
Contemporary Art in Print: The Publications of Charles
Booth-Clibborn and his imprint The Paragon Press
2001–2006, London: The Paragon Press and
Contemporary Editions Ltd
Caroline Wiseman, Modern Art Now: From Conception
to Consumption, London: Strawberry Art Press
Sound and Fury: The Art of Henry Darger, text by Edward
Madrid Gomez, New York, USA: Andrew Edlin Gallery

2007 Cally Blackman, 100 Years of Fashion Illustration, London:
Laurence King
Cigalle Hanaor (ed.), Breaking the Mould: New Approaches
to Ceramics, London: Black Dog Publishing
Katharine Stout with Lizzie Carey-Thomas (eds),
The Turner Prize and British Art, London: Tate Publishing

2008 Judith S. Schwartz, Confrontational Ceramics,
Philadelphia, Pennsylvania: University of
Pennsylvania Press

2009 Emmanuel Cooper, Contemporary Ceramics, London:
Thames & Hudson
Imogen Racz, Contemporary Crafts, Oxford: Berg

2010 Christopher Dell (ed.), What Makes a Masterpiece?
Encounters with Great Works of Art, London: Thames
& Hudson

2011 Lucinda Hawksley, 50 British Artists You Should Know,
London: Prestel
Michael Petry, The Art of Not Making: The New
Artist/Artisan Relationship, London: Thames & Hudson
Edmund de Waal, The Pot Book, London: Phaidon
Art, Power, Diplomacy: The Untold Story of the Government
Art Collection, contributions by Richard Dorment,
Adrian George, Penny Johnson, Cornelia Parker,
Andrew Renton and Julia Toffolo, London: Scala
Publishers

2012 Hossein Amirsadeghi (ed.), Sanctuary: Britain's Artists
and Their Studios, London: Thames & Hudson

2013 Anna Moszynska, Sculpture Now, London: Thames
& Hudson

ARTICLES BY GRAYSON PERRY

The Times

Perry wrote a column for The Times from 7 September 2005
to 24 October 2007. A selection is listed here:

2005 'Forget Trinny and Susannah – I'll make my own taste,
thanks', 21 September
'The emotional kitchen that cooks up our dreams
is a steamy, messy place', 2 November

2006 'Does therapy "cure" the artistic impulse?', 4 January
'It's all me, me, me', 11 January
'It's a private view and I'm on public display',
25 January
'Child death and rural voodoo: My delight in the
dark side', 1 February
'Yes, performance art is extreme and silly, but it does
have a point', 22 March
'Let the artisans craft our future', 5 April
'From cod and chips to sequined codpiece', 14 June
'My self-esteem goes under the hammer', 21 June
'Why do I go on making an exhibition of myself?',
5 July
'Orgasms in marble? No, Radio 4 does it for me',
4 October
'It's not a drag to be the centre of attention',
20 December

2007 'Forgery is the sincerest form of flattery', 4 April
'A catwalk lesson after a fashion for all fine artists',
11 April
'Letting it all hang out: My life as a naked artist',
20 June
'What links François Boucher and Martin Parr?
They're in my art Top Ten', 5 September
'Bye, thanks, and now it's back to the wheel world',
24 October

Blog

Perry's blog, written in the voice of his teddy bear,
Alan Measles, was launched in May 2010. Postings have
commented on everything from Perry's adventures at
art fairs and literary festivals to happiness, consumerism
and the over-use of mobile phones in public.
http://alanmeasles.posterous.com

Other Articles

1994 'Fear and loathing', *artists newsletter (Clay supplement)*, July, p. 30

'Grayson Perry: Anarchic potter', *Ceramic Review*, no. 150, pp. 26–27

1997 'A Potter's Day', *Ceramic Review*, no. 163, p. 58

'Off centre: Theme park pottery, Bideford', *Ceramic Review*, no. 167, Sept/Oct, p. 9

2004 'Be still my beating art! I won the Turner, now which frock to wear?', *The Times (T2)*, 18 May, pp. 4–5

2005 'A refuge for artists who play it safe', *Guardian*, 5 March

'Who do you think you're calling an outsider?', *Evening Standard (Review)*, 16 August, p. 35

2007 'Censorship is based on fear, not sensitivities towards ethnic minorities', *The Art Newspaper*, December

'My life in fashion: Grayson Perry', *The Times*, 12 December

2008 'The way I see it: Grayson Perry', *New Statesman*, 3 April

'The last word: Grayson Perry on Britishness', *Art World*, issue 5, June/July, p. 146

2009 'Grayson Perry lassos thoughts with a pen', *Guardian*, 19 September

2010 'If you have ever felt a class apart, this column is for the likes of you', *Guardian*, 31 January

'Who cares about culture cuts when Top Gear is doing well in Poland?', *Guardian*, 12 May

'This is a healthy moment for art', *Guardian*, 31 May

2011 'My night and days at the British Museum', *Observer (The New Review)*, 18 September, pp. 8–11

2012 'Opinion: Grayson Perry on taste', *RA Magazine*, issue 115, Summer

ARTICLES AND REVIEWS

1982 David Dawson and Rob La Frenais, 'New image and Neo-Naturism', *Performance*, Oct/Nov, no. 19, pp. 5–7

1986 Patrick Hughes, 'Eccentric circles', *Harpers and Queen*, June, pp. 124–27

1987 Robin Dutt, 'Pottery comes of age', *Independent*, 15 September

Tom Baker, 'Pots', *The Face*, November, no. 91, p. 25

1988 Grayson Perry and Jonathan Sidney, 'Unsophisticated sophistication – the paradox of Grayson Perry', *Ceramic Review*, no. 112, pp. 24–26

1989 Louisa Buck, 'Art rage: Grayson Perry's unorthodox approach to ceramics', *Crafts*, no. 97, March/April, pp. 38–41

1993 Rhoda Koenig, 'Provocative pots', *HG [House & Garden]*, June, pp. 82–84

Sarah Howell, 'Sex pots', *World of Interiors*, July, pp. 100–1

1994 Ronald Kuchta, 'Acquired identities in contemporary ceramics', *Ceramics: Art and Perception*, no. 15, March, pp. 29–35

Lucinda Bredin, 'Learning at Claire's knee', *Observer (Review)*, 16 October, p. 8

1995 Deborah Norton and Paul Vincent, 'Grayson Perry', *Studio Pottery*, no. 13, Feb/Mar, pp. 18–21

Emmanuel Cooper, 'Grayson Perry – new works', *Crafts*, no. 133, pp. 56–57

2000 Rachel Campbell-Johnston, 'Perry: Perturbing, perverse or just potty?', *The Times*, 5 April, p. 18

Simon Grant, 'Trials of a transvestite potter', *Evening Standard*, 5 April, p. 35

Louisa Buck, 'UK artist Q&A: Grayson Perry', *The Art Newspaper*, no. 103, May, p. 69

K. Bevan, 'Grayson Perry', *Ceramic Review*, no. 184, p. 46

Alex Farquharson, 'Inside out', *Art Monthly*, no. 242, pp. 1–6

Ian Wilson, 'Thrilling balance: Grayson Perry – Zwischen Provokation und Schock/Between kitsch and shock', *Keramik Magazin/Ceramic Magazine*, no. 4, pp. 28–31

2001 Helen Sumpter, 'Look out! The tranny's gone potty', *Big Issue*, no. 428, 12–18 March

Maria Alvarez, 'The provocative potter', *Daily Telegraph (Magazine)*, 14 April

Waldemar Januszczak, 'At the Saatchi Gallery, you'll find proof that New Labour really is working', *Sunday Times (Culture)*, 29 April, pp. 10–11

Jonathan Jones, 'If I had a hammer...', *Guardian*, 5 May

Brian Sewell, 'A touch of smut with a hand from Saatchi', *Evening Standard*, 18 May, pp. 28–29

Faye Tzanetoulakou, 'Grayson Perry', *Kerameiki Techni: International Ceramic Art Review*, no. 39, December, pp. 39–43

2002 John Preston, 'Him and her big feats of clay', *Sunday Telegraph (Review)*, 8 September, p. 5

Rhoda Koenig, 'Potter of the perverse', *Independent (Review)*, 17 September

Nick Hackworth, 'Satirical guerrilla in our midst', *Evening Standard*, 24 September

Waldemar Januszczak, 'It's all wearing thin', *Sunday Times (Magazine)*, September

Damien Hirst, 'What a clay day', *Tatler*, October, pp. 44–46

2003 Kate McIntyre, 'Shock art on a pot', *Ceramic Review*, no. 199, Jan/Feb, pp. 24–27

Rachel Campbell-Johnston, 'Constant change can track...', *The Times*, 30 May

Malgorzata Sadowska, 'Pisk geniusza', *Przekroj*, Nr 28/3029, 13 July

Fiona Maddocks, 'It's easier to be a tranny than a craftsman...', *Evening Standard*, 17 July, p. 43

Jessica Berens, 'Frock tactics', *Observer (Magazine)*, 21 September, pp. 17–24

'Turner at 20', *Tate Magazine*, November

Stuart Jeffries, 'Top of the pots', *Guardian*, 21 November

Peter Aspden, 'Ceramics with a social agenda', *Financial Times*, 8 December

Louise Jury, 'Grayson Perry a surprise winner as the judges acknowledge a "subtle shock"', *Independent*, 8 December

Luke Leitch, 'Dressed for success', *Evening Standard*, 8 December, p. 7

Alan Riding, 'Transvestite potter wins Turner Prize in art', *New York Times*, 8 December

Rachel Campbell-Johnston, 'He's not as potty as he looks', *The Times*, 9 December, pp. 6–7

John Walsh, 'Skirting the issue', *Independent*, 10 December

Cosmo Landesman, 'I'm a man, a woman and a piece of art', *Sunday Times*, 14 December

2004 Ria Higgins (interview), 'A life in the day', *The Times*, 1 February, p. 62

Sheryl Garratt, 'Pot art and parenting', *Junior*, April, pp. 34–38

Liz Hoggard, 'Grayson Perry: The heraldry of the subconscious', *Selvedge*, issue 00, May/June, pp. 22–25

Tony Magnusson, 'Pots of gold', *Pol Oxygen*, issue 9, June

Beatrice Colin, 'Pot head', *Black Book*, Fall issue

Charlotte Cripps, 'Perry potter and the glittering prize', *Independent Review*, 27 September, p. 14

Rosie Millard, 'Potty about dressing up', *The Times (Body & Soul)*, 9 October, pp. 6–7

Arifa Akbar, 'Turner Prize winner charts his insecurities in pottery', *Independent*, 15 October, pp. 16–17

Caroline Boucher, 'Grayson's still hot to pot', *Observer (Review)*, 17 October

Lisa Jardine, 'Savaged by ceramics', *The Times (T2)*, 20 October

Mark Hooper, 'How fragile we are', *i-D Magazine*, November

2005 Shane Enright, 'Grayson Perry: Urbane guerrilla?', *Ceramics Monthly*, March

Duncan Fallowell, 'Tea with Grayson Perry', *PARKETT*, no. 75, pp. 6–14

2006 Lynn Barber, 'Grayson Perry: The Interview', *Observer*, 8 January, pp. 6–9

'The Charms of Lincolnshire', *Lincolnshire Life*, February

Mary Thomas, 'Art review: British artist's beautiful ceramics carry pointed messages', *Pittsburgh Post Gazette*, 19 April

Michael Odell (interview), 'This much I know', *Observer (Magazine)*, 25 June, pp. 10–11

Alastair Sooke, '"I don't go out of my way to shock"', *Daily Telegraph*, 26 June, pp. 26–27

Morgan Falconer, 'The Charms of Lincolnshire', *World of Interiors*, July, pp. 124–25

Hermione Eyre, 'What should I wear?', *Independent on Sunday*, 2 July, p. 27

Charlotte Higgins, 'The past, through a glass darkly', *Guardian*, 5 July

Louise Jury, 'From frocks to smocks: Perry's show celebrates rustic life', *Independent*, 5 July

Nick Hackworth, 'Poetic Perry shows the power of change', *Evening Standard*, 6 July

Waldemar Januszczak, 'The chamber of secrets', *Sunday Times*, 6 July, p. 17

Vinny Lee, 'These are a few of my favourite things', *The Times (Magazine)*, 8 July, pp. 64–69

Jonathan Jones, 'Perry's rural magic casts the right spell', *Guardian*, 10 July

Sarah Kent, 'Exhibition of the week', *Time Out*, 12 July

Sue Hubbard, 'The Charms of Lincolnshire', *Independent*, 14 July

Laura Cumming, 'Could he be stringing us along?', *Observer*, 16 July

Martin Coomer, 'Lincoln bounty', *Big Issue*, 24 July

Charles Darwent, 'The handmade tale: The strangely subversive rise of craft in art', *Modern Painters*, July–Aug, pp. 86–88

Caroline Smith, 'The girlie show', *Attitude*, August, pp. 20–21

Gabriel Coxhead, 'Ploughman's bunch', *Financial Times*, 1 August

Javier Pes, 'Costume drama', *Museum Practice*, Autumn, pp. 32–35

Marcus Field, 'Grayson Perry: The Charms of Lincolnshire', *Crafts Magazine*, Sept/Oct, pp. 63–64

Liz Hoggard, 'Grayson Perry: The Charms of Lincolnshire', *Selvedge*, issue 13, Sept/Oct, p. 89

Dominic Lutyens, 'Art houses', *Observer (Magazine)*, 22 October

Louise Taylor, 'Grayson Perry: The Charms of Lincolnshire', *Ceramic Review*, Nov–Dec

Anthony Barnes, 'Grayson Perry, carpet bomber, and his bear', *Independent on Sunday*, 10 December

John Walsh, 'Pot luck', *Independent*, 16 December

2007 Waldemar Januszczak, 'Tomorrow's old masters', *Sunday Times*, 1 April

D.H. Rosen, 'Parodies in pottery', *Japan Times*, 17 May

Janice Blackburn, 'Why go potty for ceramics?', *Financial Times*, 26 May

Naoko Aono, *GQ Japan*, June

Daily Yomiuri, 5, 6, 7, 8, 9 June

Lucy Birmingham Fujii, 'My Civilisation: Grayson Perry', *Metropolis*, 22 June

Daily Yomiuri, 26, 27, 28, 29 June

Ito Junji, *Signature*, Aug–Sept

Rachel Campbell-Johnston, 'A Turner for the worse', *The Times*, 2 October

Adrian Searle, 'Tenner for your thoughts', *Guardian*, 11 October

2008 Charles Darwent, 'Old hat or the new bag?', *Art Review*, April

Ken Johnson, 'An insider perspective on an outsider artist', *New York Times*, 18 April

Blake Morrison, 'Uncool Britannia', *New Statesman*, 1 May

Tom Lubbock, 'The neglected heroes of British art', *Independent*, 2 May

Rebecca Rose, 'Lunch with the FT: Grayson Perry', *Financial Times*, 3 May

Mark Brown, 'The face of a nation – but is it ours?', *Guardian*, 5 May, p. 3

Richard Cork, 'A land of loners, misfits and Mrs Thatcher', *Independent on Sunday*, 11 May

Sean O'Hagen, 'Before all the shouting started', *Observer*, 11 May

Waldemar Januszczak, 'Eee, it were grim back then', *Sunday Times*, 18 May

Tom Lubbock, 'Modesty blaze', *Independent*, 19 May

Rupert Christiansen, 'A treasure trove of gritty Britishness', *Daily Telegraph*, 28 May

Cathy Lomax, 'Grayson Perry: Unpopular Culture', *Daily Telegraph*, 3 June

Peter Campbell, 'In Bexhill', *London Review of Books*, 5 June

Andrew Lambirth, 'The savvy Mr Perry', *Spectator*, 7 June

Oliver Basciano, 'Unpopular Culture', *Art Review*, July

Vicky Richardson, 'Unpopular Culture', *Blueprint*, August

Michaela Crimmin, 'I want to make a temple', *RSA Journal*, Autumn

Annabel Freyberg, 'Spinning a yarn', *Daily Telegraph (Magazine)*, 1 November

Katie Kitamura, 'Grayson Perry: My Civilisation', *Contemporary*, issue 95, pp. 68–69

2009 Vici MacDonald, 'Grayson Perry: The artful dresser', *Art World*, issue 9, Feb/Mar, pp. 32–43

'Grayson Perry plans secular "temple for everyone"', *The Art Newspaper*, June, no. 203, p. 6

Luke Tebbutt, 'Grayson Perry is let loose on Liberty', *Guardian*, 20 August

Louisa Buck, 'Artist interview: "The *Guernica* of the credit crunch"', *The Art Newspaper*, September, no. 205, p. 40

Ossian Ward, 'A day in the life of Grayson Perry', *Time Out*, 24 September

'Grayson Perry defrocks for Frieze', interview, *Esquire*, October

Charlotte Higgins, 'Grayson Perry's The Walthamstow Tapestry goes on display in London', *Guardian*, 6 October

Jackie Wullschlager, 'Pot luck', *Financial Times*, 10 October

Waldemar Januszczak, 'Dressed to thrill', *Sunday Times (Culture)*, 18 October

Emmanuel Cooper, 'The conscious courting of controversy', *Crafts*, November/December, pp. 49–50

2010 Helen Weaver, 'Grayson Perry', *Art in America*, March, p. 160

Morgan Falconer, 'Review of *Grayson Perry*, Thames & Hudson', *World of Interiors*, April

Chay Allen, 'Grayson Perry: Jacky Klein', *The Art Book*, volume 17, issue 3, August, pp. 49–50

2011 Sarah Walters, 'Interview: Grayson Perry', *CityLife*, 28 January

Anna McNay, 'Grayson Perry: Visual dialogues', *Studio International*, 9 February

Peter Aspden, 'One man civilisation', *Financial Times*, 30 July, p. 8

Fiona Maddocks, 'In the studio: Grayson Perry', *RA Magazine*, issue 112, Autumn

Rachel Campbell-Johnston, 'I've had kidney stones, my bones are starting to ache and I'm going deaf...', *The Times*, 27 September, pp. 10–11

Jane Wright, 'Do not look too hard for meaning', *Metropolitan*, October, pp. 58–66

Harriet Walker, 'Grayson Perry', *Another*, October, pp. 114–121

Charlotte Higgins, 'Pots, pilgrims and a severed ponytail: Perry takes over the British Museum', *Guardian*, 4 October

Brian Sewell, 'Grayson Perry, British Museum – review', *Evening Standard*, 6 October

Mark Hudson, 'Grayson Perry: The Tomb of the Unknown Craftsman, British Museum', *The Arts Desk* (www.theartsdesk.com), 8 October

Laura Cumming, 'One man and his teddy', *Observer (Review)*, 9 October

Nigel Farndale, 'Grayson Perry is tired of living a double life', *Sunday Telegraph (Seven)*, 9 October, pp. 12–13

Camilla Long, 'I'm the new Jamie Oliver', *Sunday Times*, 9 October

Charles Spencer, 'I'll admit it: Grayson Perry's got pots of talent', *Telegraph*, 10 October

Waldemar Januszczak, 'Potty but brilliant tribute to the art of craft', *Sunday Times (Culture)*, 16 October, pp. 10–11

Susannah Frankel, 'High fashion meets "a little girl Margaret Thatcher". It's a very stylish collaboration', *Independent*, 19 October, pp. 24–25

Clive Joinson, 'Art Review: Grayson Perry at the British Museum', *New Statesman*, 21 October

'Grayson Perry calls art world "disengaged"', BBC News online, 25 October

Rosie Millard, 'Is this all a joke?', *Radio Times*, 29 October–4 November, pp. 18–21

Judd Tully, 'In the Studio: Grayson Perry', *Art+Auction*, November, pp. 84–90

Juliet Rix, 'Grayson Perry's holiday heaven and hell', *Telegraph*, 17 November

2012 Simon Jablonski, '20 Q&As: Grayson Perry', *Dazed Digital*, January

Anna Somers Cocks, 'Artist Interview: Grayson Perry', *The Art Newspaper*, 17 February

Decca Aitkenhead, 'Decca Aitkenhead meets Grayson Perry', *Guardian (G2)*, 26 March, pp. 6–9

Gerard Gilbert, 'Television Choices: From tattoos to tans – Grayson Perry's guide to Britain's tribes', *Independent*, 2 June

Katy Wheeler, 'Turner prize-winning eccentric Grayson Perry gives his verdict on Sunderland', *Sunderland Echo*, 4 June

Mark Hudson, 'In the Best Possible Taste with Grayson Perry, Channel 4, review', *Telegraph*, 5 June

Sue Steward, 'Grayson Perry: The Vanity of Small Differences, Victoria Miro – review', *Evening Standard*, 7 June

Travis Riley, 'Grayson Perry: The Vanity of Small Differences at Victoria Miro, London', *Aesthetica*, 9 June

Anthony Horowitz, 'Grayson Perry: What class am I? All three!', *Telegraph*, 10 June

Maya Davies, 'Grayson Perry weaves a titillating and tantalising tale of taste in new show', *It's Nice That*, 11 June

Rosie Millard, 'Grayson Perry: taste is as important as ever', *Radio Times*, 12 June

Susanna Rustin, 'Grayson Perry and Suzanne Moore on taste and class', *Guardian*, 15 June

Amelia Reynolds, 'Grayson Perry: The Vanity of Small Differences', *Whitewall*, 18 June

Jane Simon, 'Grayson Perry meets those with pots of cash on Channel 4 in last of series', *Mirror*, 19 June

Elizabeth Fullerton, 'Dressing for Success', *ARTnews*, September, pp. 82–87

TV AND RADIO

2001 'The Other Side: Grayson Perry and the Triumph of Innocence', Production Company: Ideal World, Director Cordelia Donohoe, first broadcast on Channel 4, 16 February

2003 'Contemporary Visions: Grayson Perry', Director Sue Aron, first broadcast on BBC Two, 6 October

'R.A.M.: Grayson Perry', Film made for VPRO (Dutch National Public Broadcasting Corporation), Director Jos van den Bergh, first broadcast on 14 December

2005 'Why Men Wear Frocks', Written and presented by Grayson Perry, Production Company: Seneca Productions, Director Neil Crombie, first broadcast on Channel 4, 16 February

2006 'The Interview: Grayson Perry', Presenter Carrie Gracie, Producer Kirsten Lass, first broadcast on BBC World Service, 18 January

'Spare Time', Written and presented by Grayson Perry, Production Company: Seneca Productions, Director Neil Crombie, first broadcast on More 4, 20 September

'The South Bank Show: Grayson Perry', Production Company: ITV Productions, Director Robert Bee, first broadcast on ITV1, 17 December

2007 'Desert Island Discs – Grayson Perry', Presenter Kirsty
Young, first broadcast on BBC Radio 4, 18 February
'Hardtalk Extra: Grayson Perry', Interview with Gavin
Esler, first broadcast on BBC World News, 30 March
'theEYE: Grayson Perry', Illuminations Media

2010 'Grayson Perry on Creativity and Imagination', Written
and presented by Grayson Perry, Producer Gavin
Heard, first broadcast on BBC Radio 4, 6 July
'With Great Pleasure', Written and presented by
Grayson Perry, Producer Christine Hall, first broadcast
on BBC Radio 4, 20 July
'Grayson on His Bike', Written and presented by
Grayson Perry, Producer Nicki Paxman, first broadcast
on BBC Radio 4, 1 November

2011 'Imagine – Grayson Perry: The Tomb of the Unknown
Craftsman', Presenter Alan Yentob, Director Neil
Crombie, first broadcast on BBC One, 1 November

2012 'All in the Best Possible Taste', Written and presented
by Grayson Perry, additional narration by Stephen
Mangan, Production Company: Seneca Productions,
first broadcast on Channel 4, 5 June, 12 June and
19 June
'Grayson Perry: In Confidence', Presenter Laurie
Taylor, Production Company: Associated Rediffusion
Productions, Director Roger Pomphrey, first broadcast
on Sky Arts, 6 August

acknowledgments

My thanks go to Grayson Perry for his openness, good
humour and great generosity of time and spirit; to
Philippa and Flo; to Victoria Miro and the staff at her gallery
for their invaluable support; to the numerous collectors,
curators and photographers who kindly gave their
assistance; to my commissioning editor, Jamie Camplin,
for his belief in this book, and in me; and to all those
who have been instrumental in the book's research
and production – Christine Antaya, Oriana Fox and,
at Thames & Hudson, Pauline Hubner, Ginny Liggitt,
Katie Morgan, Theresa Morgan, Sarah Praill, Abigail Shapiro,
Celia White and my sterling editor, Julia MacKenzie. My
special thanks go to my family for their love and continual
encouragement, especially my parents, Grandma Pat, James,
and my sister Suzy, to whom this book is dedicated.

picture credits

All works by Grayson Perry © 2013 the
artist and Victoria Miro Gallery, London

Photo SB/GP/VMG = Stephen Brayne,
courtesy of the artist and Victoria Miro
Gallery, London.
Photo SW/GP/VMG = Stephen White,
courtesy of the artist and Victoria Miro
Gallery, London

(l) = left, (r) = right, (a) = above, (b) =below

p. 1 Private collection, photo
SB/GP/VMG; pp. 2–3 Private collection,
New York, photo Eric Harvey Brown;
pp. 6–7 Photo SB/GP/VMG; p. 12
Collection of the artist, photo
SB/GP/VMG; p. 14 (l) Photo courtesy of
the artist; p.14 (r) Photo The Neo
Naturist Archive, courtesy England & Co;
p. 15 Anselm Kiefer, Nuremberg, 1982.
Acrylic, emulsion and straw on canvas,
280 × 380 (110¼ × 149⅝). © the artist; p. 16
John Tarlton, Hatfield Broad Oak family
picking potatoes, from John Tarlton's Essex:
A County and its People in Pictures
1940–1960, English Countryside
Publications, 1988. Photo © John
Tarlton; p. 17 (l) and (r) Photos courtesy
of the artist; pp. 18–19 Installation
subsequently destroyed, photos
courtesy of the artist; p. 20 Collection
of the artist; p. 21 Collection of the artist;
pp. 22–23 Collection of the artist;
pp. 24–25 Collection of the artist, photos
SB/GP/VMG; p. 26 Photo courtesy of the
artist; p. 27 Private collection, courtesy
England & Co, photo courtesy England
& Co; p. 28 James Birch, London, photo
SB/GP/VMG; p. 29 Collection Jane
England, photo courtesy England & Co;
pp. 30–1 James Birch, London, photos
SB/GP/VMG; p. 32 Collection of the artist,
photo SB/GP/VMG; p. 33 (l) Private
collection, photo courtesy England & Co;
p. 33 (r) Collection of the artist, photo
SB/GP/VMG; p. 34 James Birch, London,
photos SB/GP/VMG; p. 35 Private
collection; pp. 36–37 Louisa Buck,
London, photos SB/GP/VMG; p. 38
Collection of Victoria and Warren Miro,
photo SB/GP/VMG; p. 40 Bernard Leach,
Globular vase with folded rim, 20th
century. Stoneware with ash glaze,
18.3 × 14.2 (7¼ × 5⅝). © John Leach/Crafts
Study Centre 2009; p. 41 (l) and (r) Photos
courtesy of the artist; p. 42 (l) Location
unknown; p. 42 (r) Thomas Toft, English
slipware dish, 17th century. DIAM. 50.5
(19⅞). British Museum, London, photo
Peter J. Davey; p. 43 Photo Eric Great-Rex;
pp. 44–45 Collection of Mark Eden,
London, photos SB/GP/VMG; p. 46
Collection of the artist, photos
SB/GP/VMG; p. 47 Dimitris
Daskalopoulos collection, Greece,
photo Nikos Markou; p. 48 Chadha Art
Collection, The Netherlands, photo
SB/GP/VMG; p. 49 Private collection,
England, photo courtesy of the artist;
p. 50 (l) Kinkozan factory, painted by
Sozan, Vase with lilypads and fish, 19th
century. H. 58 (22⅞). The Haas Collection;
p. 50 (r) and p. 51 Collection of Victoria
and Warren Miro, photos SB/GP/VMG;
p. 52 From the collections of Glasgow
City Council, cared for by Culture and
Sport Glasgow (Gallery of Modern Art),
photo SB/GP/VMG; p. 53 Location
unknown, photo courtesy of the artist;

p. 54 Private collection, photo
davidtolley.com; p. 55 Collection
Sandeep Reddy, India, photo
SB/GP/VMG; p. 56 Private collection,
New York, photos Eric Harvey Brown;
p. 57 Collection of the artist, photo
SB/GP/VMG; p. 58 Private collection,
photo SB/GP/VMG; p. 59 Private
collection, photo SB/GP/VMG; p. 60
Private collection, photos SB/GP/VMG;
p. 61 Burger Collection, Hong Kong,
photo SB/GP/VMG; p. 62 Frank Gallipoli
Collection, photo SB/GP/VMG; p. 63
Collection Manchester City Galleries,
photo SW/GP/VMG; p. 64 Private
collection, photo SB/GP/VMG; p. 66 (l)
Photo Philippa Perry, courtesy of the
artist; p. 66 (r) George Cruikshank,
The British Beehive, 1867. Etching, 43.6 × 30
(17⅛ × 11¾); p. 67 William Powell Frith,
The Railway Station, 1862. Oil on canvas,
116.8 × 256.5 (46 × 101). Photo Royal
Holloway and Bedford New College,
Surrey/Bridgeman Art Library; pp. 68–69
The Saatchi Gallery, London, photos
SB/GP/VMG; p. 70 Collection of Charles
J. Betlach II, photo SB/GP/VMG; p. 71
Private collection, London, photo
SB/GP/VMG; pp. 72–73 Private collection,
photo SB/GP/VMG; p. 74 Courtesy Susan
D. Goodman Collection, New York, photo
SB/GP/VMG; p. 75 Private collection,
courtesy White Cube, London, photo
courtesy of the artist; p. 76 Private
collection, Stockholm, photo
SB/GP/VMG; p. 77 William Hogarth,
A Rake's Progress: The Rake at the Rose
Tavern, 1735. Etching and engraving,
35.5 × 41 (14 × 16⅛). Photo Eileen Tweedy;
p. 78 Collection of Paul E. Hertz and
James Rauchman, New York, photos
Eric Harvey Brown; p. 79 A. Clayton,
London, photos SB/GP/VMG; p. 80 (a)
and p. 81 Courtesy of the artist and
Victoria Miro Gallery, London, photos
Anna Arca; p. 80 (b) Jack Smith, After the
Meal, 1952. Oil on canvas, 112 × 121
(44⅛ × 47⅝). Photo Arts Council
Collection, Southbank Centre. © the
artist and Flowers East Gallery, London;
pp. 82–83 Collection of John A. Smith
and Vicky Hughes, London, photos
SB/GP/VMG; p. 84 Leeds Museums and
Galleries (City Art Gallery), photo ©
Leeds Museums and Galleries (City Art
Gallery) /Bridgeman Art Library; p. 85
The Collection, Lincoln, UK, photos
SB/GP/VMG; pp. 86–87 21st Century
Museum of Contemporary Art,
Kanazawa, photos SB/GP/VMG; p. 88
Courtesy of the artist and Banners of
Persuasion, photo SB/GP/VMG; p. 90
(l) and (r) Collection of the artist, photo
Stephen Brayne, courtesy of the Victoria
Miro Gallery, London; p. 91 (l) Photo
courtesy of the artist; p. 91 (r) Photo
Stephen Brayne, courtesy of the artist;
pp. 92–93 Collection Stedelijk Museum,
Amsterdam, photos Stedelijk Museum,
Amsterdam; p. 94 (b) American School,
Stowage of the British Slave Ship 'Brookes'
Under the Regulated Slave Trade Act of 1788.
Engraving. Photo Library of Congress,
Washington, D.C./Bridgeman Art
Library; p. 95 Programming Red Tape
Designs, assembling Nicola Bateman.
The Potteries Museum & Art Gallery,
Stoke-on-Trent (purchased as part of the
Contemporary Art Society's Special
Collection Scheme), photos SB/GP/VMG;
p. 96 Photo Rob Weiss; p. 97 Collection of
the artist, photos courtesy of the artist;
p. 98 (l) Brass plaque showing Oba

sacrificing leopards, 16th century.
38.5 × 32 × 5 (15⅛ × 12⅝ × 2). British
Museum, London; p. 98 (r) and p. 99
photos SB/GP/VMG; p. 100 Private
collection, courtesy White Cube,
London, photo Stephen White, courtesy
White Cube, London; p. 101 Private
collection, London, photos SW/GP/VMG;
p. 102 Ole Faarup R. Collection,
Copenhagen, photo SB/GP/VMG; p. 103
Private collection, photo SB/GP/VMG;
p. 104 Patricia Ferguson, photos
SB/GP/VMG; p. 105 Collection Jonathan
Goodman, London, photo Stephen
Brayne, courtesy Stedelijk Museum,
Amsterdam; p. 106 (a) Pieter Bruegel,
Hunters in the Snow, 1565. Oil on panel,
117 × 162 (46⅛ × 63¾). Kunsthistorisches
Museum, Vienna; p. 106 (b) and p. 107
The Saatchi Gallery, London, photos
Stephen Brayne, courtesy Stedelijk
Museum, Amsterdam; pp. 108–9 (a)
© Grayson Perry & The Paragon Press,
photo Prudence Cuming, courtesy The
Paragon Press; p. 110 Private collection,
photo courtesy of the artist; p. 111 Private
collection, photo Stephen Brayne,
courtesy Stedelijk Museum, Amsterdam;
p. 112 Private collection, photo courtesy
of the artist; p. 113 Private collection,
photo SB/GP/VMG; p. 114 and p. 115 (a)
Collection Sandra and Giancarlo
Bonollo, photos SB/GP/VMG; p. 115 (b)
Henry Darger, Untitled, date unknown.
From In the Realms of the Unreal. Mixed
media on paper, 55.9 × 106.7 (22 × 42).
Copyright Kiyoko Lerner, Courtesy of
Edlin Gallery, New York; p. 116 Courtesy
of the artist and Banners of Persuasion,
photo SB/GP/VMG; p. 117 Collection of
the artist, photo SB/GP/VMG; p. 118 21st
Century Museum of Contemporary Art,
Kanazawa, photo SB/GP/VMG; p. 119
Charlotte Chamberlain, USA, photos
SB/GP/VMG; p. 120 Collection Stedelijk
Museum, Amsterdam; p. 121 Photos
SB/GP/VMG; p. 122 Collection of Mario J.
Palumbo Jr, New York, photo
SB/GP/VMG; p. 124 Cover of The World of
Transvestism, Vol. 17, no. 9 © Swish
Publications, London; p. 125 (l) and (r)
Photos courtesy of the artist; p. 127 (l)
and (r) Claire, 2009, from 'Grayson Perry:
The Artful Dresser', Art World magazine,
issue 9, February/March 2009, pp. 35 and
36, photos Mark Read/Twenty Twenty
Agency; pp. 128–29 Charlotte
Chamberlain, USA, photos John White,
courtesy Garth Clark Gallery, New York;
p. 130 Elizabeth Roseberry Mitchell,
Graveyard quilt, 1839. Pieced appliqué
and embroidered cotton, 215.9 × 205.7 (85
× 81). Kentucky Historical Society; p. 131
Programming Red Tape Designs,
assembling Melissa Rigby. Collection
Stedelijk Museum, Amsterdam
(purchased with financial support from
the Mondriaan Foundation), photo
SB/GP/VMG; pp. 132–33 Programming
Red Tape Designs, assembling Melissa
Rigby. Collection of the artist, photos
SB/GP/VMG; p. 134 Collection David
Teiger, USA, photo SB/GP/VMG; p. 135
From the collections of Glasgow City
Council, cared for by Culture and Sport
Glasgow (Gallery of Modern Art), photo
courtesy of the artist; p. 136 Photo Rob
Weiss; p. 137 Collection of the artist,
photo SB/GP/VMG; p. 138 and p. 139 (b)
Programming Red Tape Designs,
dressmaker Sonja Harms. Purchased
for Nottingham Castle through the
Contemporary Art Society's Special

index

Page numbers in **bold** refer to illustrations